INSIDE PARIS

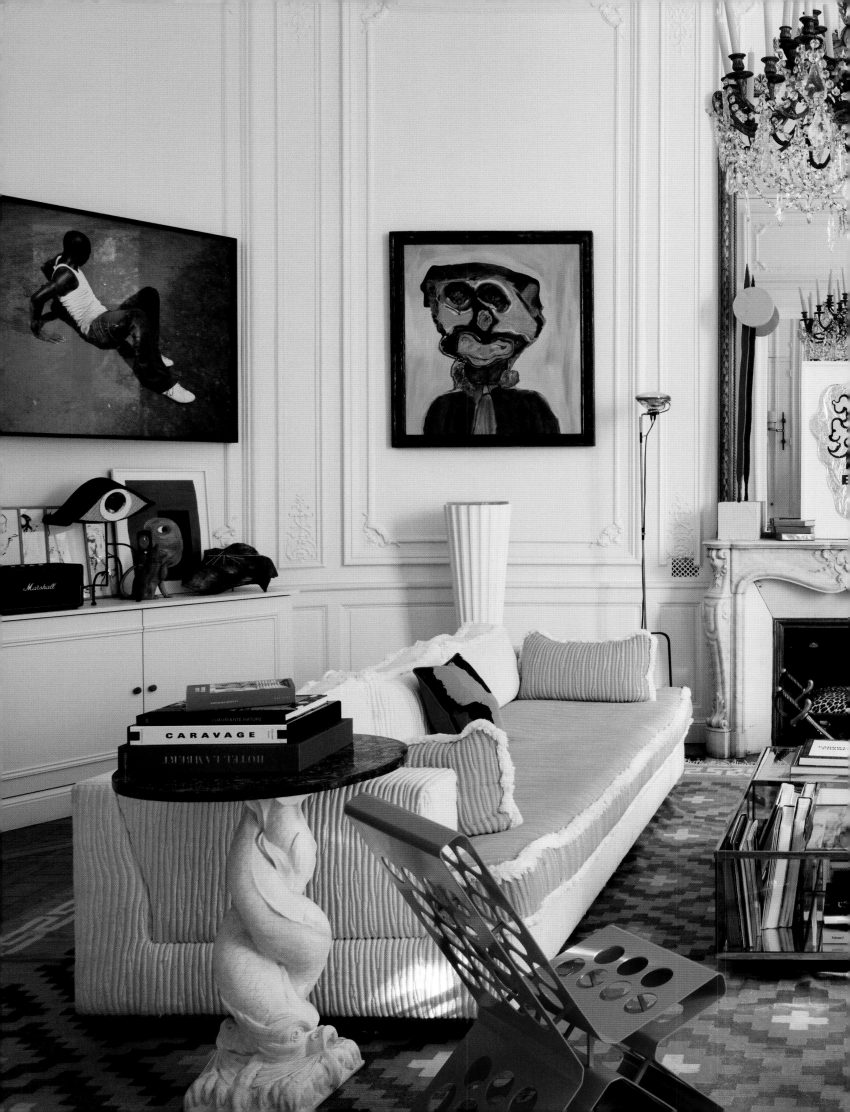

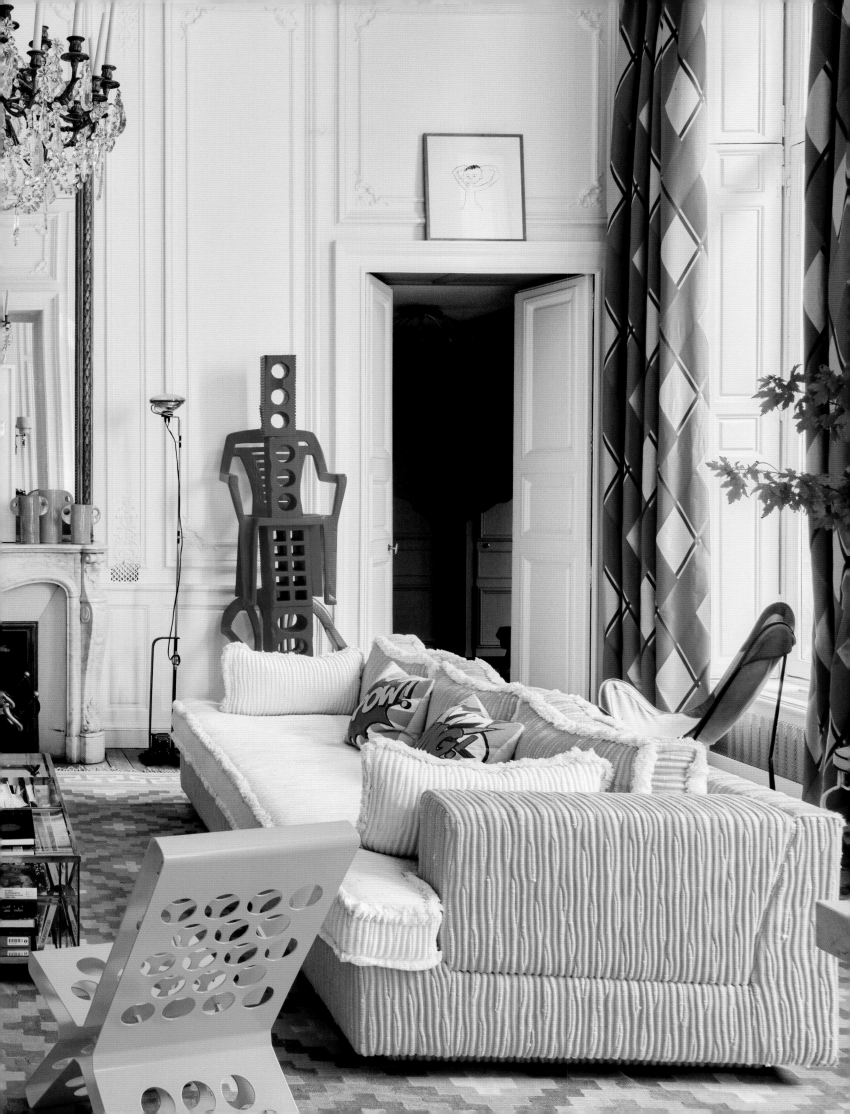

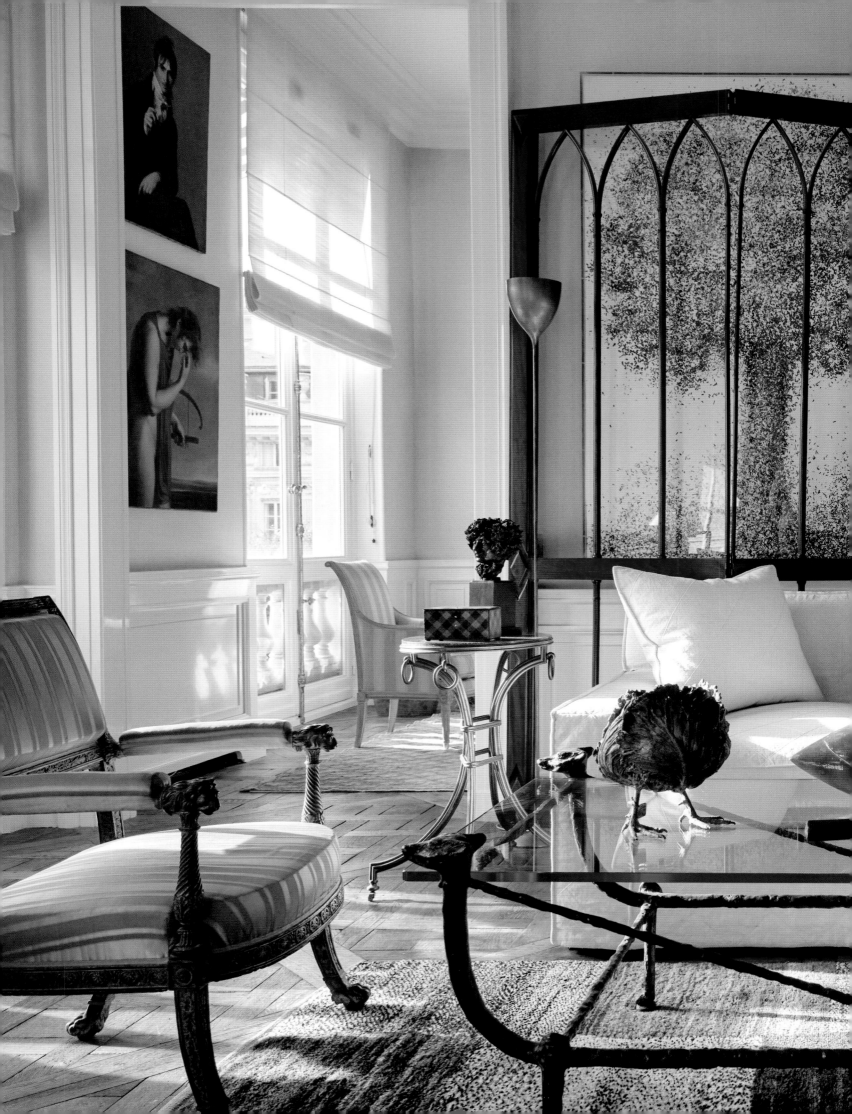

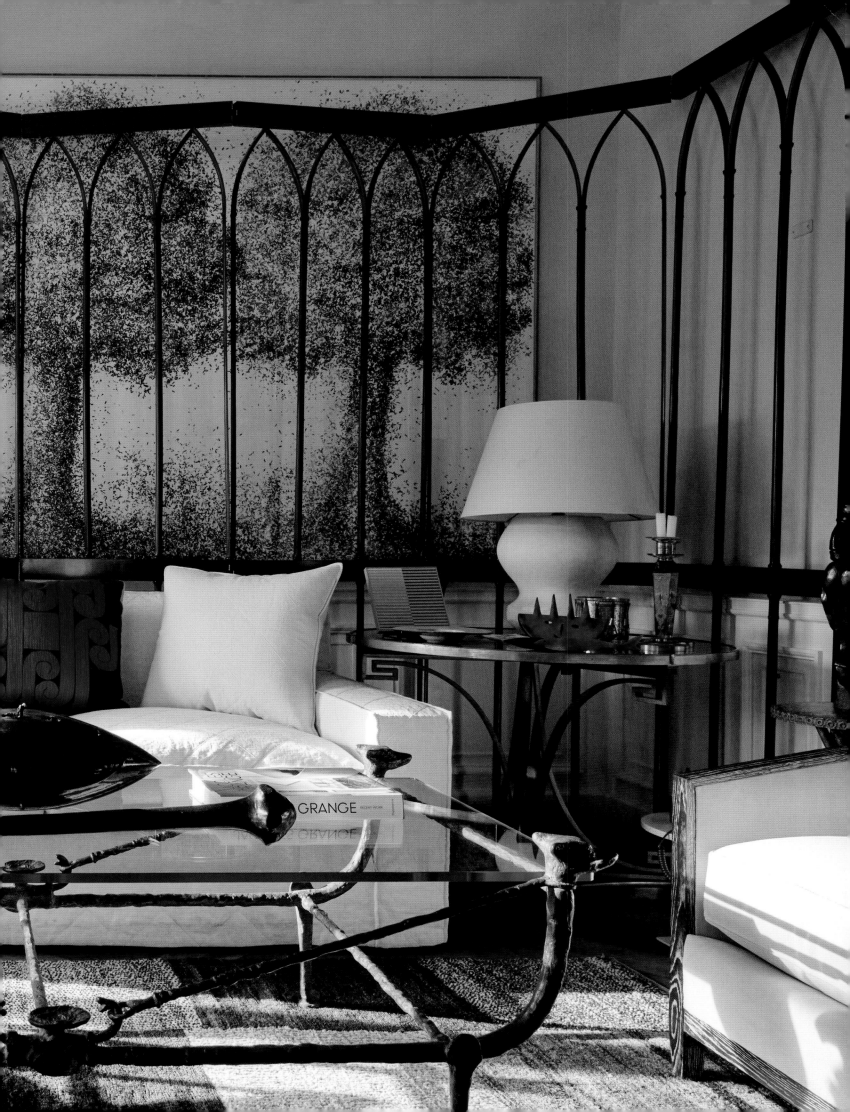

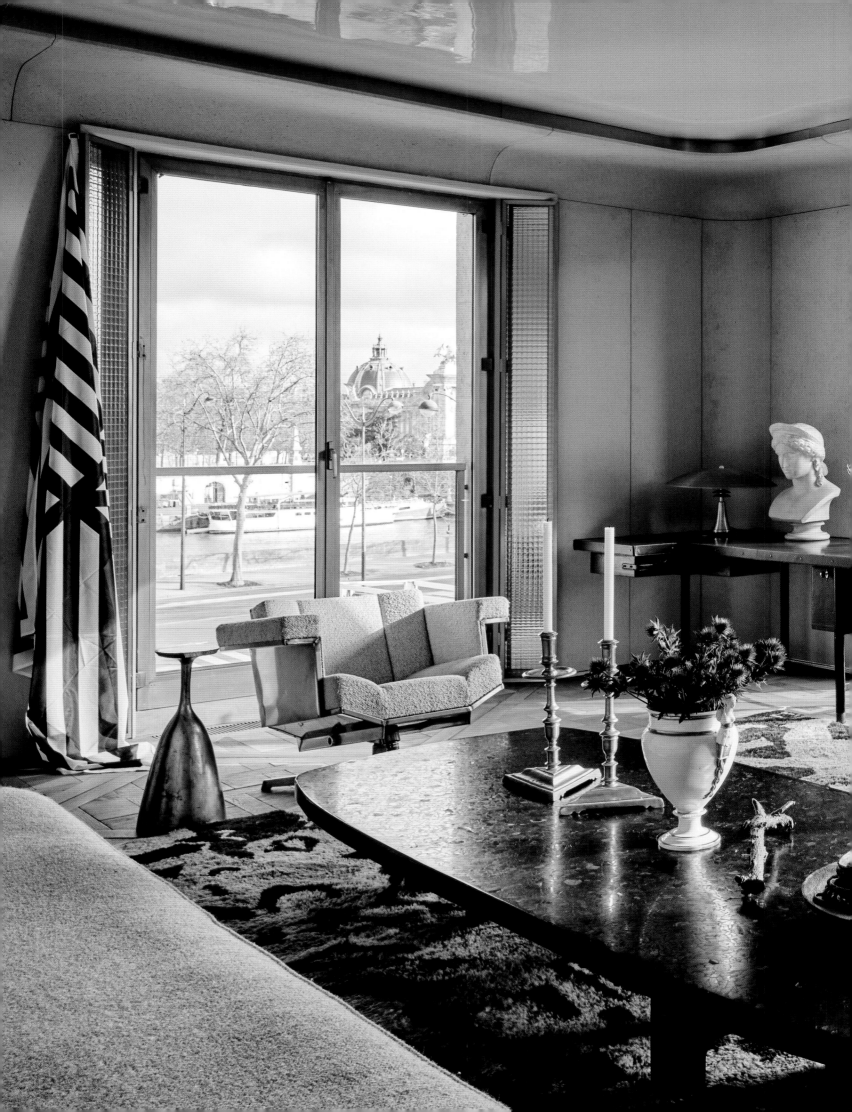

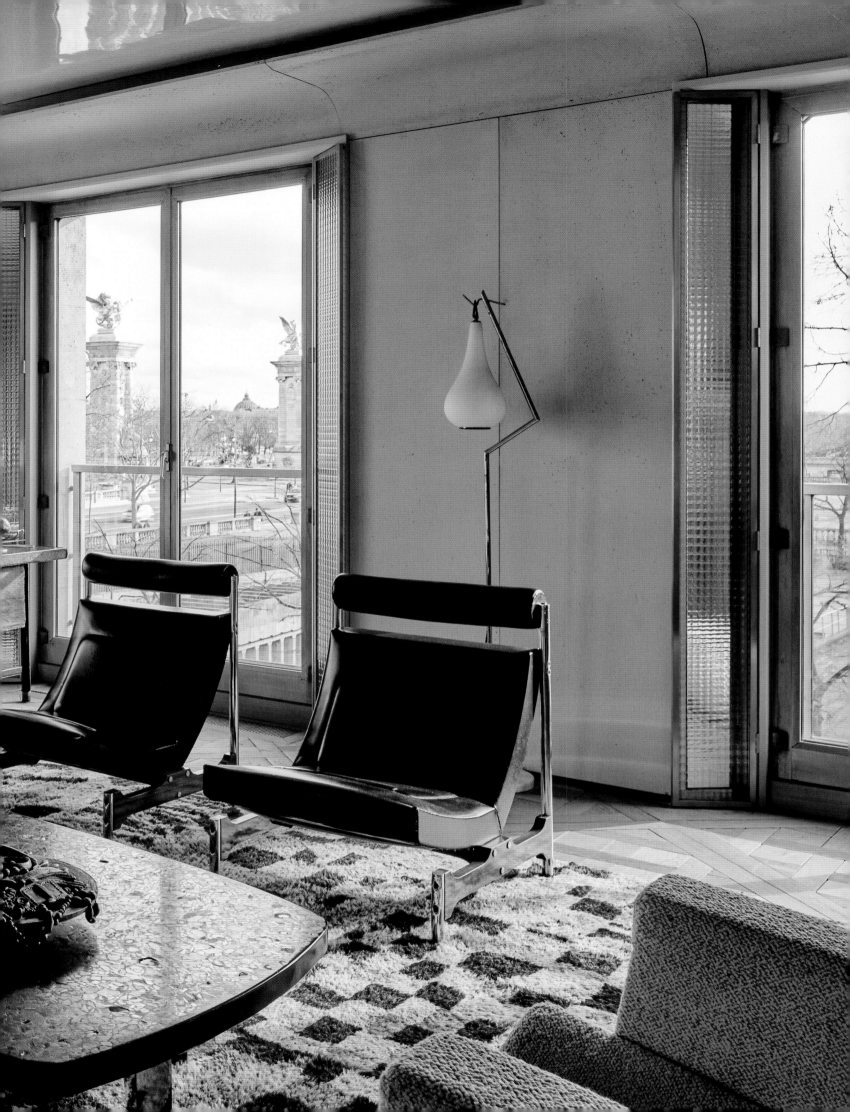

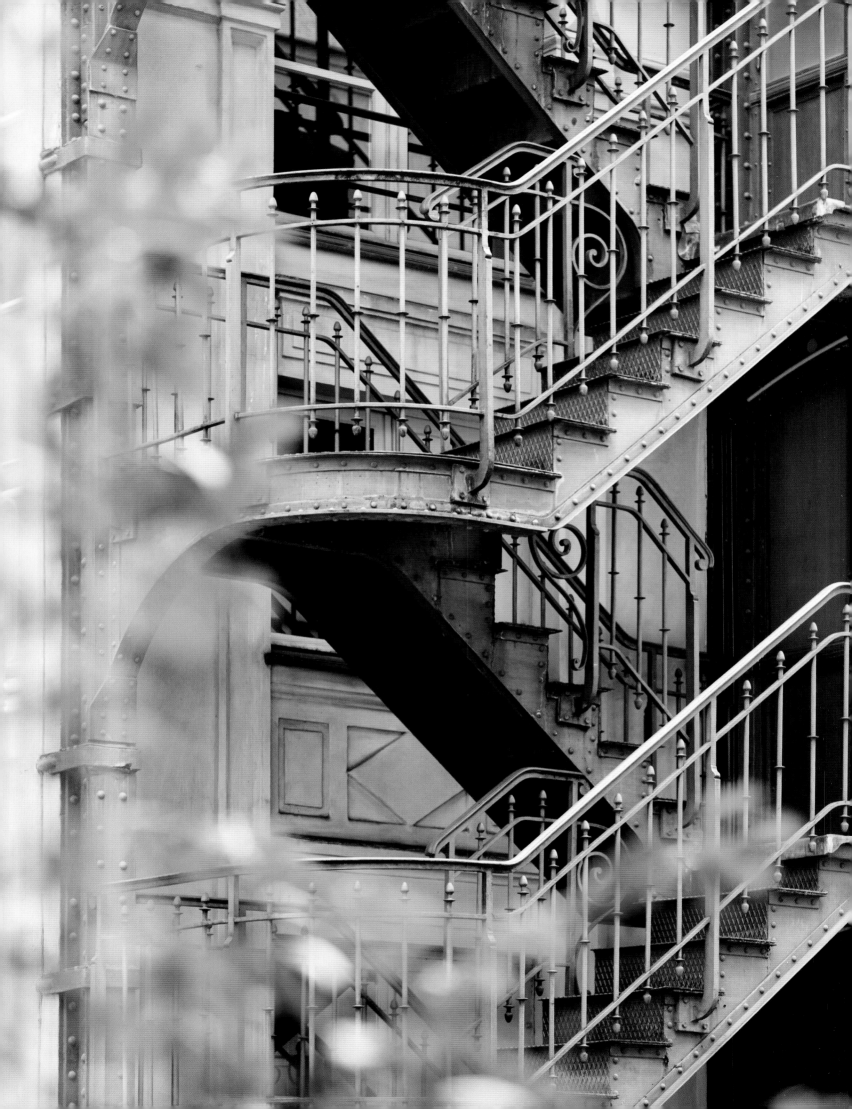

INSIDE PARIS

RICARDO LABOUGLE

FOREWORD BY MATHILDE FAVIER

VENDOME

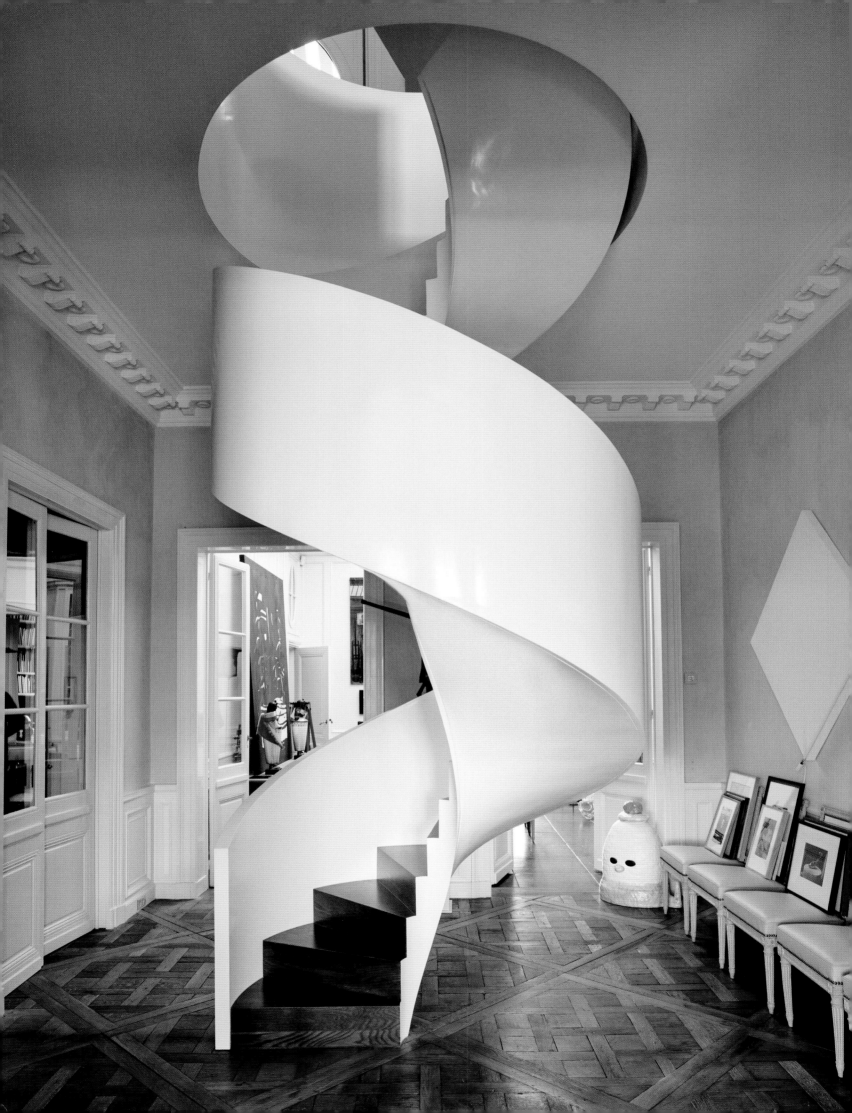

CONTENTS

FOREWORD

MATHILDE FAVIER

"Buenos Aires is the wife, Paris the mistress," as the Argentinians have been saying for generations. An enduring love affair has intricately bound these two cities since 1906, their passionate dance epitomized by the tango.

It is always said that Argentina and France are not so different—that Buenos Aires and Paris are very similar in their space, architecture, and style, shaped by Haussmann, and in the great beauty of both cities. Perhaps that is why Ricardo Labougle, as an Argentinian photographer, has instinctively selected iconic Parisians as his subjects and with his discerning eye captured every detail of their intimate spaces, and the nuances that define the essence of Paris. His photographs embody his charisma and charm.

I welcomed Ricardo into my home with immediate confidence, along with Jacques Grange, Terry de Gunzburg, Fifi Chachnil, and other luminaries whose exquisite taste defines Paris. It is with great pride that I sign the foreword of his book. These pages resonate with emotions, intrigue, and a sense of timeless elegance, eloquently illustrating the grandeur and allure that encapsulate the soul of my beloved city.

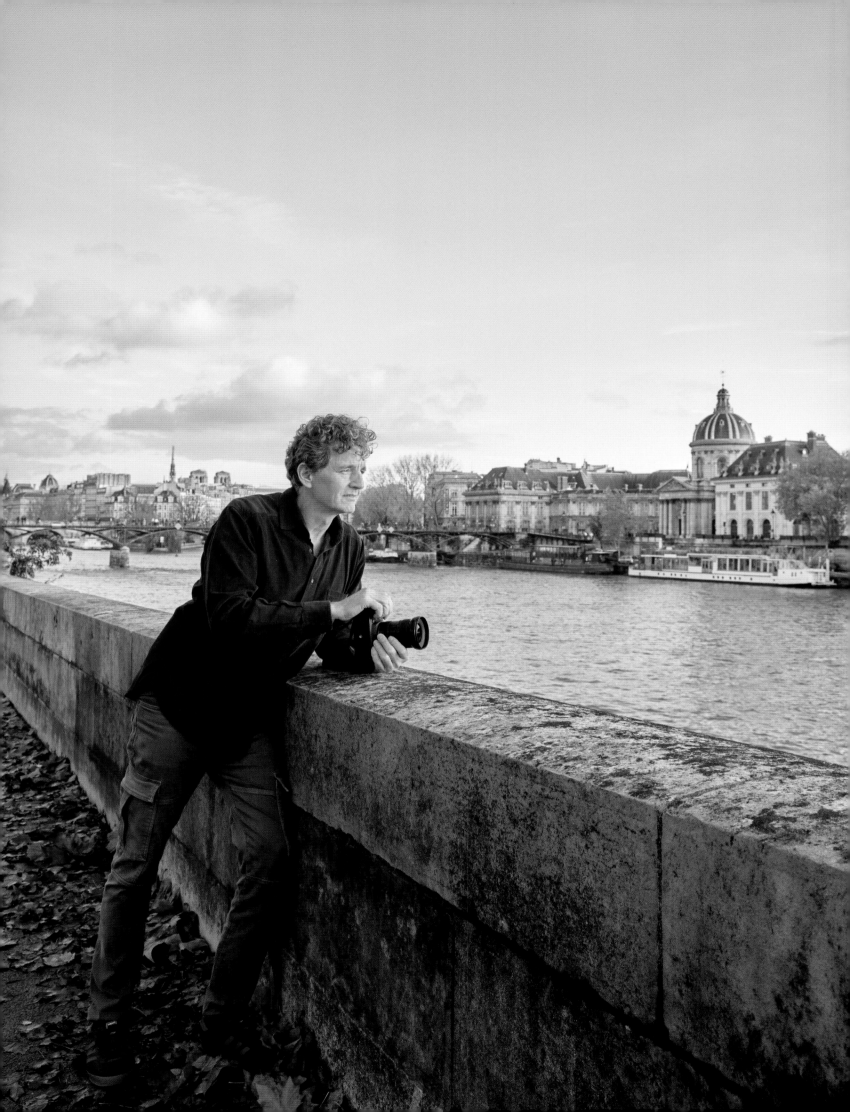

INTRODUCTION

RICARDO LABOUGLE

On my first trip to Europe, Paris was my first stop. I was twenty years old. At the time, I didn't realize that I was beginning a lifelong relationship, but Paris has been and continues to be an inexhaustible source of inspiration, both personally and professionally.

I find it difficult to express myself through words. My specialty is knowing how to look, and I like to think that my photos speak for me. I'm someone who takes risks, but once I accept a challenge, I dedicate myself to it and embrace it fully. When I began this project, my first step was to settle in Paris—I wanted to immerse myself in the city, to understand it, and to capture everything that happens here, as if I were myself a Parisian. The experience was more than positive, and I'm still not sure if I want it to end.

The City of Light is unique, seductive, timeless, breathing romance and creativity. Its streets tell stories of centuries past, and its imposing monuments project a sense of grandeur that transcends time. Couples hold hands and kiss openly, unafraid to show affection. With its changing light and its profound aesthetic changes in each season of the year, the city becomes the setting of a grand narrative, brightening the gray days of winter with the golden light of street lamps, staining autumn trees with colors, softening spring afternoons with the first cherry blossoms, and suffusing parks and riverbanks filled with people with brilliant summer sunsets.

The Seine is at the center of everything that happens in Paris, whether on the Rive Gauche or the Rive Droite—both sides of the river are equally enticing, and I can't say that I have a particular preference for either. The constant flow of energy across its bridges is invigorating. The river offers a connection to nature that is echoed in the city's green spaces. I was enchanted to discover that in Paris there are more gardens than I would have imagined, many of them tucked away. You will glimpse some of them in these pages.

One of the things that surprised me as I visited Parisian homes was the number of books I saw—in libraries, on tables and chairs, even in the kitchen. The writer Jorge Luis Borges imagined paradise as a library, and in France reading and literature have always been important. I believe this has resulted in a fluidity of thought and articulation that is evident in the way Parisians decorate their houses.

Whether for its vibrant character and bohemian spirit, its close connection to culture, or its perfect framing of beauty and elegance in all their forms, Paris is the ultimate epicenter of that driving force of lifestyle and state of mind known as *joie de vivre*. This attitude defines Parisians and is evident in their customs, particularly those surrounding food and fashion. Parisians have a heightened awareness of fashion—it is a part of life in the city and something you can feel around you.

I have been fortunate to get to know a little of the lives of some of the most outstanding professionals in the worlds of art, decoration, architecture, antiques, and fashion—some French born, and others who have come from elsewhere and made Paris their place in the world. I want to thank all of them for generously opening the doors of their homes to make this book possible. From the house of a seventeenth-century former governor of Paris to a 1960s flat with a twenty-first-century restoration, all the homes featured here have a character and an originality that convinced me to include them.

With this book, I invite you to join me on an intimate journey through a selection of Parisian interiors. These spaces bear witness to the lives and dreams of those who inhabit them. Each corner tells a story, each object carries with it a fragment of memory. The ability of these rooms to evoke emotions and awaken the imagination fascinates me, and I hope they can provoke the same sensations in you.

So, unleash your inner *flâneur* and join me on this journey inside Paris. Let's discover together the secrets that lie behind each door, and let ourselves be captivated by the beauty and charm of the interiors of the most beautiful city in the world.

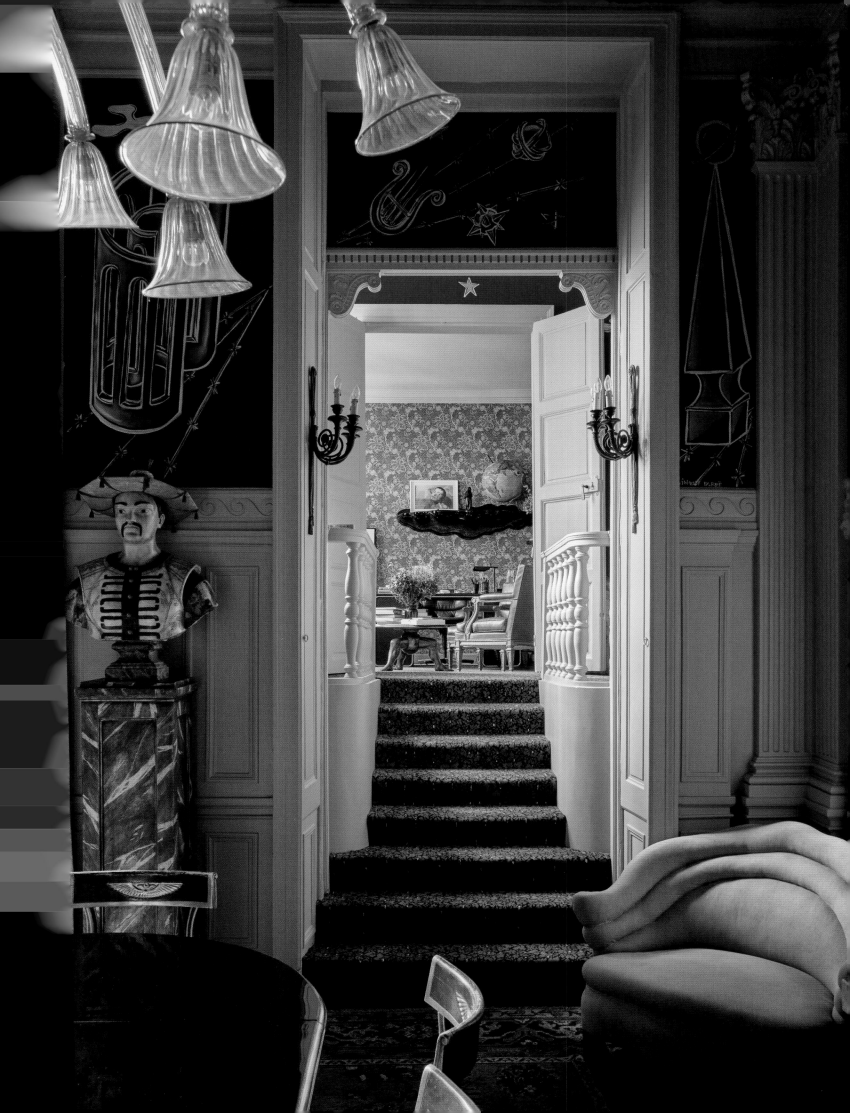

CLASSICAL/ HISTORICAL/ MAGNIFICENT.

JOSEPH ACHKAR
AND MICHEL CHARRIÈRE

Joseph Achkar and Michel Charrière are decorators and art lovers. Through the process of bringing back to life a seventeenth-century hôtel particulier, they found a way to express their idea of beauty. Once the residence of the Duke of Gesvres, built in 1652 by Antoine Lepautre, the house was being used as the headquarters of a bank when Joseph and Michel found it. They began their restoration by demolishing everything that did not belong to the original building and then gradually restored the original interior layout.

Upon entering, we come across the salle de garde, then, following the enfilade, the footmen's antechamber. Further on is the duke's room, and finally, a room of mirrors, unique in Paris for having survived intact since the seventeenth century. Its ceiling is painted by Louis de Boullogne, known for his frescoes in the Palace of Versailles. The room houses some historical gems: a seventeenth-century daybed in perfect condition and a console displaying Mongolian silverware from the same period. Other artworks include a portrait of the Duke of Berwick by the French artist Hyacinthe Rigaud and a bronze sculpture by Pompeo Leoni. With their incomparable vision and style, Joseph and Michel have, throughout the house, incorporated furniture, boiserie, and tapestries found in antique shops, as well as objects from their collection, formed over more than forty years of traveling the world.

Photographing this magical and history-laden environment was a dream for me, with the light that plays through the windows of the enfilade and the reflections of the mirrors. The poetic and respectful manner in which Joseph and Michel worked on this historic building earned them great recognition, including from the French government, which entrusted them with the restoration of the Hôtel de la Marine on the Place de la Concorde.

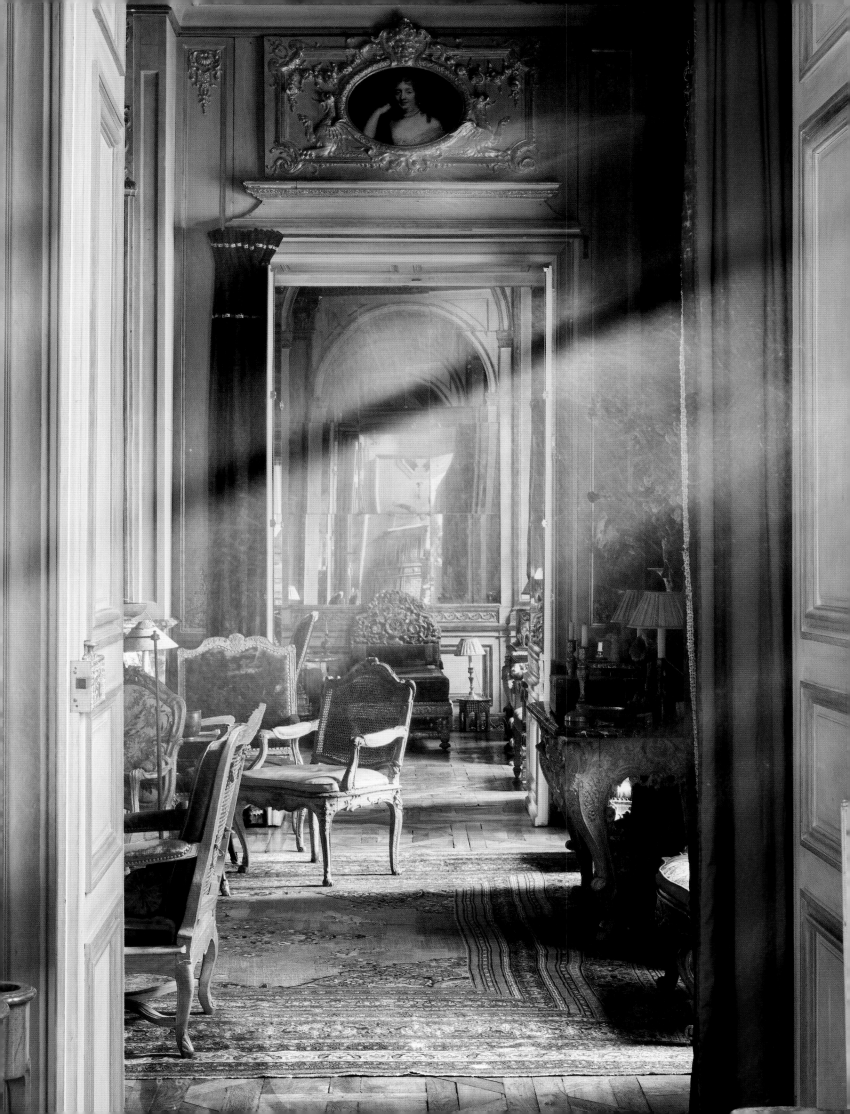

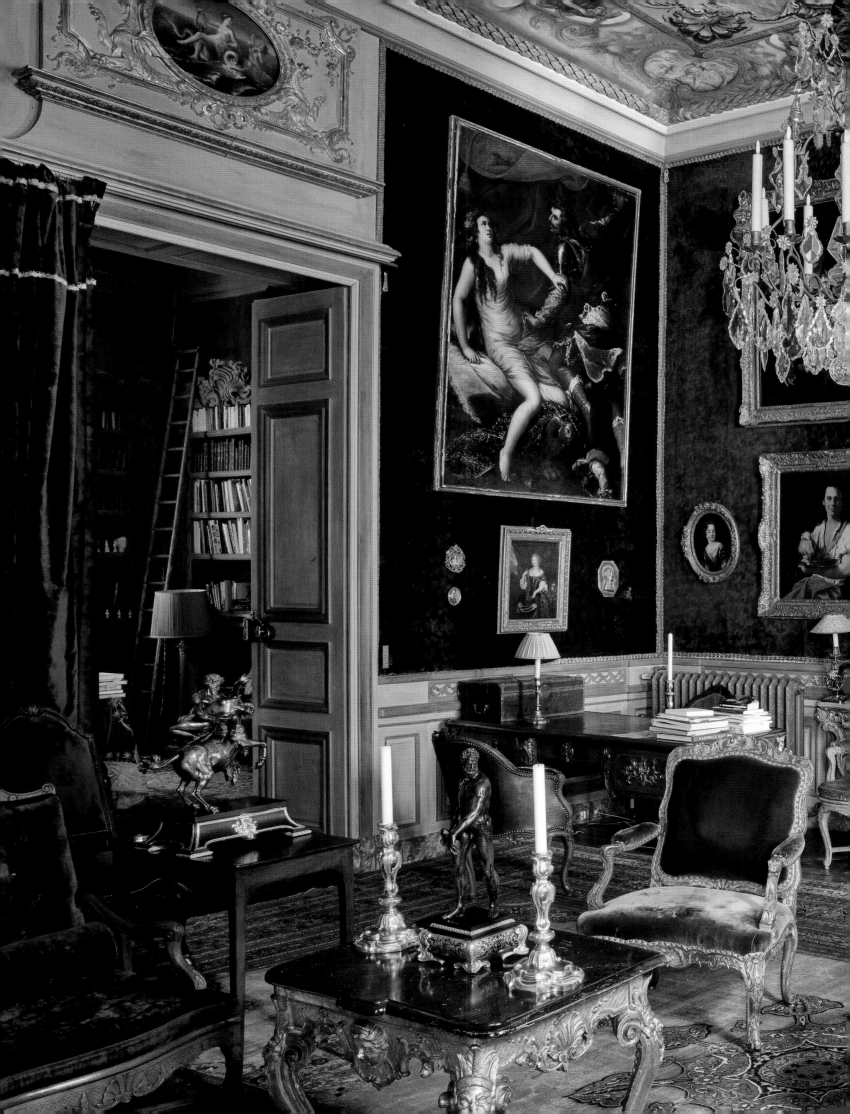

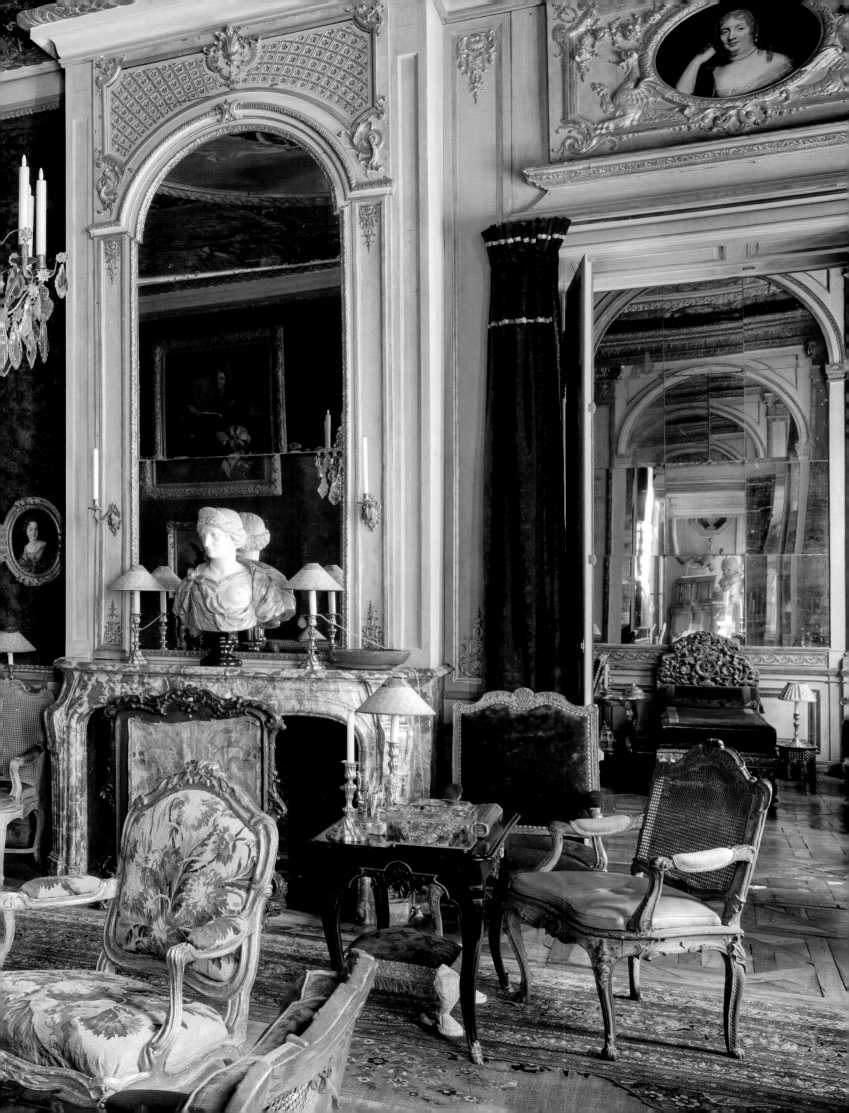

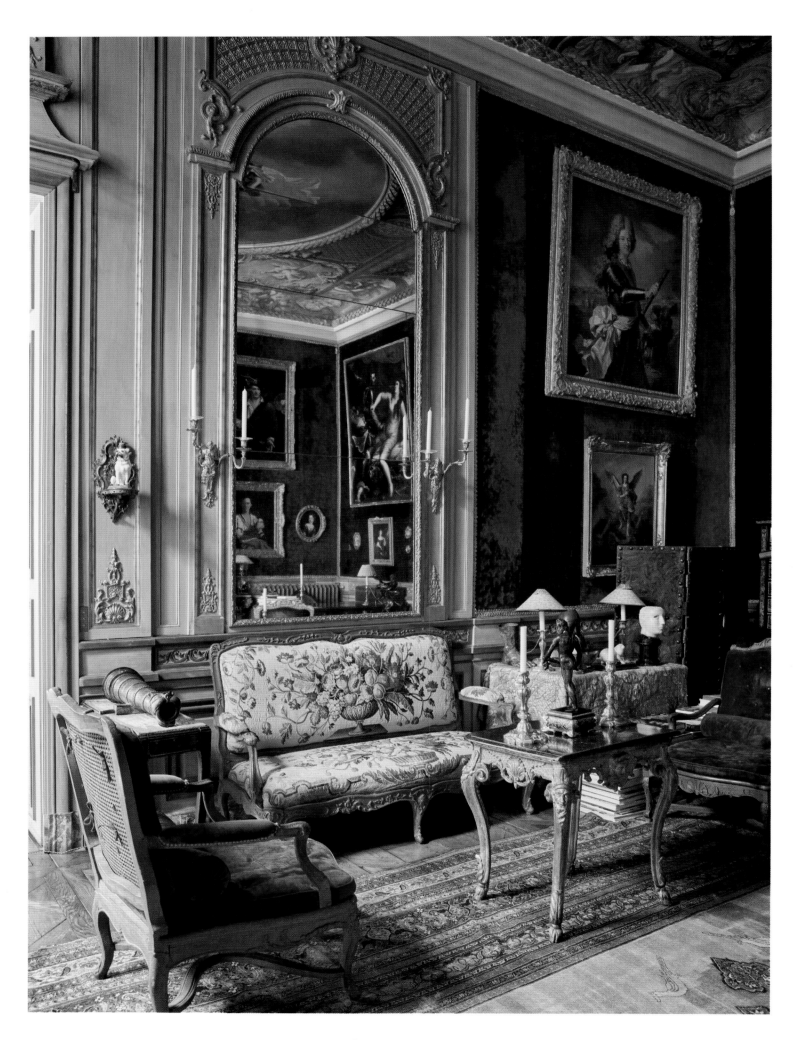

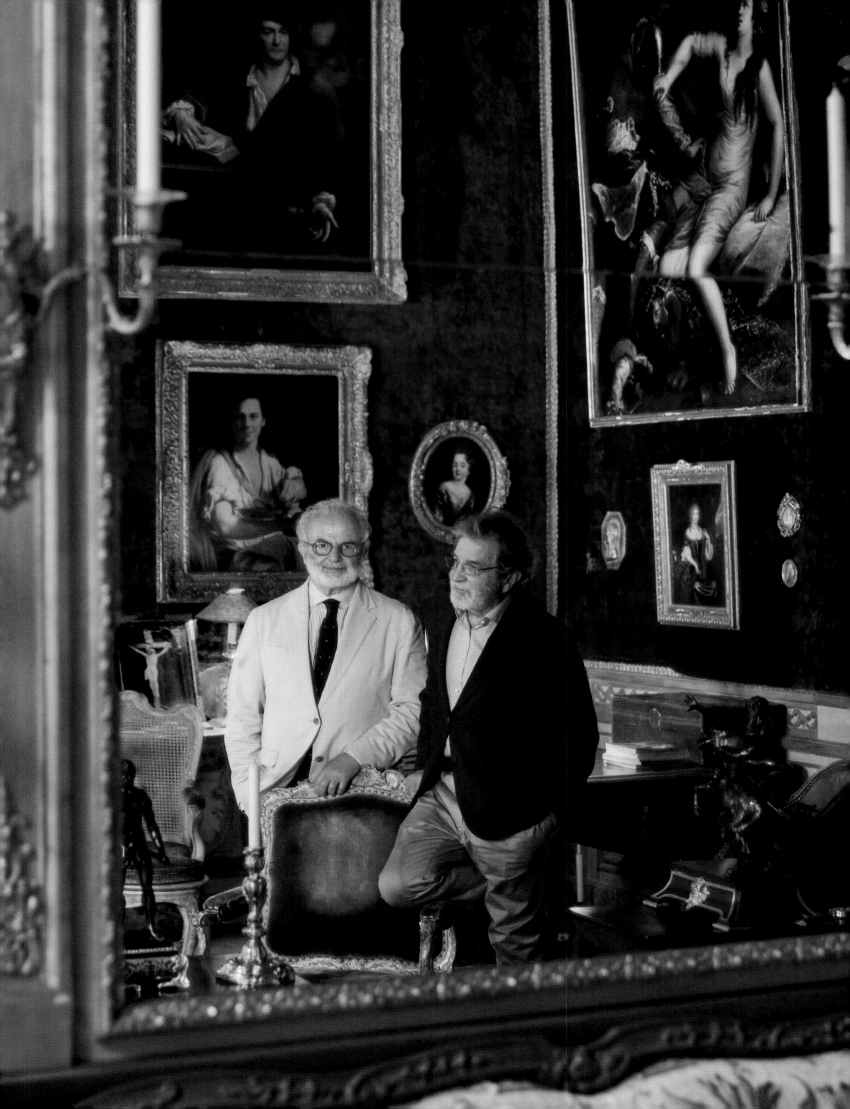

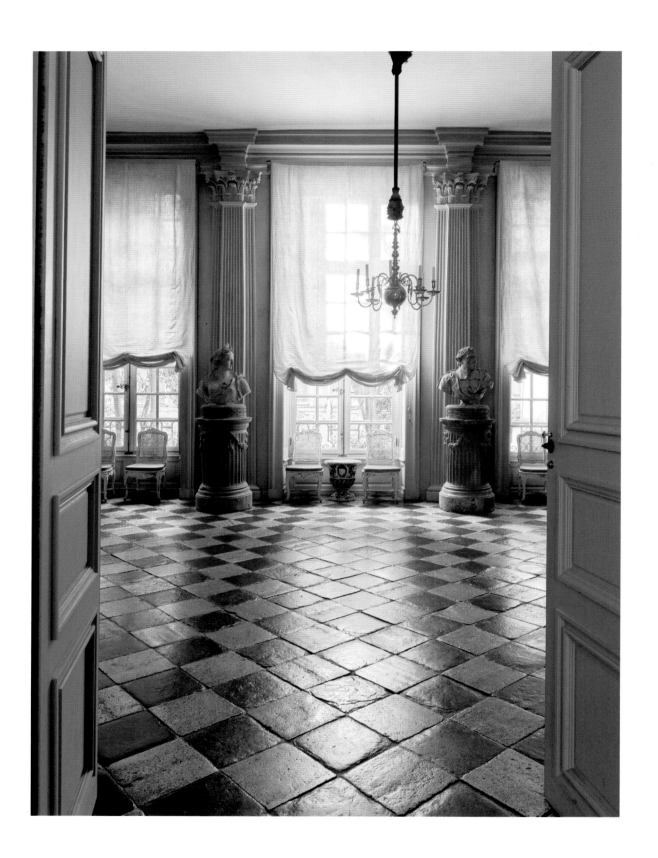

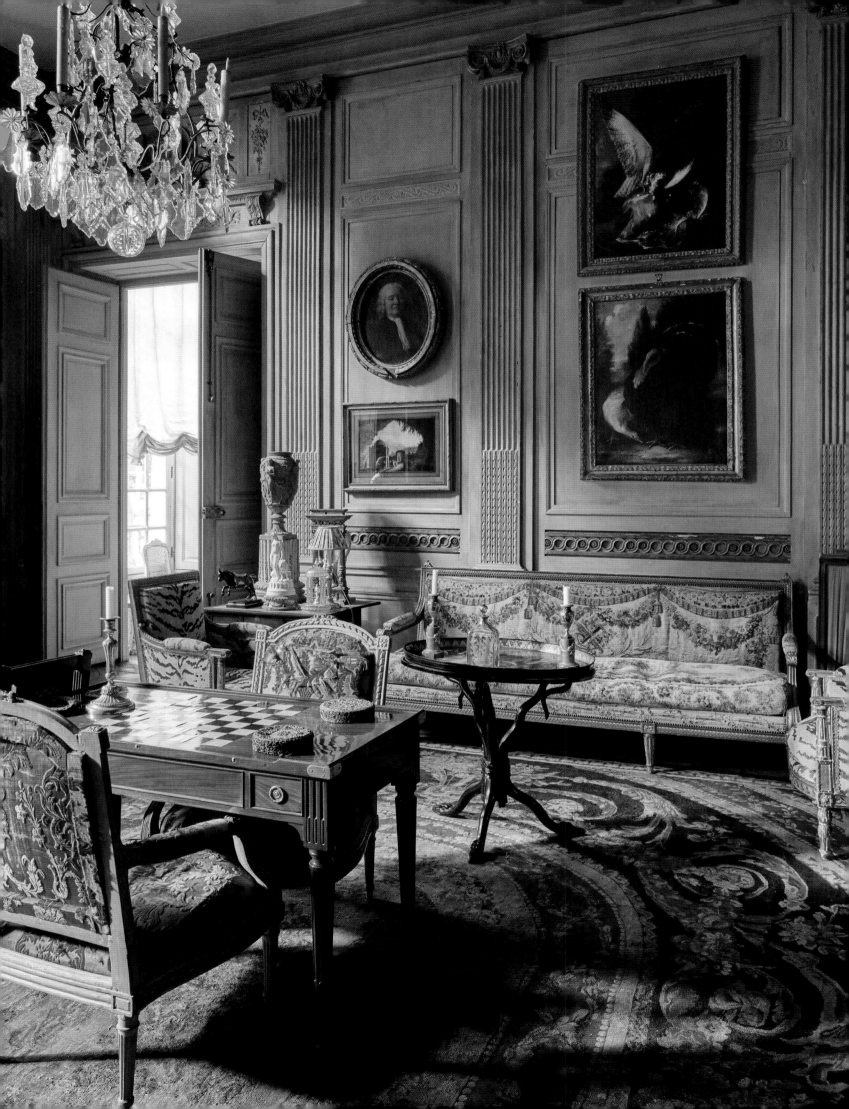

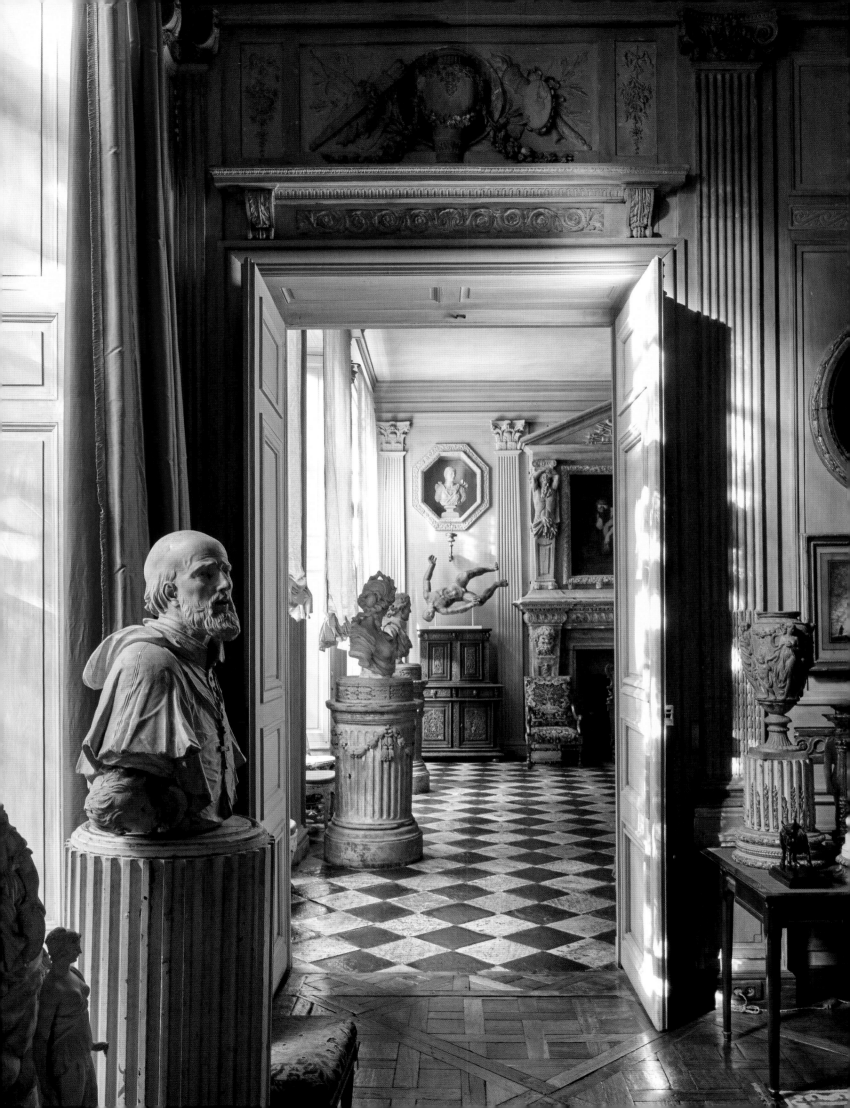

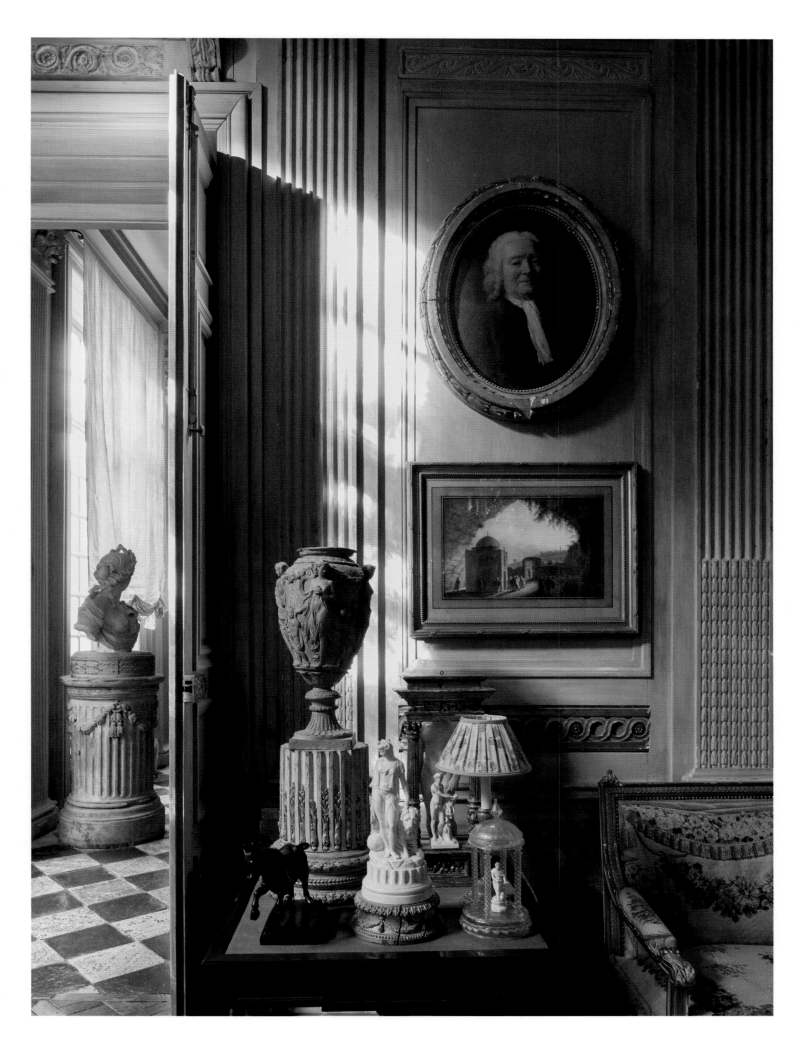

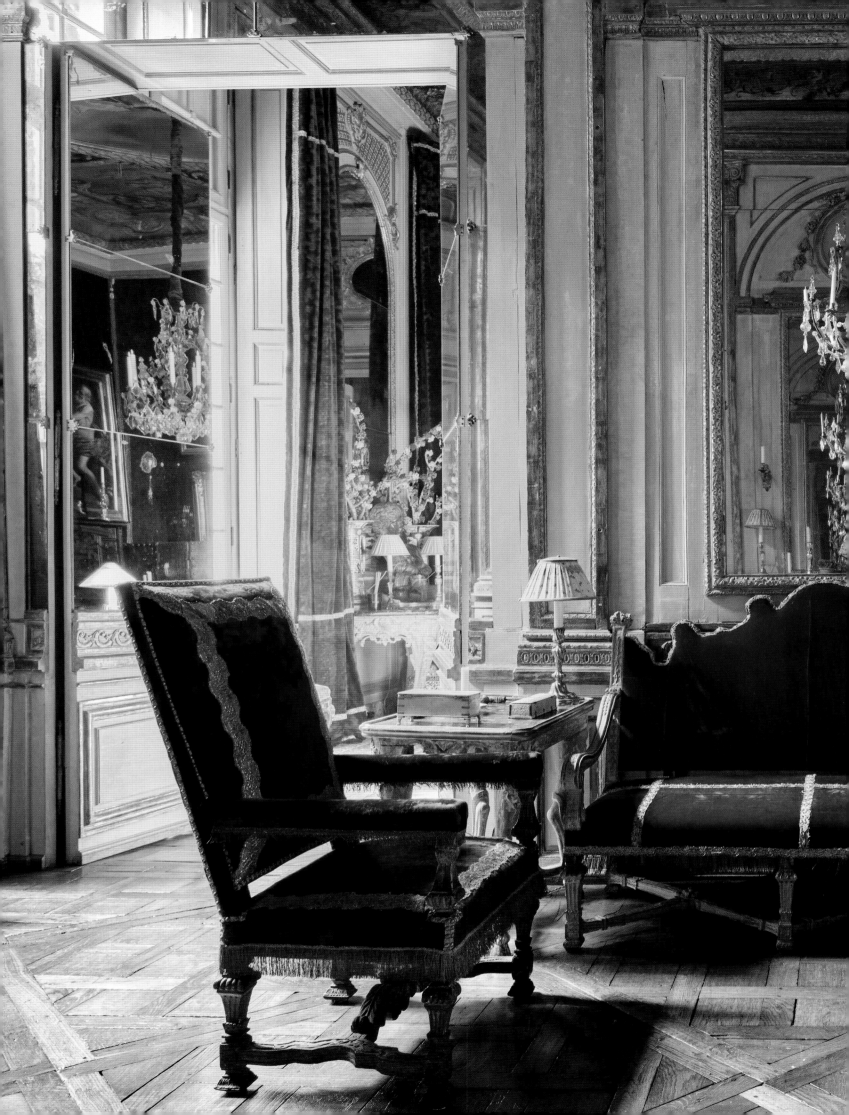

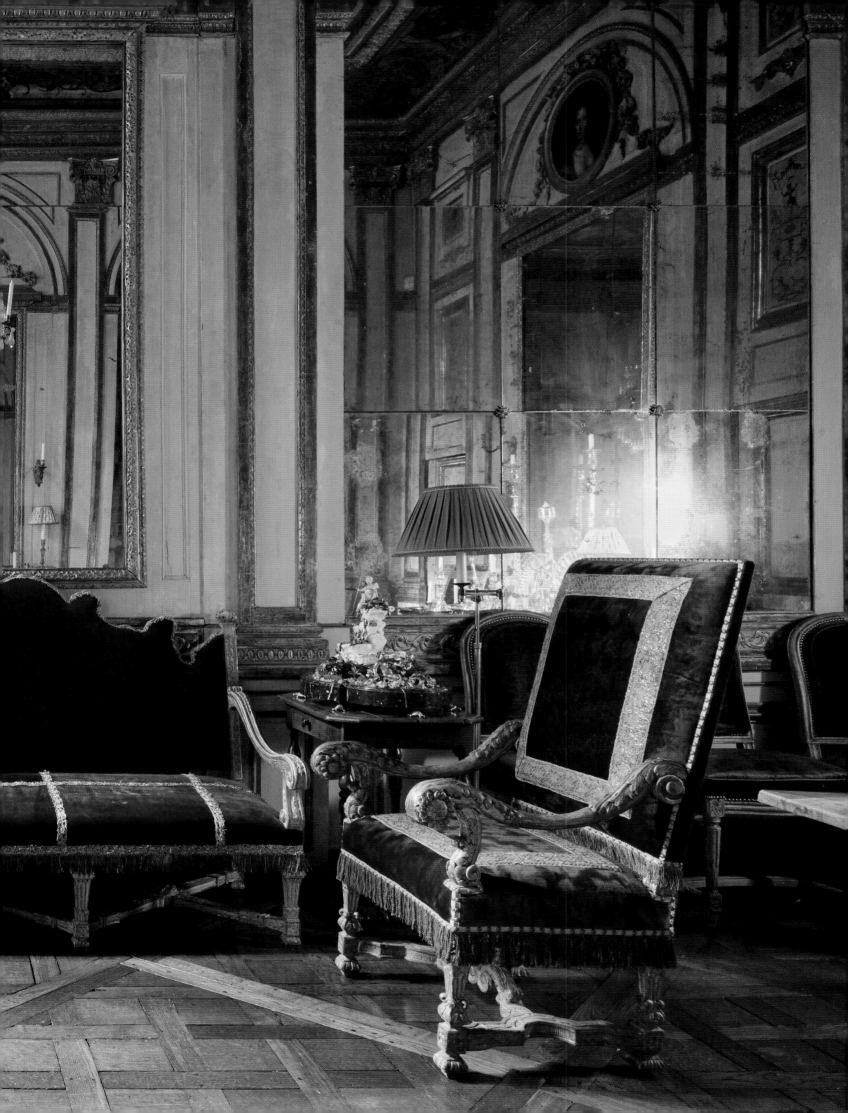

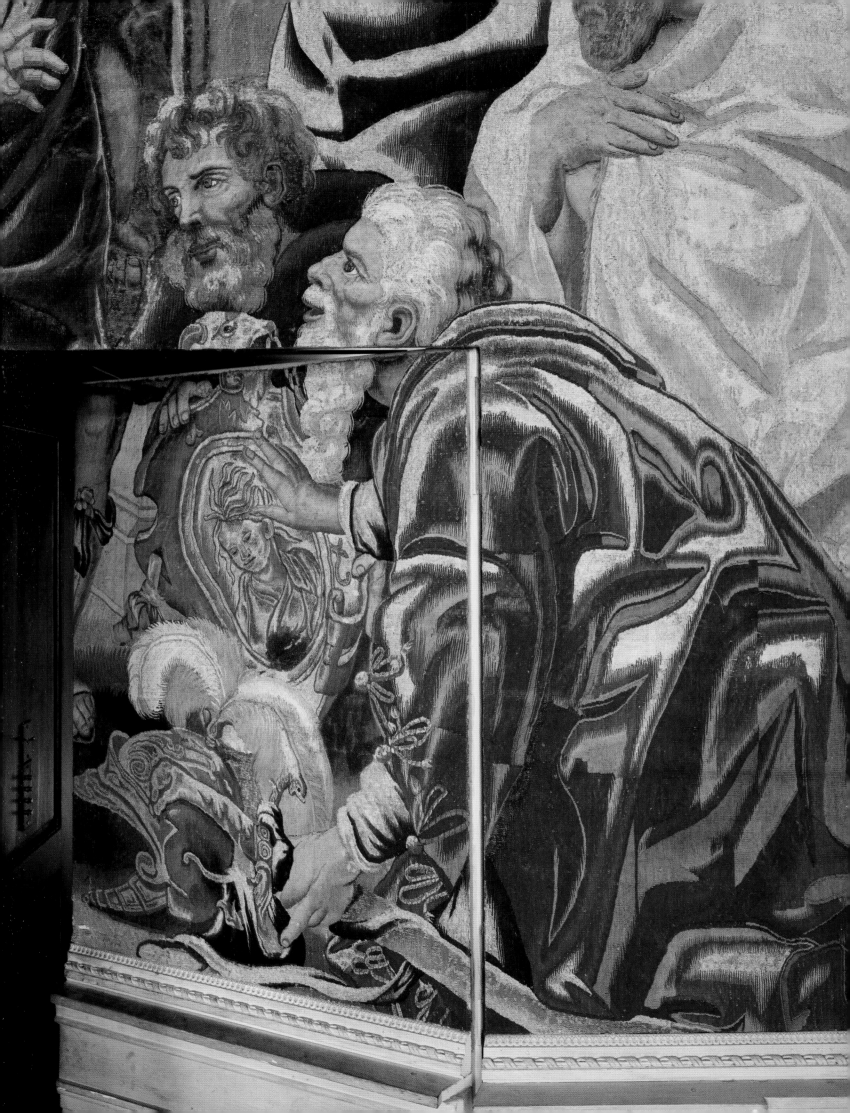

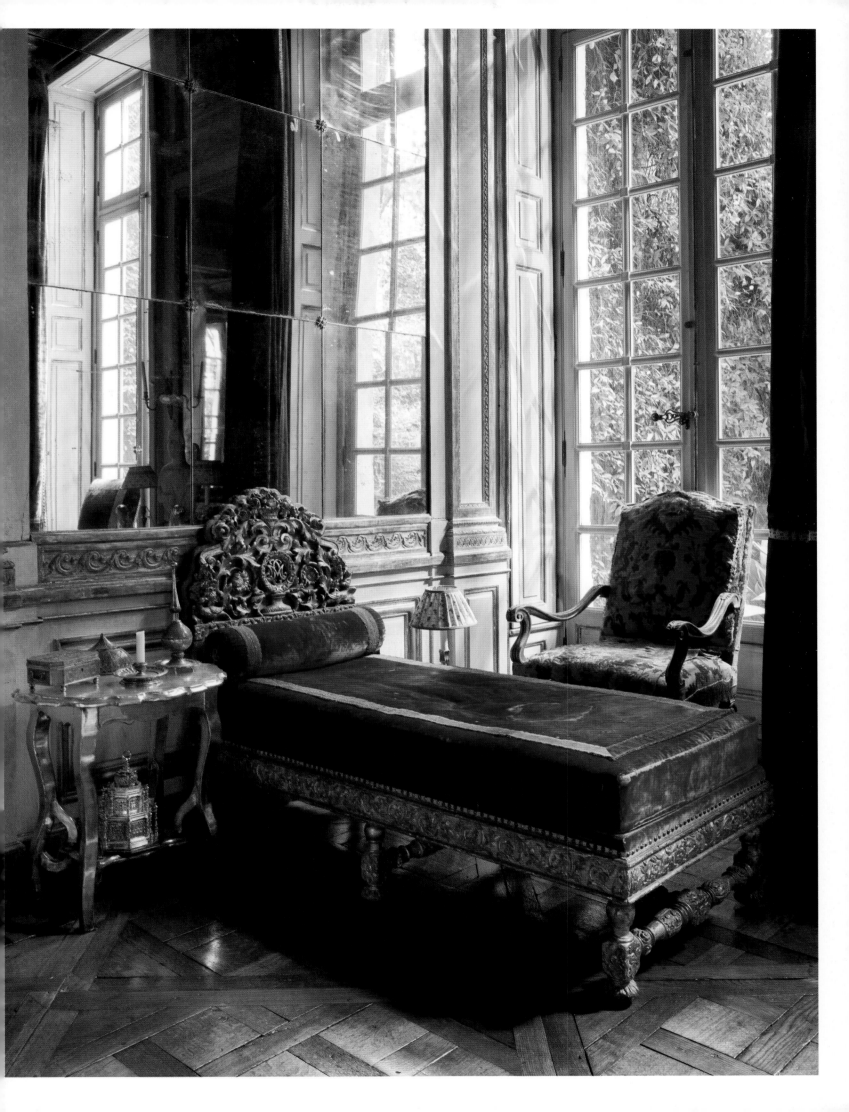

GLAMOROUS/ SENSUAL/ FEMININE.

FIFI CHACHNIL

No journey through Paris is complete without a stop in Montmartre. It's a different Paris, bohemian, irreverent, and playful, where the spirit of Joséphine Baker still reigns. At the foot of the hill, facing the famous Moulin Rouge, Fifi lives with a postcard view of the renowned cabaret that has been a source of inspiration for artists throughout history. Its theatrical spirit infuses her home and continues to inspire her.

The interior of Fifi's home quickly reveals her personality: creative, fun, welcoming, and dreamy. Soft textures and colors both bold and feminine dominate every space. She adorns furniture, lamps, and objects with muslin in different shades to add a touch of "froufrou," as she charmingly puts it with a smile. I'm struck by her interventions, like the cozy spot for her cat Renée Lapin, from whom she is inseparable, and the curtain covering the washing machine. Everything exudes the flair of an artist. I always appreciate meeting people with this kind of sensitivity—it makes my work incredibly enjoyable. Fifi's friend Vincent Darré had told me about her and what a delightful surprise it would be to meet her.

A writer and singer as well as a renowned worldwide designer of fashion and lingerie, Fifi draws inspiration from the sensual and feminine side of Paris. However, she detests excess formality and is quick to talk about her passion for music, a creative outlet that has become crucial for expressing her poetic and artistic side. She shares with me one of her songs that speaks of her perspective on her beloved city, leaving me with a resonating phrase: "Les souvenirs d'un Paris si petit peuvent contenir tout l'amour de la vie" (The memories of such a small Paris can contain all the love of life). Step inside and savor this authentic place, steeped in the unique essence of this city.

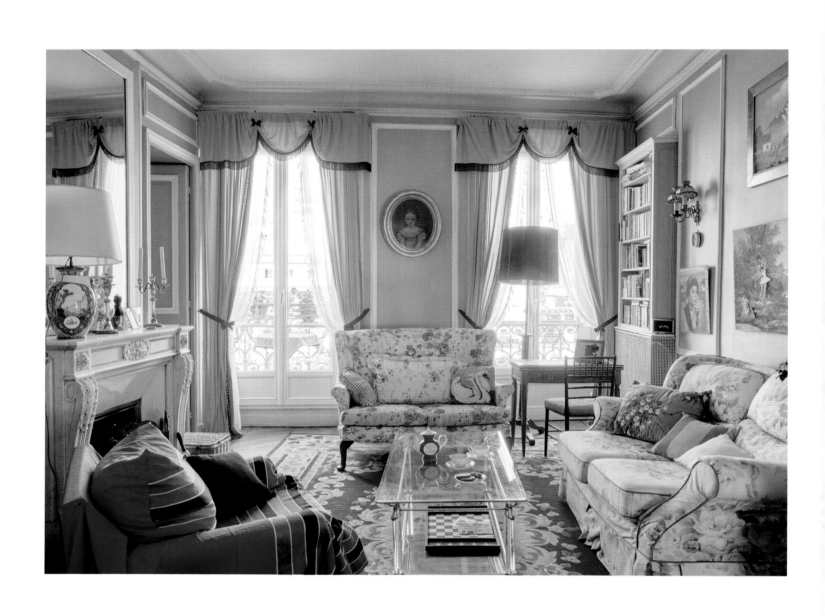

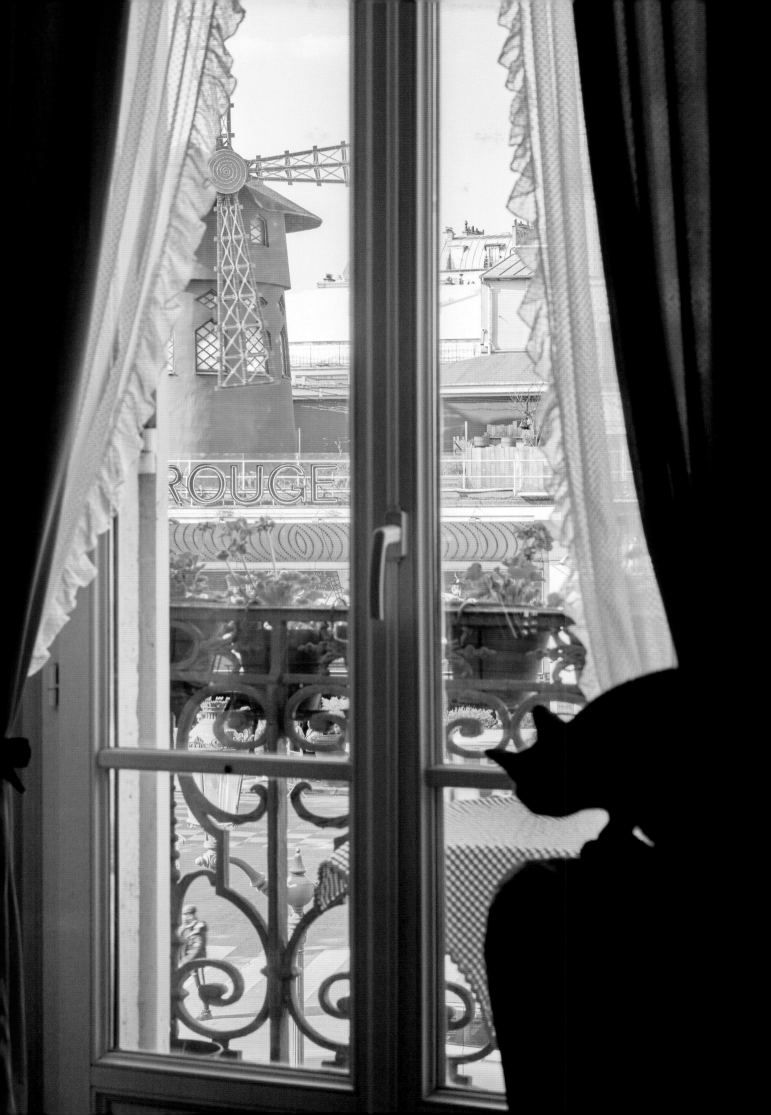

PENGUIN BOOKS

THE HOUSE
IN PARIS

ELIZABETH
BOWEN

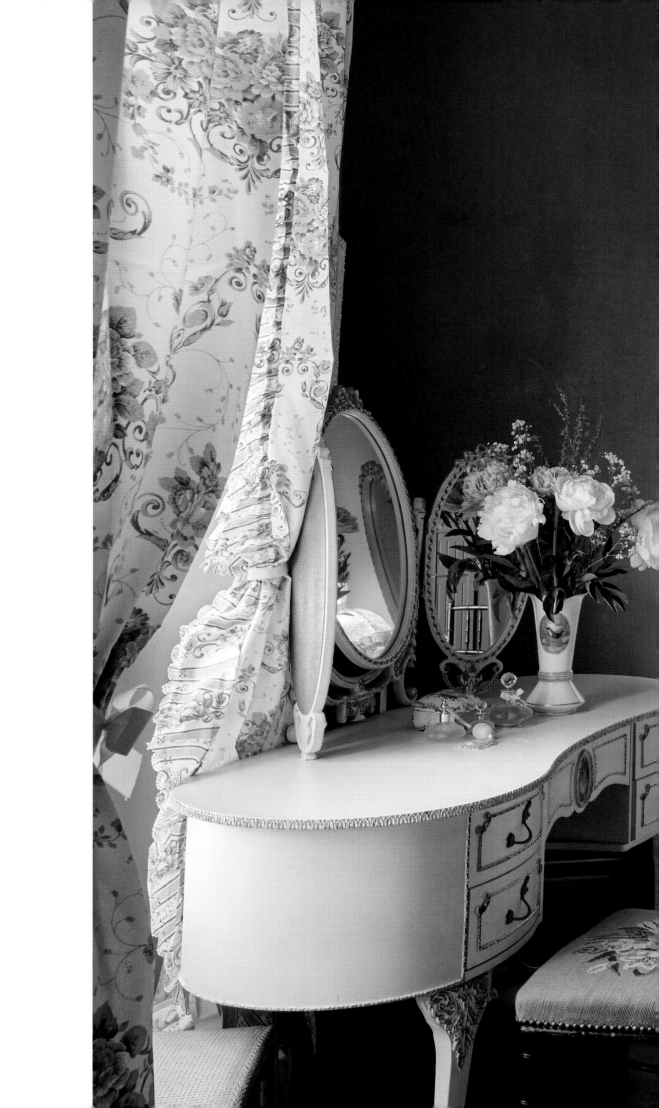

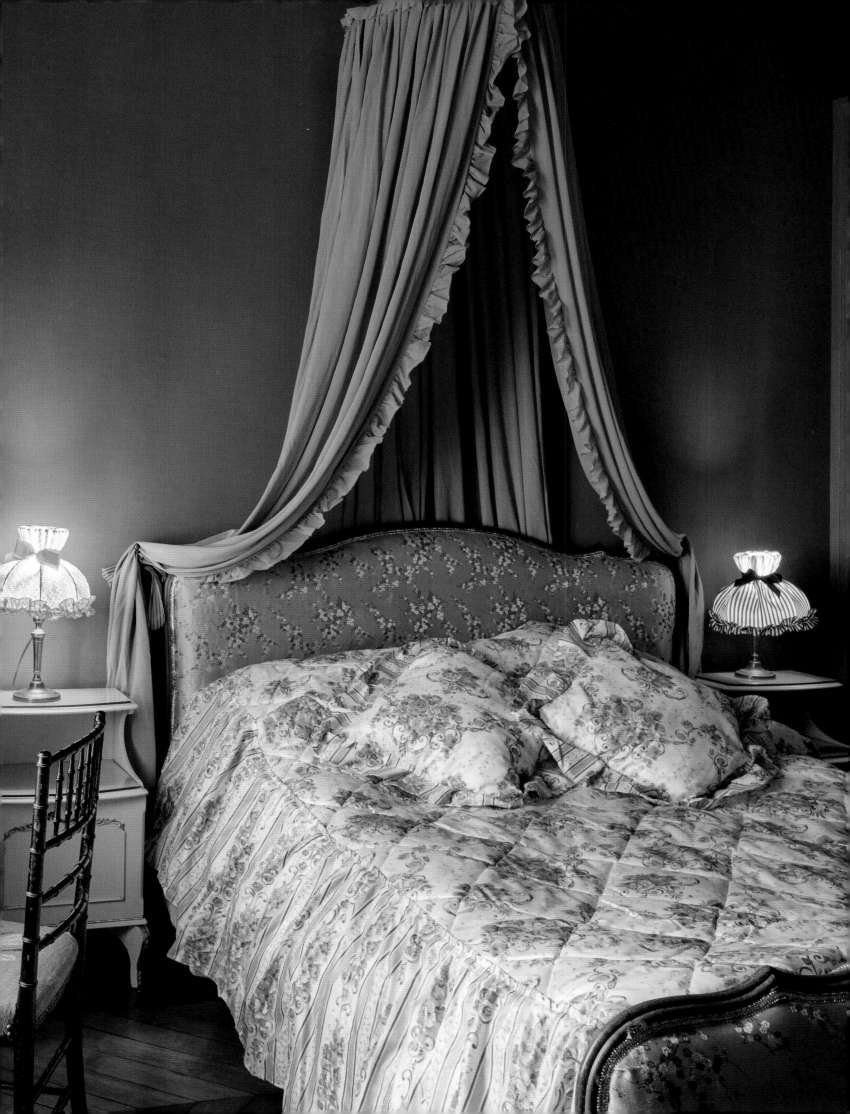

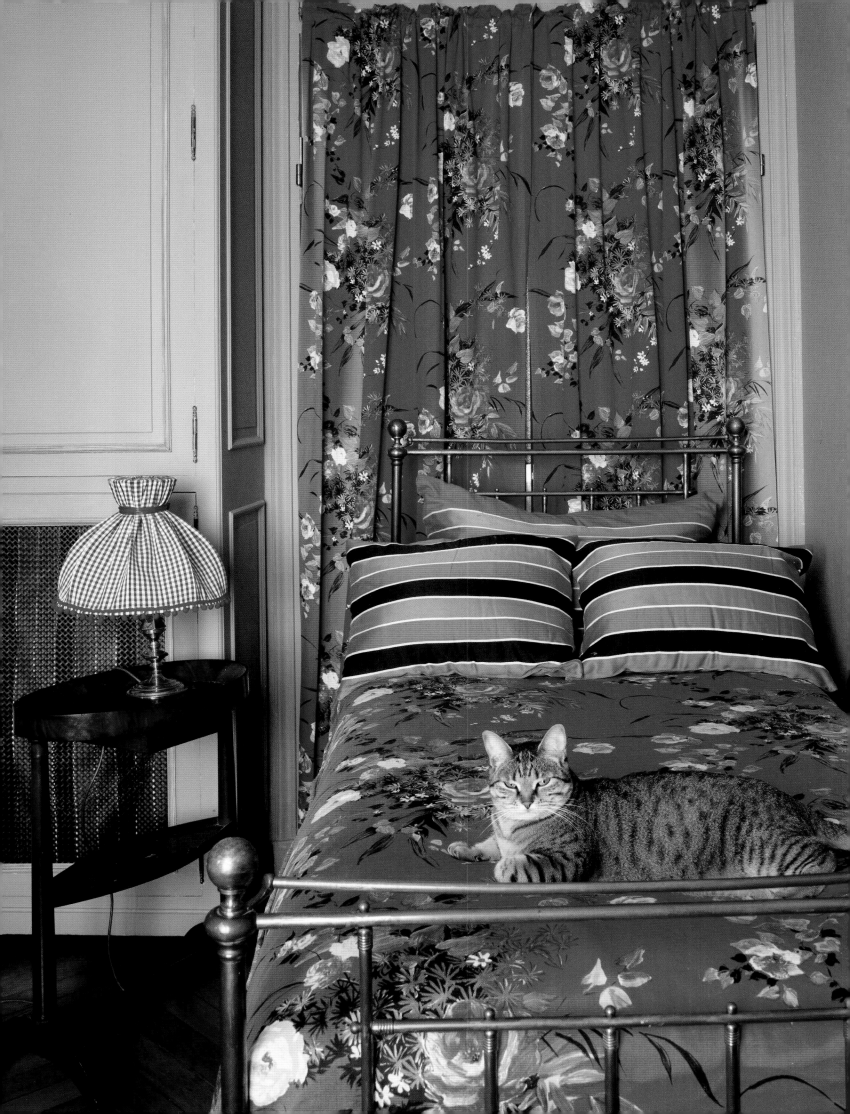

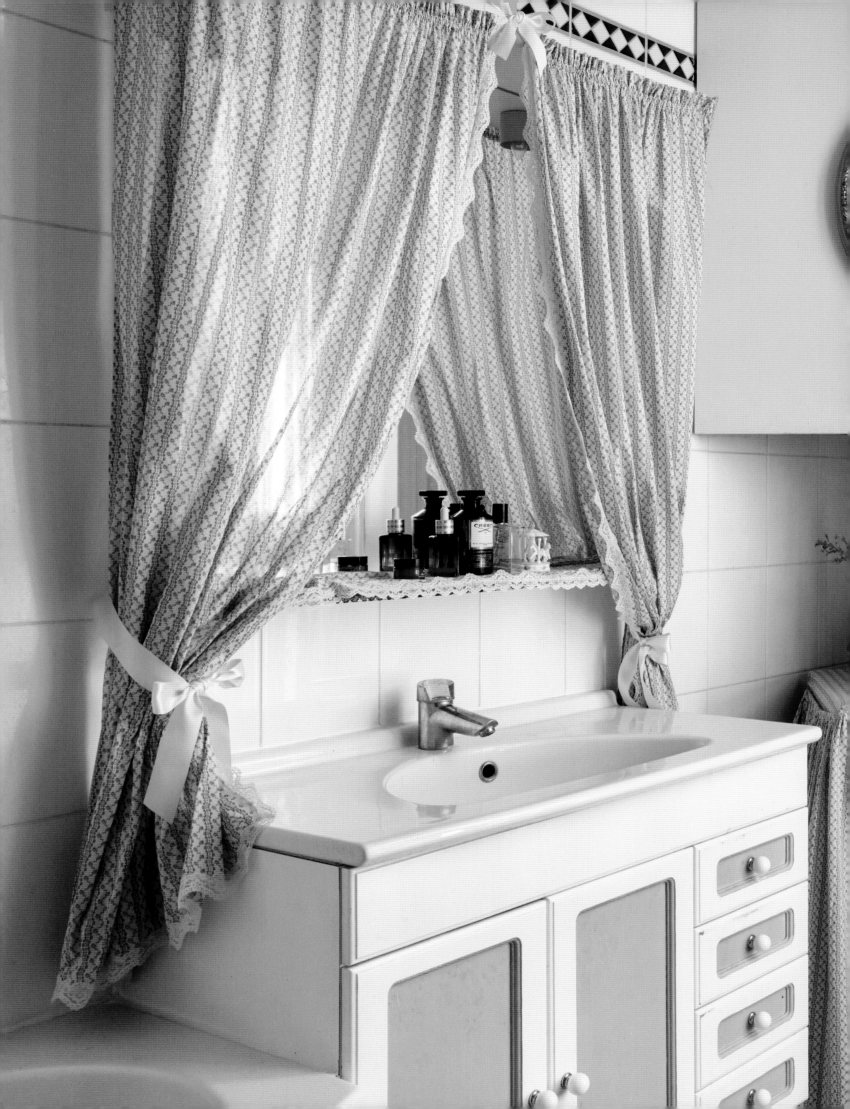

ARTISTIC/
EXTRAVAGANT/
ECLECTIC.

VINCENT DARRÉ

I had the pleasure of meeting Vincent Darré at a dinner organized by Françoise Dumas at the Arab World Institute on the occasion of a major exhibition on Uzbekistan. It was a magical night, straight out of a tale from the *One Thousand and One Nights*—the perfect opportunity to meet someone like him. He is unprejudiced, transgressive, and very charming, with an inner genius that is reflected in his work. The following summer, I visited him with the intention of capturing his home amid the trees in the heart of the elegant 7th arrondissement.

Whenever I see Vincent, he is always drawing something—a new piece of furniture or decorations for a castle, a beach hut, a boutique, or a bottle of champagne. He recalls that the first time his friend Isabelle Adjani visited him, the first thing she said was that she felt like she was entering one of his drawings. "Everything starts with a watercolor," Vincent says, "and reality has to end up being similar."

He loves places dedicated to reverie. His bedroom is a theatrical dream covered in wallpaper that he designed for the Ritz suite, with a baroque Italian bed and pagoda curtains in Tony Duquette fabric—"A folly of a little prince." Vincent's kitchen pays homage to the Tente Tartare of the Château de Groussay, designed by Emilio Terry. All the trompe-l'oeil paintings are done by an artisan. His living room, like a veranda overlooking the gardens, is an invention inspired by Mediterranean voyages. The furniture is a blend of different collections that he has designed over the years, with added pieces from friends and flea markets. "I love mixes where chance lets poetry wander," he says. The caryatids, a tribute to Jean Cocteau, guard the mystery of this magical Parisian space.

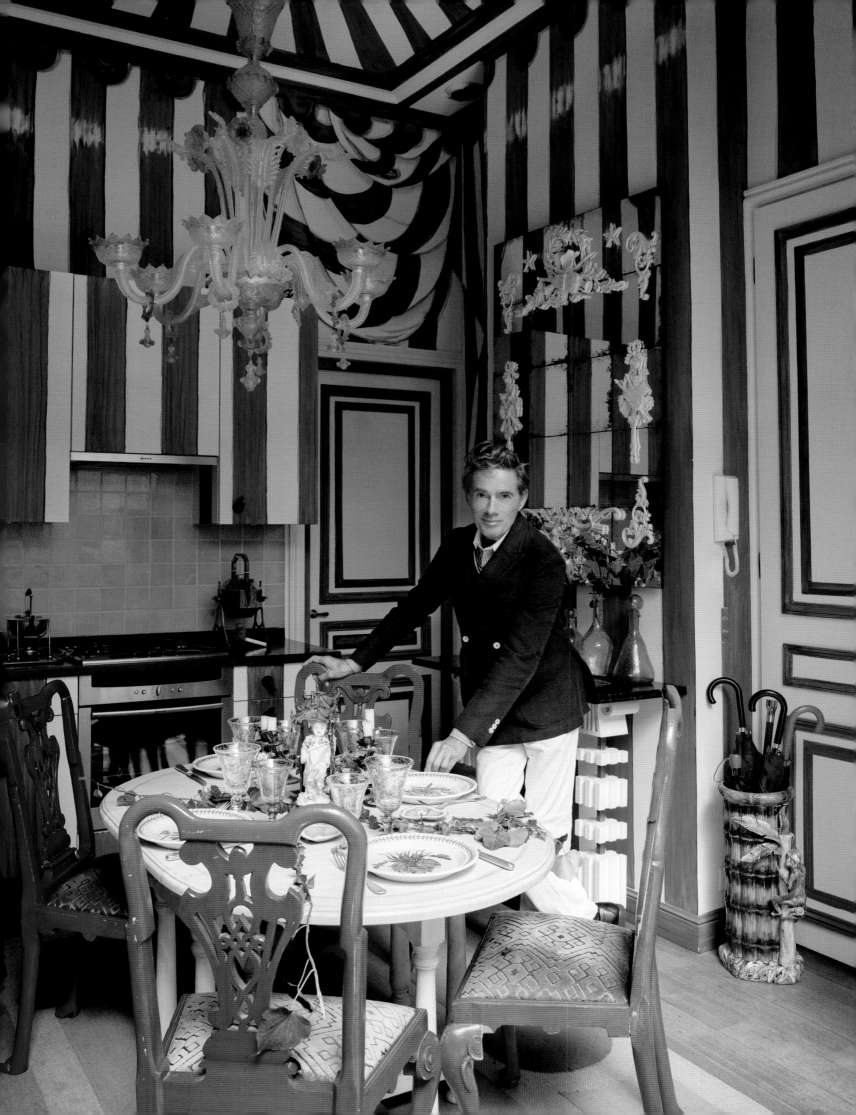

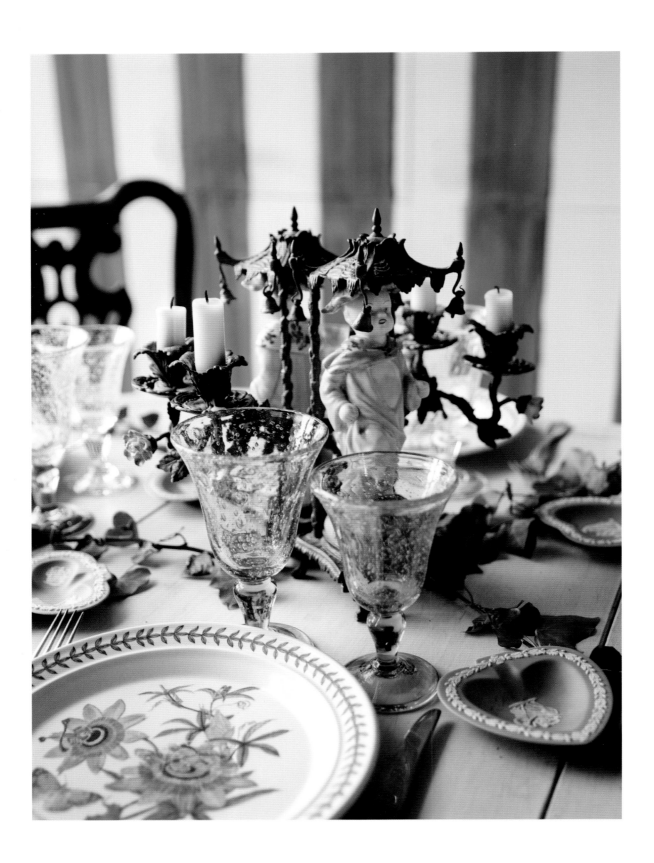

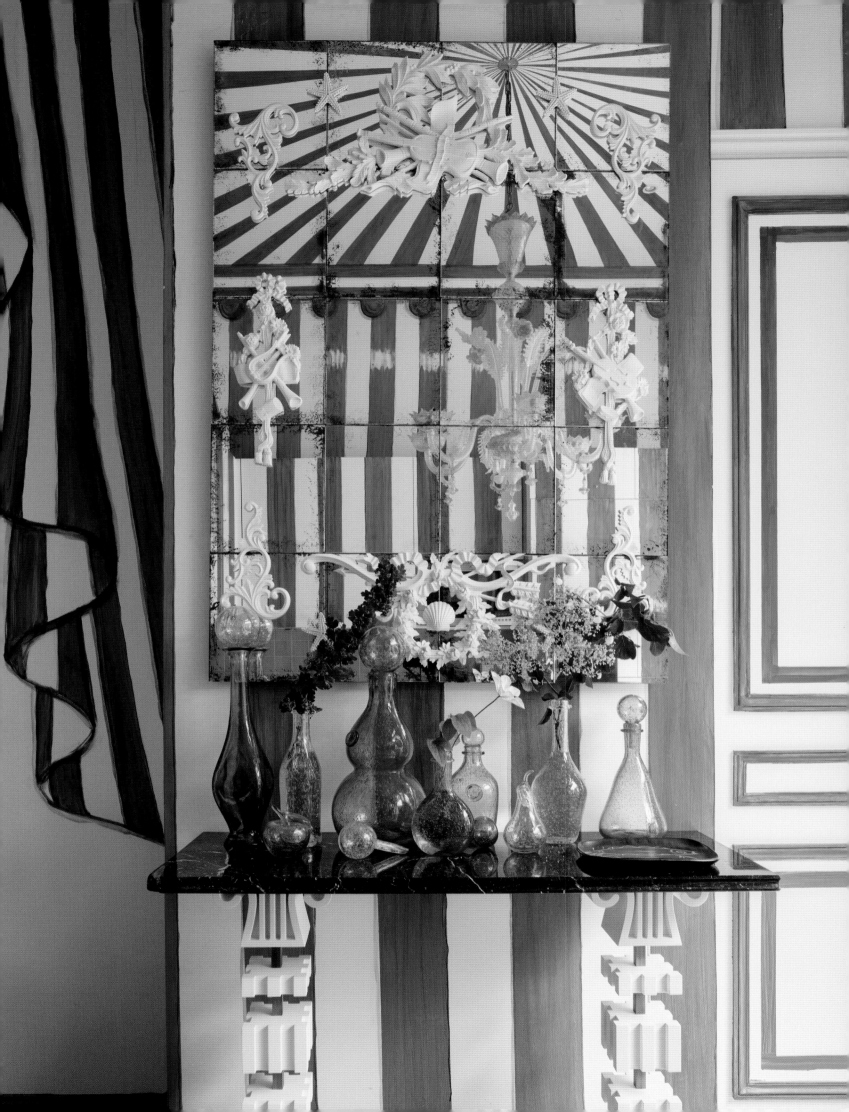

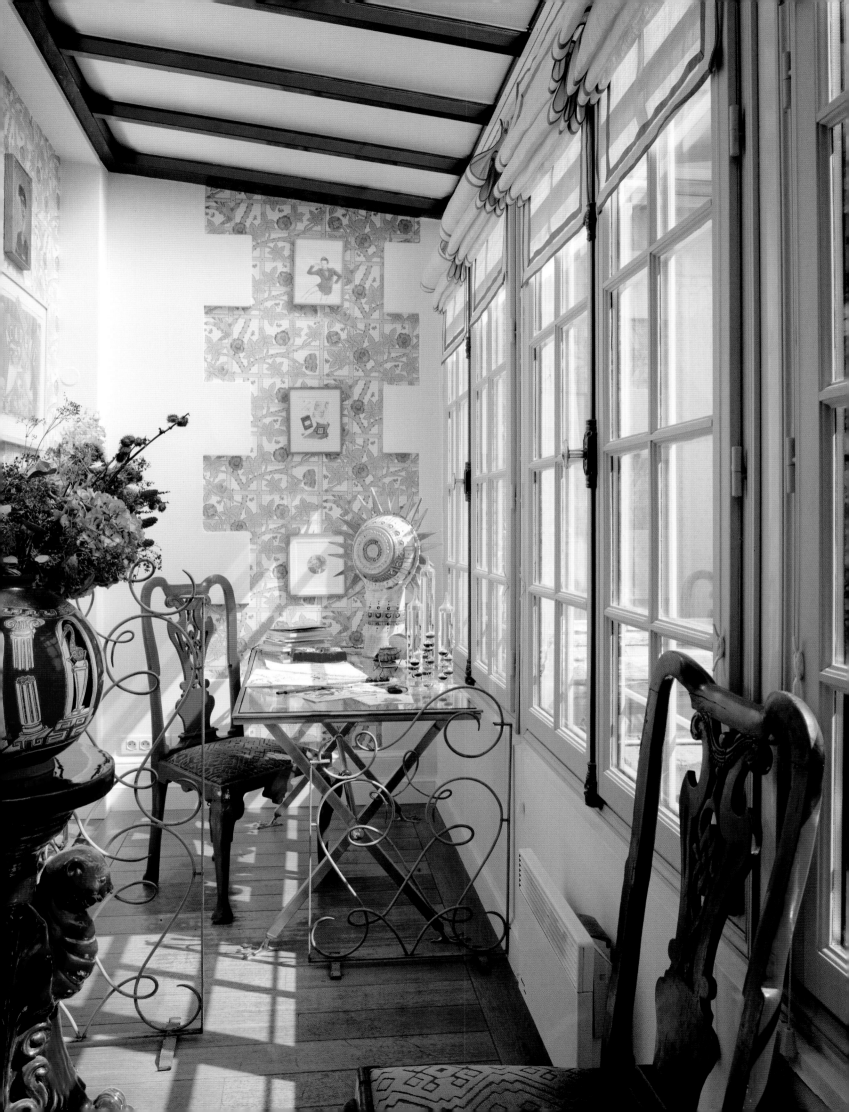

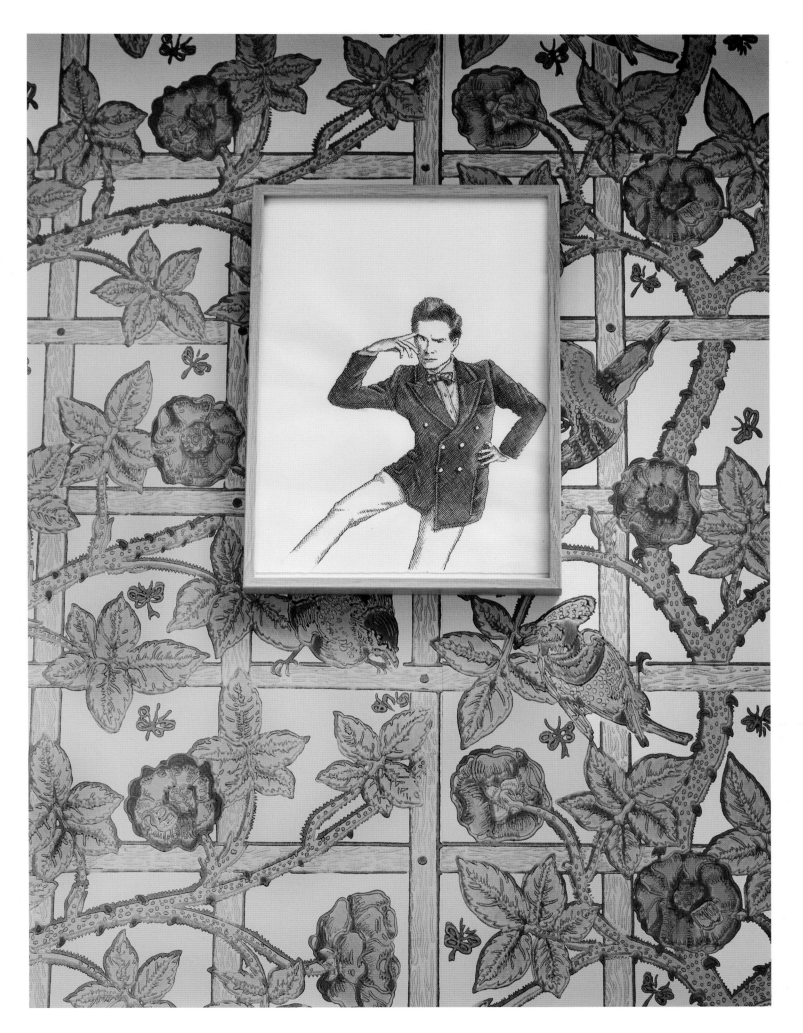

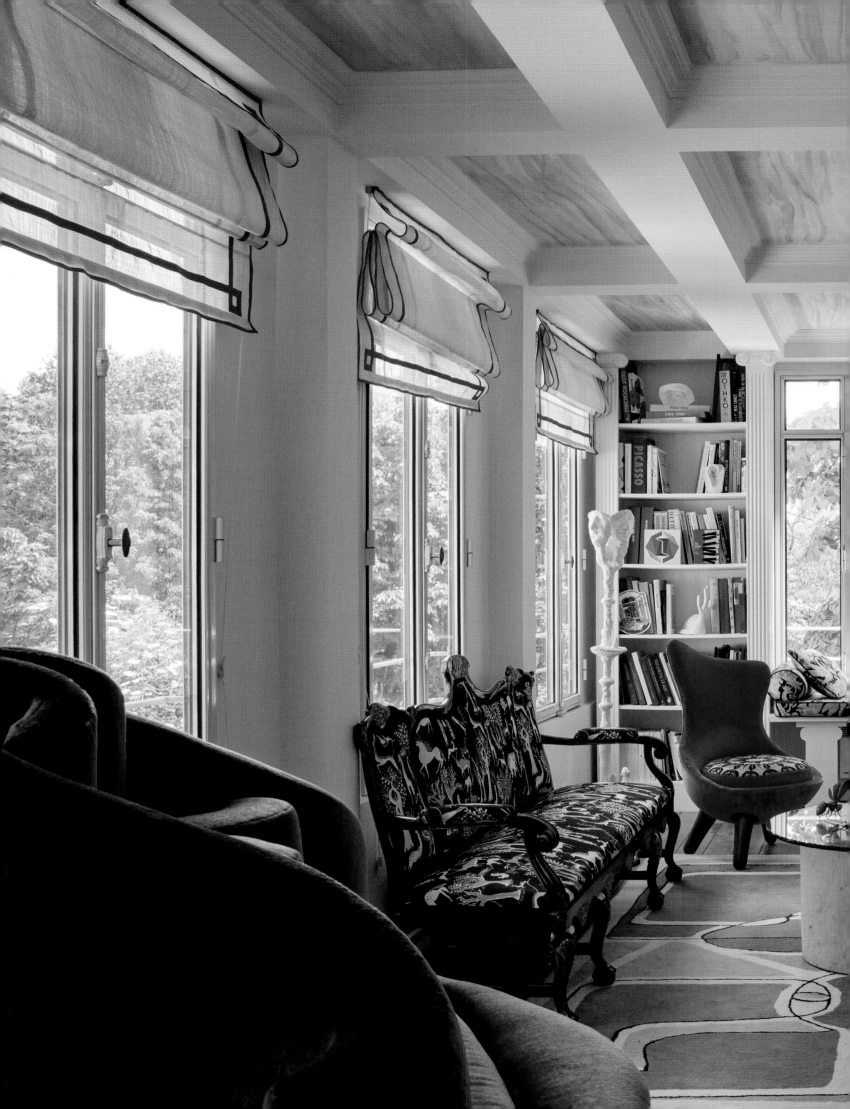

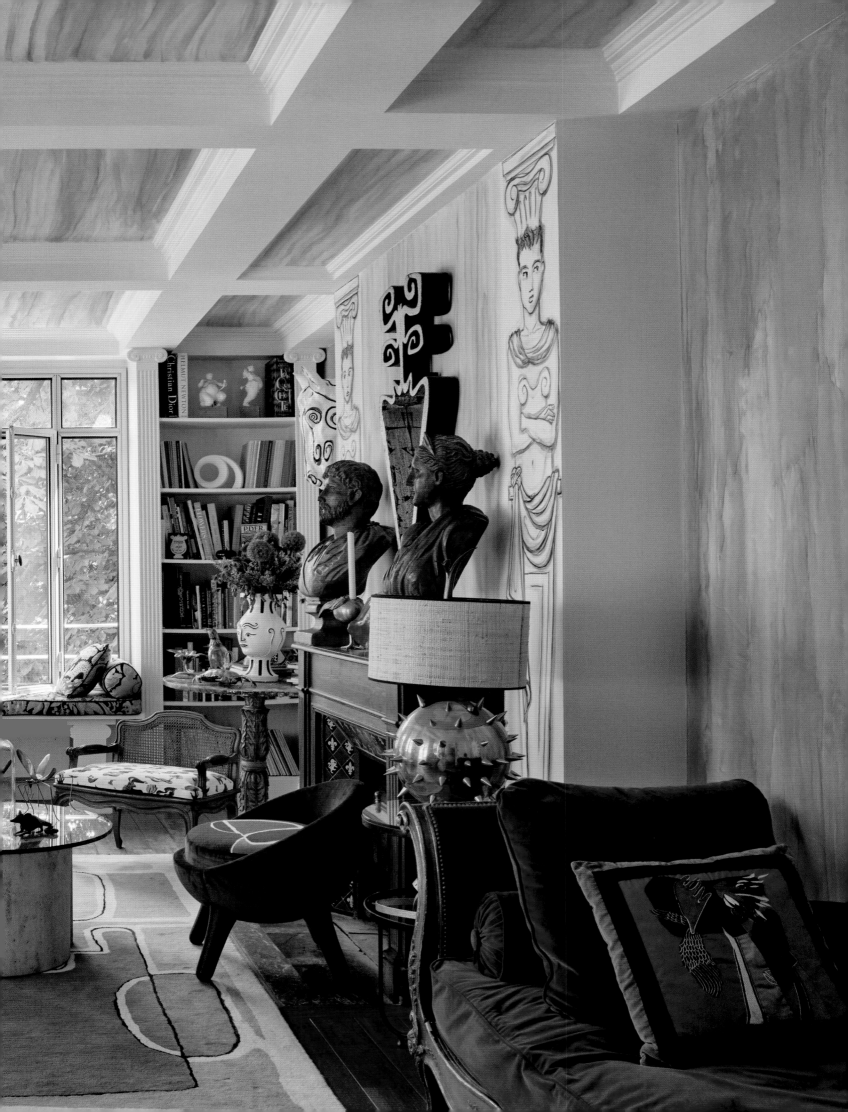

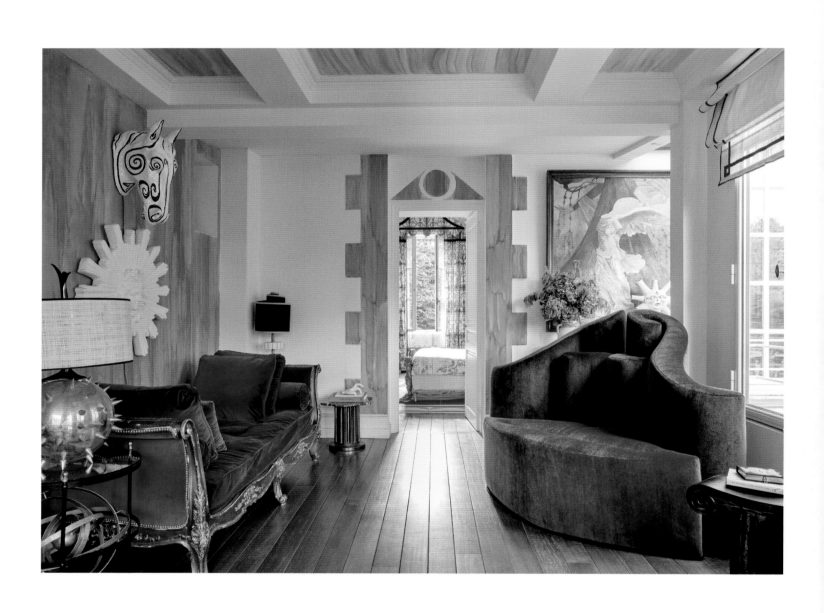

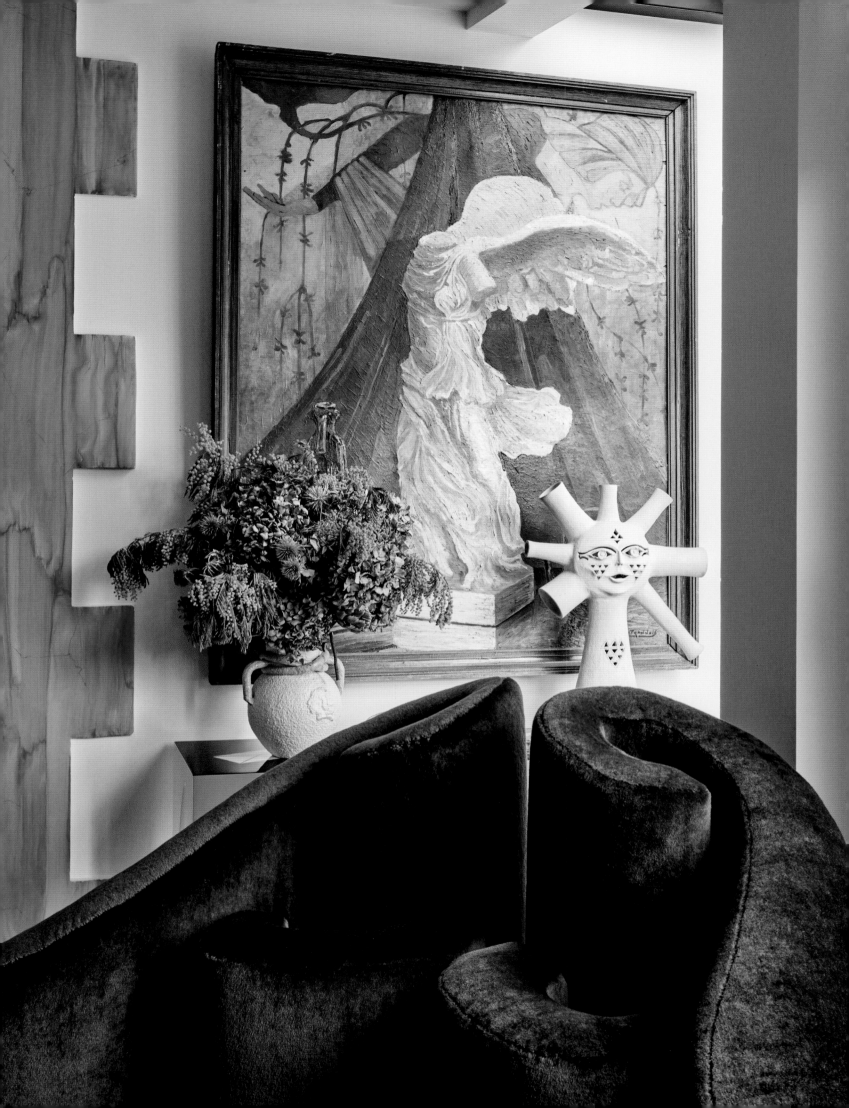

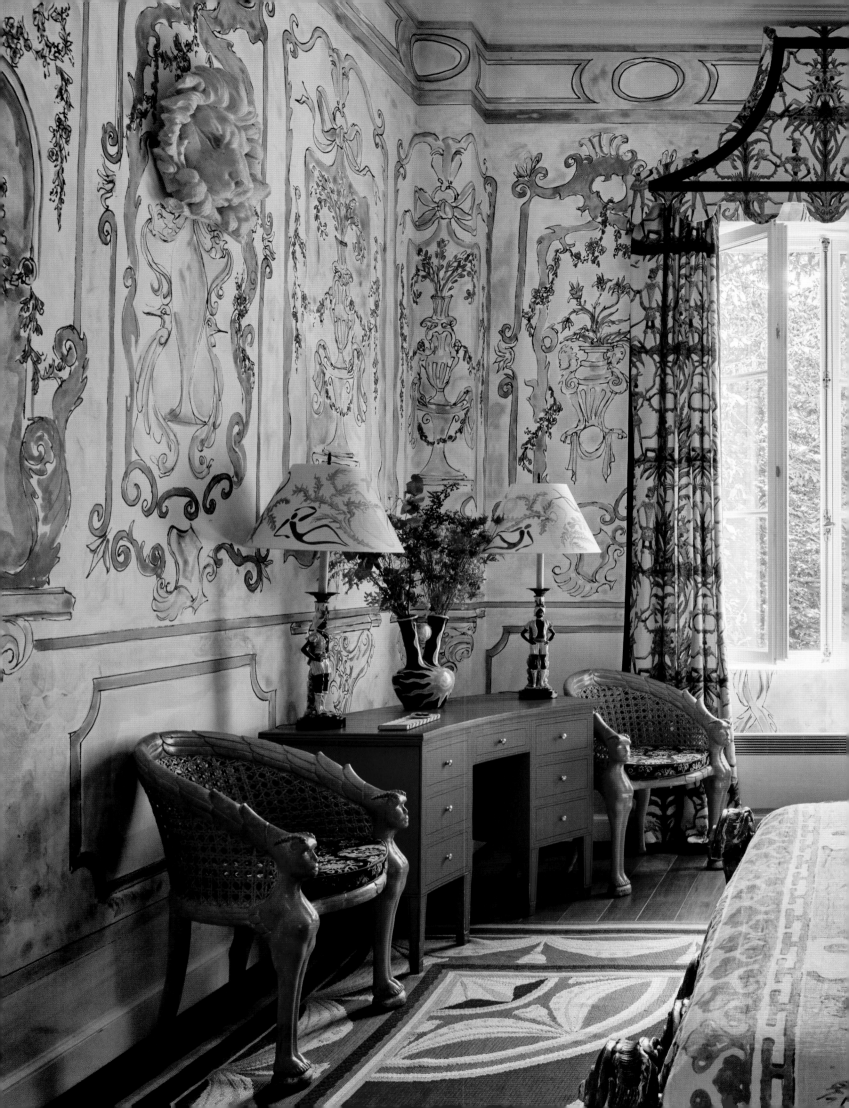

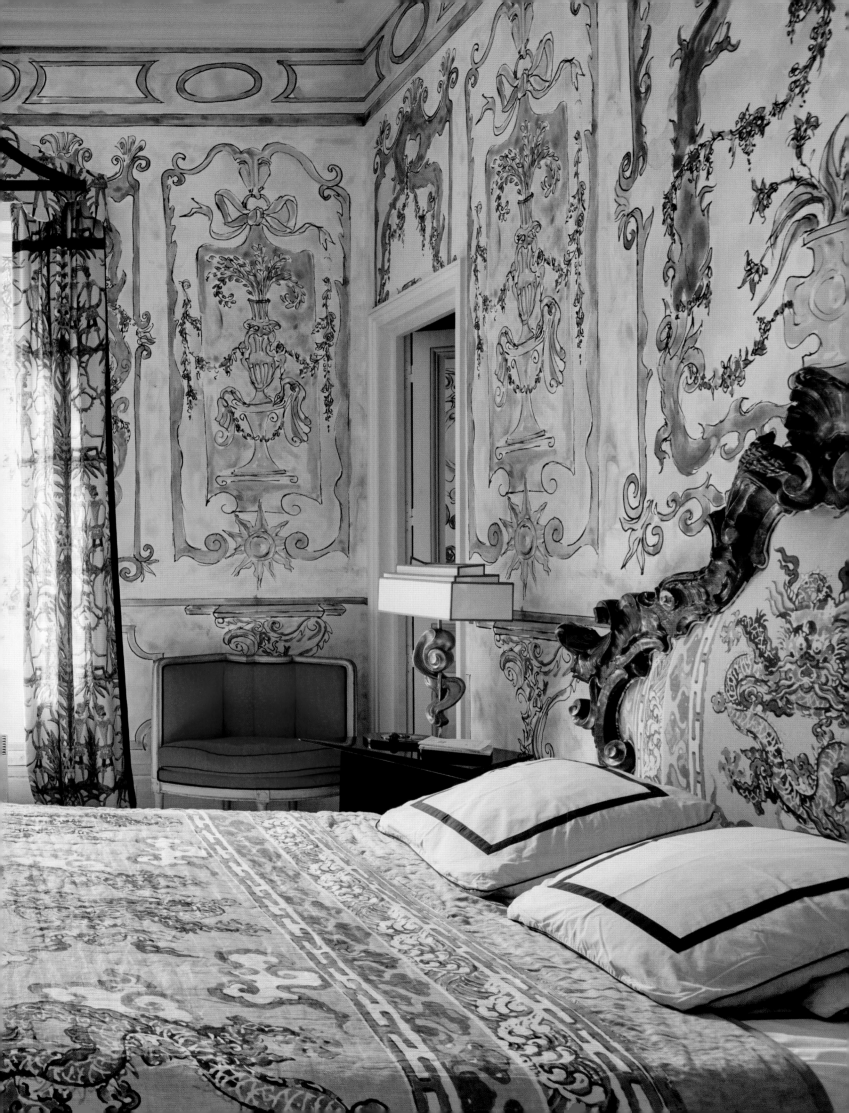

CHARLES GEOFFRION

"I've always dreamt of living on Rue de Verneuil, one of my favorite streets in Paris. It's a charming neighborhood, with its galleries, antique shops, and bookstores, just a stone's throw from Saint-Germain-des-Prés and the Right Bank," comments Charles Geoffrion, reminding me with great enthusiasm that Serge Gainsbourg and Jean-Michel Frank once lived on this street.

Charles is a young director at Mennour gallery and the manager of the Estate of Marcel Storr. He's active on social media through his Instagram account @charlesgmagne, dedicated to art and collections. His home is classical and minimalist, a structure of white walls, wood, and stone, with a prominent alabaster fireplace. Color is added through books, objects, and art. He does not think like a decorator but affirms that "contemporary painting takes on even more meaning when it's in dialogue with an ancient Roman head or a surrealist drawing, for instance." When I ask him more about the decoration of his apartment, I realize that he's engaged in the same pursuit of beauty and comfort as any professional interior designer.

He adds, "I've been collecting art for several years, such as this three-dimensional green painting by the little-known French artist Jean-Jacques Surian called *Tarzan Memorial* from 1972, which I bought at an auction a few years ago. I love his kitschy, pop style, with the pineapple-like shapes protruding from the Ripolin paint. It has become my home icon, and everyone loves it and gets attached to it! I particularly like my weavings by Marie Hazard, my surreal gouaches by Félix Labisse, my distorted portraits by Jewish Polish artist Maryan, and, of course, my drawing by Magritte, *La leçon de musique*, which is the most beautiful piece I have. Magritte is maybe my favorite painter from the twentieth century. It was my dream to be able to own one of his works."

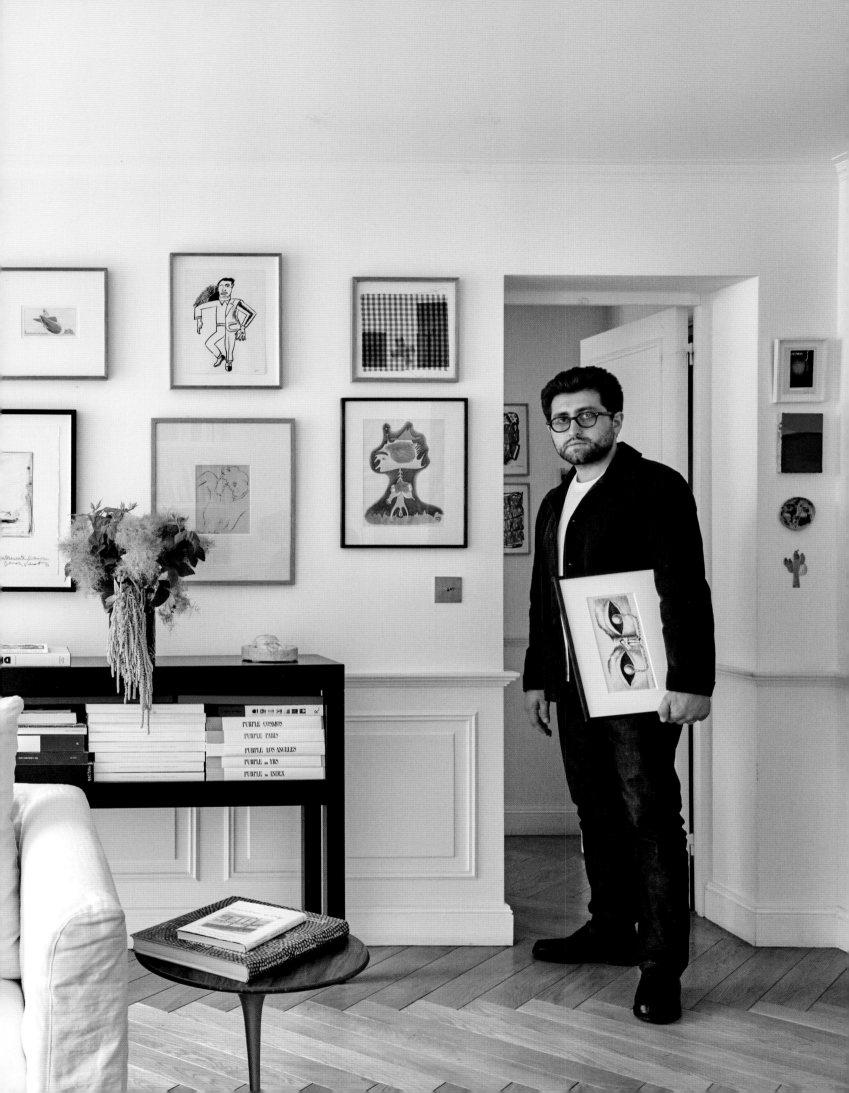

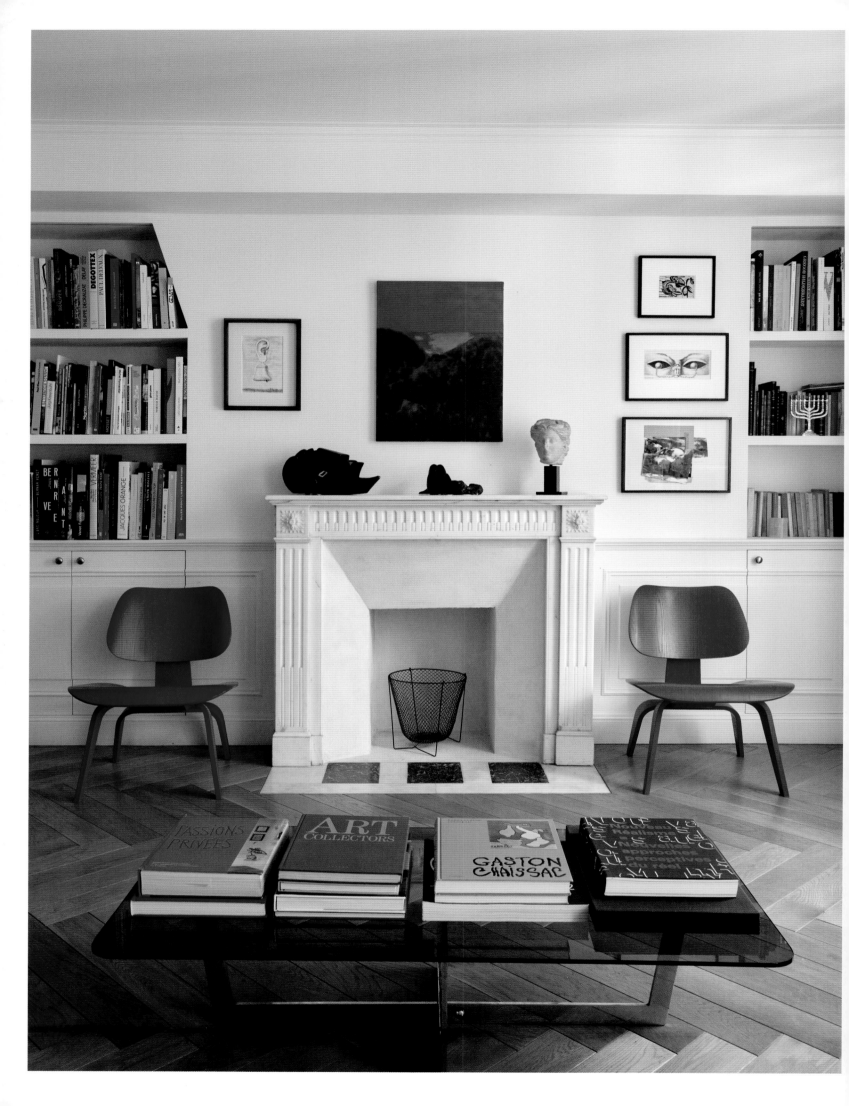

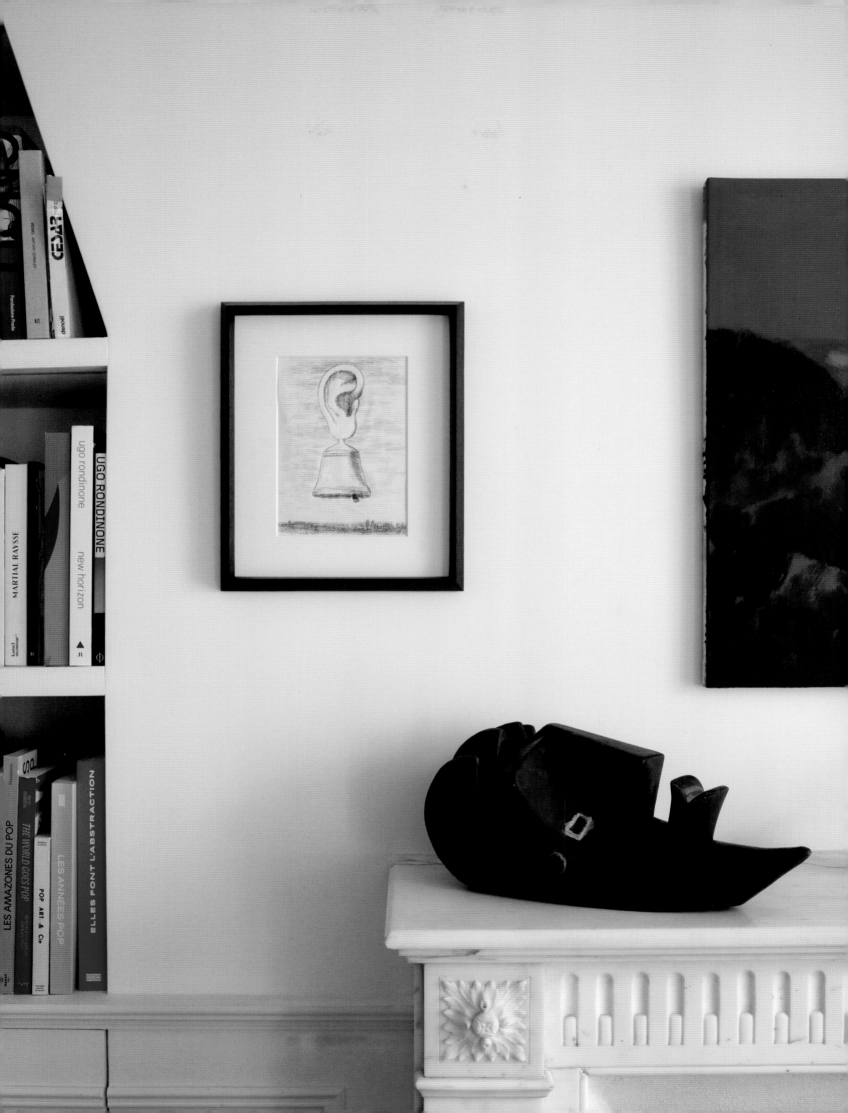

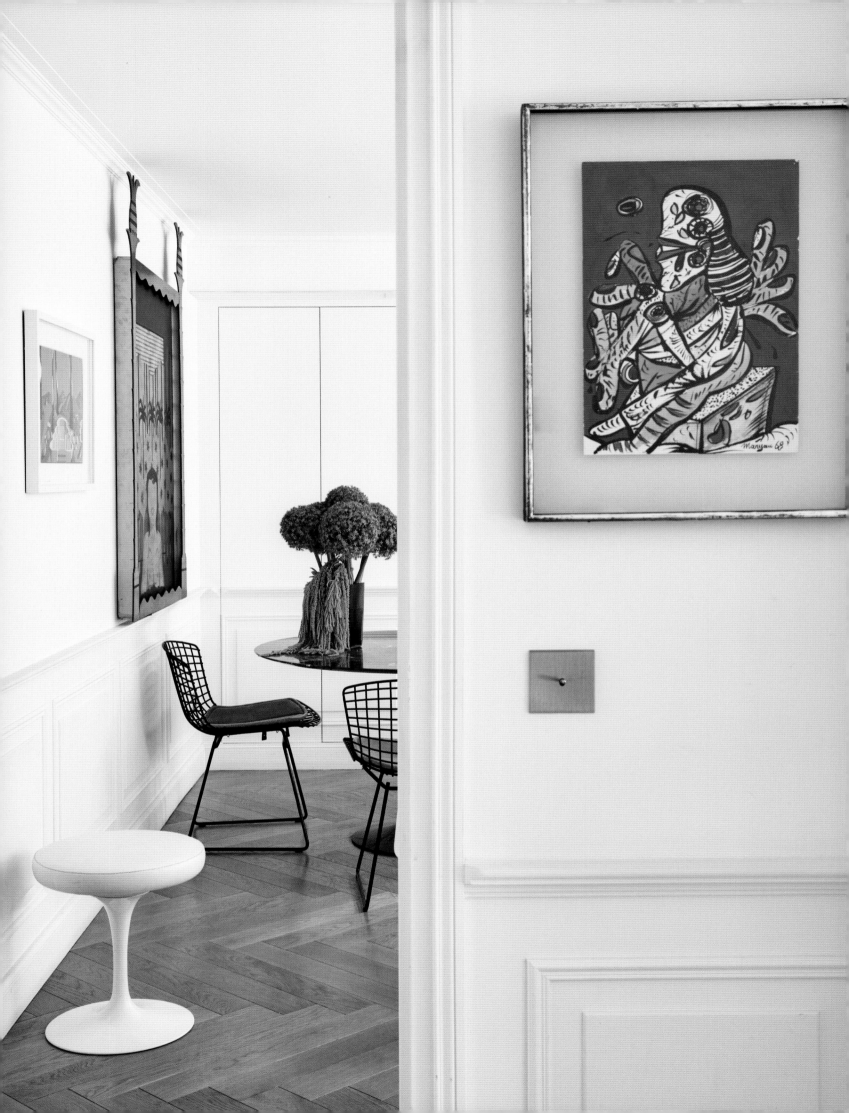

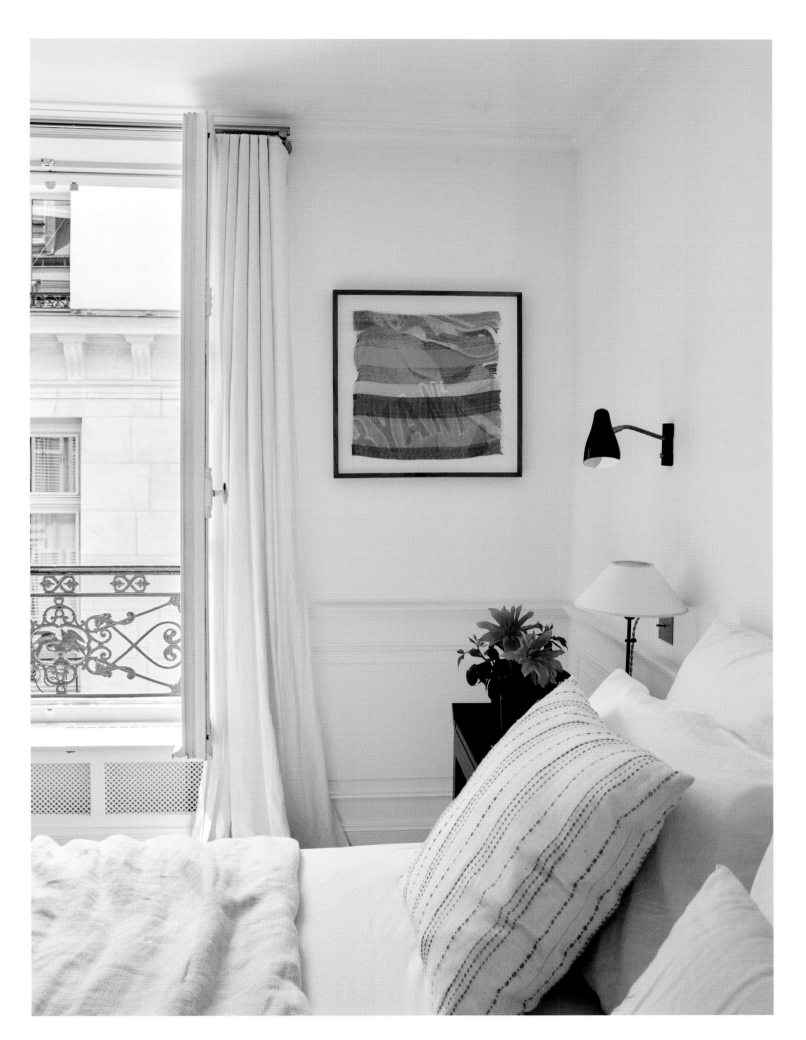

UNIQUE/
ADVENTUROUS/
INVITING.

FRANÇOISE DUMAS

Françoise Dumas is the undisputed number one of Parisian events. Le Tout-Paris has recognized her as such for years. Aristocrats, celebrities, entrepreneurs, museums, and even the Élysée Palace acknowledge that if Françoise is behind something, nothing can go wrong. Her charm and presence are magnetic, and resisting her allure is impossible. I felt the full force of this one Sunday—the only day she stays in, when not in Comporta, and receives friends—when she invited me for tea at her home, and I captured these photographs.

She lives at a corner near Parc Monceau, in the classical 17th arrondissement. Françoise has spent almost her entire life in this part of the city. When she discovered this apartment, it was love at first sight, though it needed renovating and adapting to fit her needs. She looked for help from her friends Jacques Grange and Pierre Passebon. Once Jacques had done his part with the layout, Pierre helped with the decoration; Françoise bought the Serge Roche plaster floor lamps on either side of the fireplace from Pierre's Galerie du Passage. Karl Lagerfeld also contributed a number of pieces, including the plaster-framed Serge Roche mirror that hangs in Françoise's bedroom, a pair of 1920s Berlin bedside tables, a 1930s marquetry cabinet, and some Ciboure ceramic vases. Another friend, Louis Benech, helped with the garden. I was happy to capture it in a rainy autumn afternoon, with greens and yellows shining in all their intensity.

Despite all the varied influences of this "French dream team," the house strongly reflects Françoise's character. A serene refinement is present throughout: there is no color or material that disrupts the perfect balance. Every interior and exterior space invites visitors to partake in her exquisite company and her "art de vivre à la française." Let's take the chance to enjoy this intimate glimpse of her world.

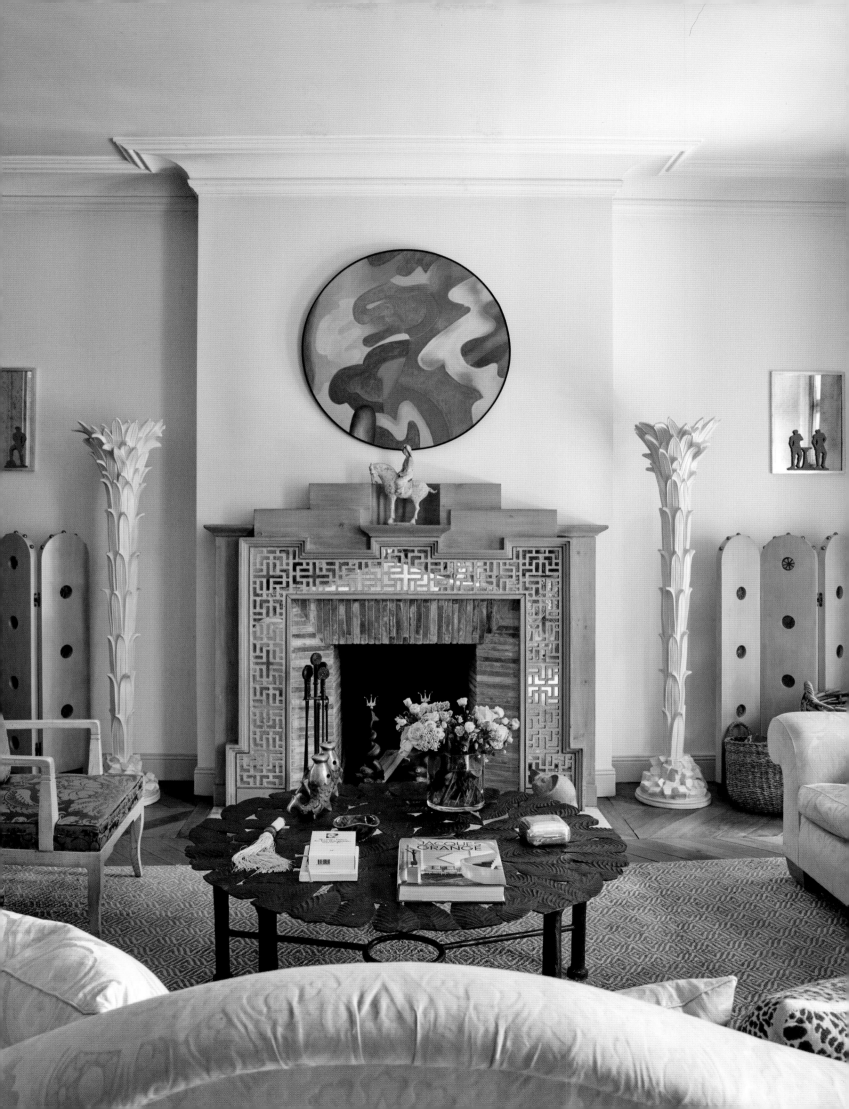

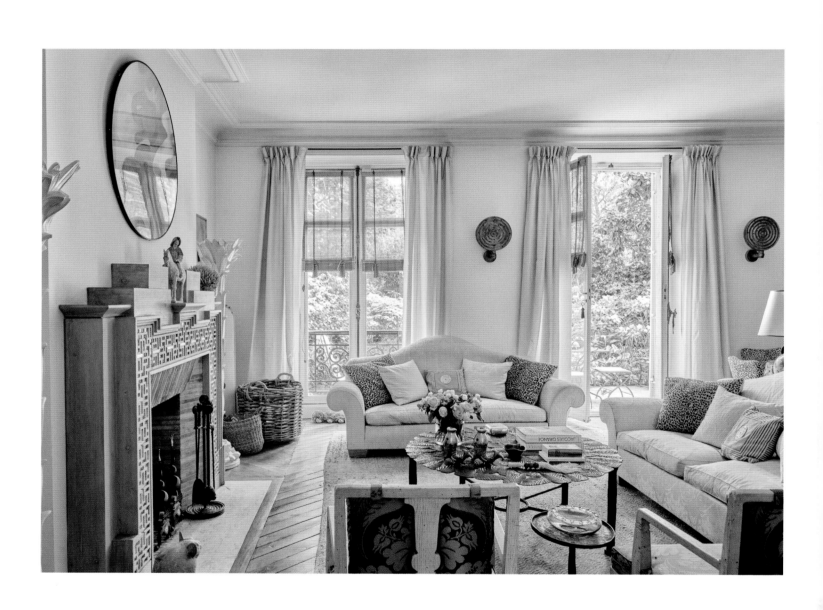

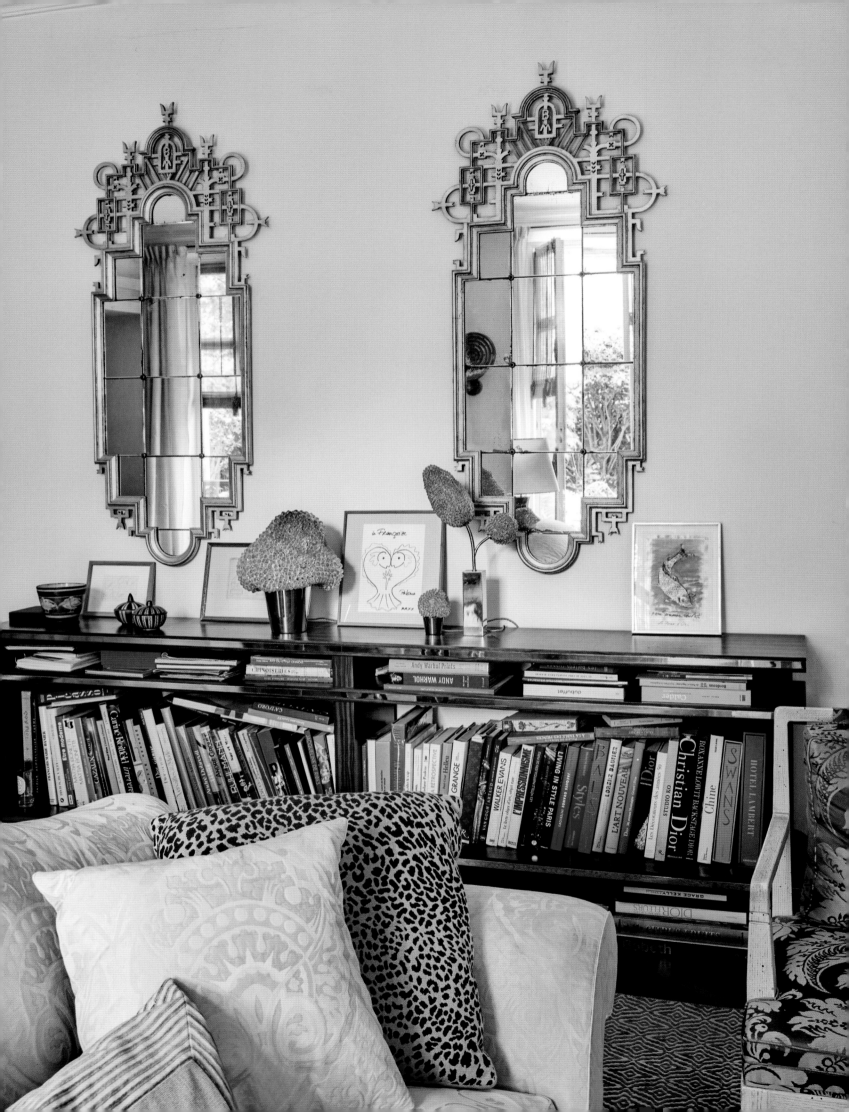

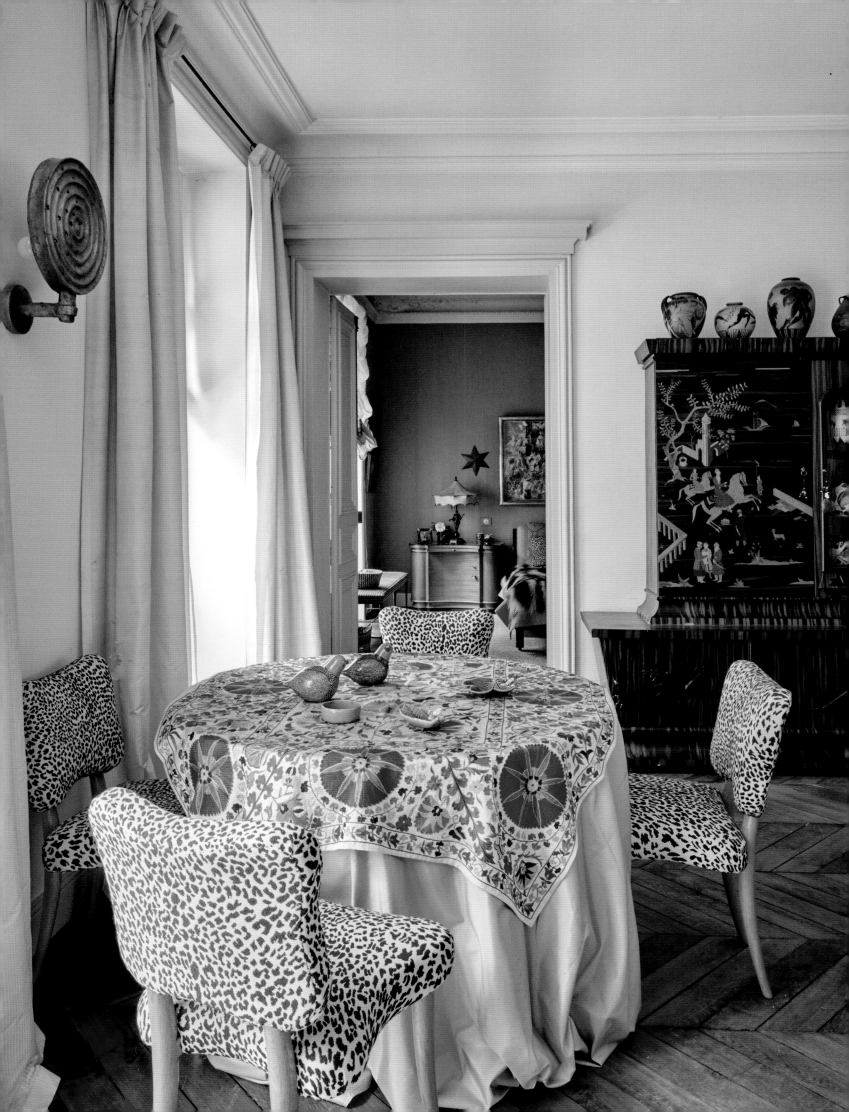

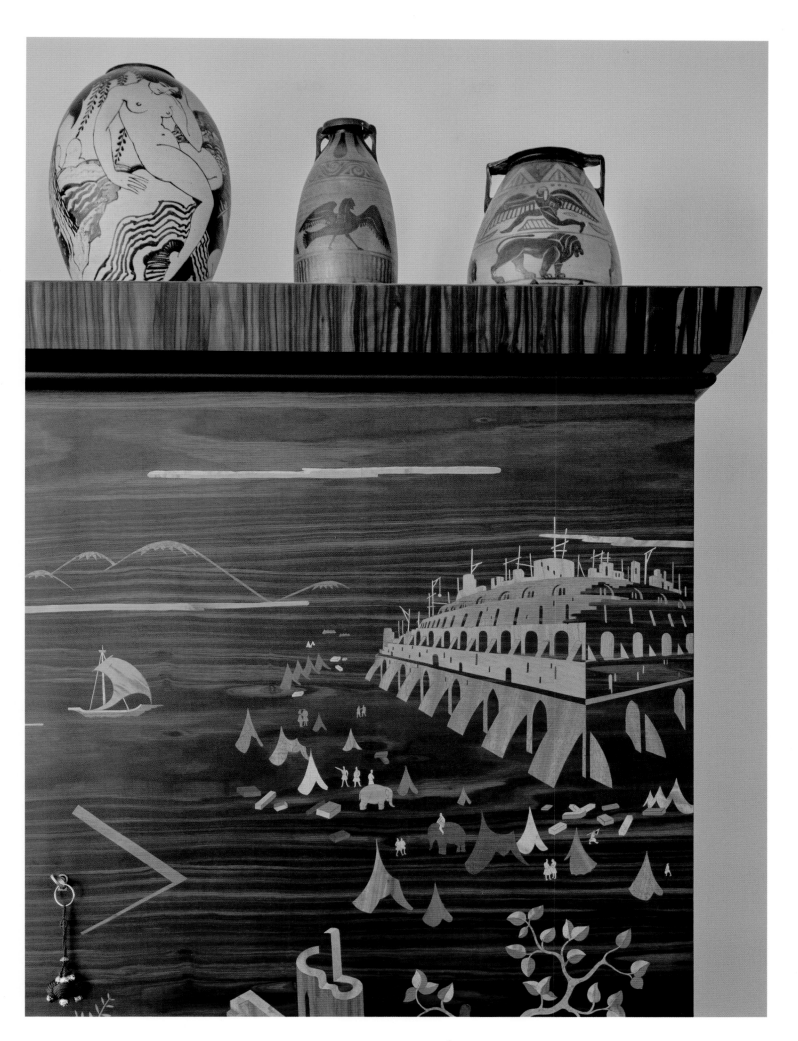

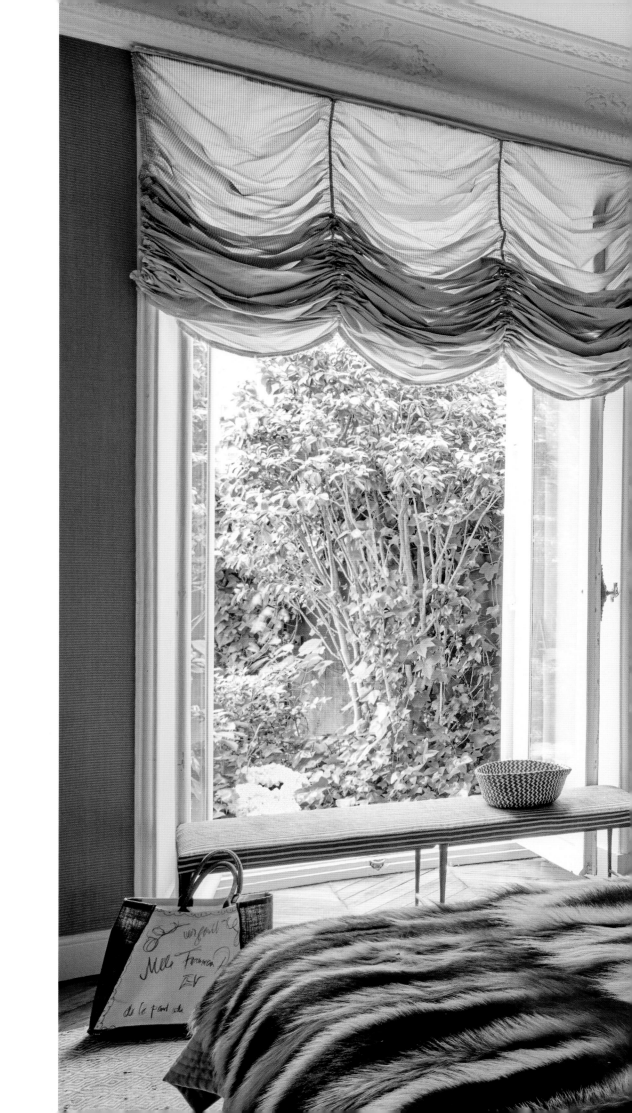

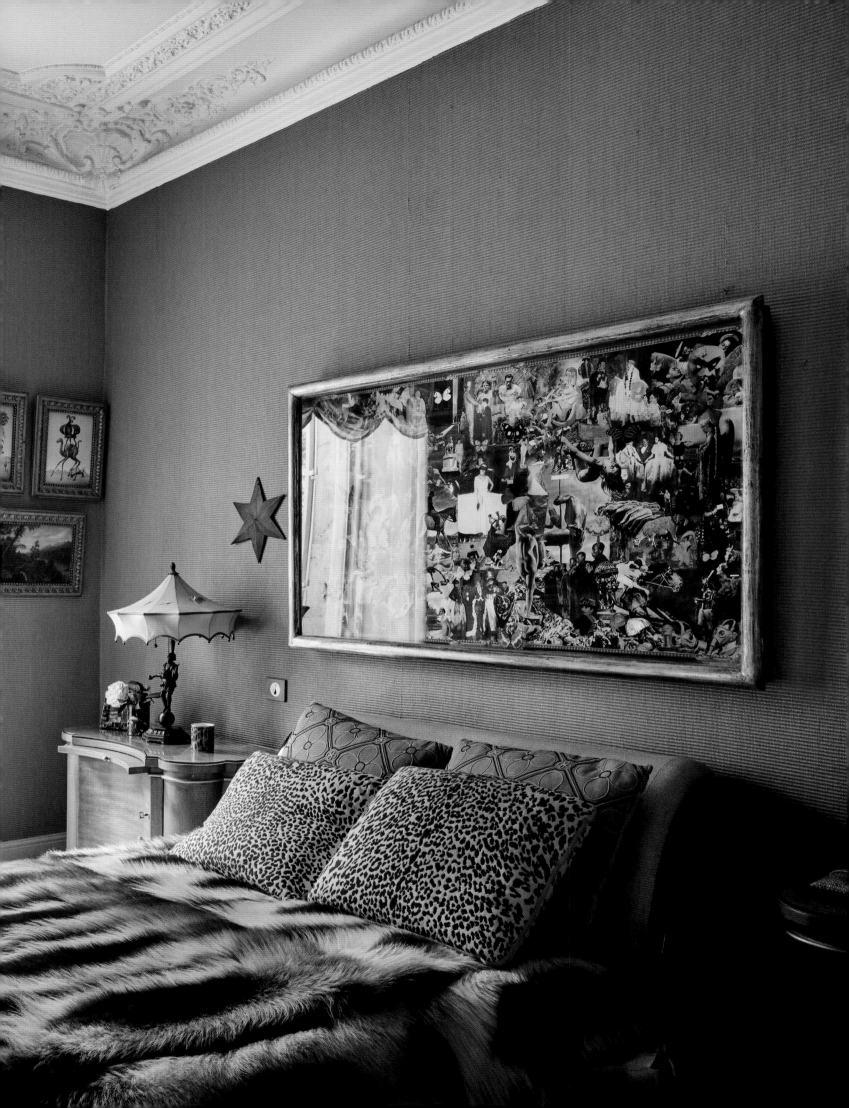

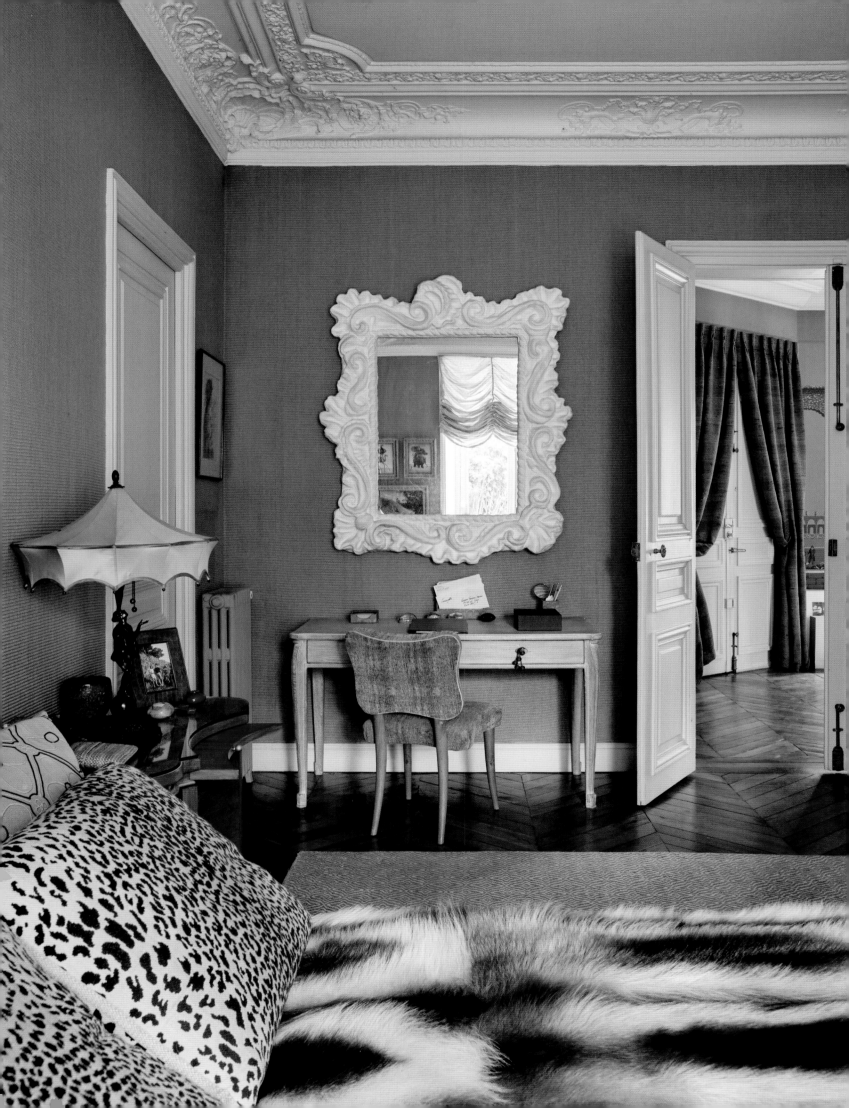

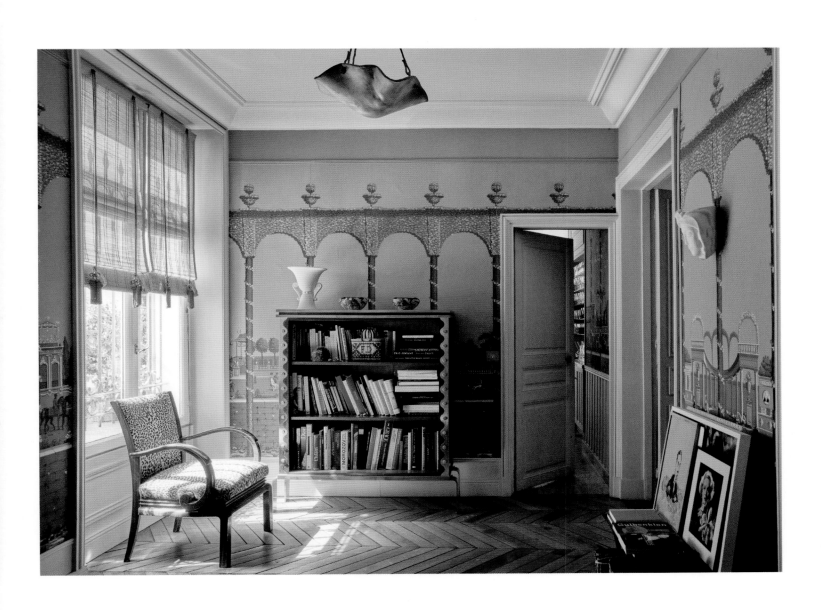

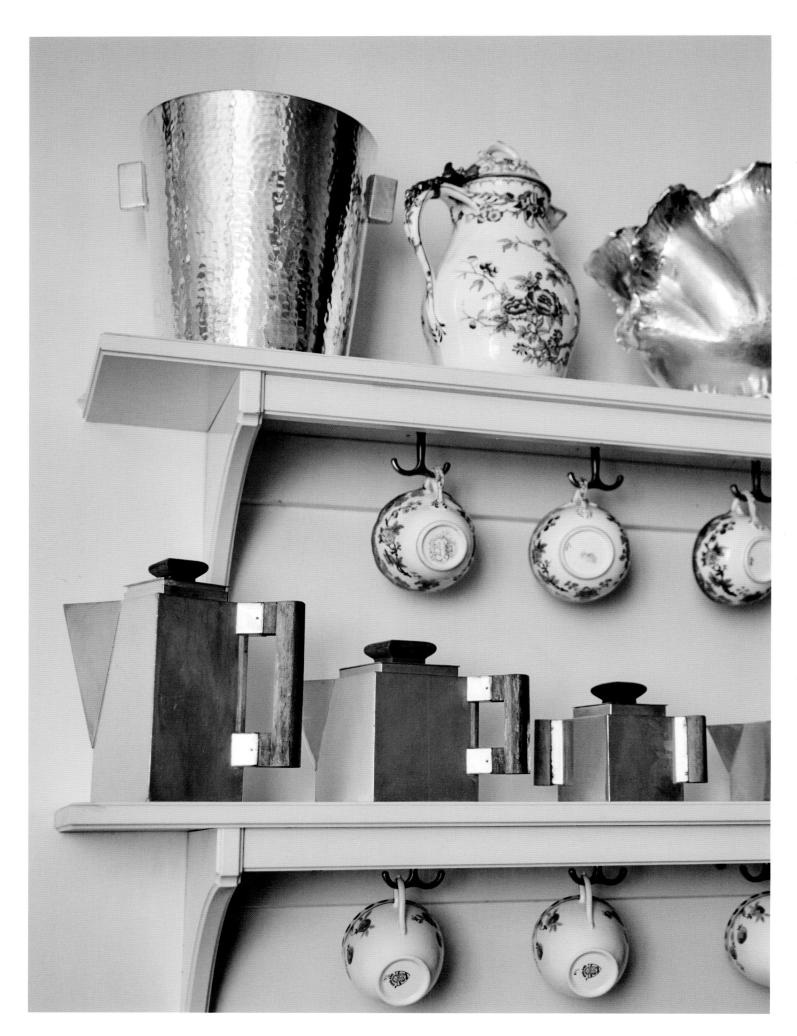

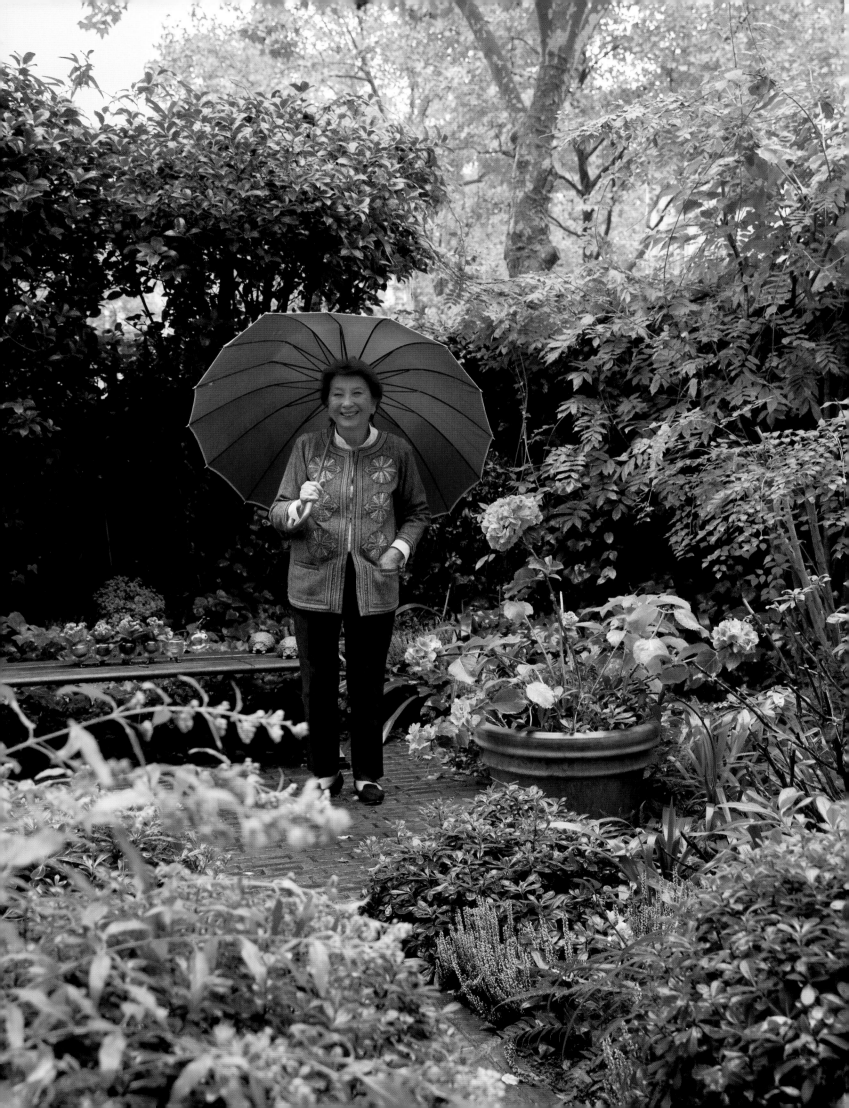

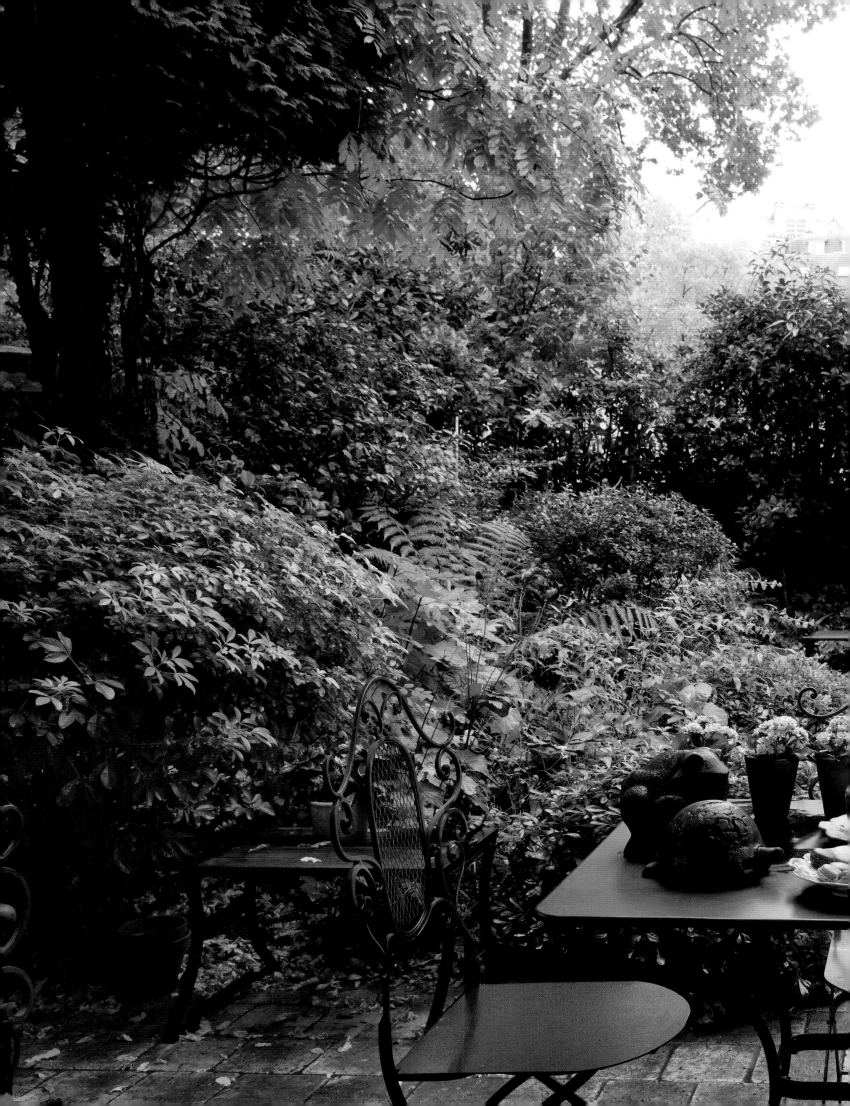

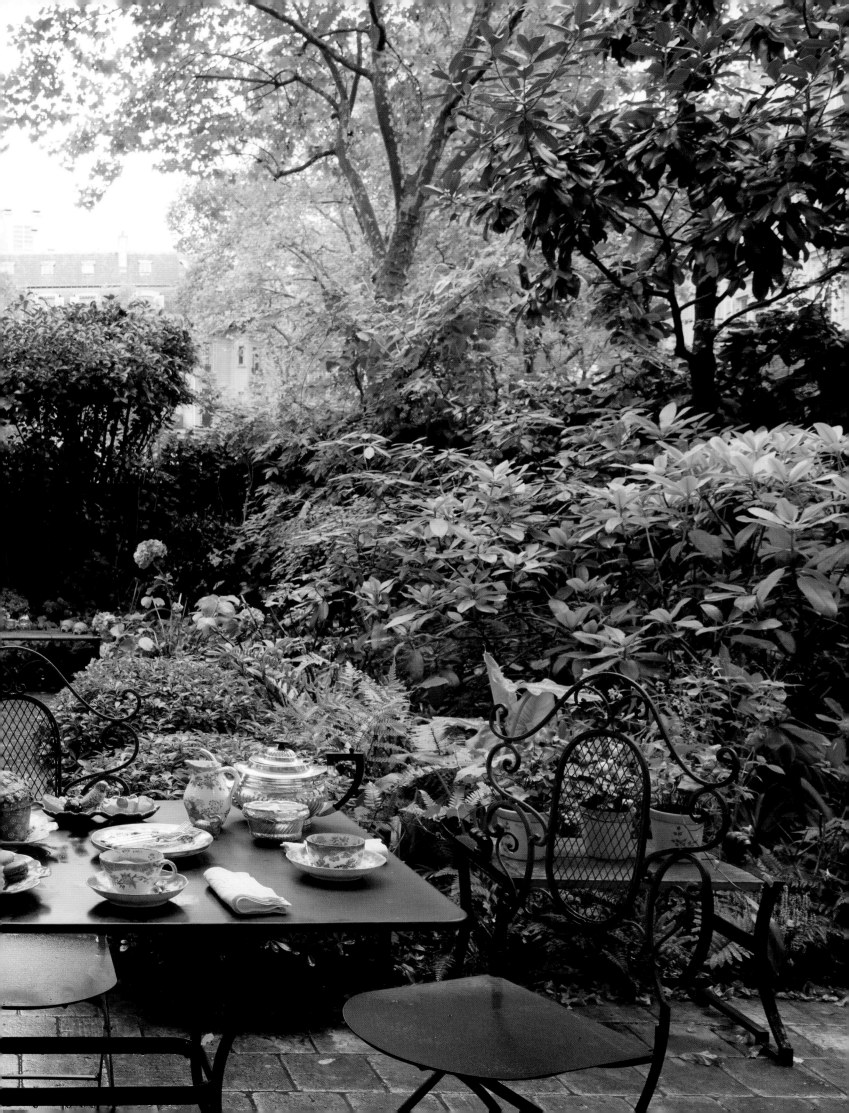

CRAFTED/
TRADITIONAL/
CHIC.

GABRIELLA CORTESE

Gabriella Cortese made her mark on the fashion universe when she founded Antik Batik in 1992. The fashion house stands out for its collections of chic, bohemian clothing and accessories that emphasize craftsmanship and artistic techniques.

Paris has been home to Gabriella since she unpacked her bags here in 1984 to continue her studies. Hailing from Turin, the "Paris of Italy," she felt immediately at home in the French capital. In 2011, after months of searching, Gabriella was captivated by a splendid residence hidden in the Nouvelle Athènes neighborhood, between Place Saint Georges and Pigalle. In the early 1900s, this area was home to artists and brothels, cabarets and the Bouglione circus. The bourgeoisie mingled here, Toulouse-Lautrec painted his dancers, and revelers went to the Moulin Rouge and drank absinthe.

The living room opens onto the garden, evoking the grand tours of the eighteenth century, to Italy but also to the East, passing through the fantastic Samarkand. For Gabriella, the house embodies her Italian childhood with a Hungarian grandmother, her discovery of India, and the dandy side of her late husband, actor Marc Rioufol, who should have lived in 1800.

The decoration, done in tandem with Italian interior designer Michela Curetti, encompasses all the spaces of the house, including the staircase with its cascade of Tom Dixon lamps. The colors of Ratti fabrics, Dedar silks, Braquenié jacquards, and de Gournay tapestries blend together. Family objects harmonize with those collected over forty years: antique side tables and an eighteenth-century love scene on the mantelpiece; Vallauris vases, barbotines, and Henriette Jansen ceramics; and photos by Antoine d'Agata.

As we enjoy pasta in the garden with Wolfy, her Jack Russell, Gabriella comments, "I have a certain taste for orientalism, and I appreciate warm colors—those that comfort the soul." The same warmth emanates from each one of her gestures.

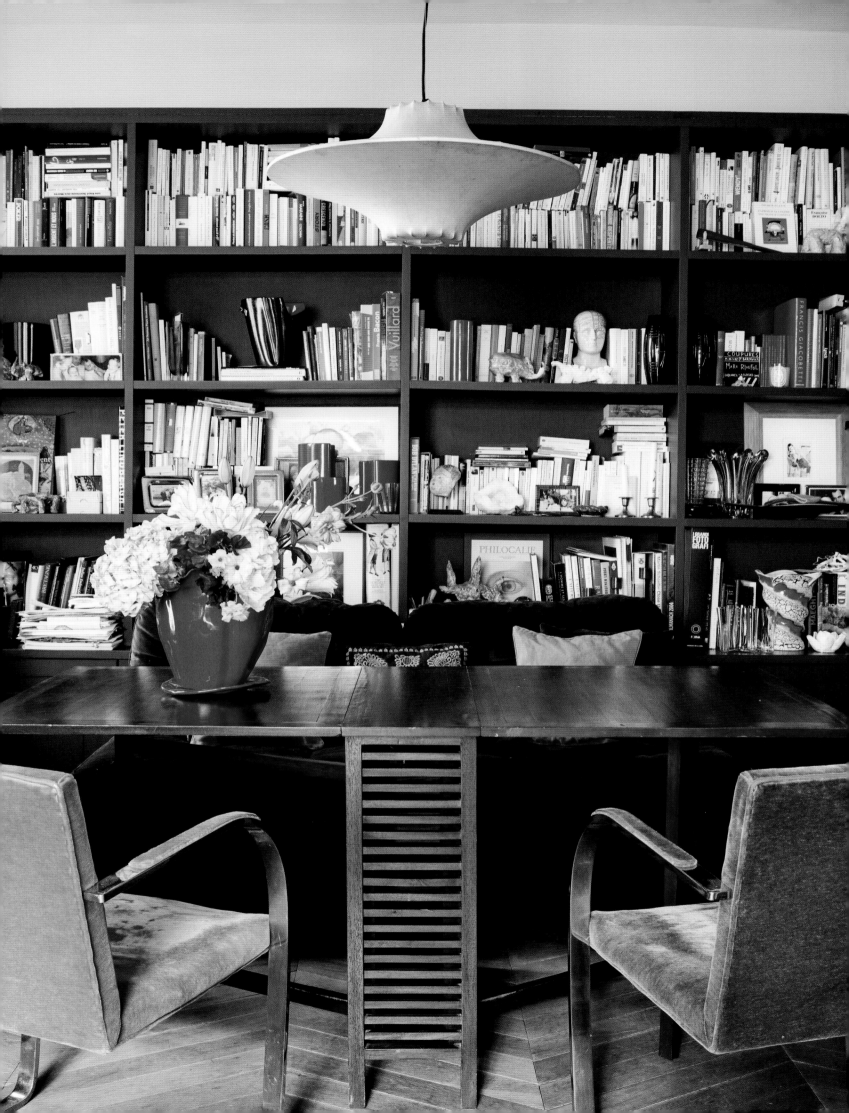

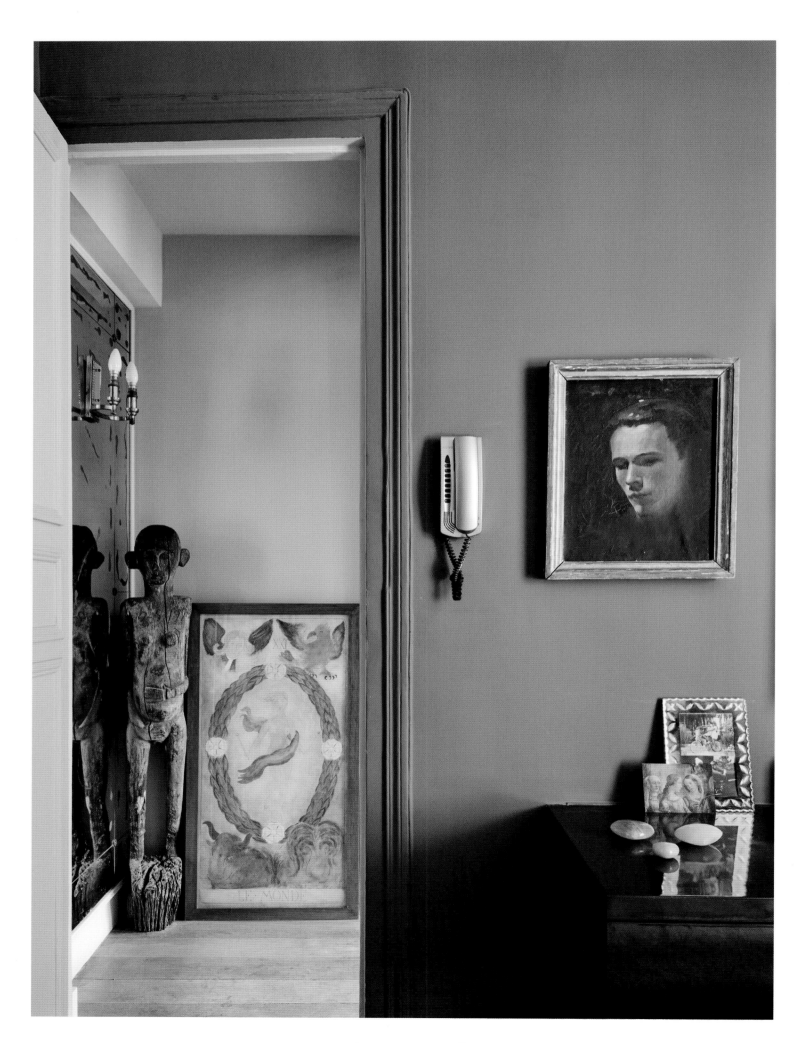

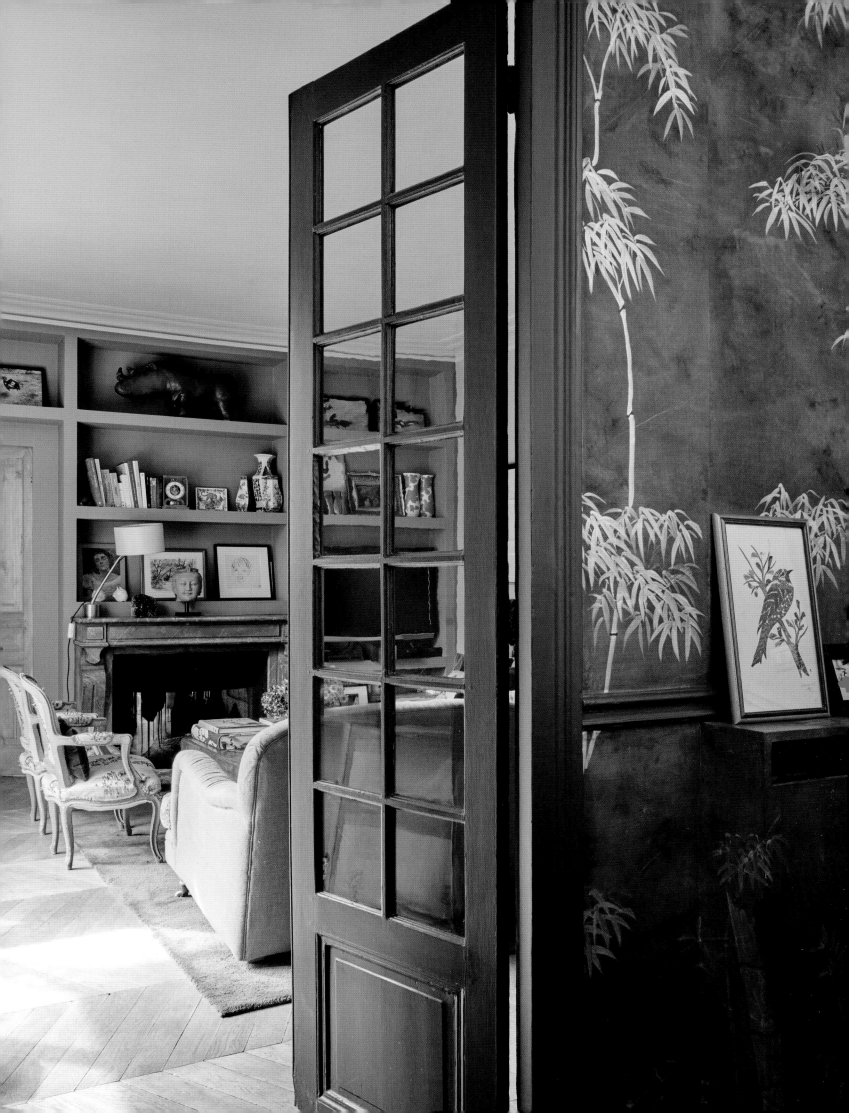

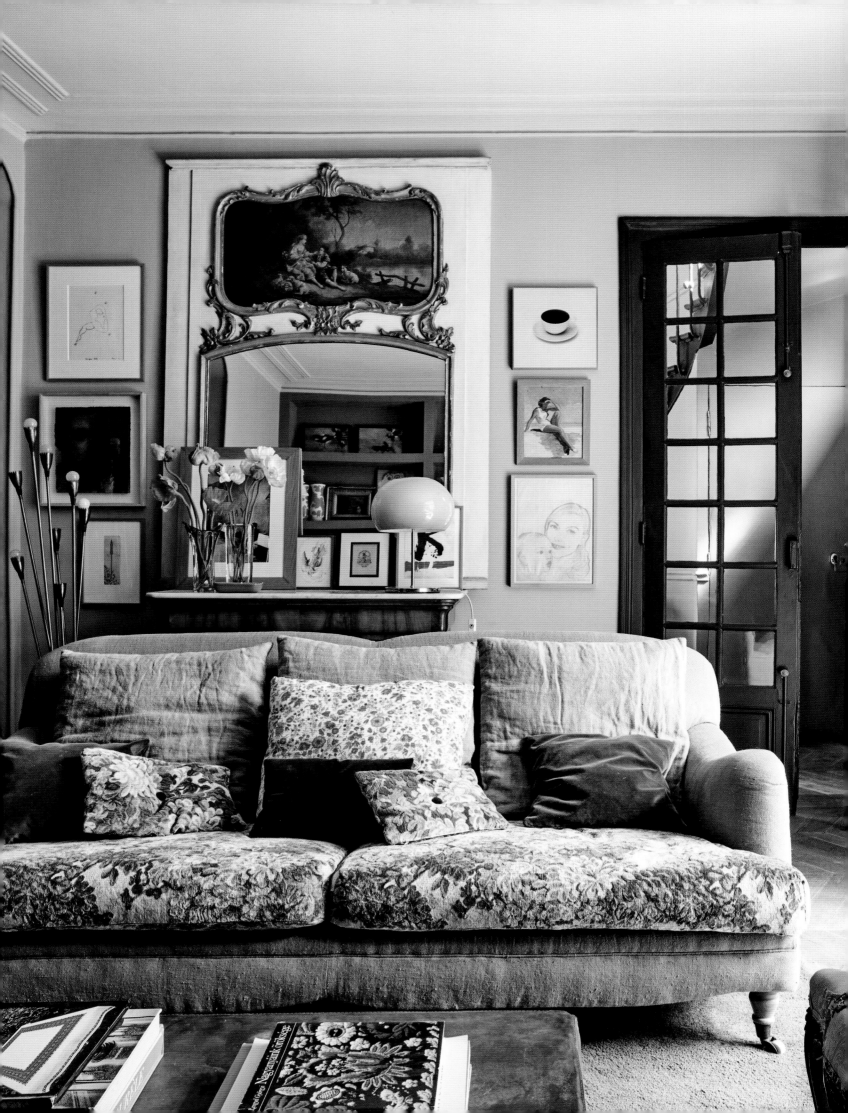

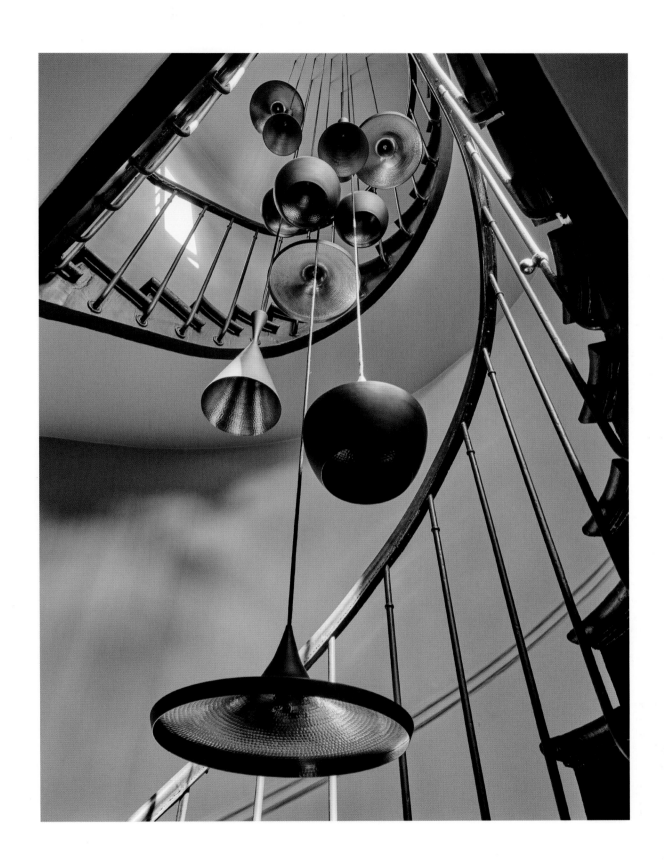

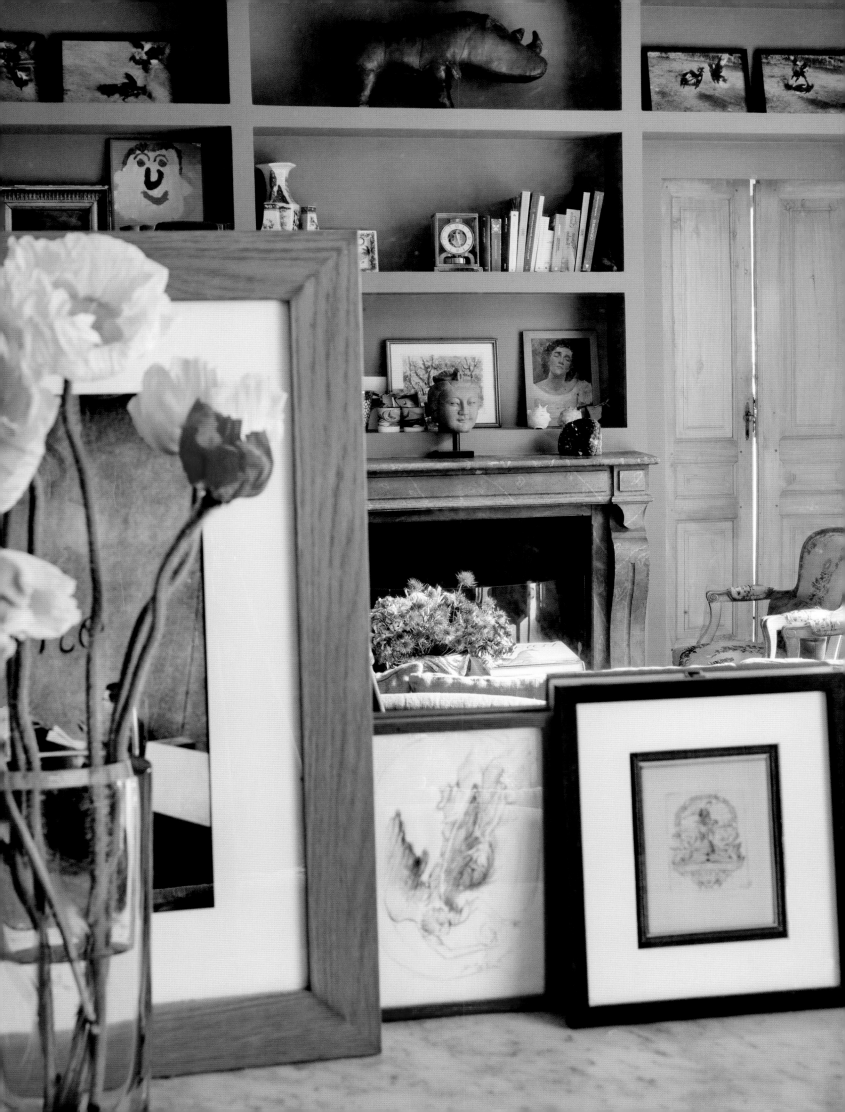

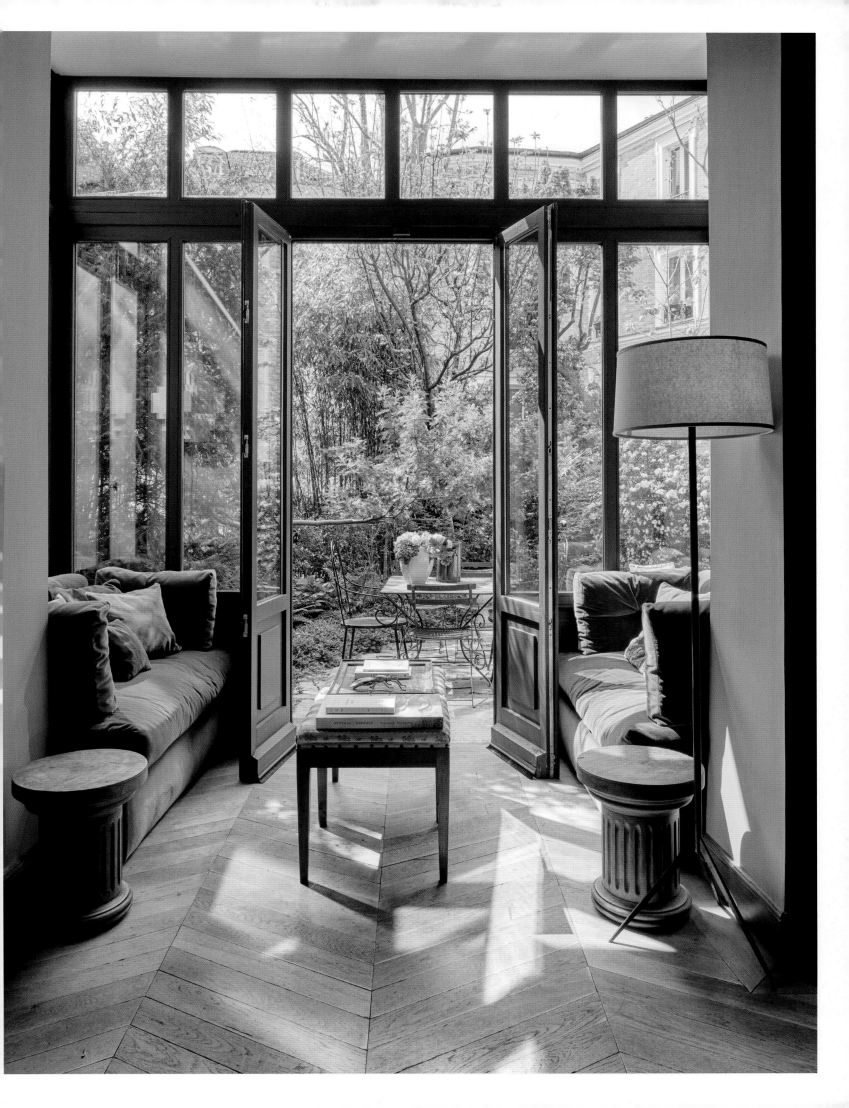

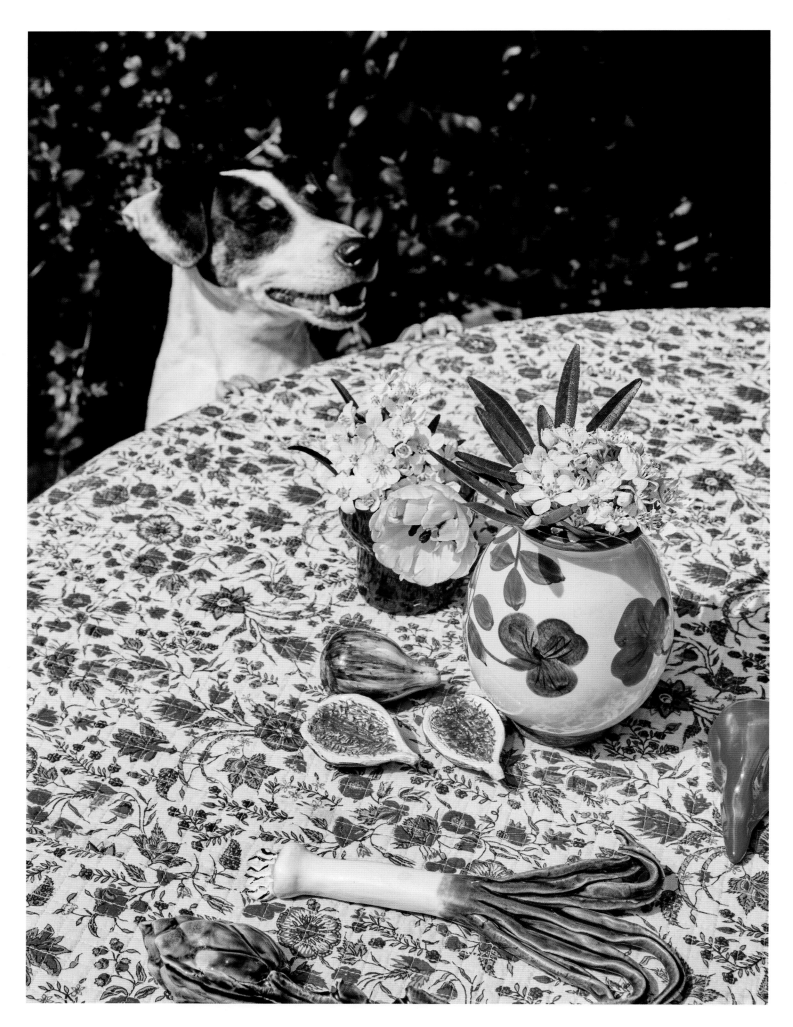

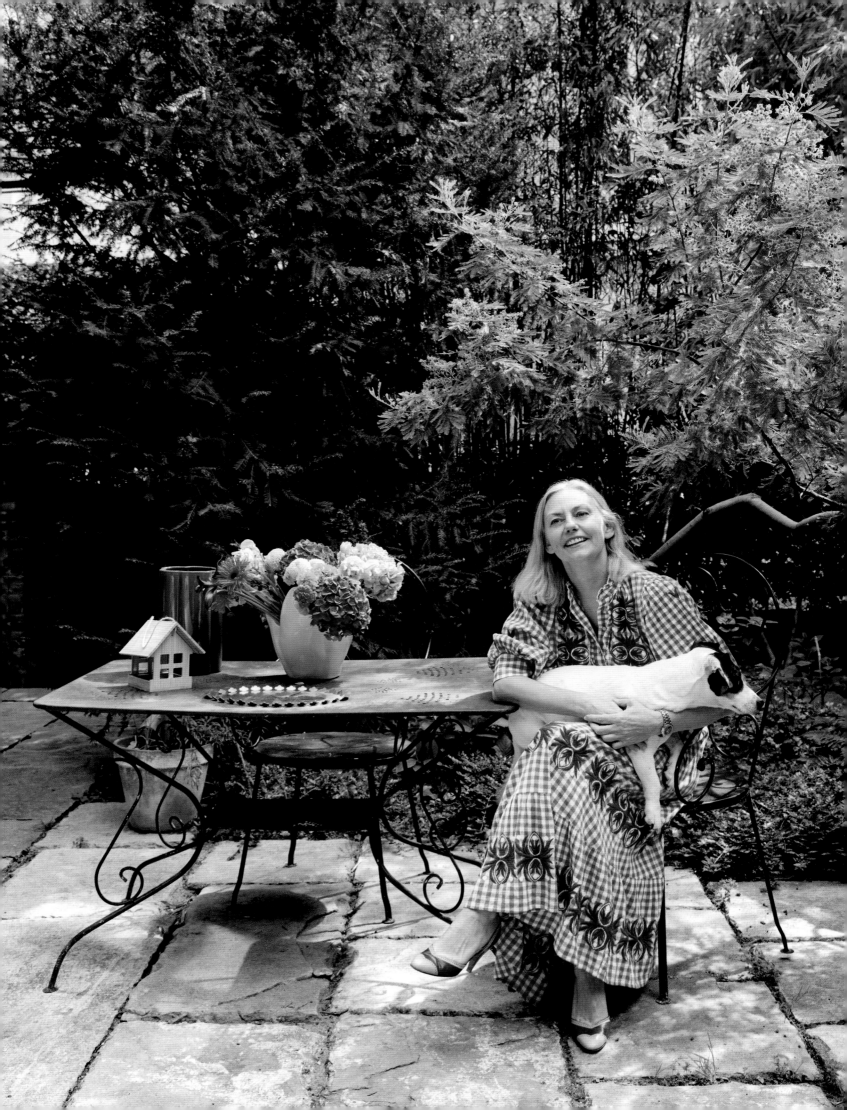

STYLISH/ POLISHED/ CULTURED.

JACOPO ETRO

Living in front of the Jardin du Luxembourg has its advantages, Jacopo shares with me, as we enter this beautiful building designed by Michel Roux-Spitz in the 1920s. The gardens, he says, are the most perfect place in the city to walk—one of the activities he enjoys the most when visiting Paris, provided the weather cooperates.

Jacopo and his family have long been immersed in the worlds of fashion and decoration through the brand that bears his name. He is a man of innate taste and elegance, with a sharp and well-trained eye. In his interior spaces, he distances himself from the eclectic and colorful designs of his work, opting for sobriety in search of the calm he needs to counterbalance a working life spent in constant motion.

His pied-à-terre in Paris is defined by pieces that may or may not be connected by style but stand out for their originality and quality, such as the 1920s screen by Eileen Gray that separates the living room from the dining area. Much of the decor references the Art Deco style of the building, with exceptions like the Doge dining table, designed by Carlo Scarpa in 1968, which adds luminosity to the ensemble.

A warm and bold red carpet throughout the apartment enhances the black and metal of the furniture, as well as the gray flannel couches, creating a warm and cozy atmosphere. The large windows and lacquered ceiling reflect the trees of the historical green space outside, inviting contemplation of nature changing with the seasons.

Since I first met him decades ago at his house in Ibiza, where we were introduced by our mutual friend Naty Abascal, I have known Jacopo to be a magnificent host. Over the years, I have captured many of Jacopo's residences, and even those of his parents, with my camera. In all of them, a sober yet functional refinement prevails.

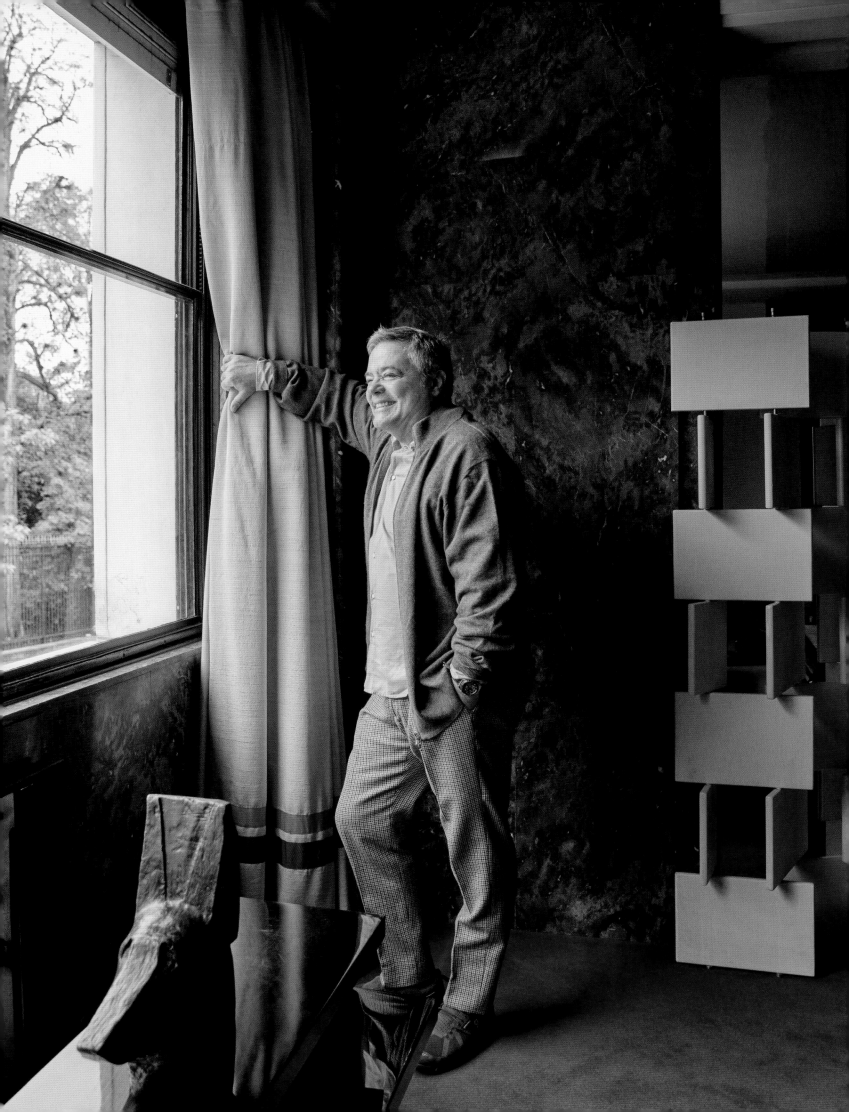

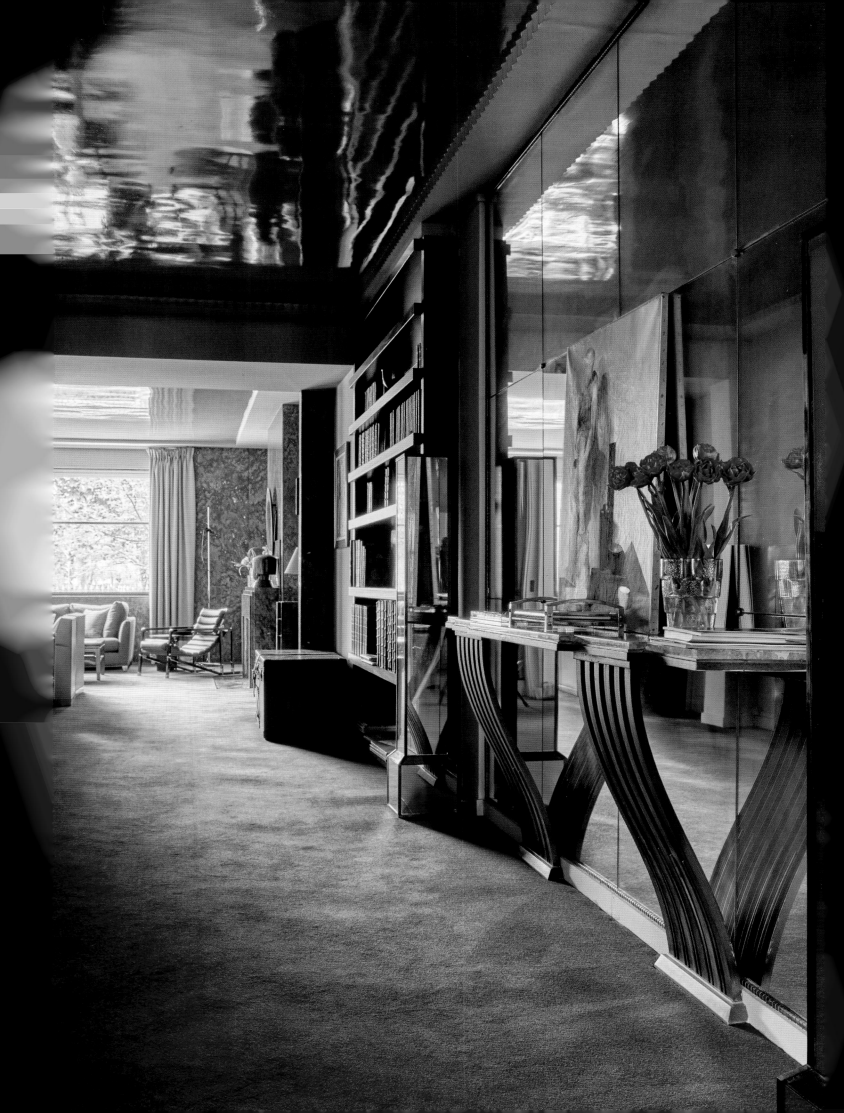

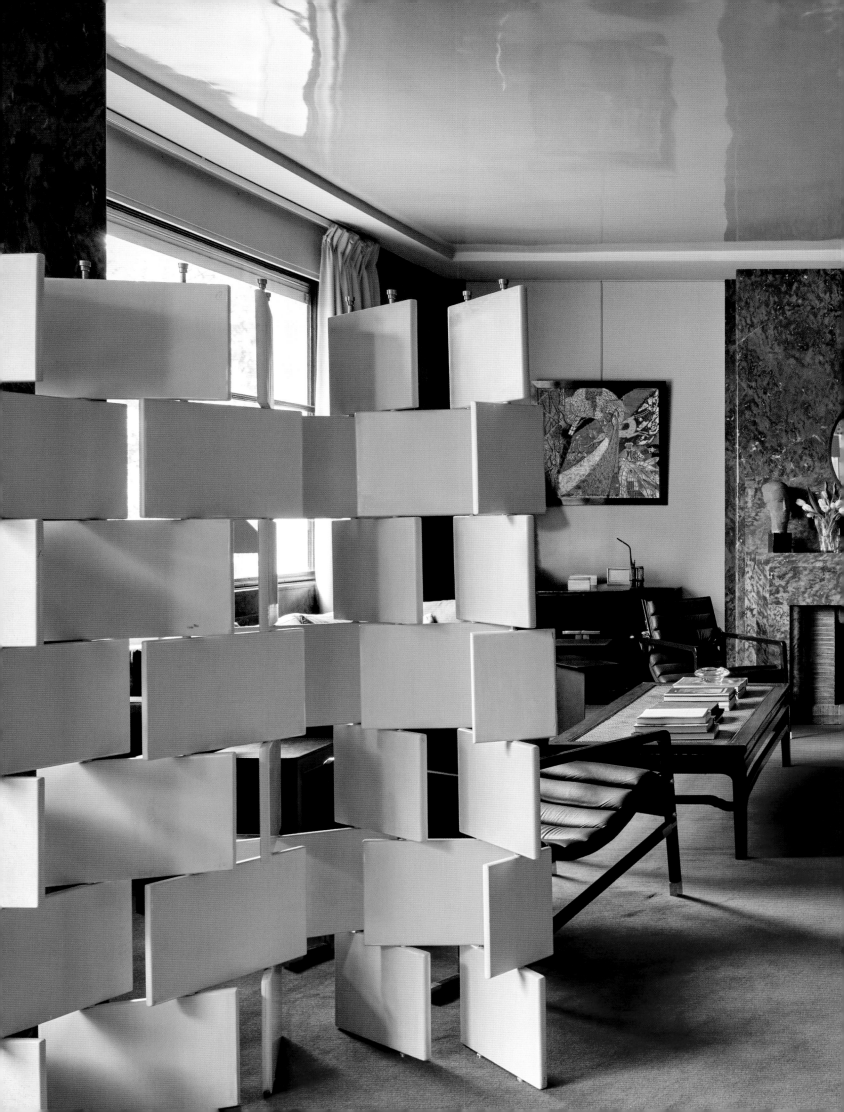

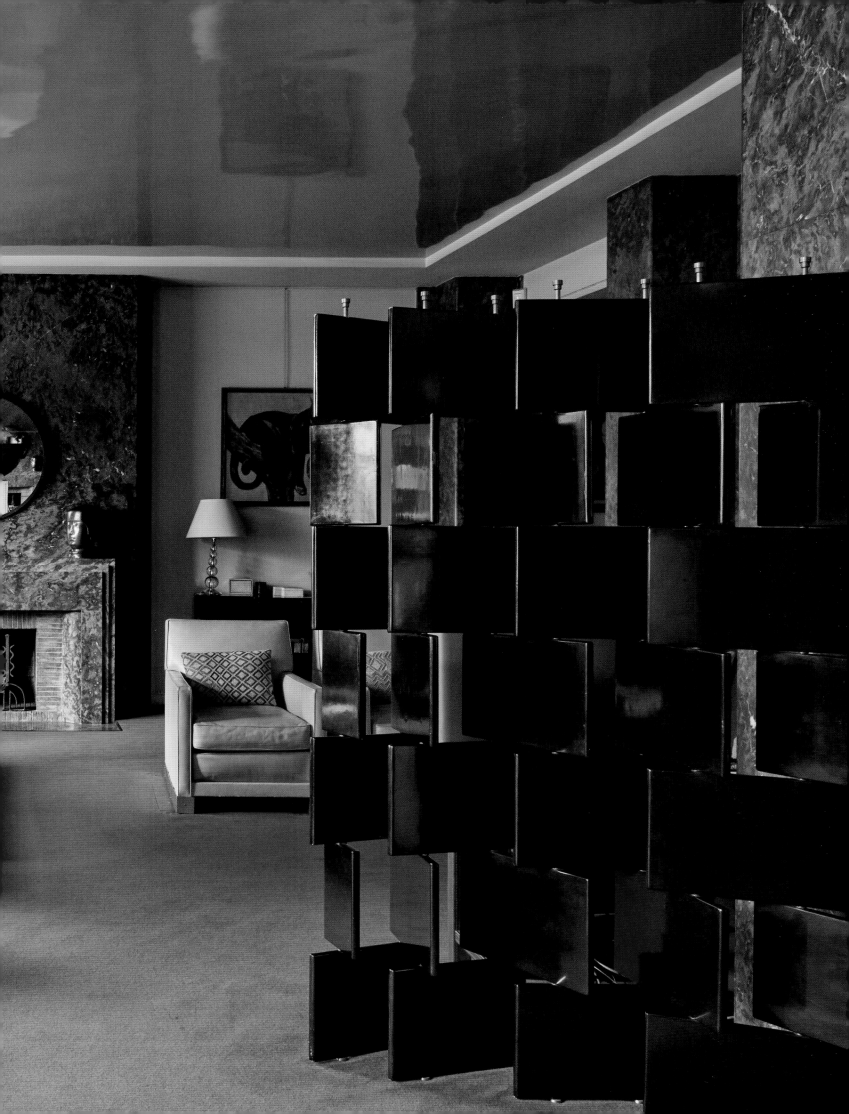

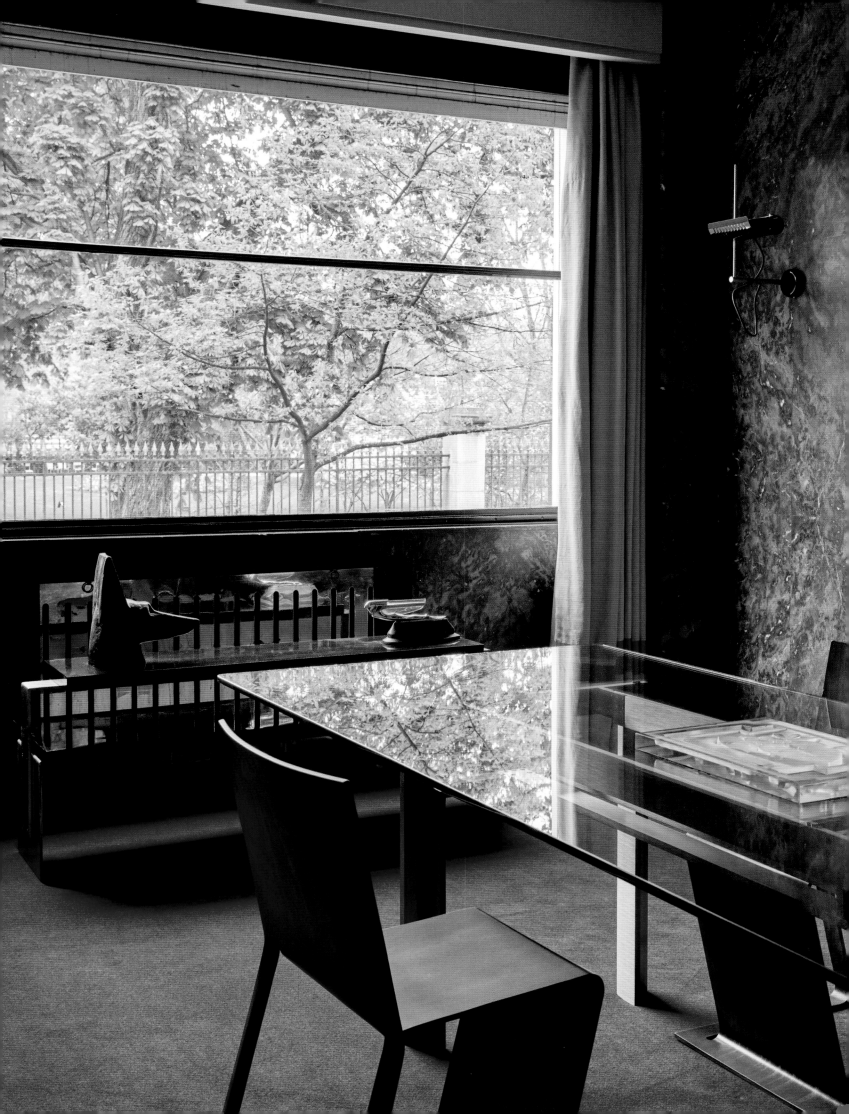

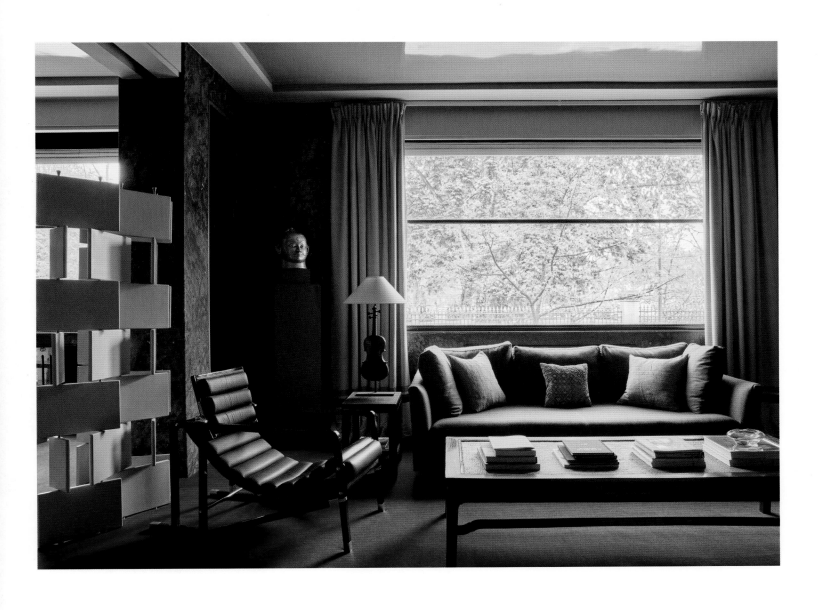

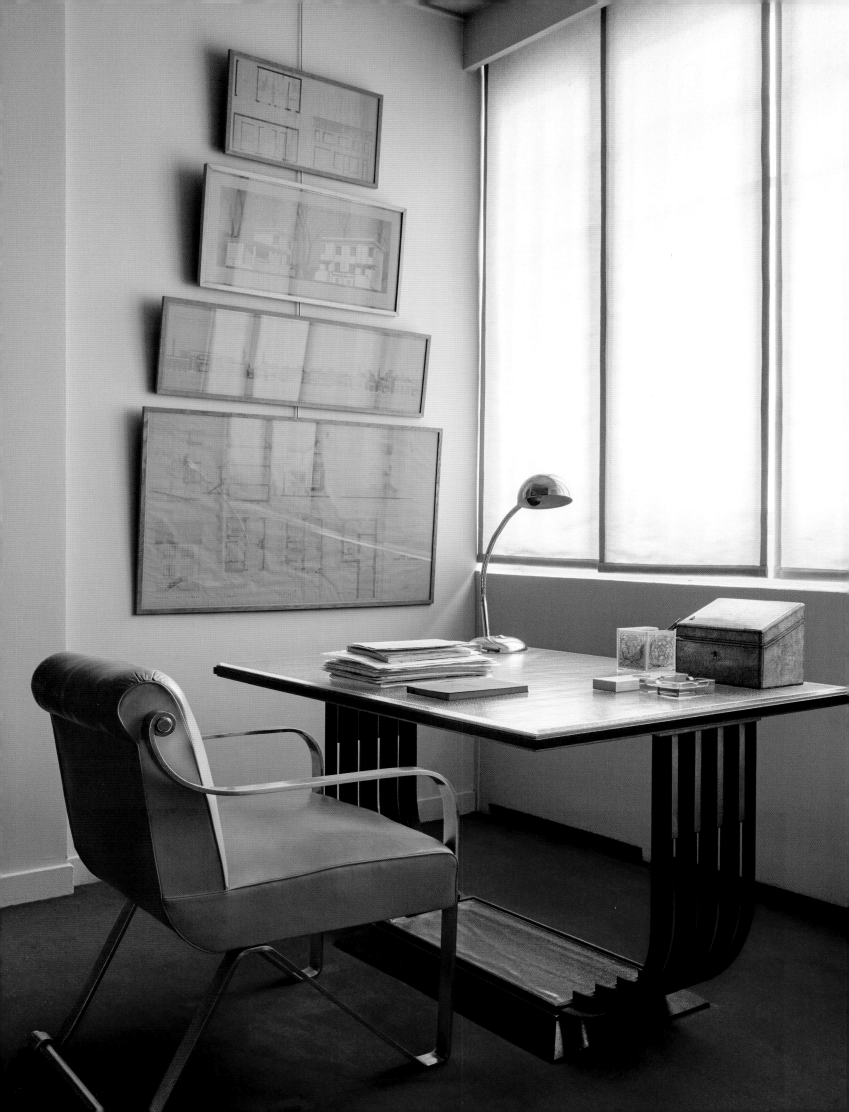

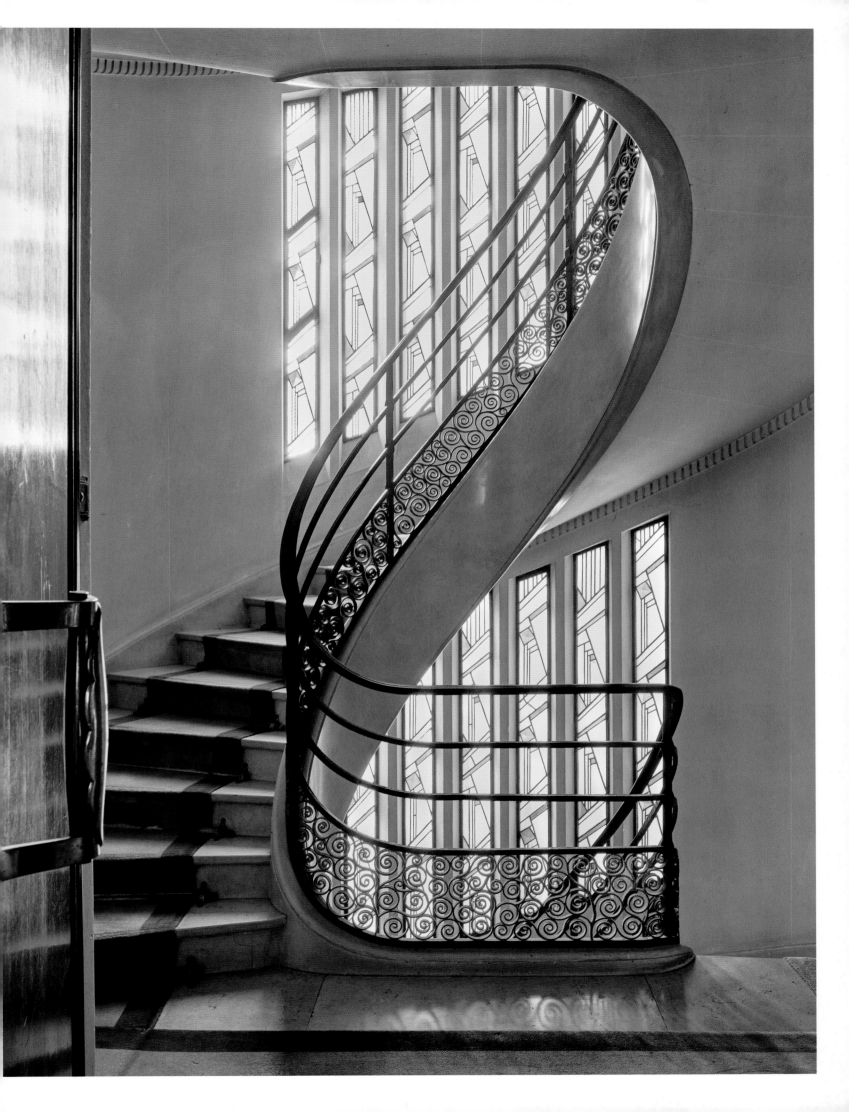

ICONIC/
COSMOPOLITAN/
INSPIRATIONAL.

JACQUES GRANGE

Jacques Grange needs no introduction. He is the king of decoration in France, and his recognition knows no borders. I had the privilege of meeting him a few years ago when I took photos of his house in Comporta. Though I spent only a brief time there, I was able to experience some of his world. Jacques naturally creates beauty and shares it in a simple and refined manner, without any stiffness.

Aristocrats, celebrities, and millionaires from around the world have been and continue to be his clients. Many of the spaces he has designed for them have left a mark on Jacques, such as the houses for Yves Saint Laurent and Pierre Bergé, including the iconic Villa Majorelle in Marrakech.

When I visited his home at the Palais-Royal, Jacques simply opened the door, gave me a quick tour, and then left me alone for as much time as I needed. The house is divided into two floors connected by a staircase designed by Grange and inspired by Le Corbusier. The structure adds a rebellious touch to the building's architecture. Once home to the writer Colette, the house—although completely renovated—still nods to its previous owner: Jacques owns the chaise longue where the famous writer received her friends, enjoying the perfectly symmetrical views of the Palais-Royal.

Jacques's vast and eclectic collection extends throughout all the spaces. Works by such artists as Robert Motherwell and Christian Bérard adorn the walls, accompanied by furniture by Marc Newson, Alberto Giacometti, and Gio Ponti, with a pendant by Man Ray in the entrance hall. This admirer of Jean-Michel Frank, Madeleine Castaing, and Yves Saint Laurent effortlessly and successfully blends all eras and styles with the contemporary. His revolutionary signature continues to shape interior decoration in France and around the world to this day.

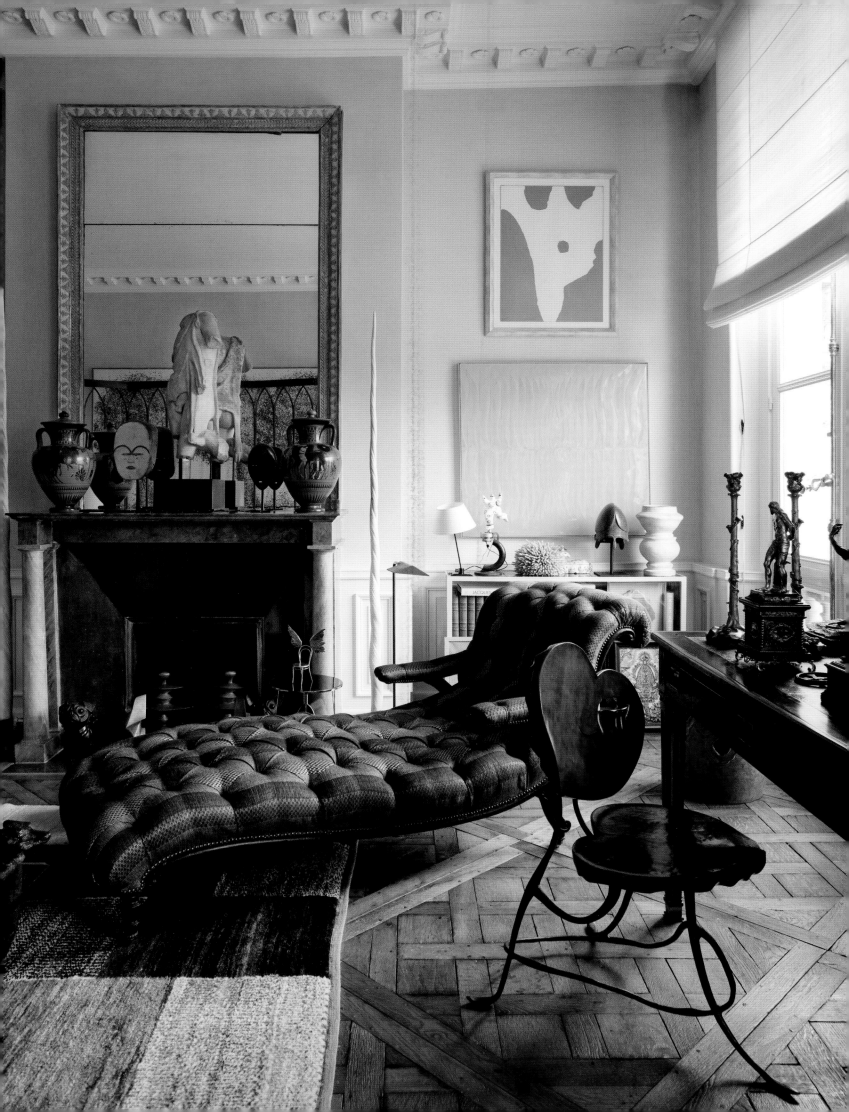

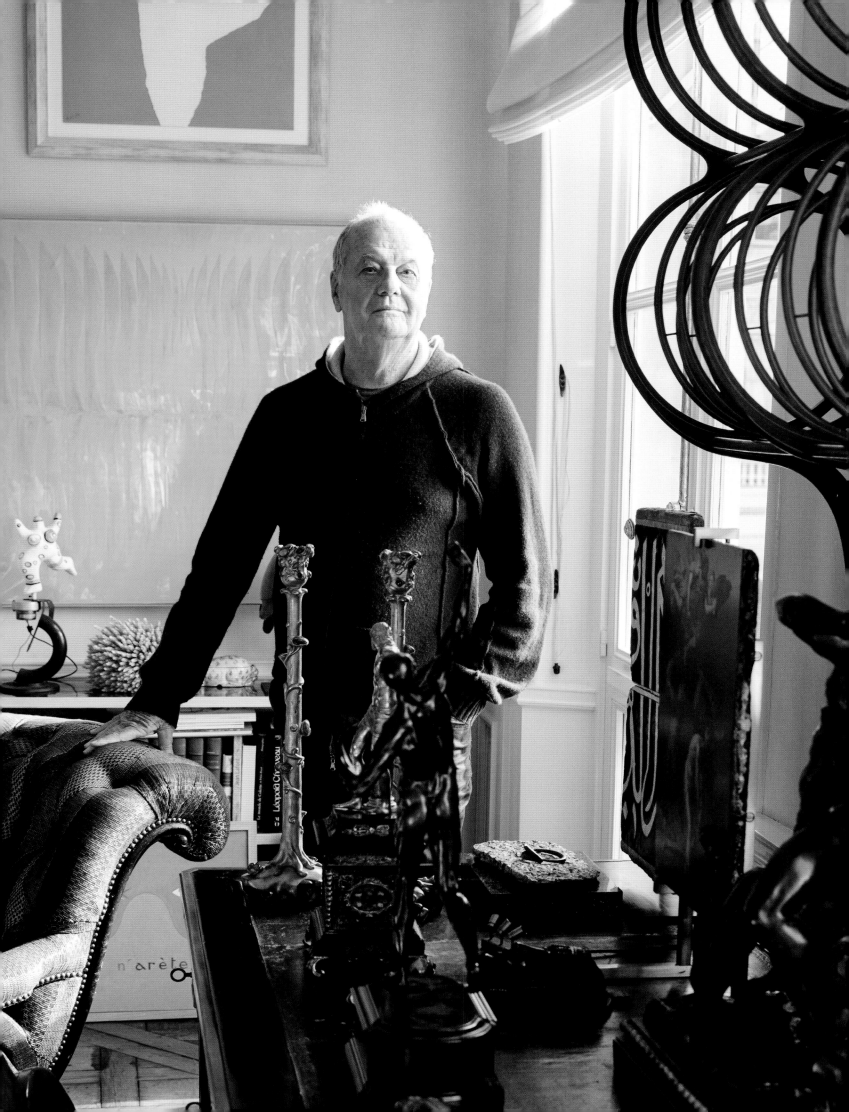

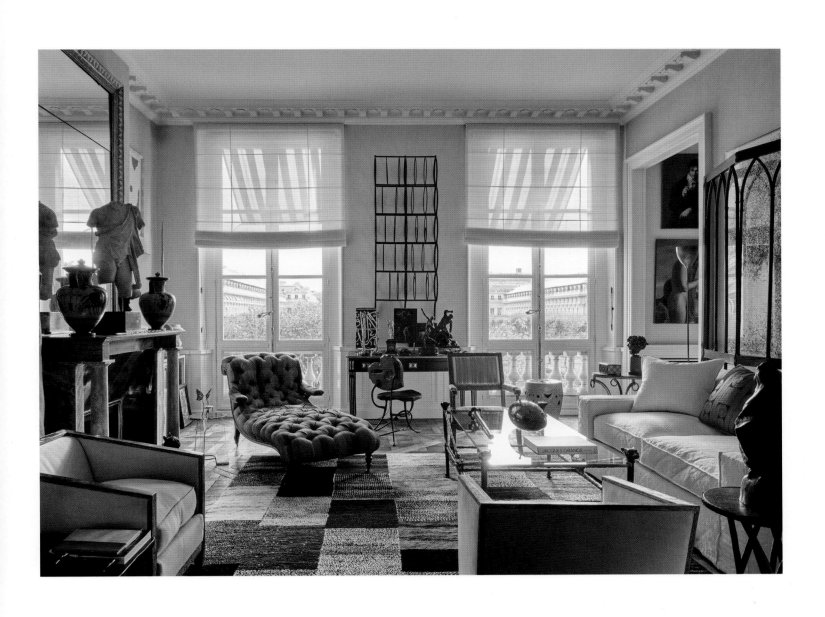

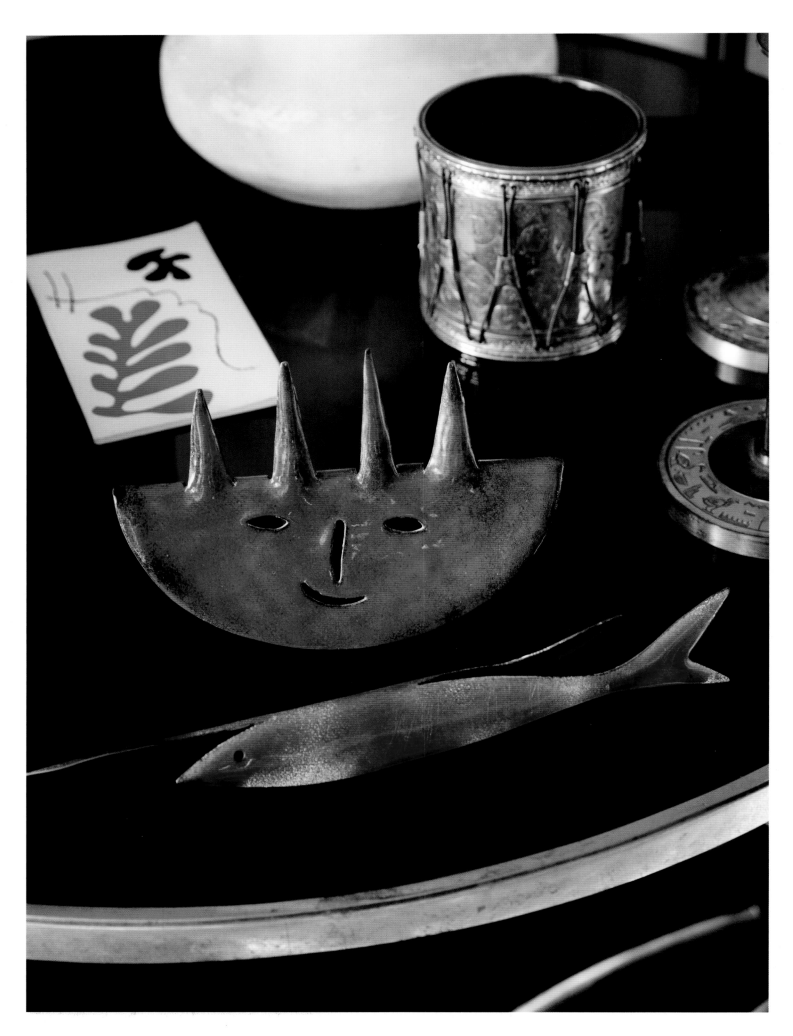

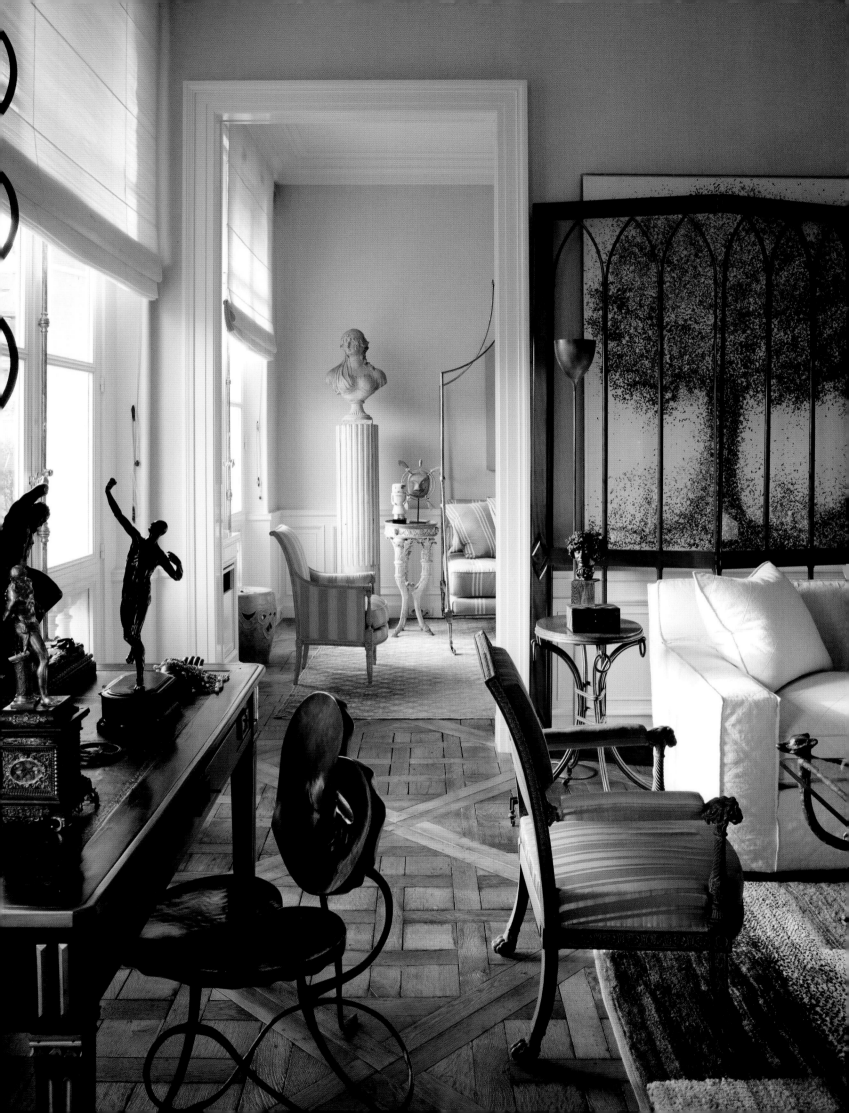

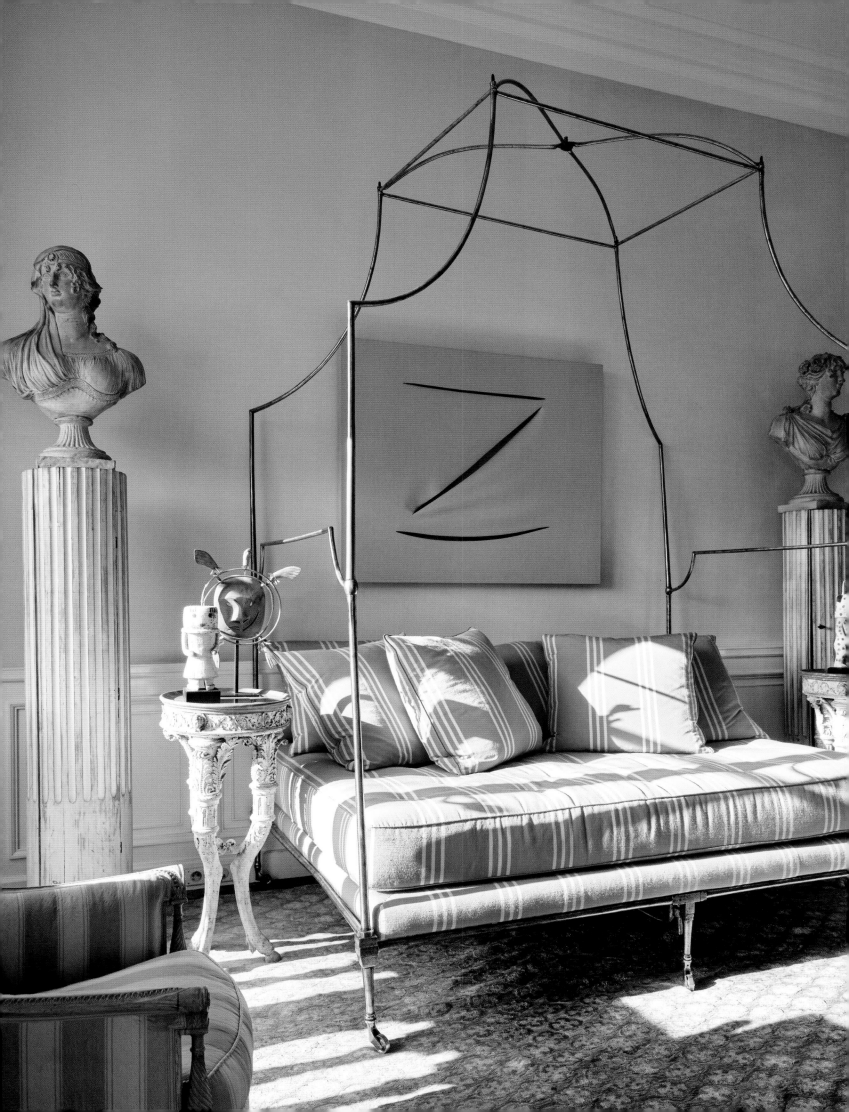

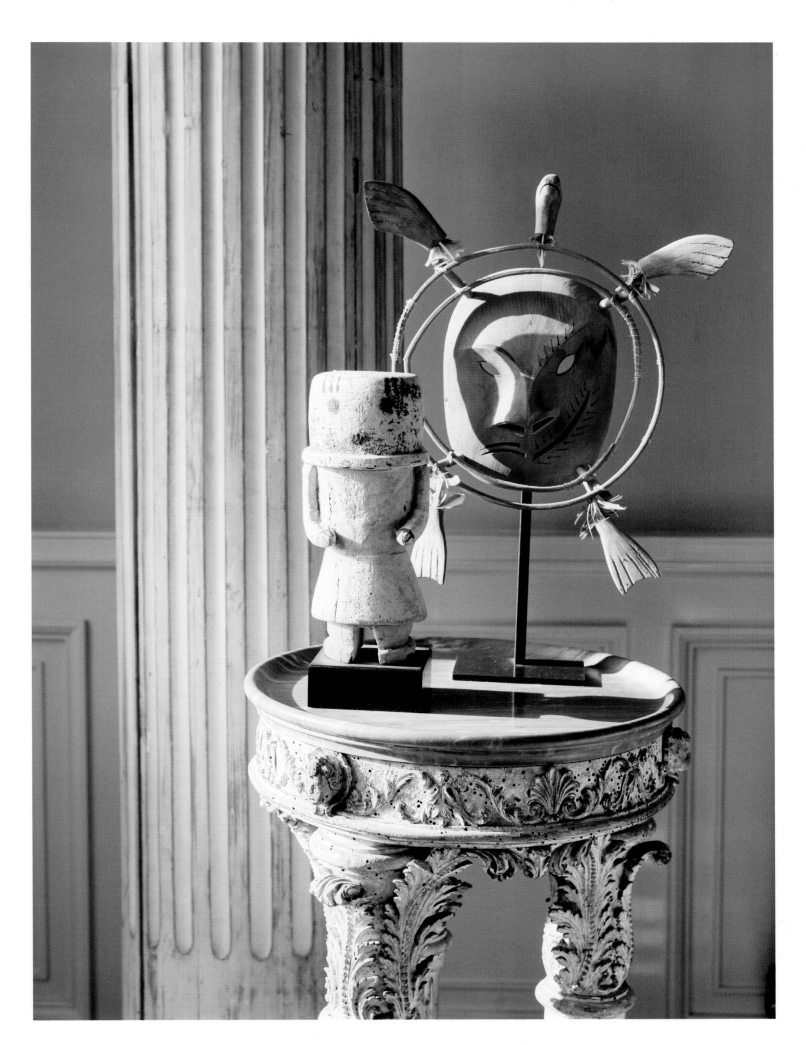

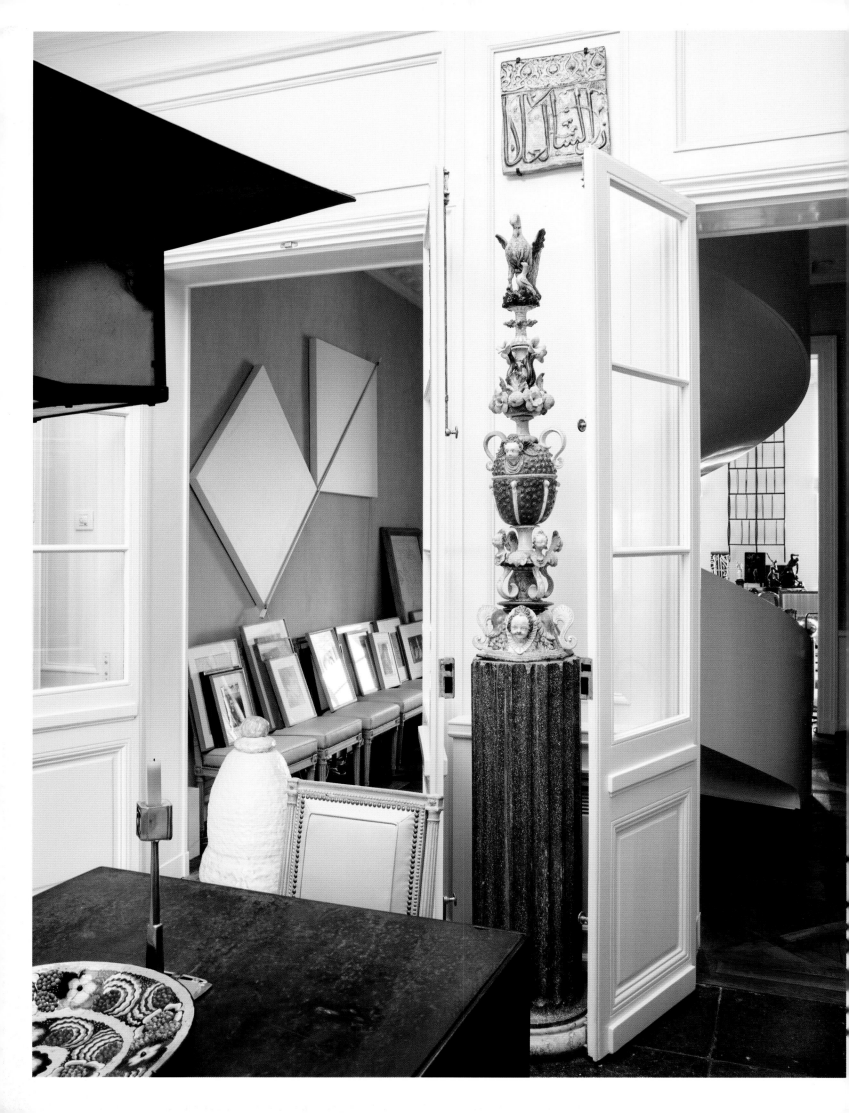

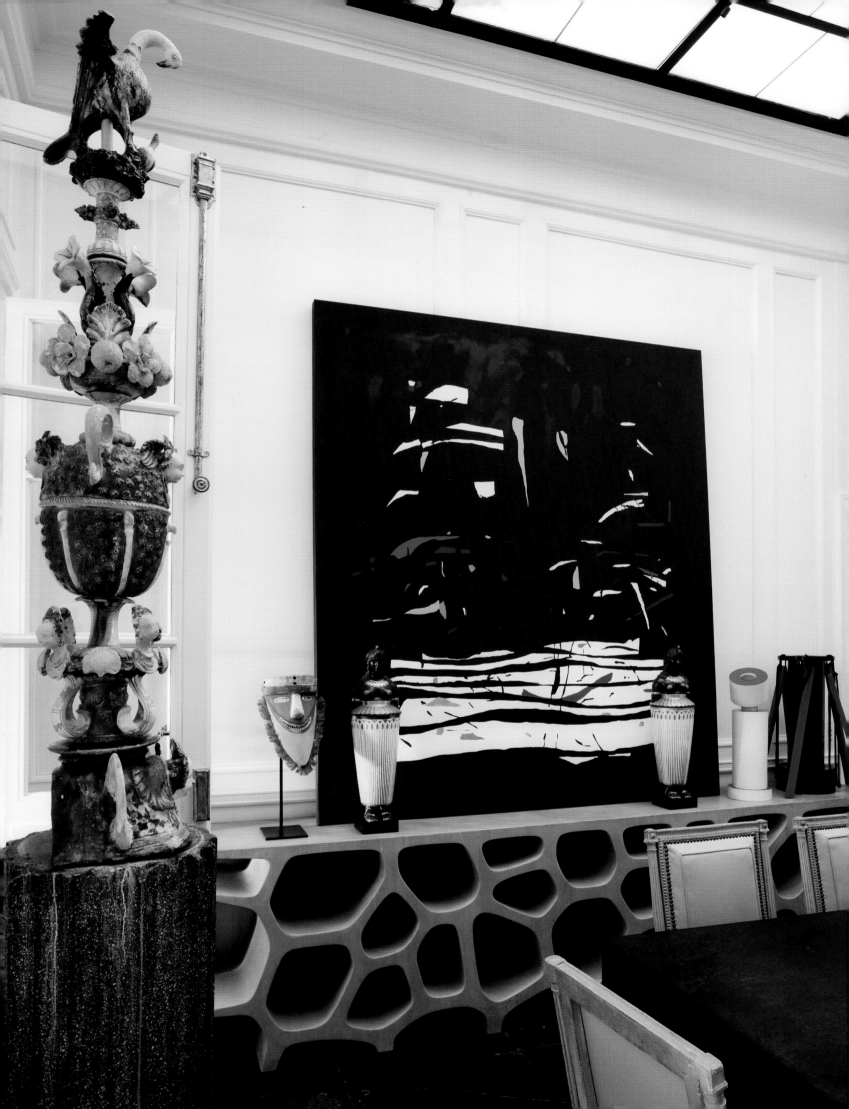

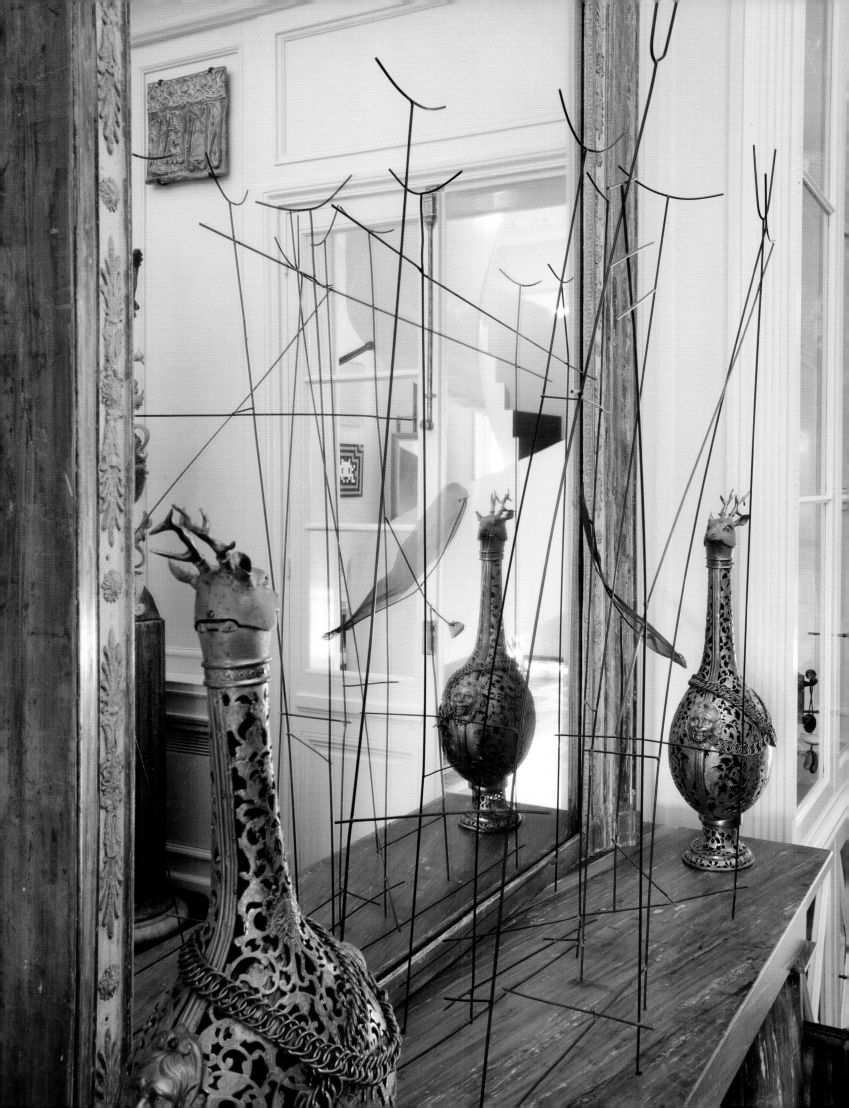

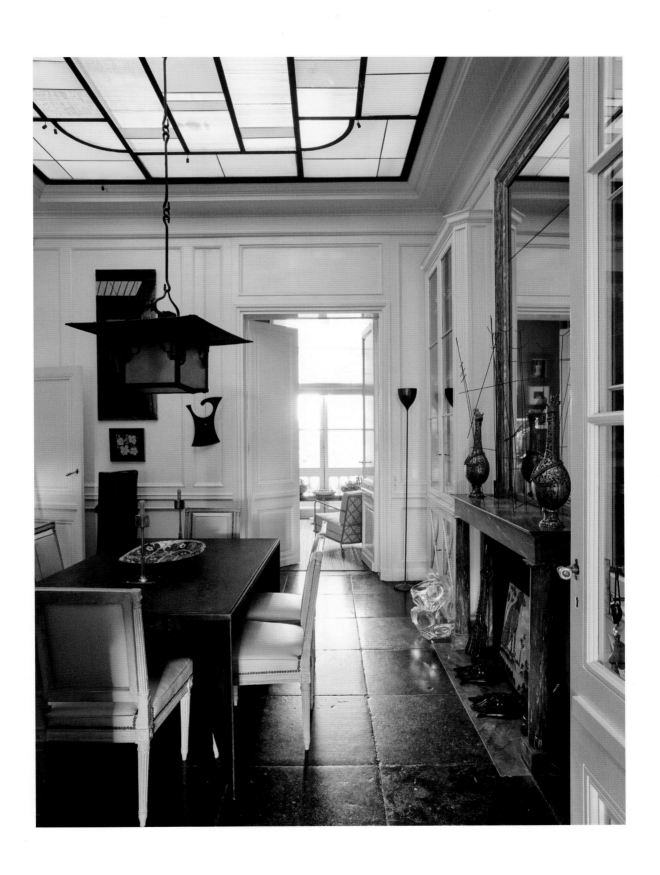

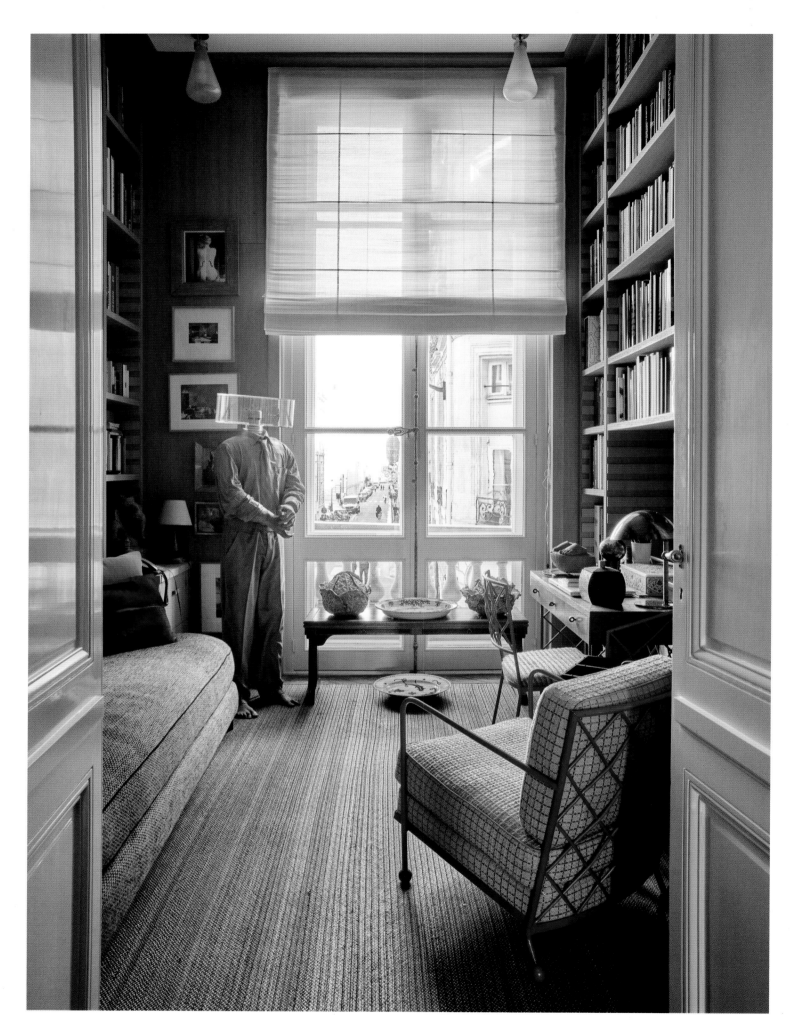

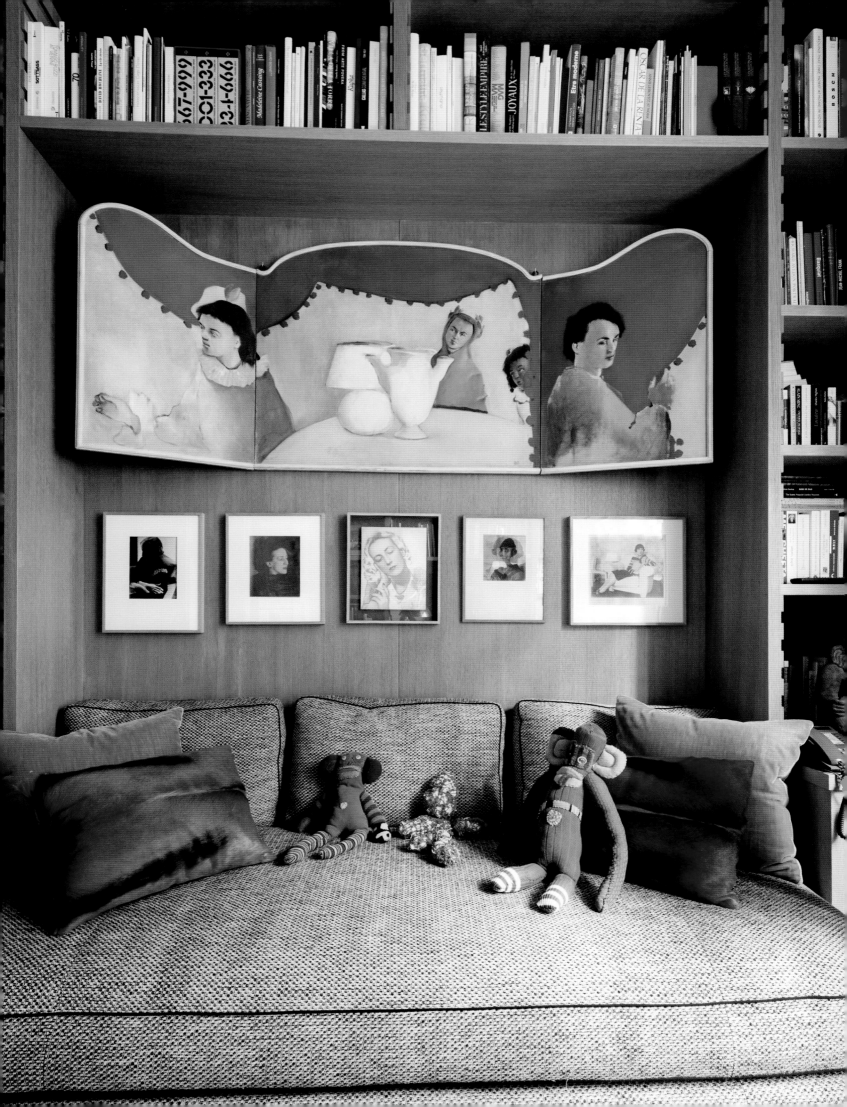

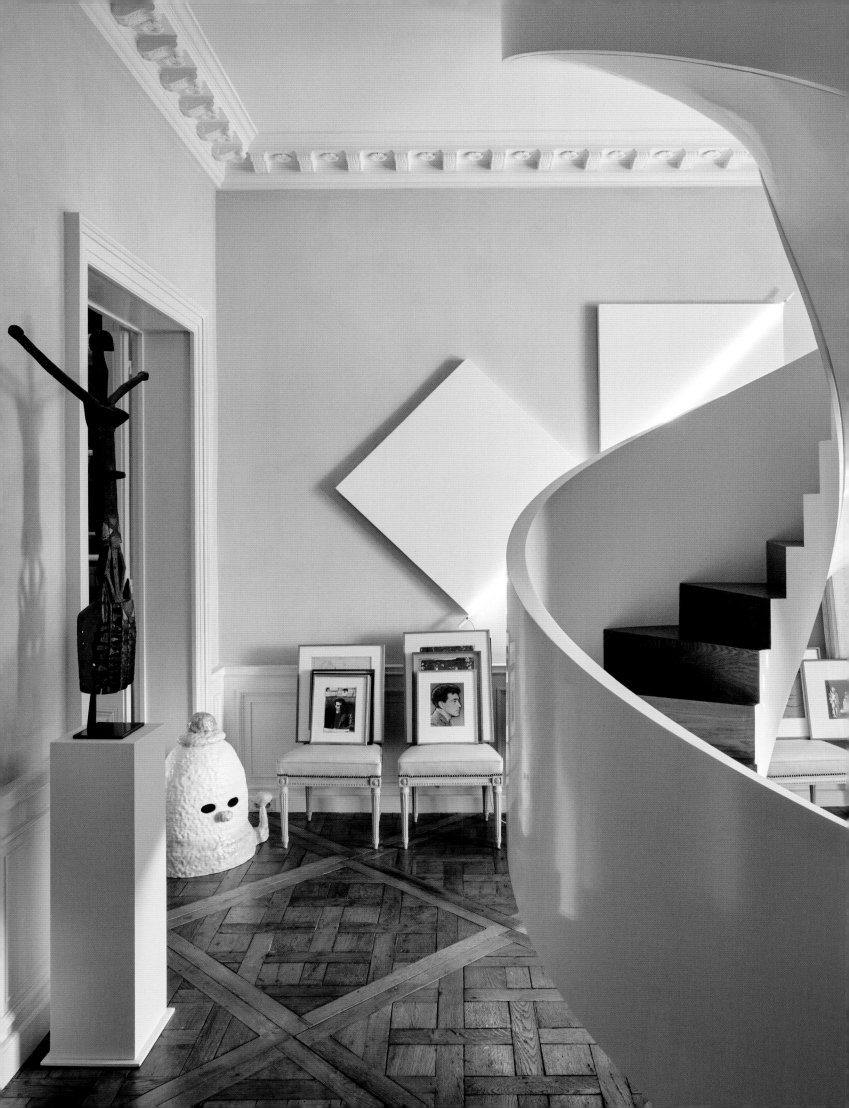

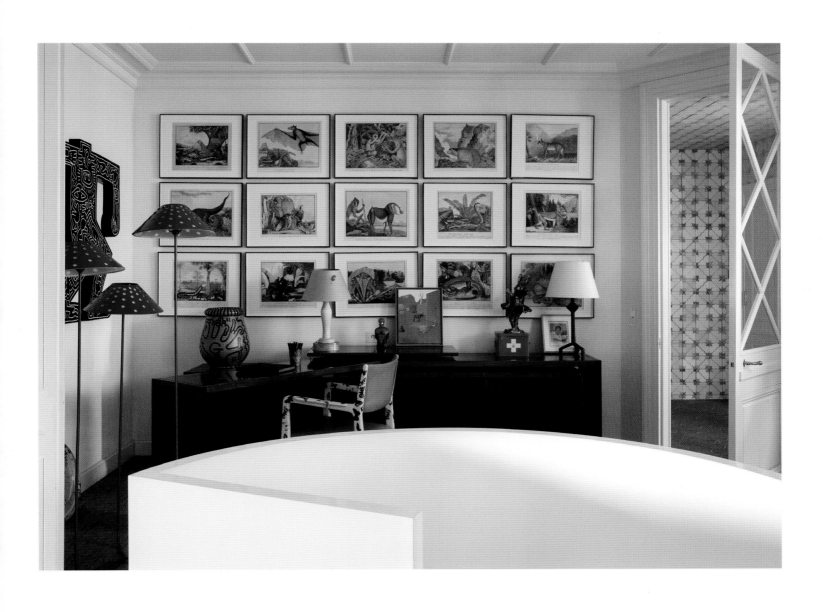

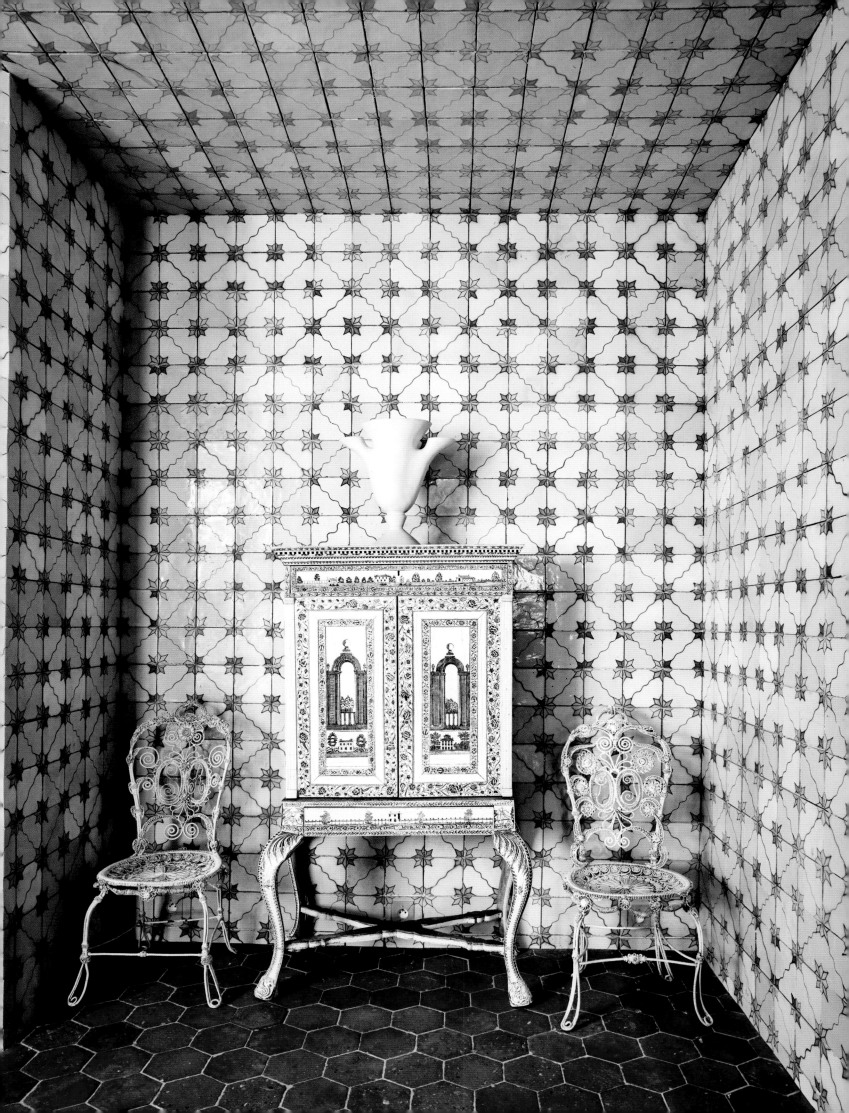

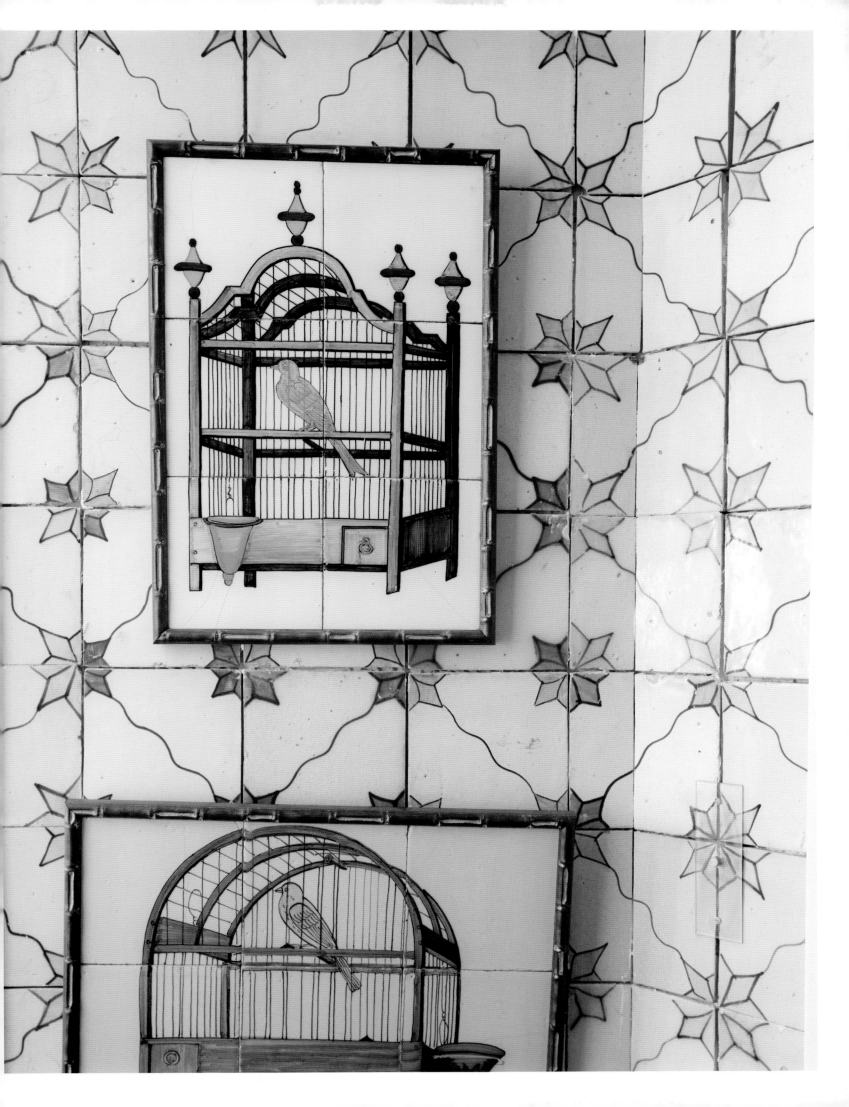

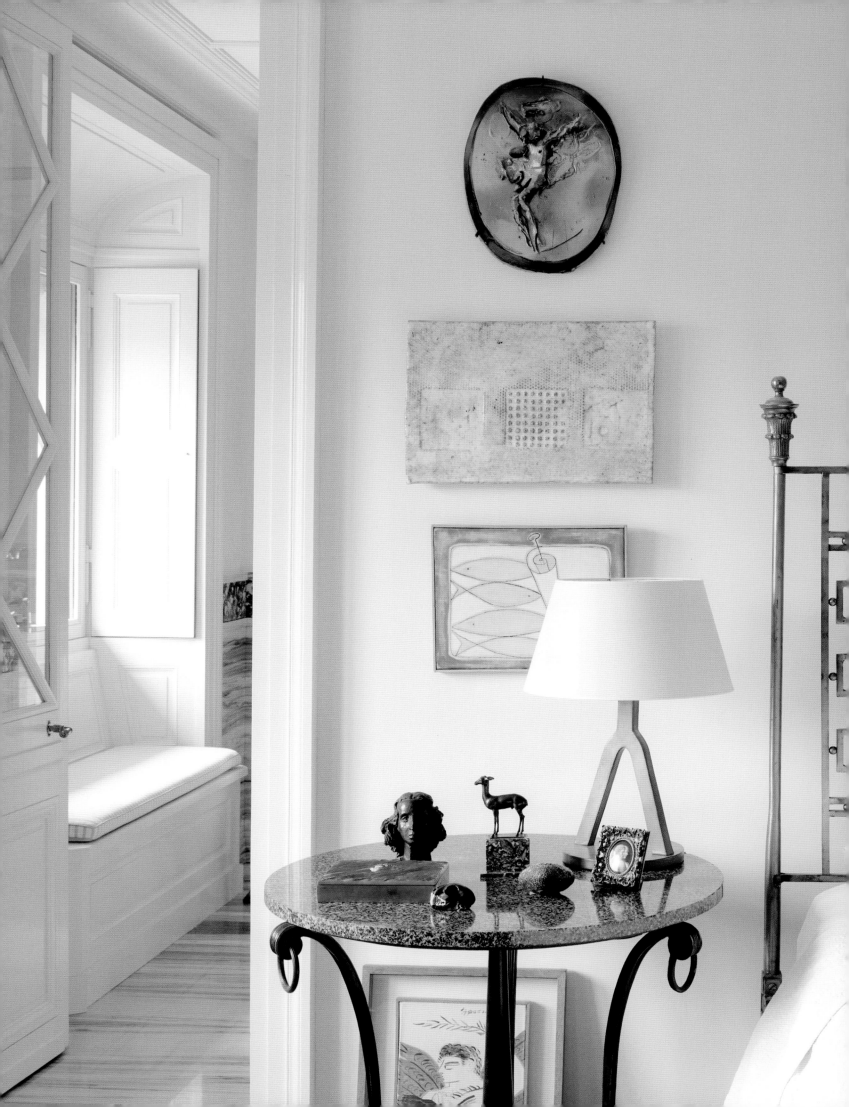

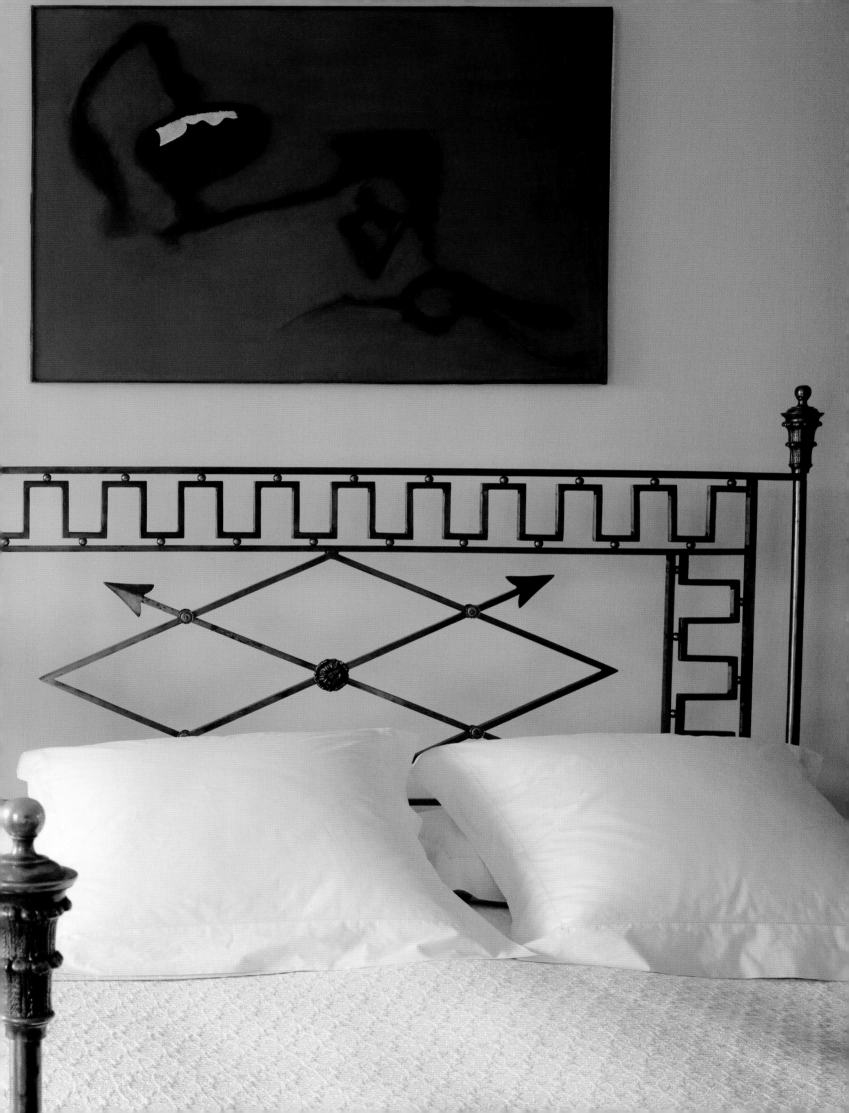

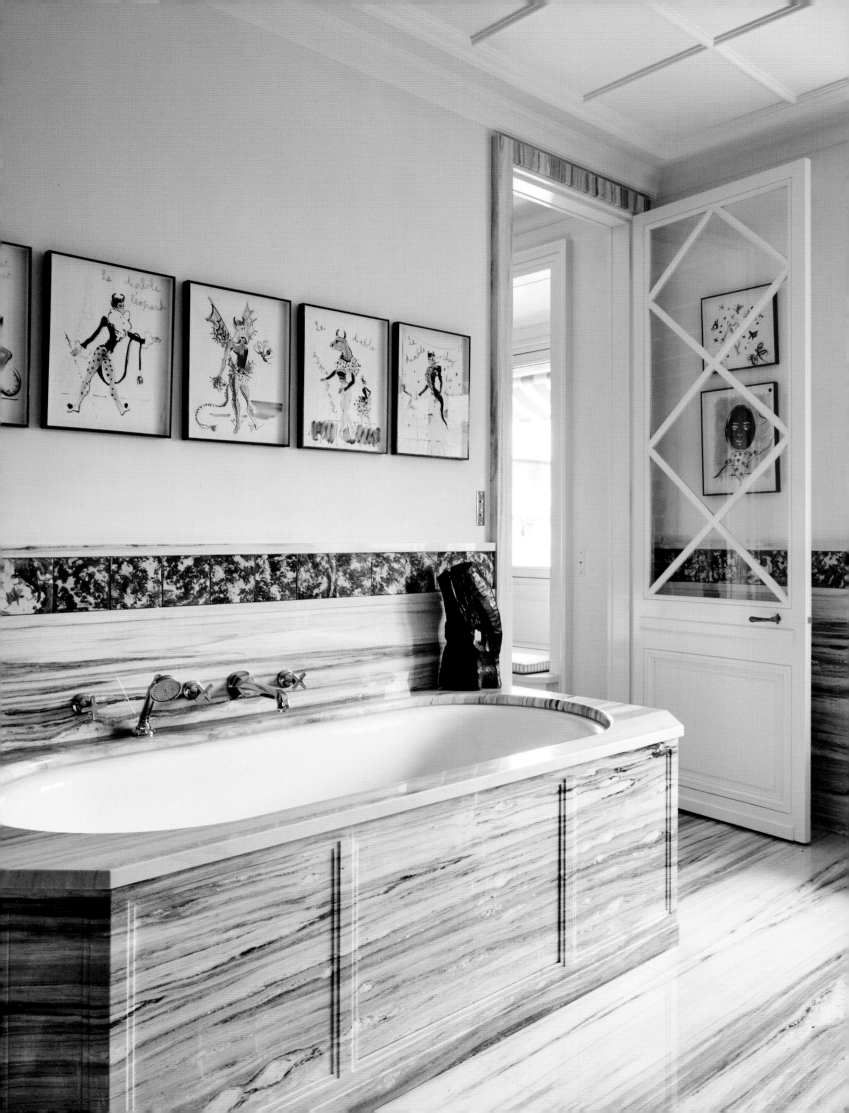

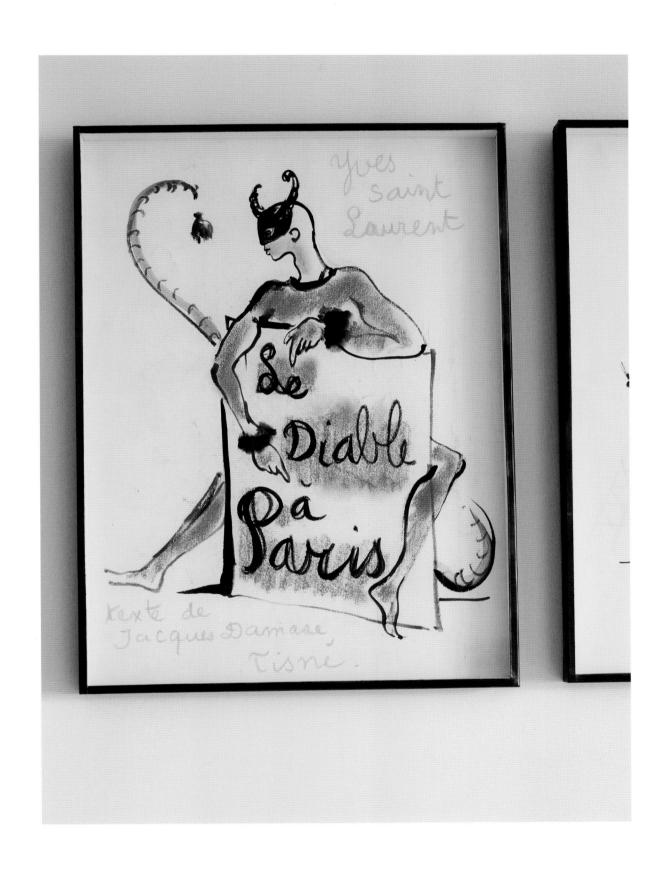

BOLD/ EMBLEMATIC/ BALANCED.

JEAN-LOUIS DENIOT

Jean-Louis Deniot belongs to the exclusive group of architects and decorators whose portfolio contains projects around the world. But it is Paris that he calls home, where his creative universe takes shape and form.

Located on the Seine, on the Quai d'Orsay, Jean-Louis's studio boasts views of the river, the Esplanade des Invalides, and the Pont Alexandre III. The skillful way in which these elements have been seamlessly integrated into every space immediately captured my attention.

The studio expresses the combination of textures, colors, furniture from various origins or designed by Deniot himself, and art from all eras that blends perfectly in his designs, for a theatrical and timeless effect that holds its form and cannot be defined by any passing trend. An occasional touch of industrial style is evident in the floor-to-ceiling windows with metal edges and the use of concrete in the library. Lacquered ceilings bring the outdoors in, reflecting the waters of the Seine and flooding every corner with natural light. Each space is decorated with Deniot's elegance and warmth, bringing a sense of home to the offices.

Jean-Louis and his team feel comfortable here, continuing to project their talent from this beautiful place. The decorator Charles Sevigny, a friend and a source of inspiration for Deniot, and Hubert de Givenchy, for whom he designed an apartment at one point, once lived a few floors above.

It was a great experience to take these photos in Jean-Louis's company, his strong personality and craftsmanship knowledge contributing to his passion for a newly completed project—in this case, his own studio. His love for his profession, together with his new operational base, give him everything he needs to continue succeeding worldwide.

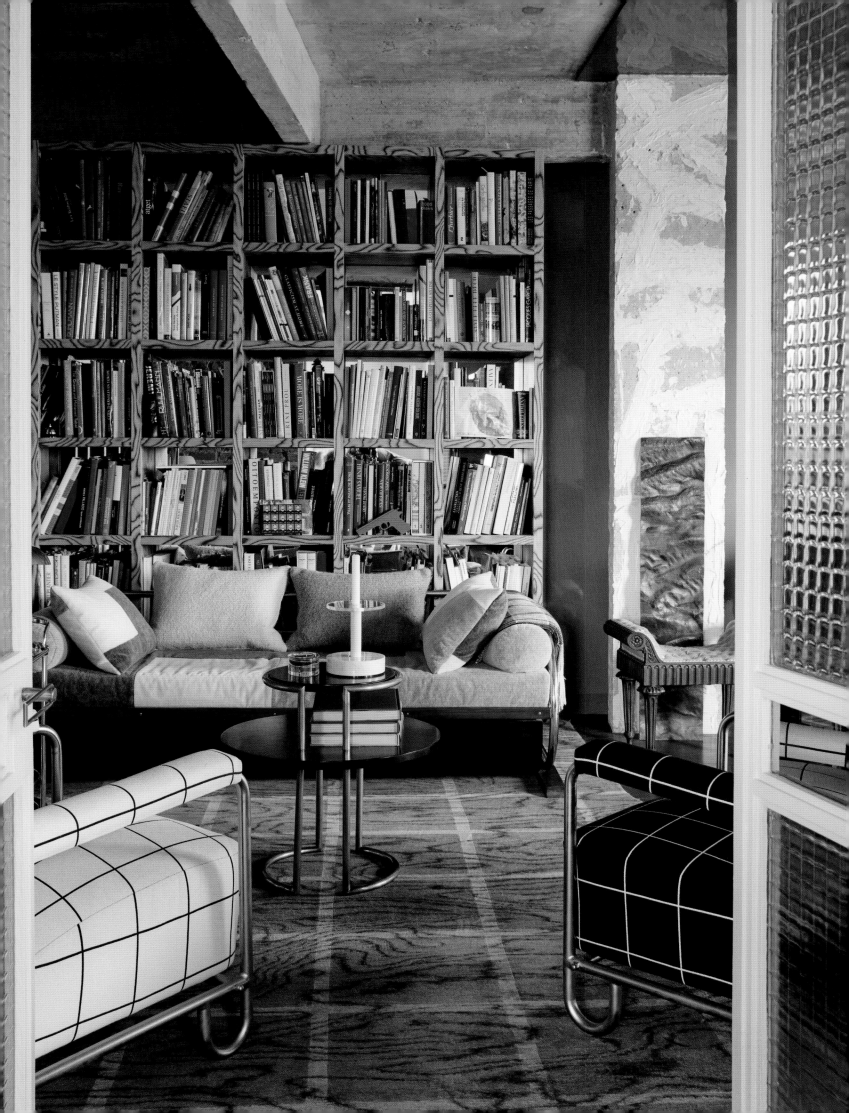

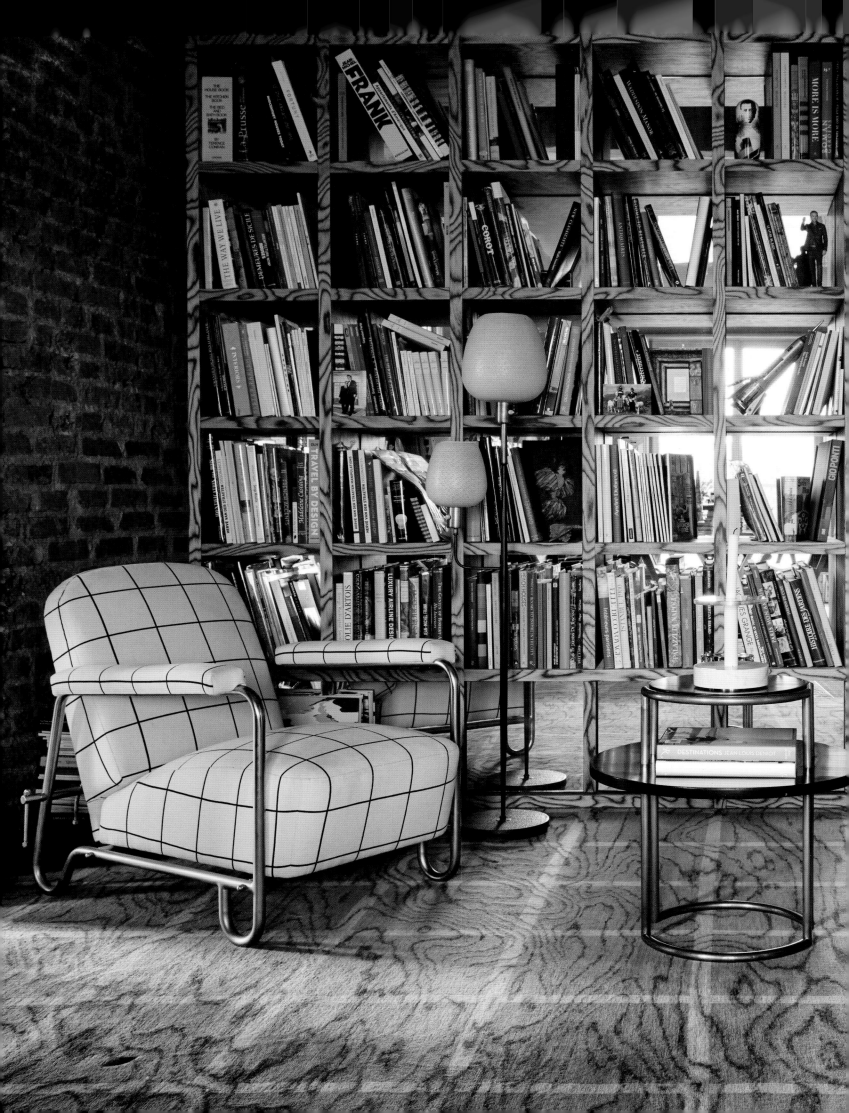

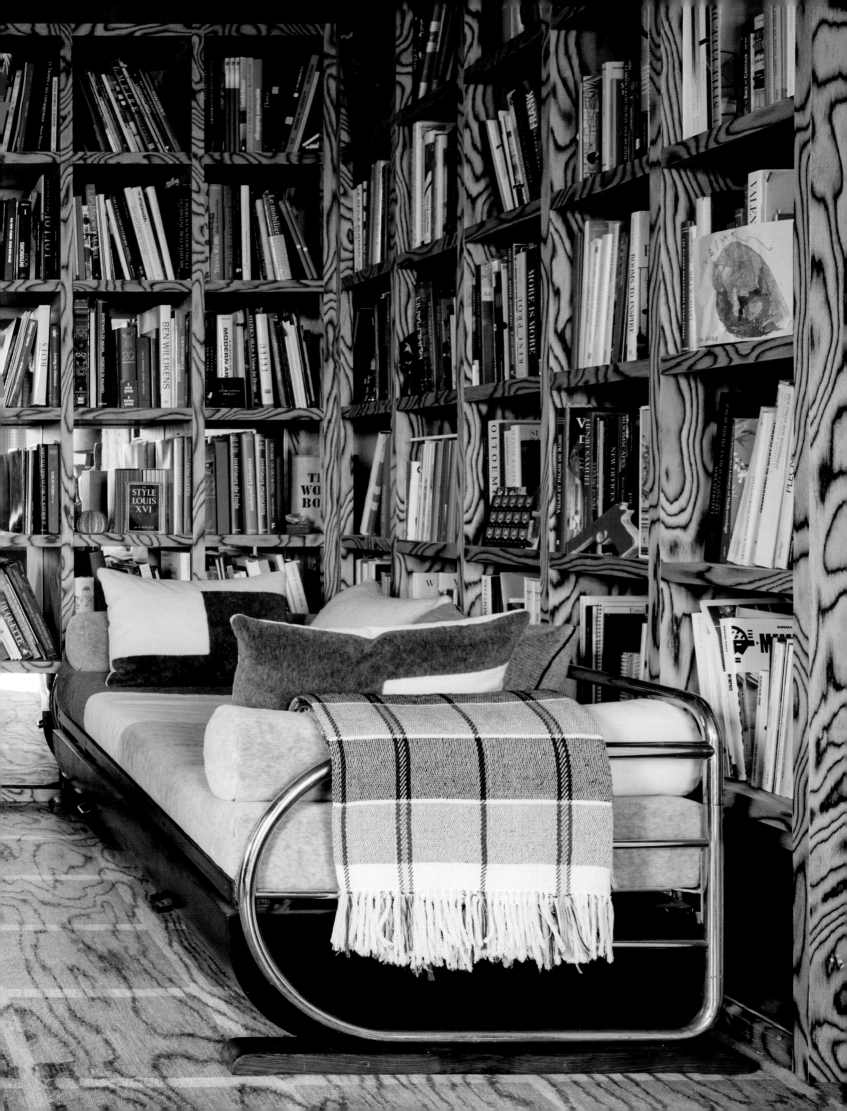

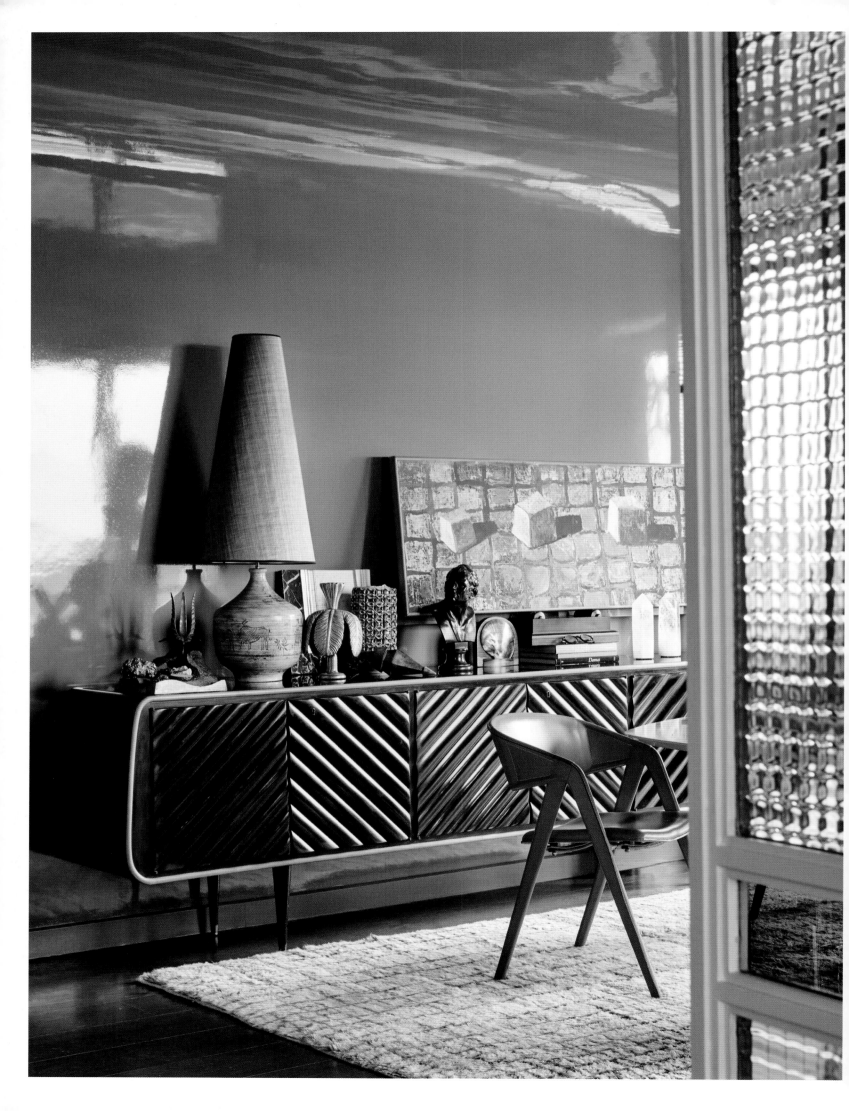

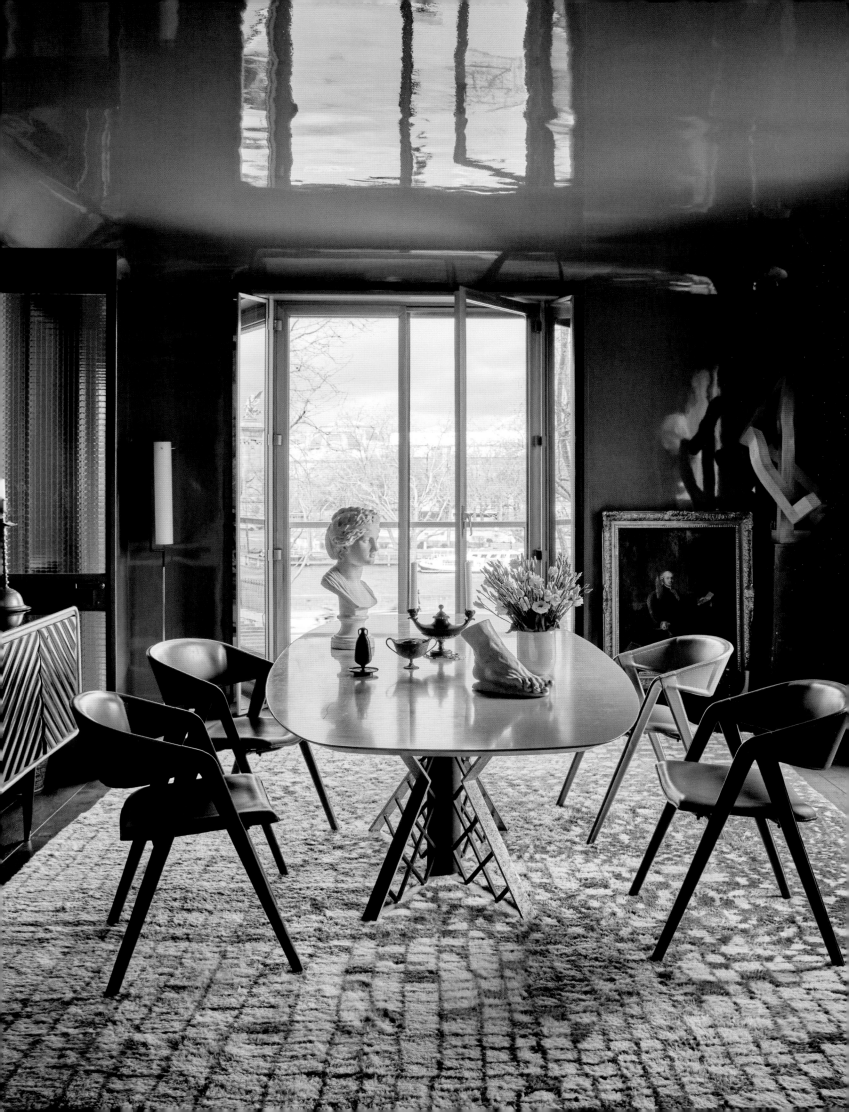

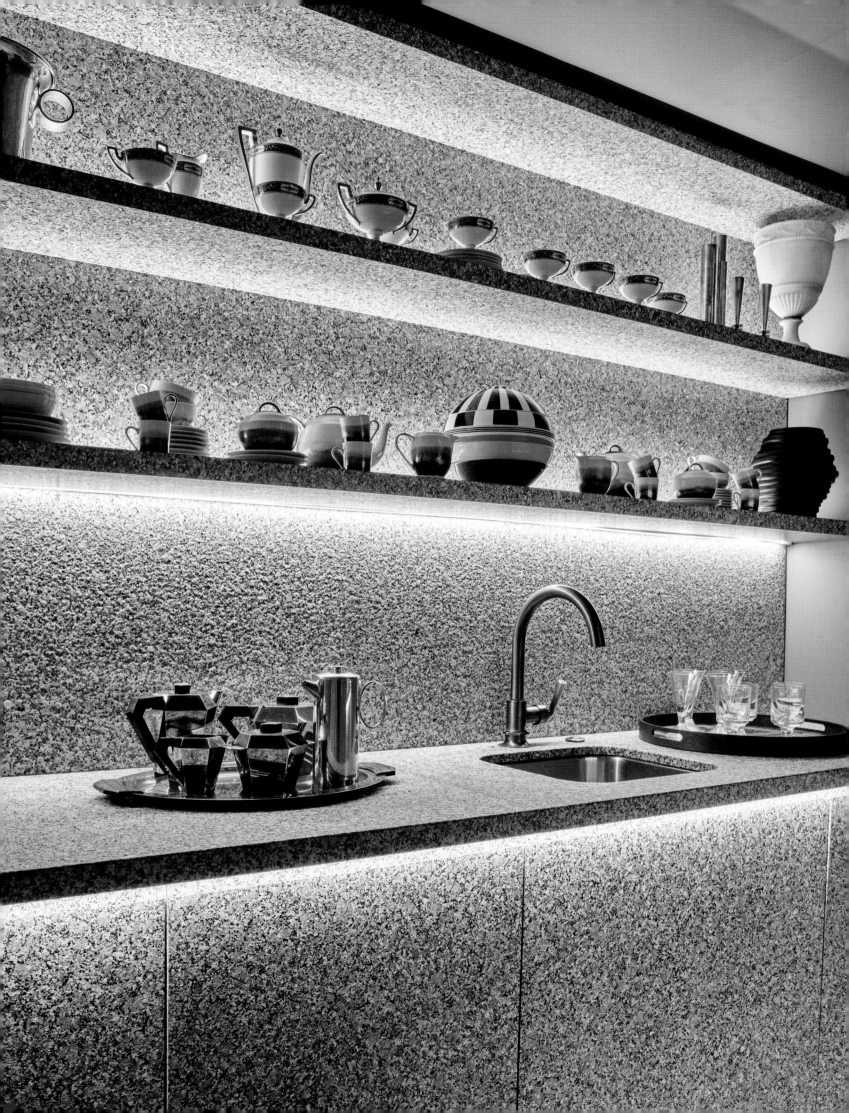

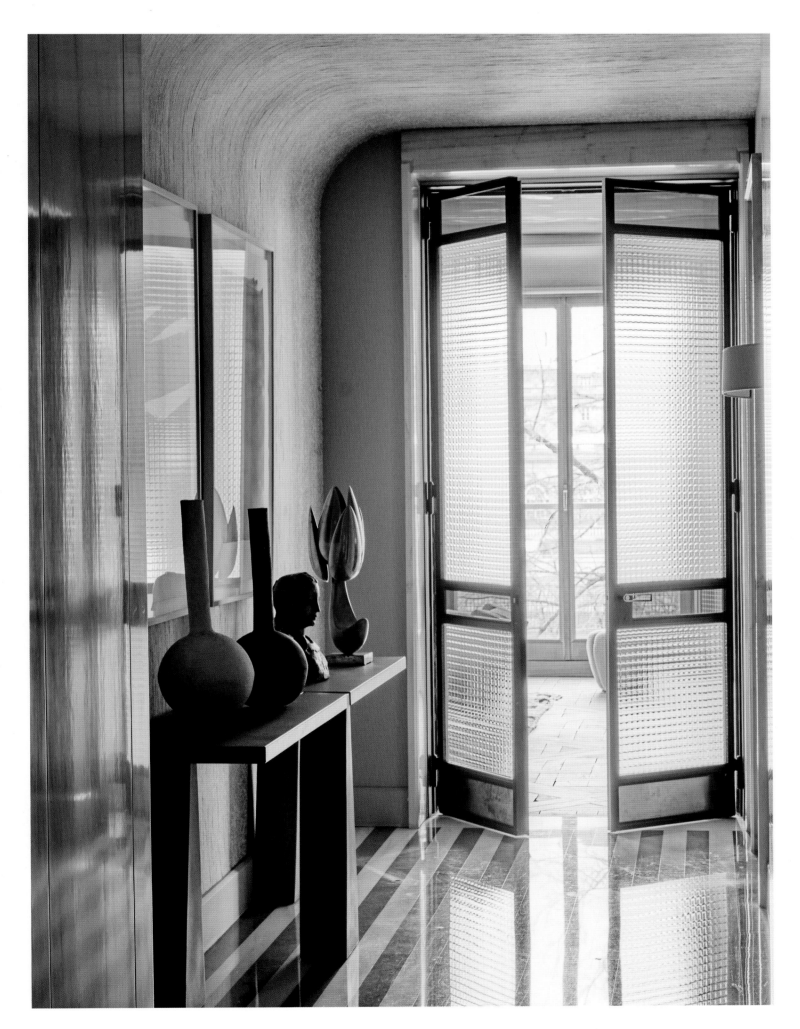

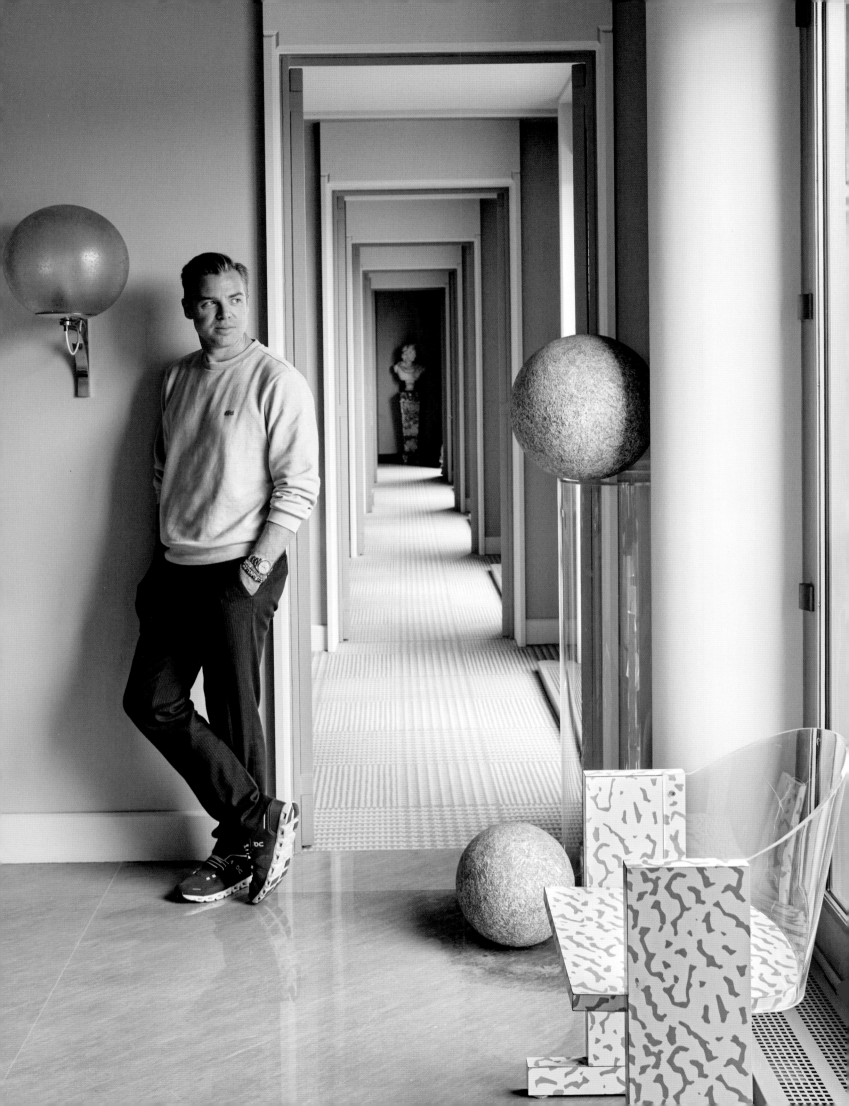

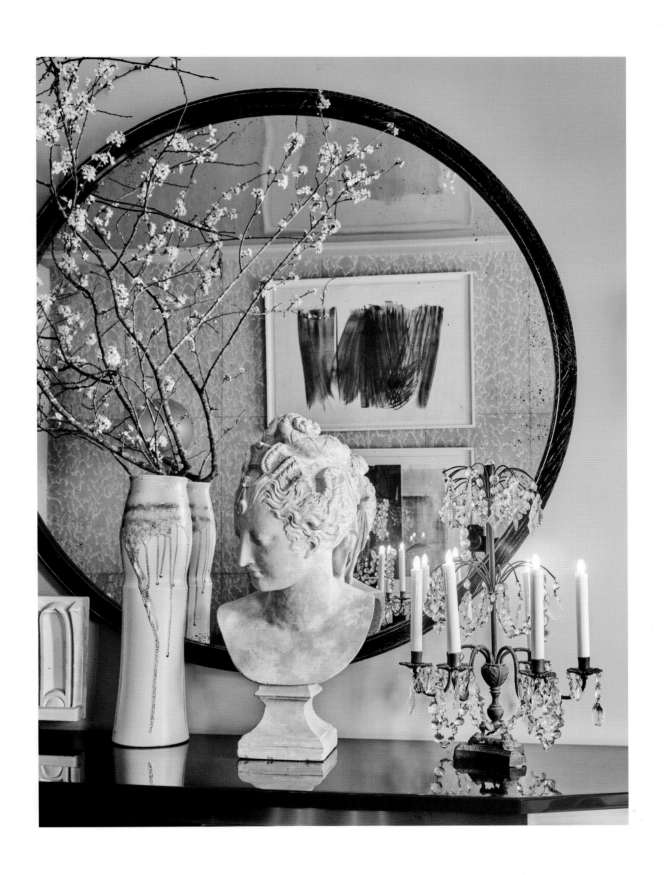

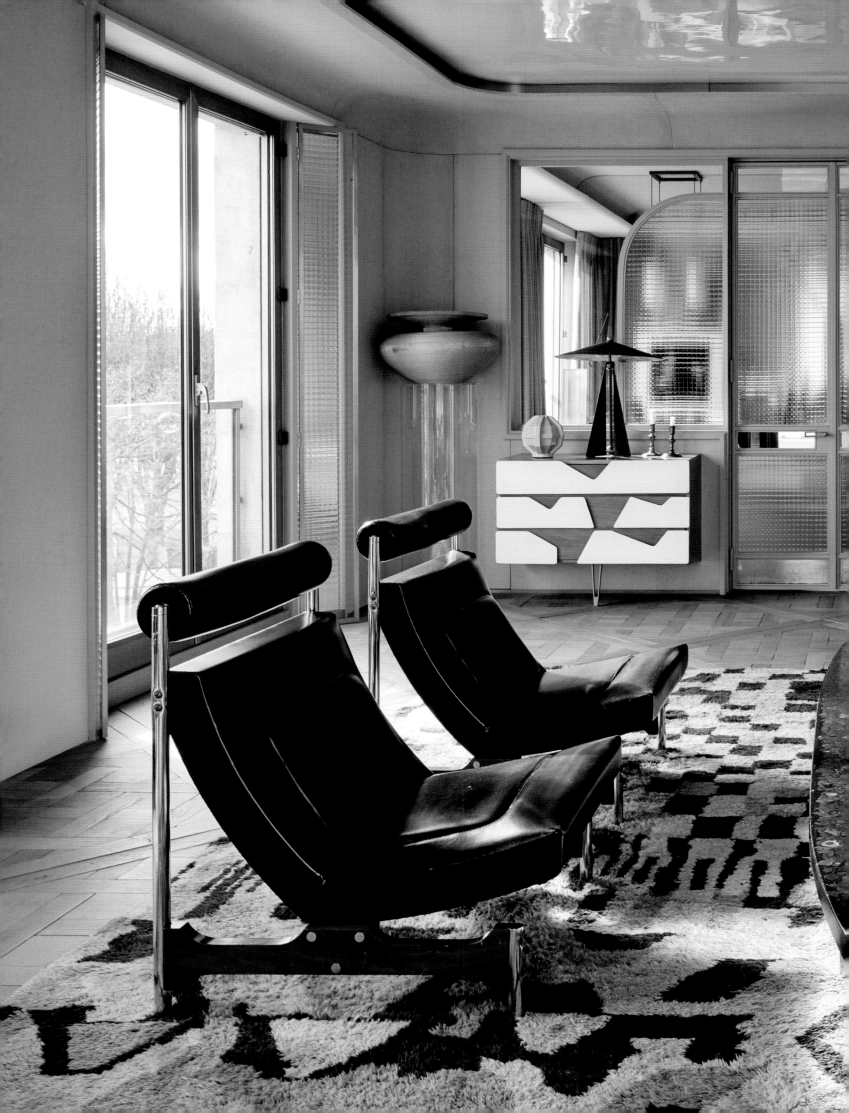

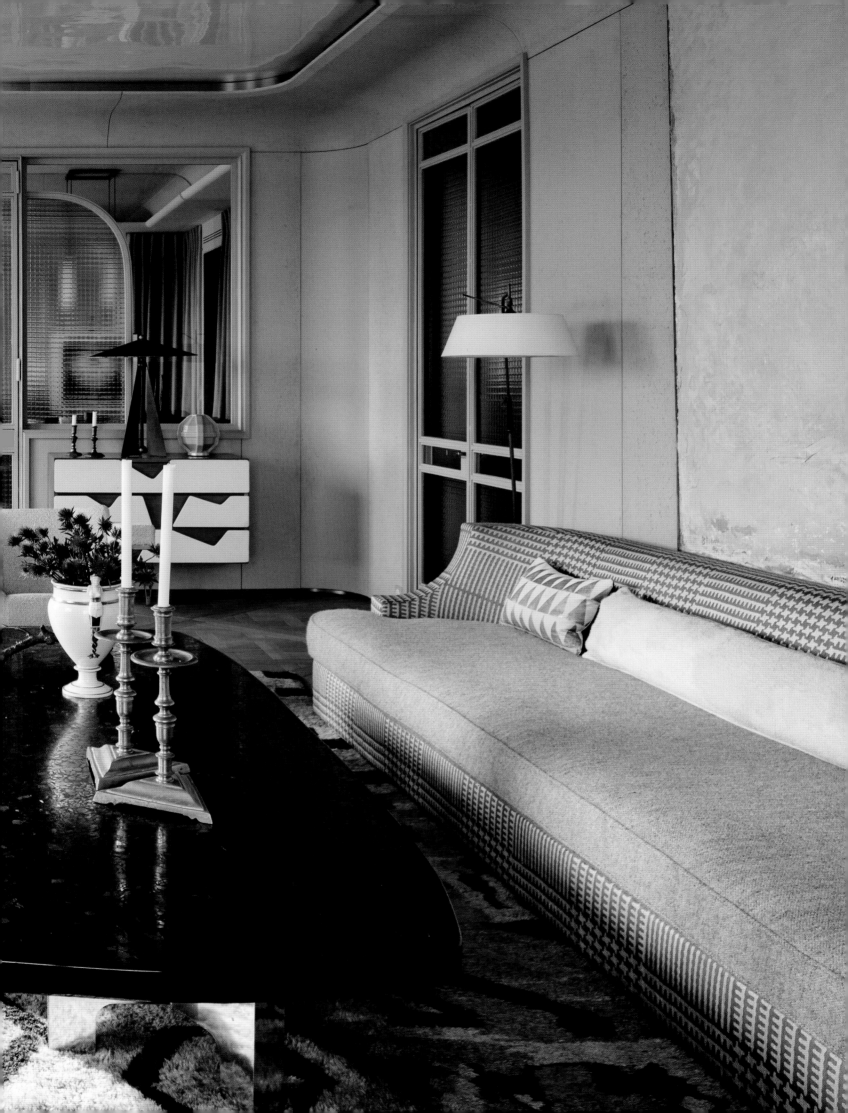

IMAGINATIVE/
DIVERSE/
CONTEMPORARY.

KARL FOURNIER AND
OLIVIER MARTY—STUDIO KO

Karl Fournier and Olivier Marty are at the pinnacle of a new generation of architects on the scene in this new millennium. Recognized worldwide, both are graduates of the École de Beaux-Arts de Paris, where they met and decided to share their lives. They now split their time between Paris and Marrakech, where their offices operate.

I met Karl one winter morning while strolling through the Marché aux Puces de Clignancourt with our mutual friend Luis Laplace, who introduced us. Already an admirer of Karl and Olivier's work, I began to learn about the personal history of this talented duo, and to understand their unique vision of design in today's world.

Studio KO include among their clients names like Agnelli and Hermès, for whom they designed iconic homes in Morocco, and Pierre Bergé, for whom they built from scratch the Yves Saint Laurent Museum in Marrakech. Their work is characterized by the blending of traditional and contemporary elements, whether in residential spaces or hotels and restaurants in various corners of the globe.

This fusion extends to their own home, a seventeenth-century building along a covered passage originally occupied by goldsmith workshops. Due to its atypical original layout, it required intervention to meet the needs of the couple and their newly arrived son. As I toured the house to begin photographing it, I felt how the private, family, and social spaces were well differentiated yet smoothly linked.

Throughout the house, various materials and styles coexist harmoniously: brutalism is incorporated seamlessly into a centuries-old floor; marble combines with birch-stained furniture and brass frames. Seventies furniture blends with both antique and more contemporary pieces, and modern paintings and photographs are interspersed with vintage items. From the windows, amidst the plants, one can see the unique iron staircase of the Palais-Royal, simultaneously radical and subtle, like a work of art—and like Karl and Olivier themselves.

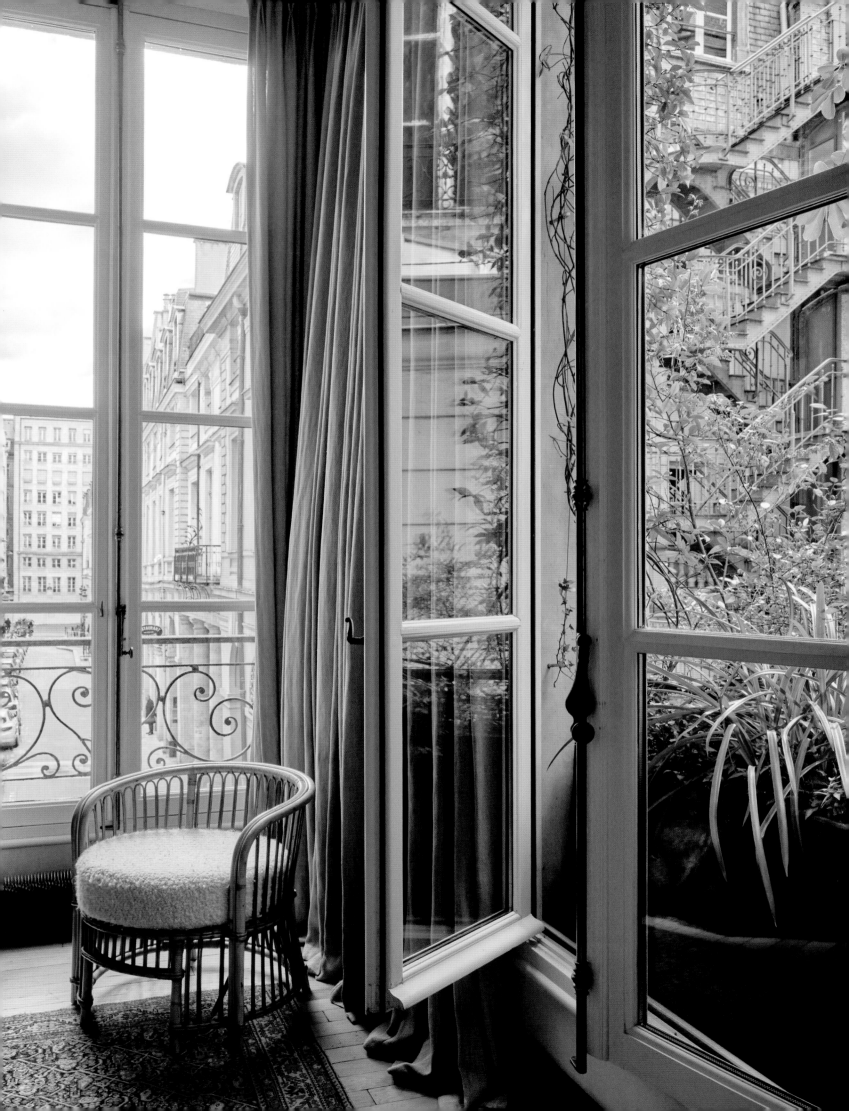

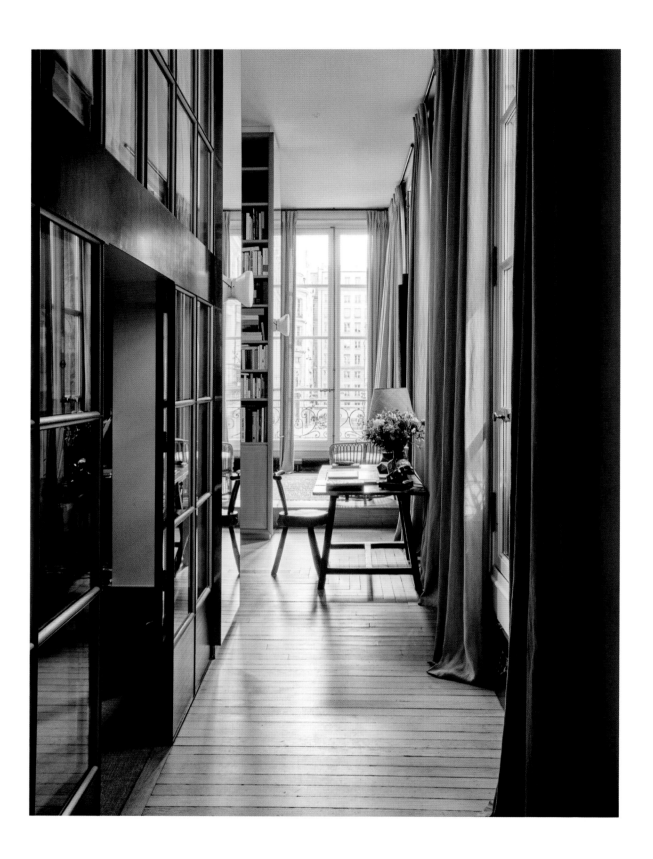

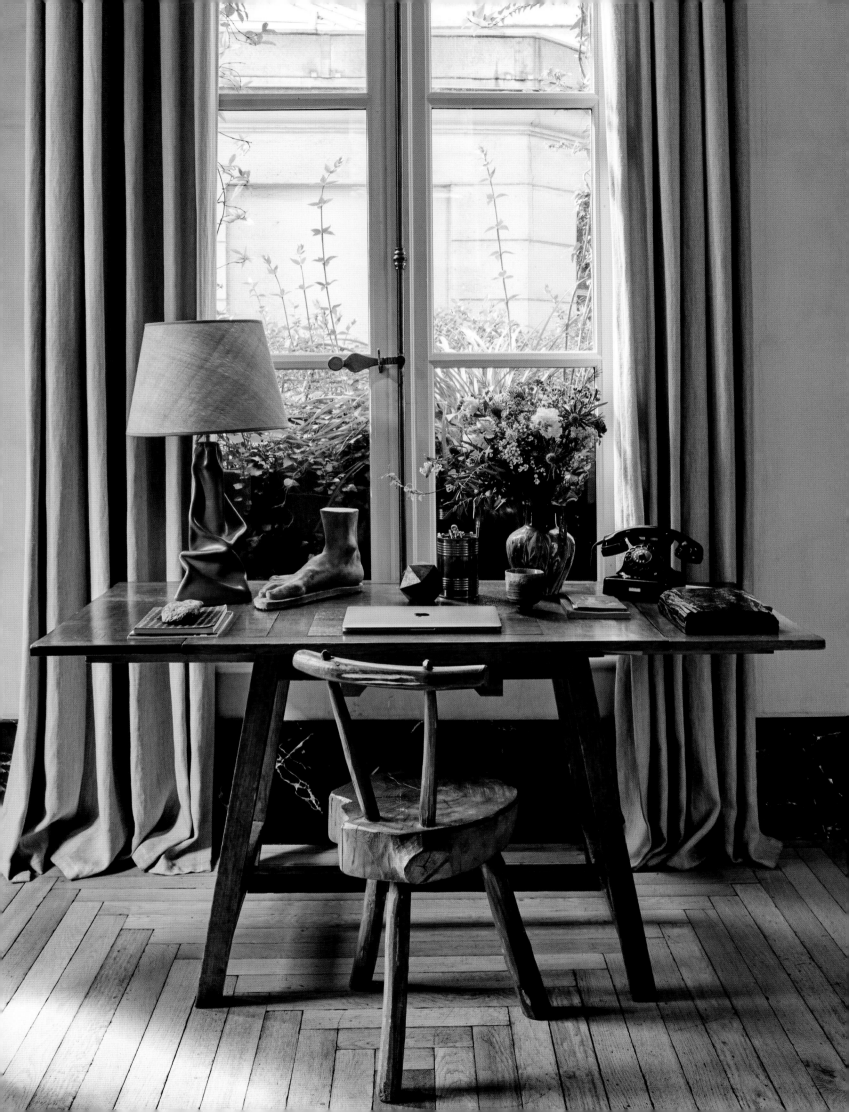

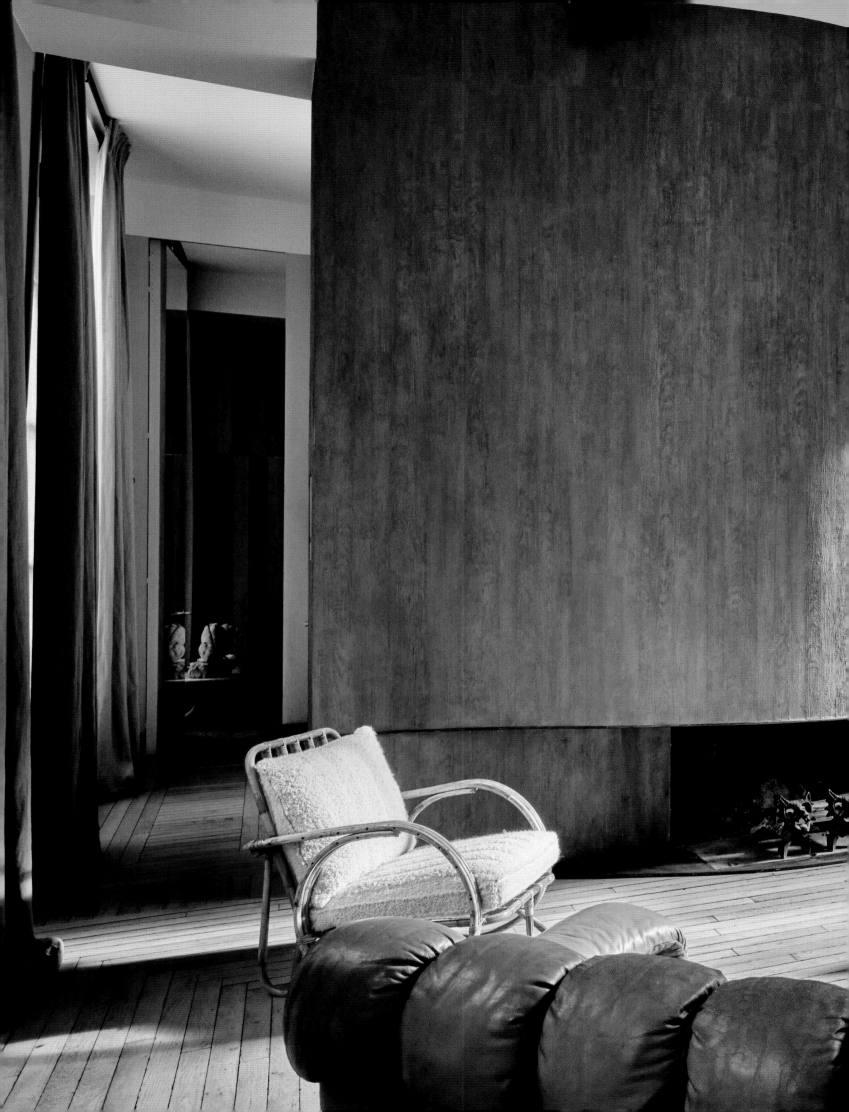

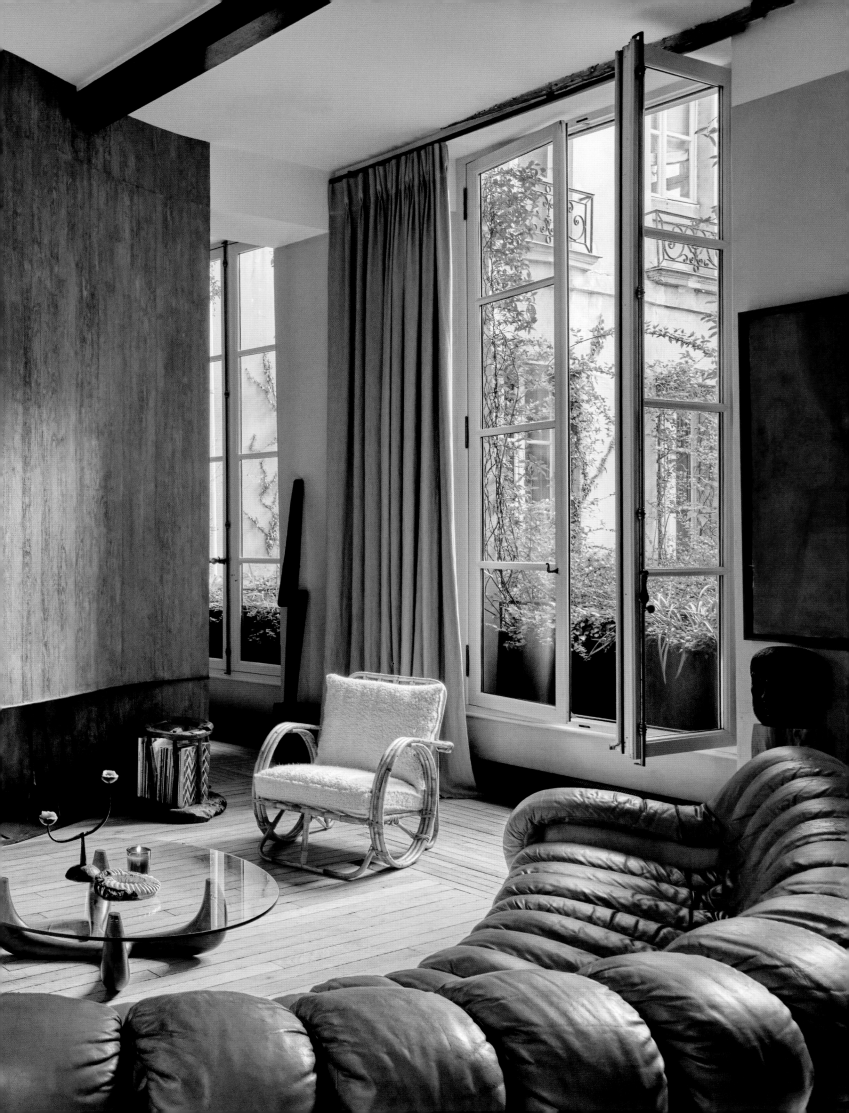

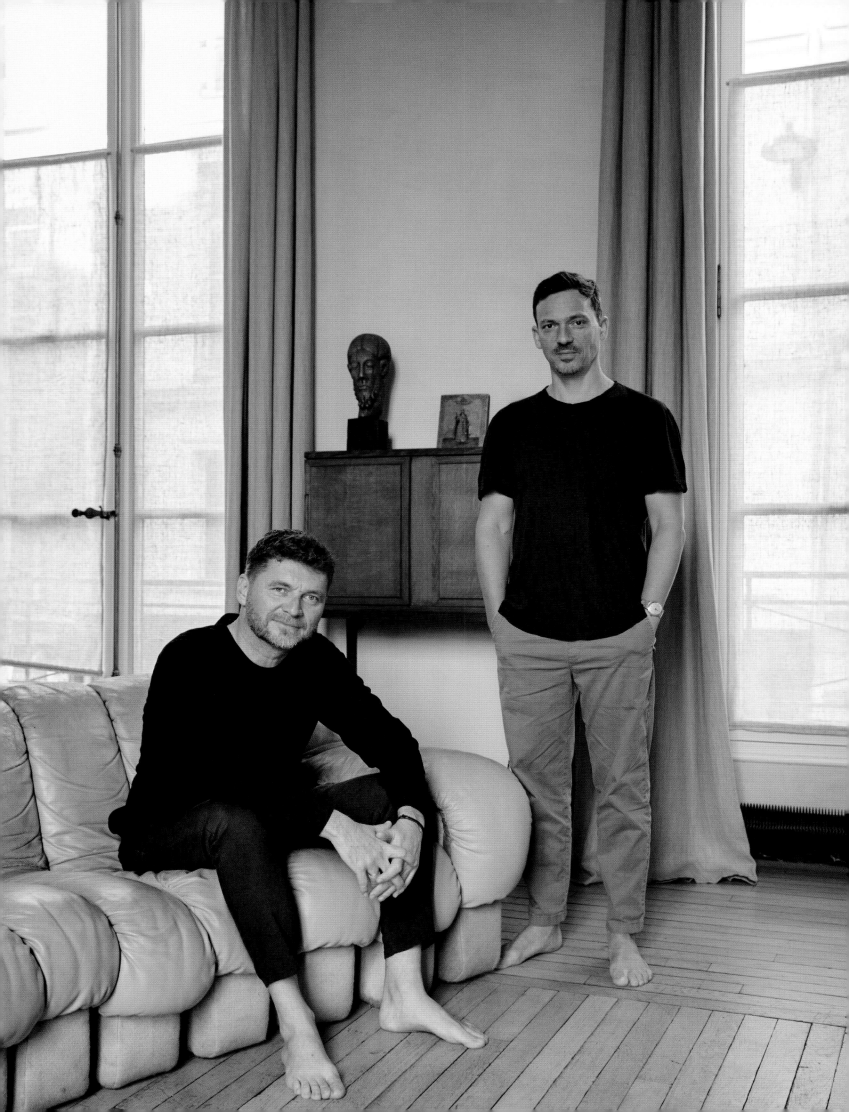

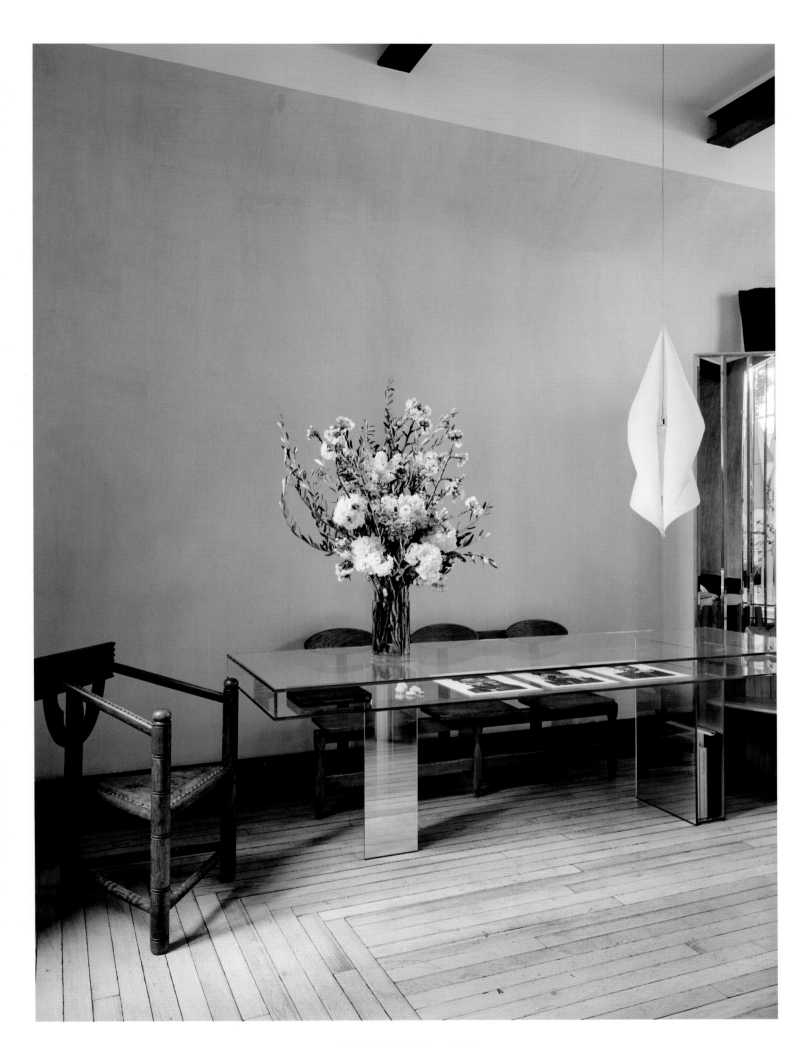

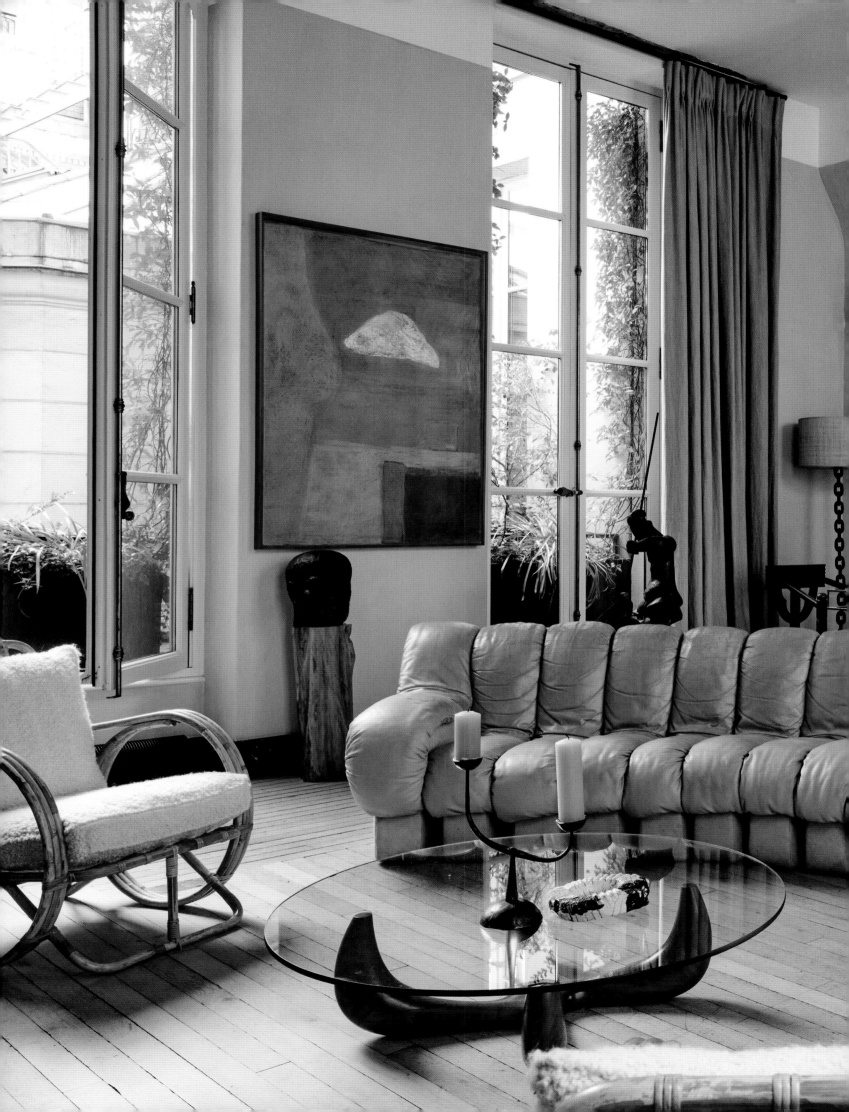

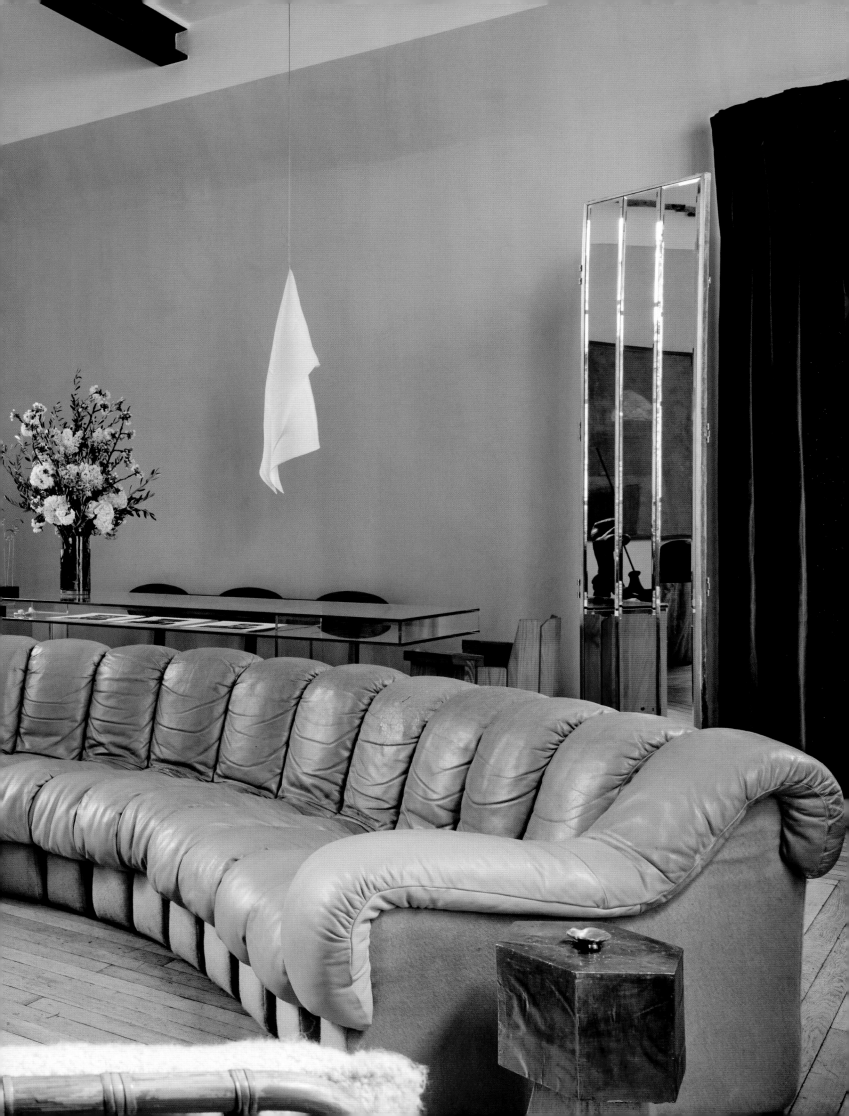

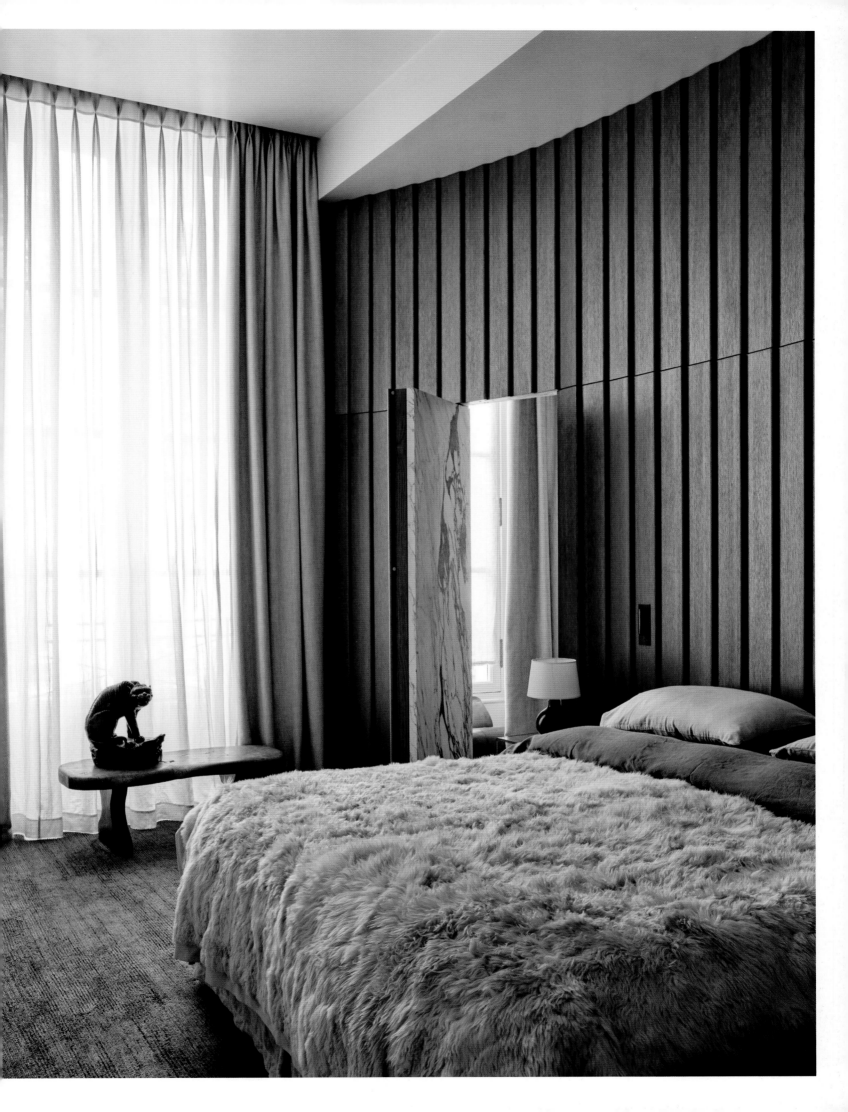

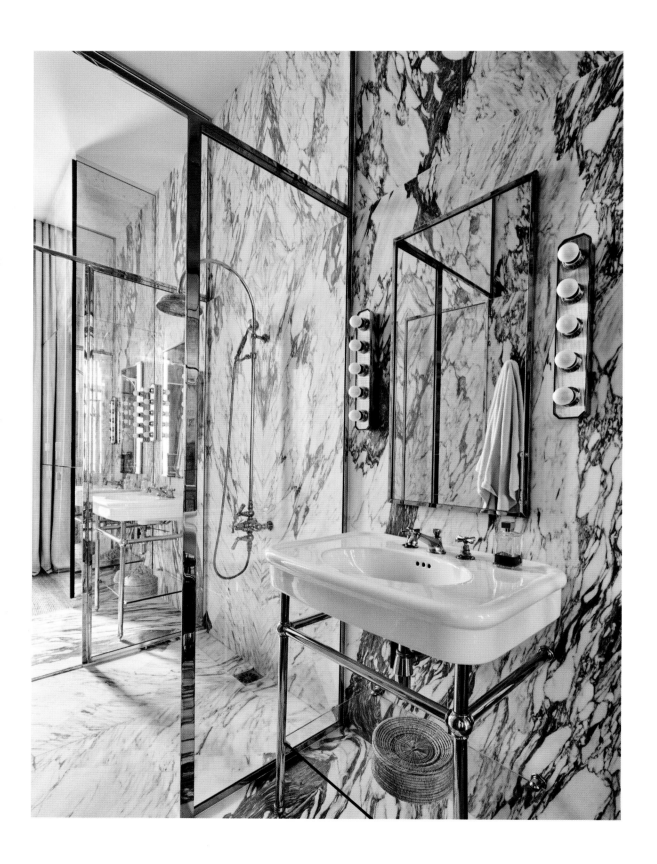

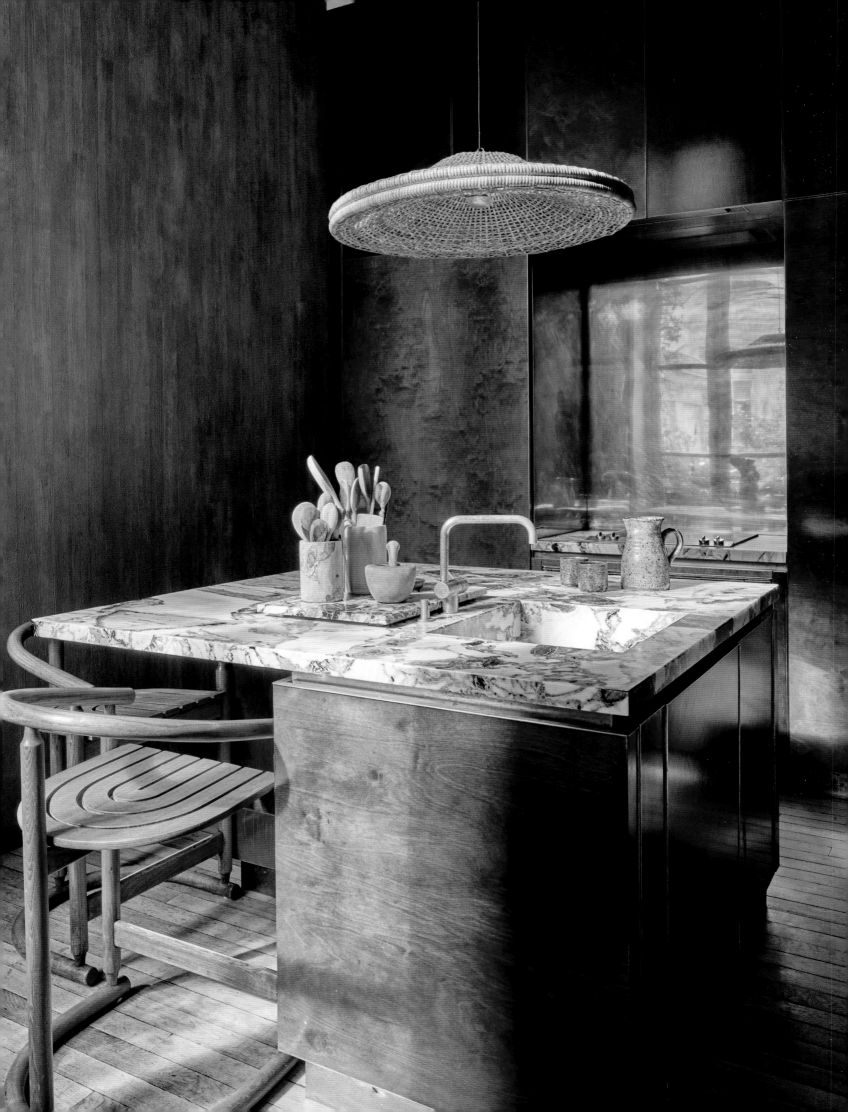

SECRET/ REFLECTIVE/ MYSTERIOUS.

MARC-ANTOINE PATISSIER

Art historian, critic, and antiquarian Marc-Antoine Patissier lives on the Montagne Sainte-Geneviève with his violin, amidst his books. He speaks eloquently about his life there:

"I have always lived in the heart of the intellectual district of Paris. The Quartier Latin, behind the Panthéon, in a Haussmannian building, in the market square. I was a professor in another era and I passionately love music. But my love of intellectual pursuits has not prevented me from engaging with physical objects. Quite the opposite.

I do not have any favorites among the works in my house. I have gathered them and given them a home. They are my children. They are the ones that speak to visitors immediately. They maintain secret and silent conversations that the visitor instinctively understands. From one room to another, they are the portrait of the one who gathered them. They speak behind my back when I am absent—also during my nightly and solitary walks among them. There is a spirit here that I inspire, and they return it to me like a turned glove. No offense: it is a sincere and timeless house, above all, a library.

For forty years, I have housed my books, which never cease to multiply, and I have a desk in every room. There are also lamps everywhere, providing the same comforting light day and night. At night, the studious atmosphere warms up. The soft and golden light, serene colors, shining oak, deep perspectives, and those mysteries in the mirrors: everything conspires then to make my friends happy."

I have walked alone through this enchanted house with my camera; however, I have not exhausted all its possibilities or uncovered all the surprises it holds. Marc-Antoine, for his part, rediscovers it with each walk, getting lost and finding himself, over and over again.

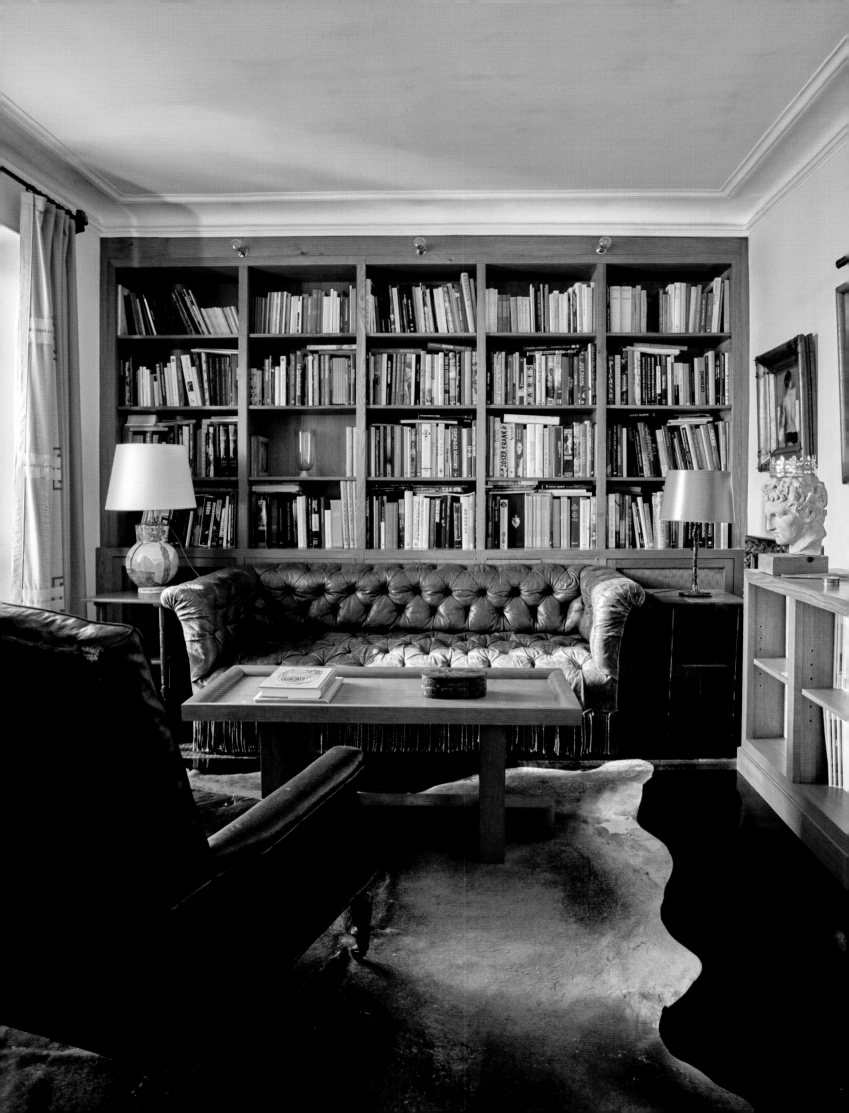

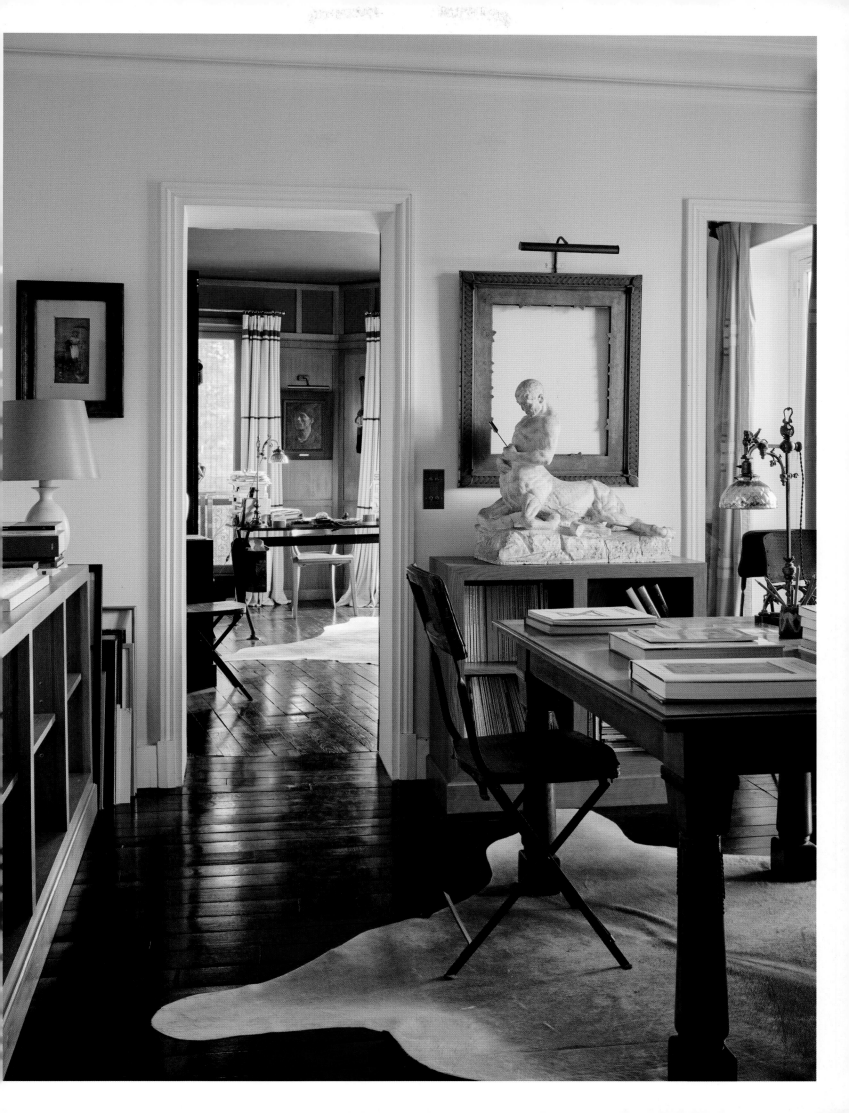

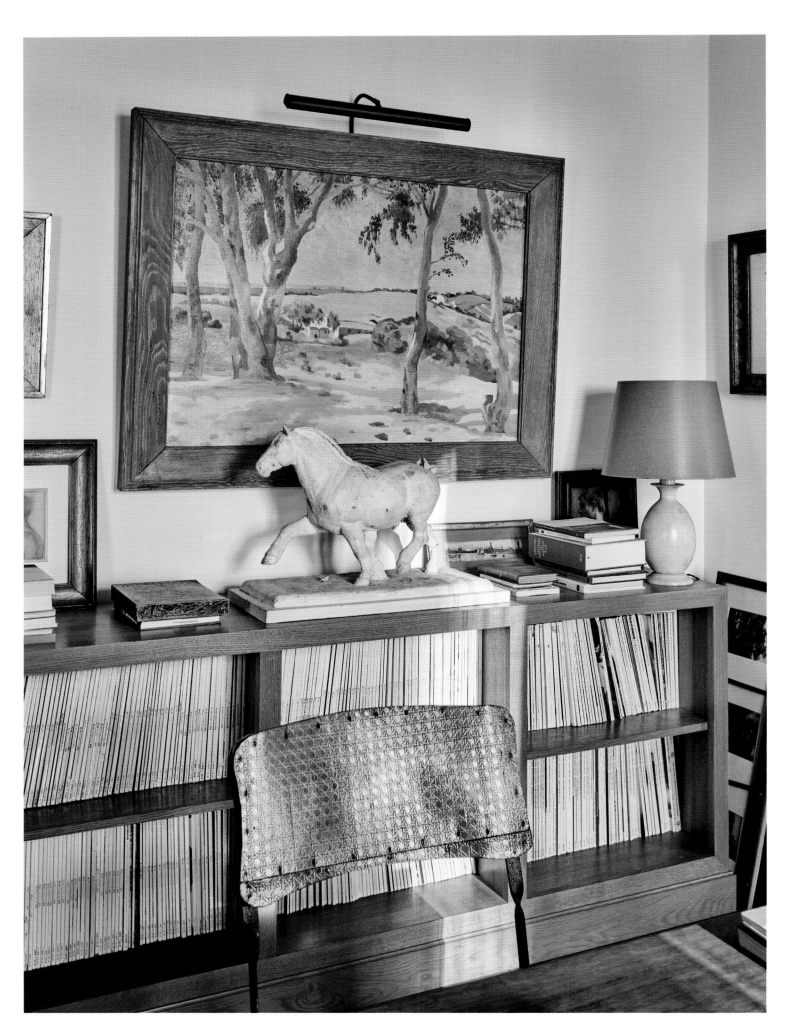

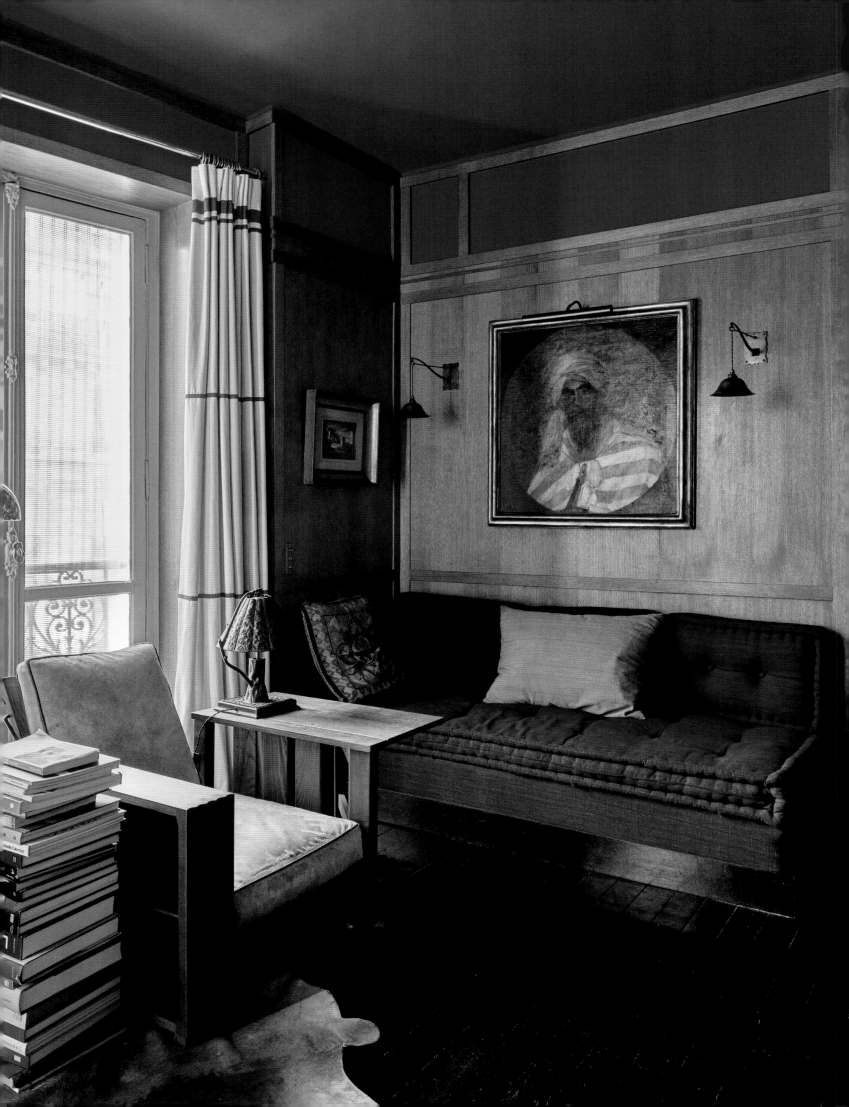

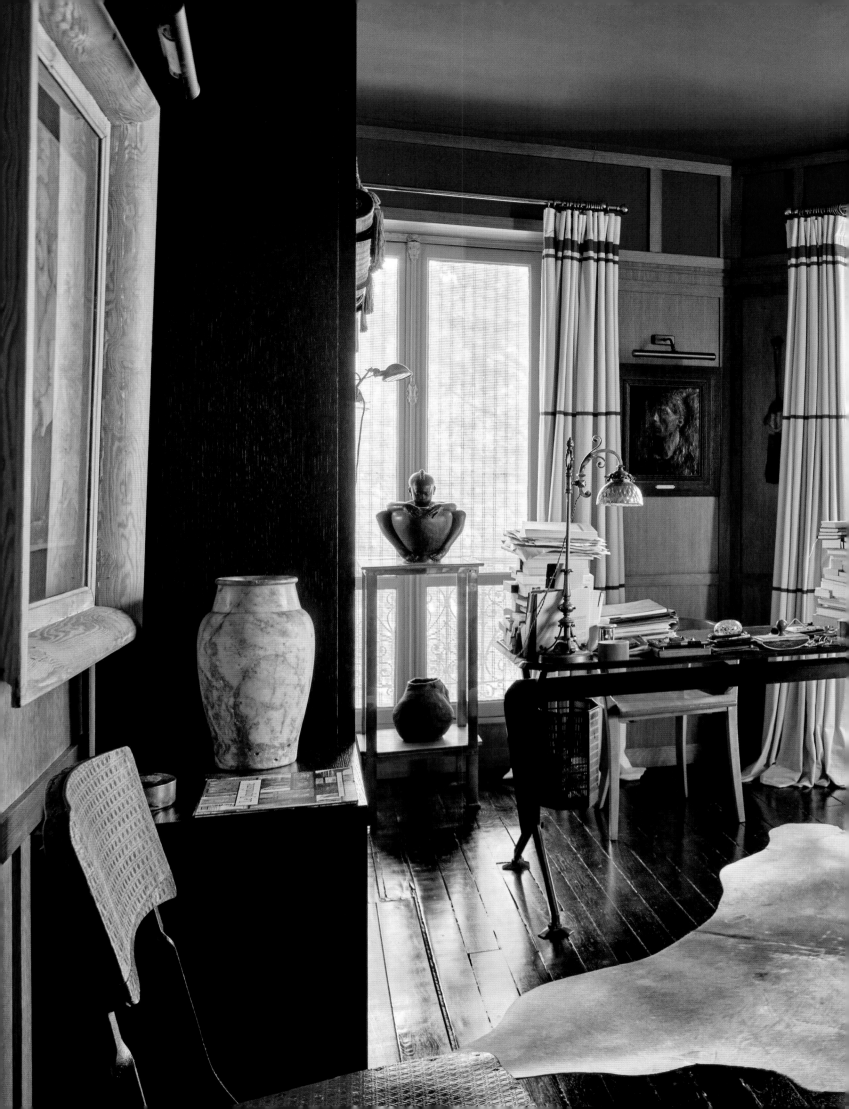

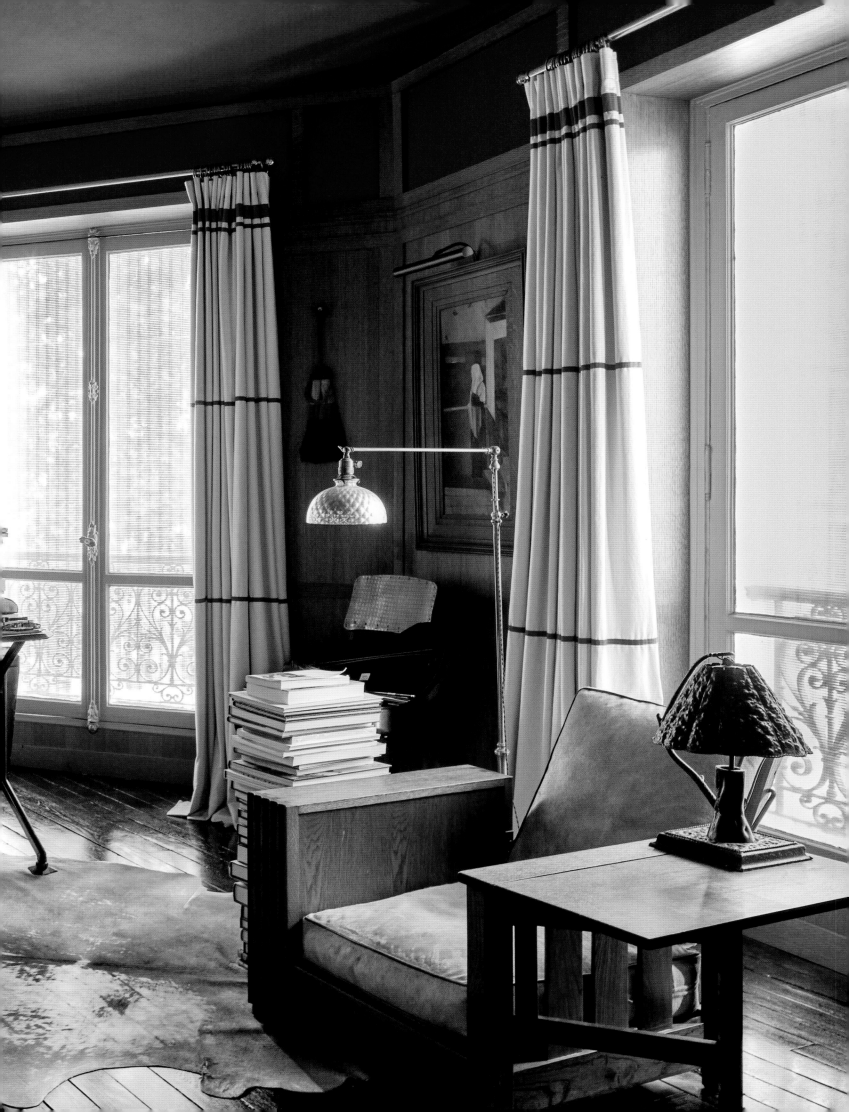

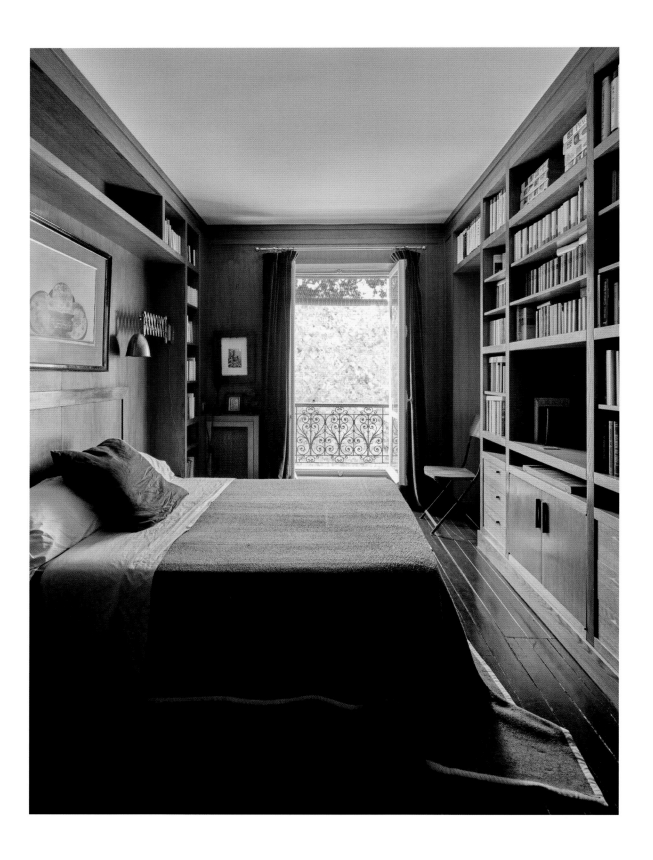

REFINED/ SOPHISTICATED/ TIMELESS.

MARTA SALA

Furniture designer Marta Sala has always lived between Milan and Paris. "I've learned to embrace and appreciate both rich and diverse cultures," she affirms. When she was looking for a place of her own, she found herself on Rue Jacob in Saint-Germain-des-Prés. "I was surprised to discover that in the middle of all the bustle of this area, this apartment is an oasis of peace, with a huge loquat tree in the courtyard, where you can still hear the bells and the birds in the morning."

I met Marta through a mutual French-Argentine friend who is now her husband. Her history with this house goes back to before her marriage, but today it is the place where she enjoys hosting, as it is here that she feels most comfortable, surrounded by furniture of her own design. She becomes passionate when talking about her work. "When a client buys a piece from you, you enter into their everyday life, so there is an ethical responsibility in that. You have to give the best in terms of design and realization. The idea is to create pieces that will become the objects of affection of the next generation."

Most of the collection in Marta's apartment is designed by the renowned architects Claudio Lazzarini and Carl Pickering, who are based in Rome. There are also three or four pieces from Federico Peri, a Milan-based designer she started working with a couple of years ago. All the pieces are manufactured in Italy by selected craftsmen under Marta's direction. She has more than eighty pieces in her collection, which is more than large enough to fill her apartment with sleek, modern lines, augmented here and there by photos or paintings that were gifted to her.

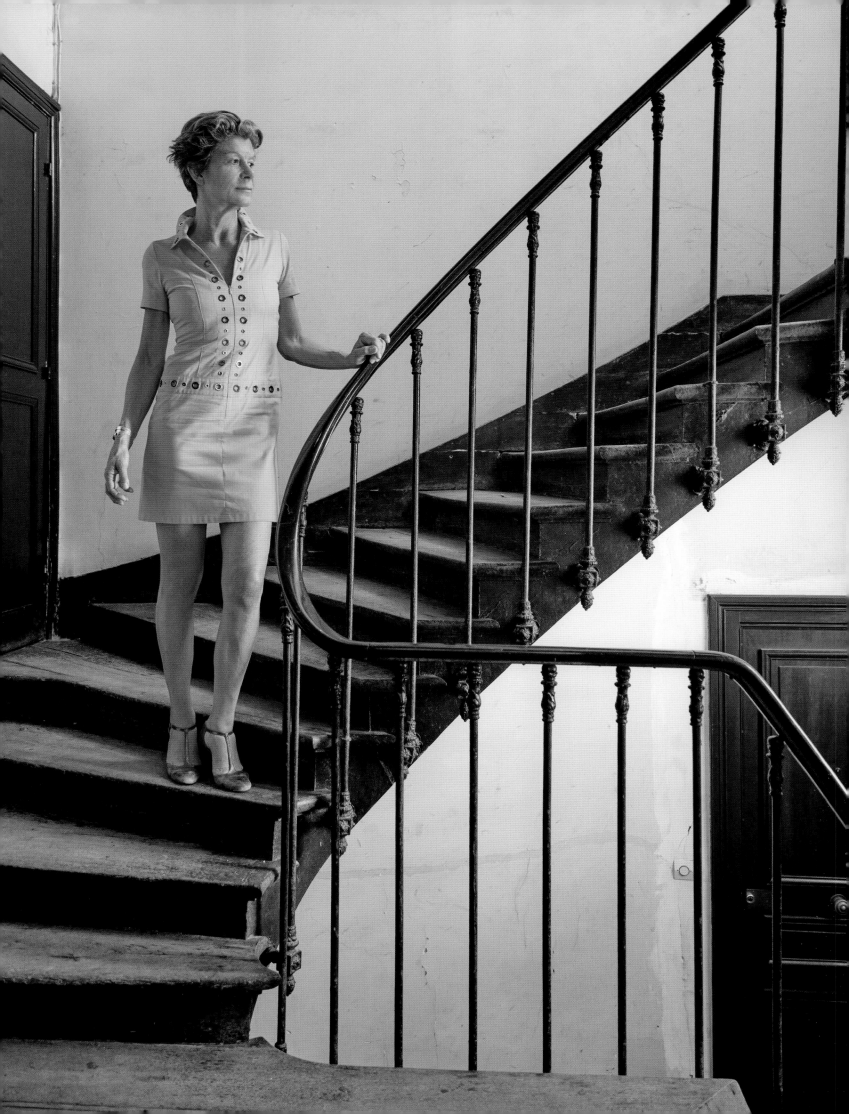

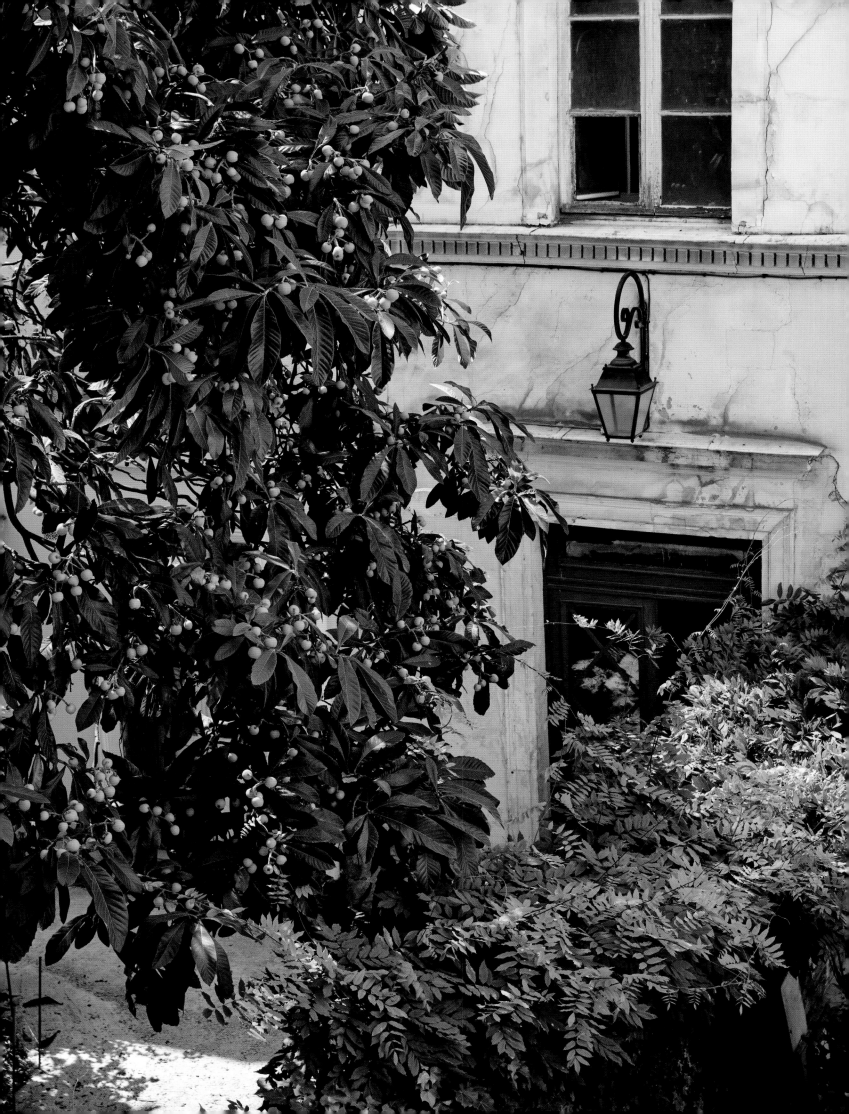

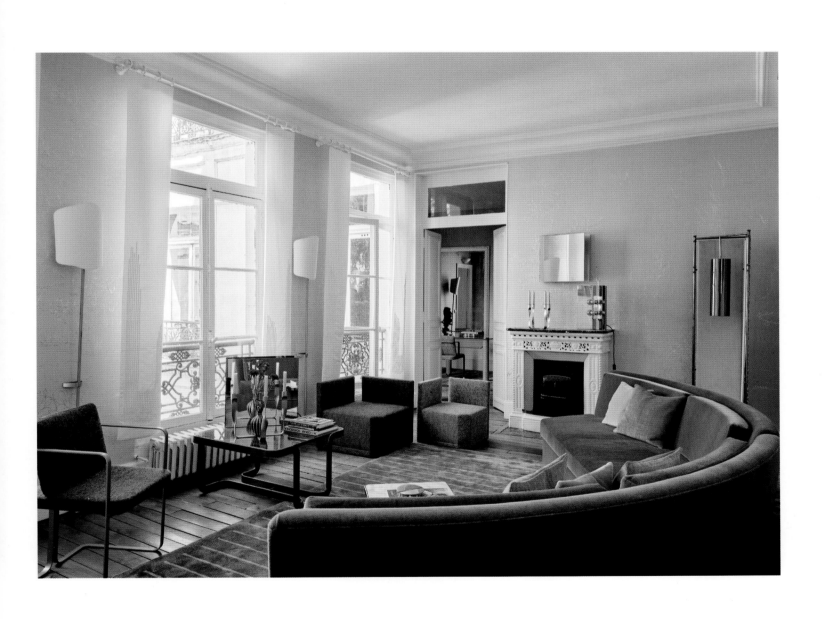

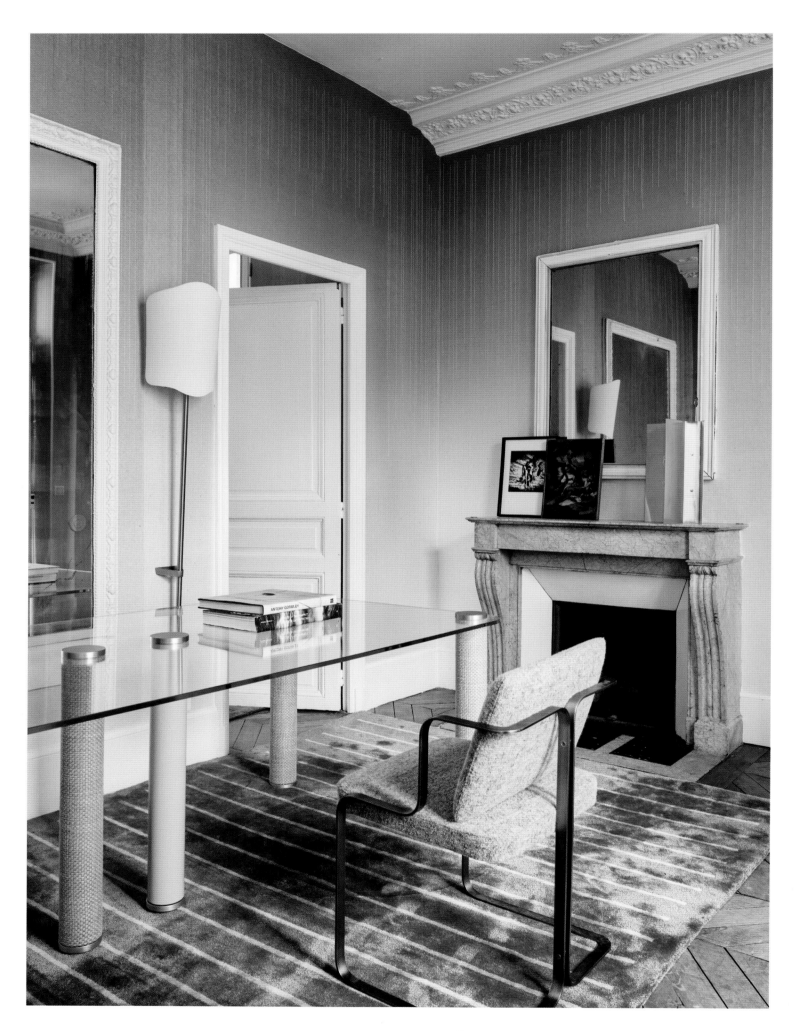

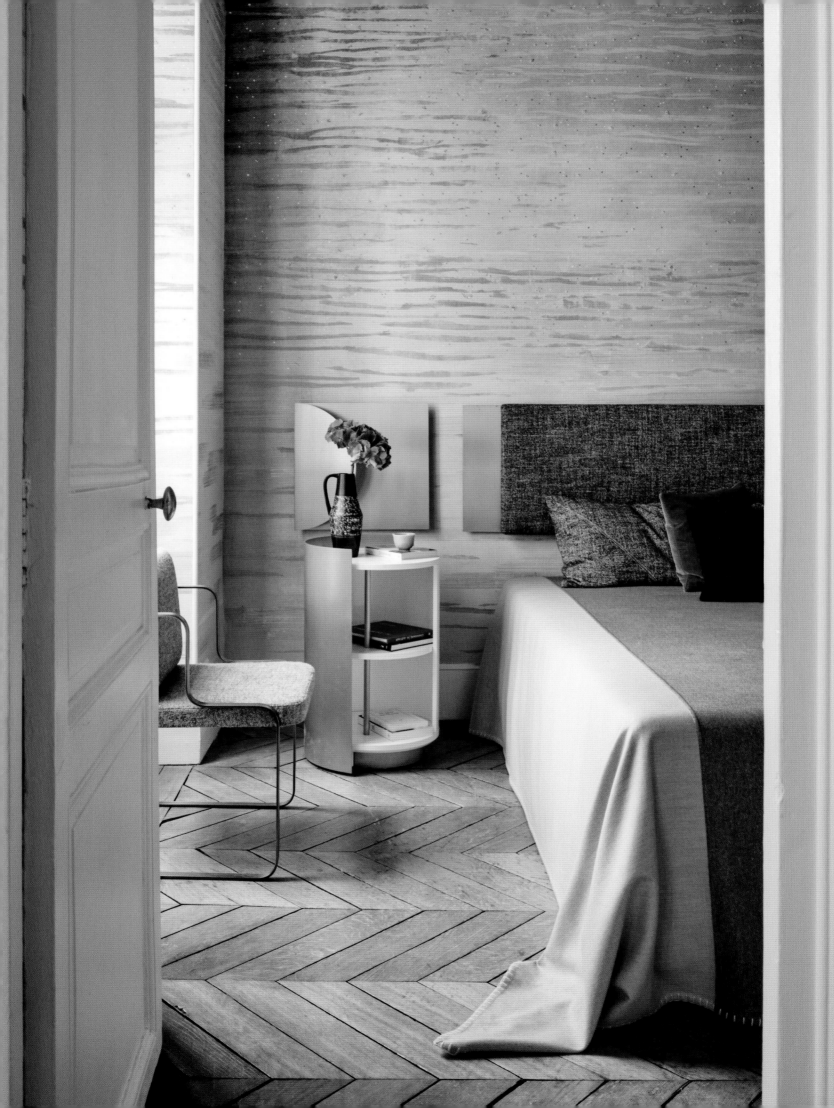

LIVELY/ FUN/ DIFFERENT.

PIERRE PASSEBON

Despite living in one of the most spectacular houses in Paris with his life partner, Jacques Grange, antique dealer and collector Pierre Passebon wanted a place where he could unleash his creative spirit. He found it in a Directoire-style building from 1826 close to his Galerie du Passage in the 1st arrondissement.

As Pierre just happens to have a decorator at home, he and Jacques both got down to work. They love working together, and have collaborated on many projects, but this one was particularly fun. Pierre didn't hold back when decorating this house. He doesn't feel limited by any preconceptions; it's simply his home, and he lets himself be guided by his intuition and sharp professional eye.

The result is a delightful melding of art and objects, centuries and cultures. As soon as I enter, I am struck by the extravagant Abyss table by Mattia Bonetti, which engages in a dialogue with the yellow animal series sculpture by Laurent Dufour, alongside which Pierre comfortably poses. A spectacular sixteenth-century Italian marble fireplace dominates the living room, in front of a sofa designed by Grange, complemented by ritual masks from Amazonian cultures. But my gaze is also drawn to a Pre-Raphaelite screen by Edward Burne-Jones and the Nabis screen in the adjoining room, next to a table by François-Xavier and Claude Lalanne.

In the kitchen, there's a nod to Pierre's other place in the world: a wall covered with nineteenth-century Portuguese tiles. Houses are generally a reflection of their owners, their personalities, desires, and fantasies. Pierre's home eloquently asserts his place as a trendsetter in the world of art.

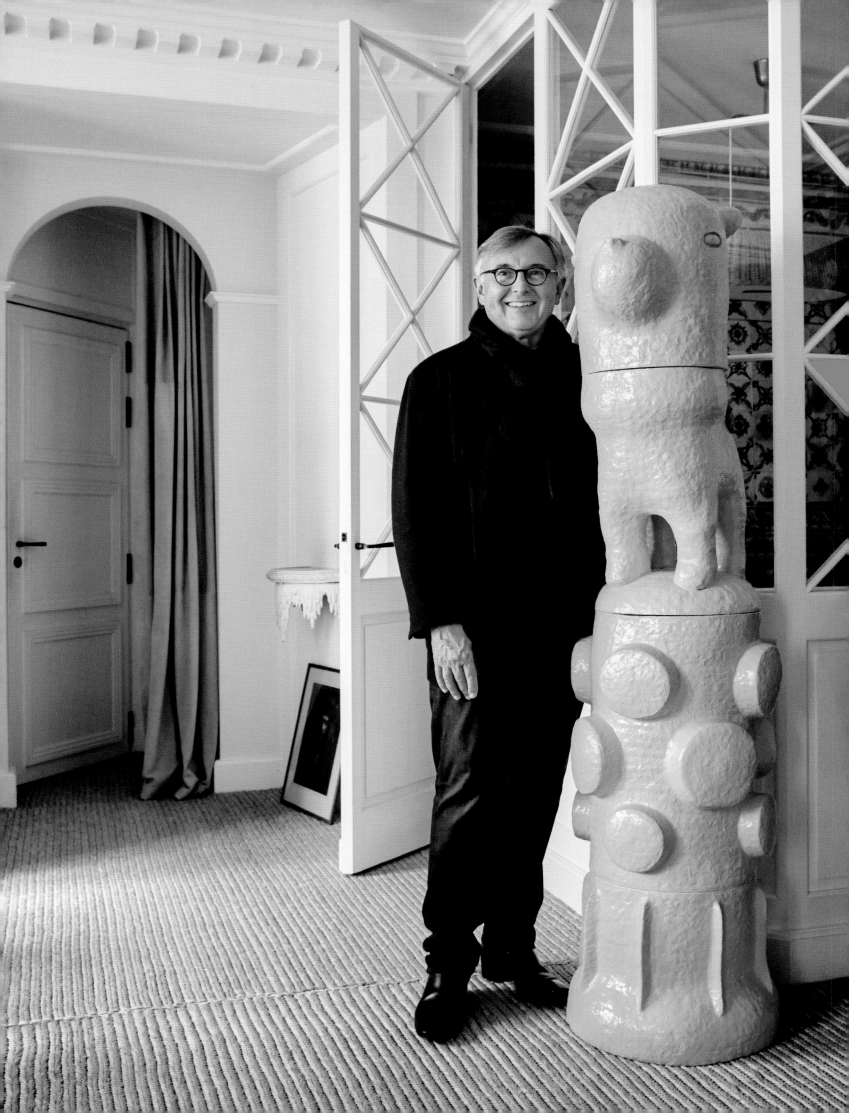

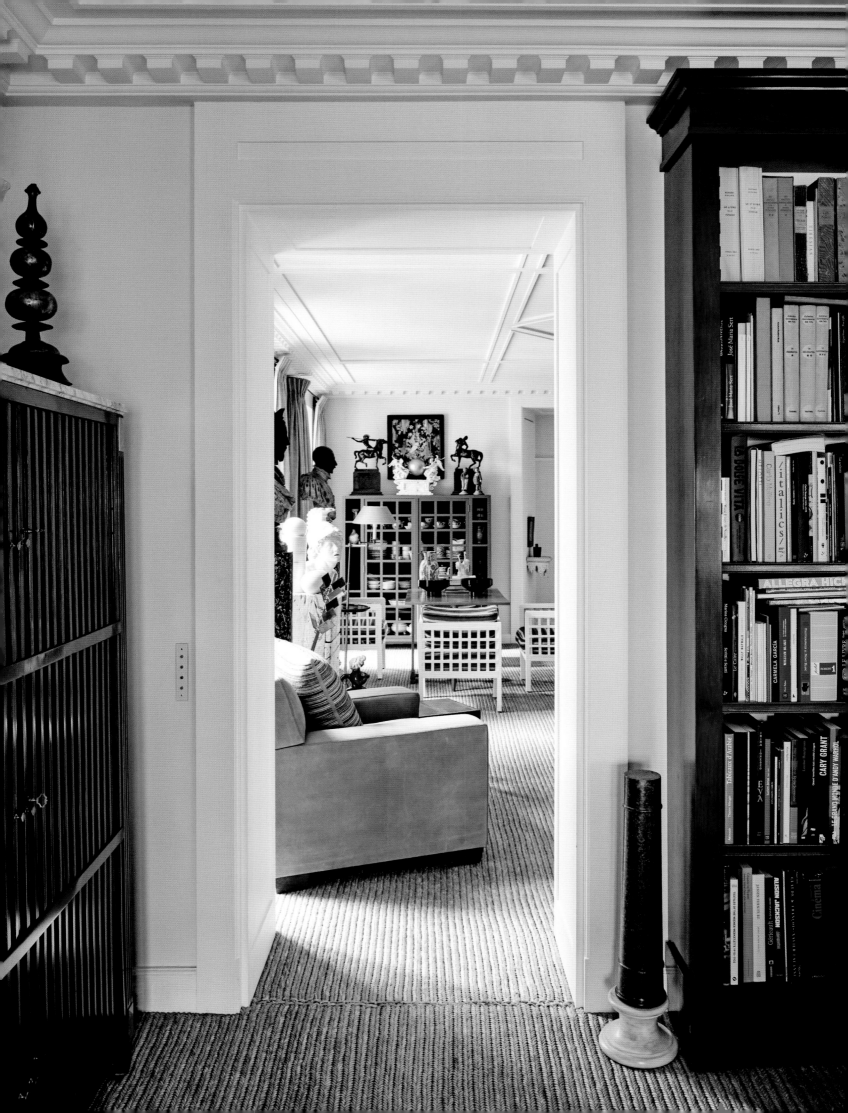

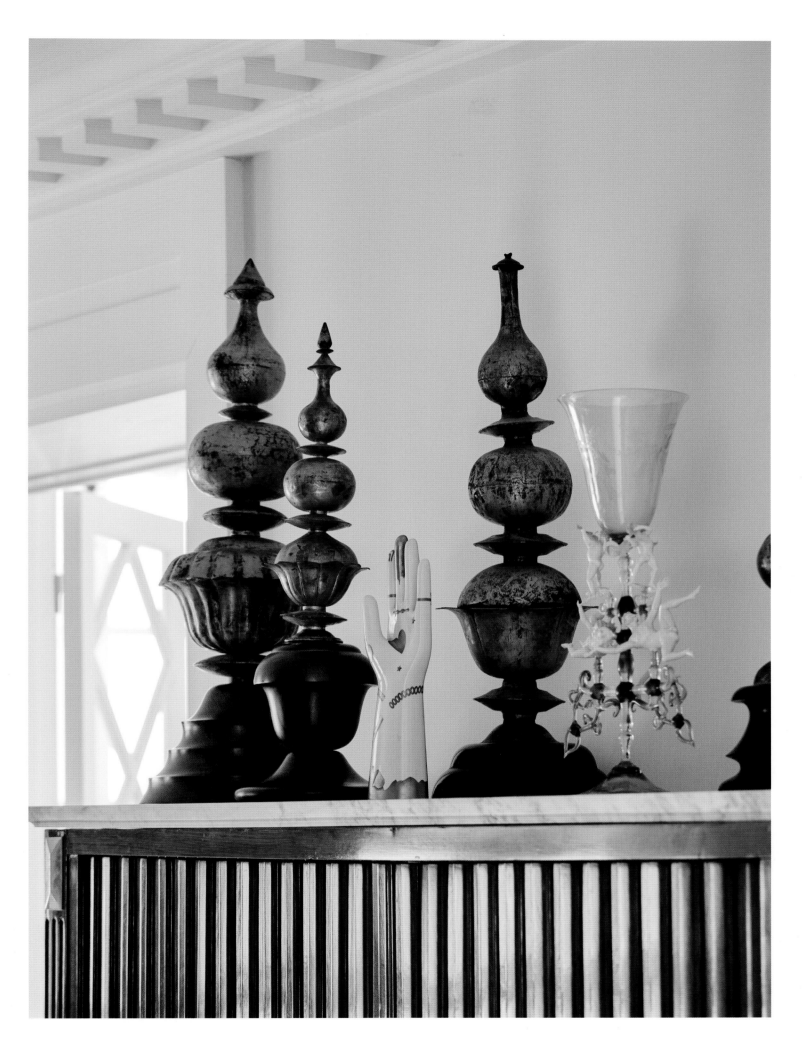

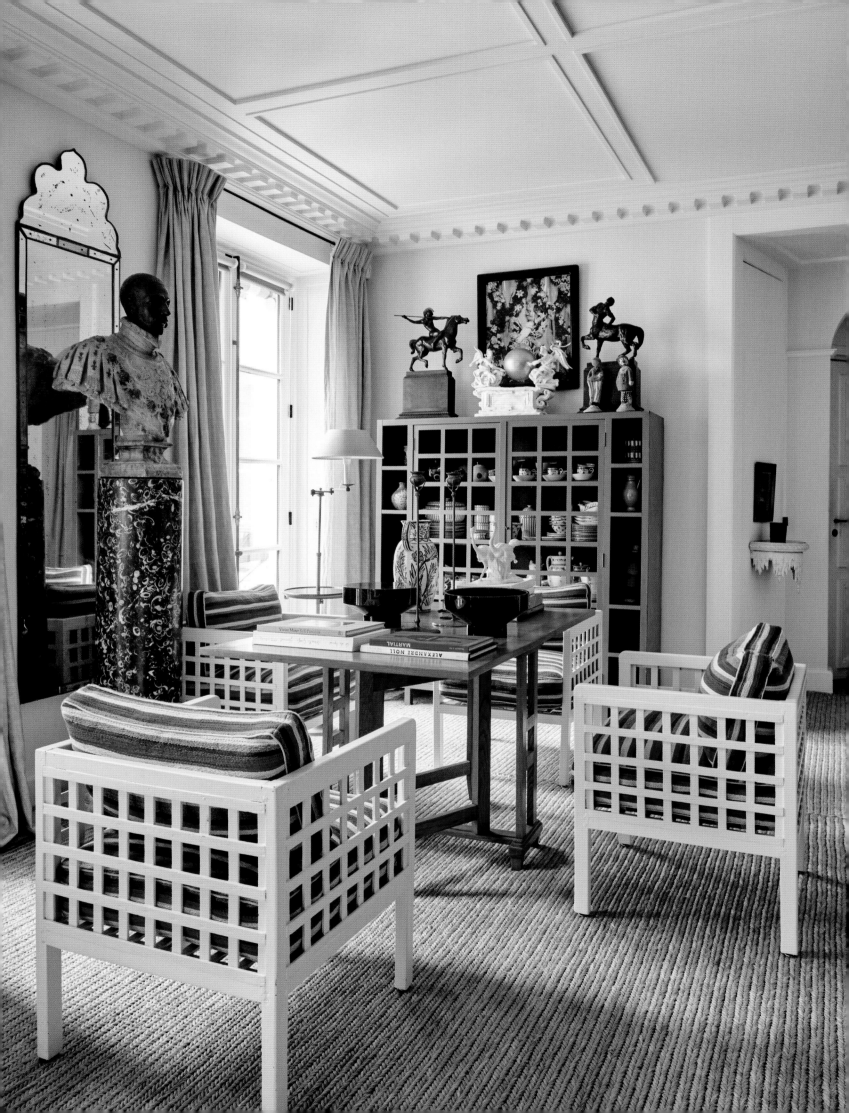

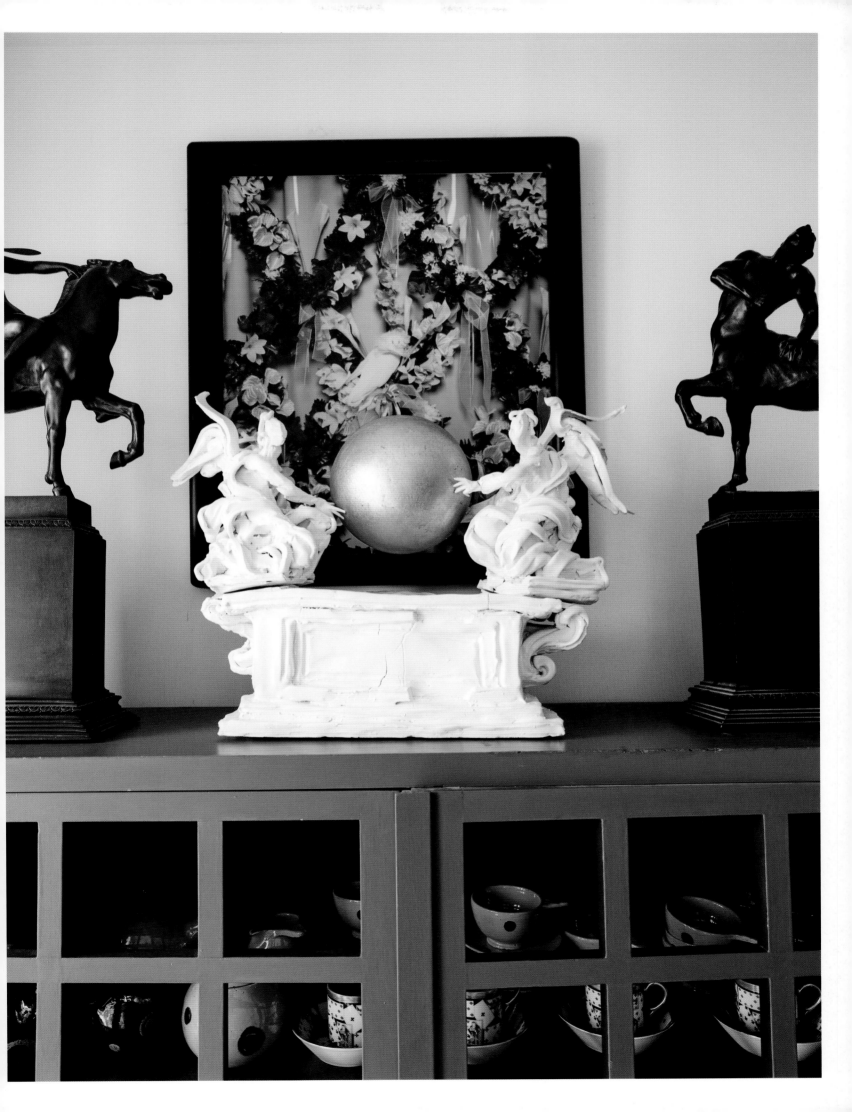

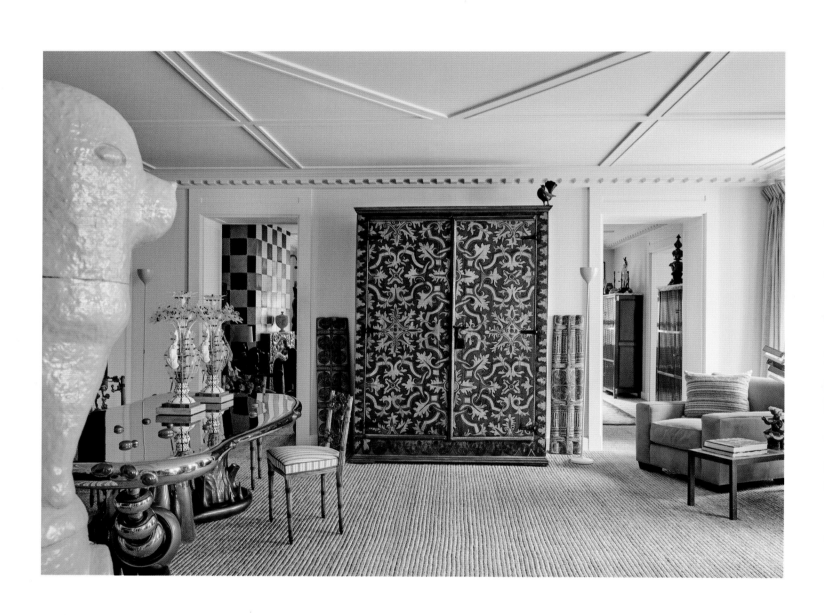

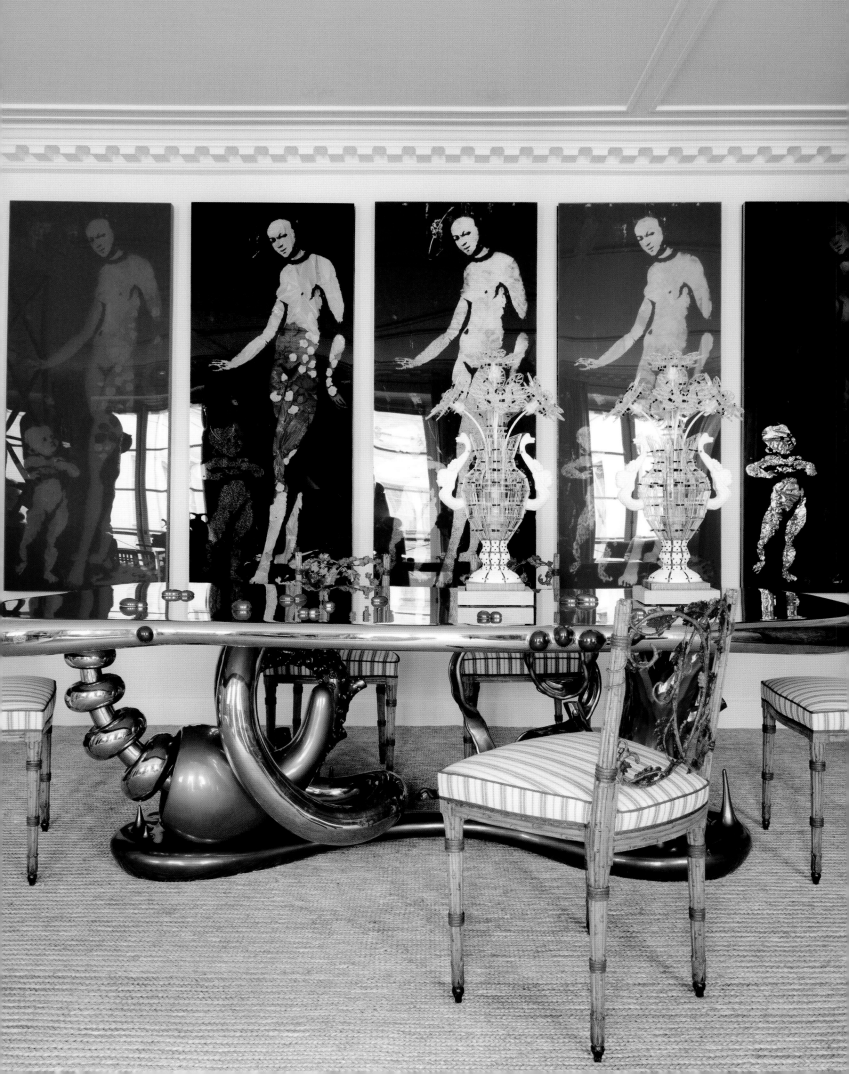

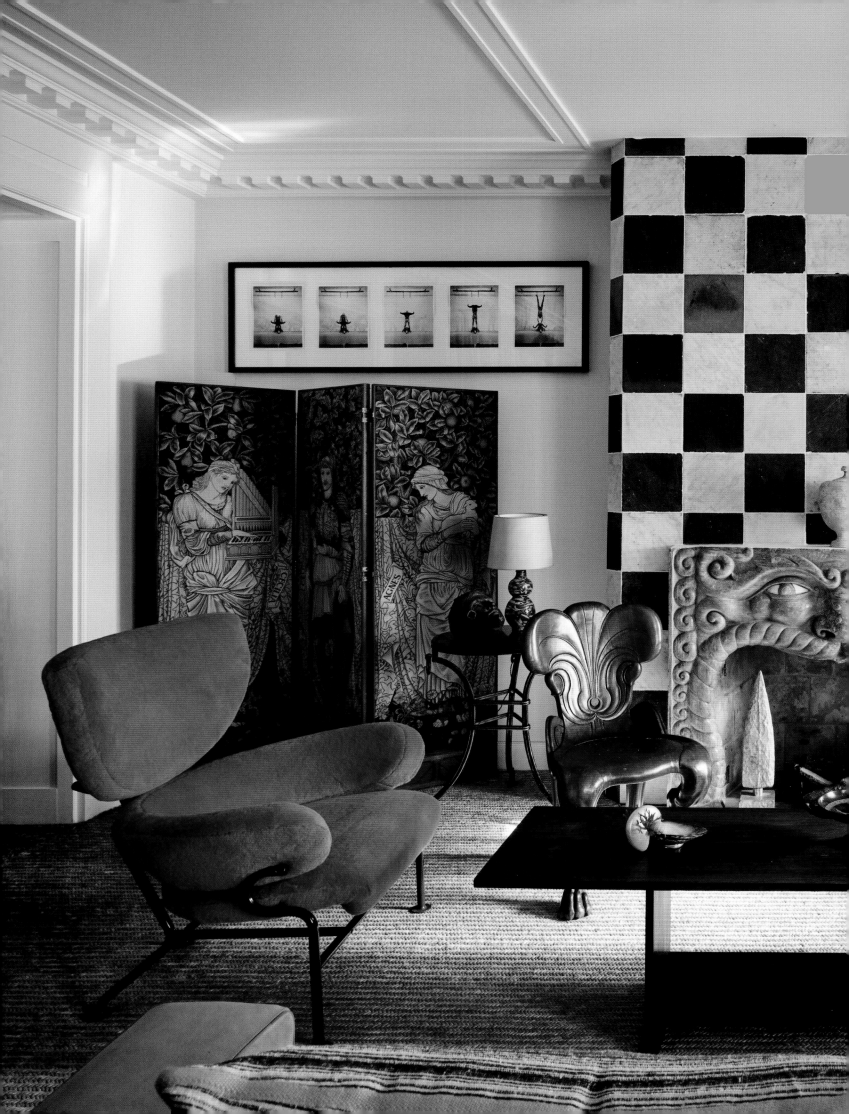

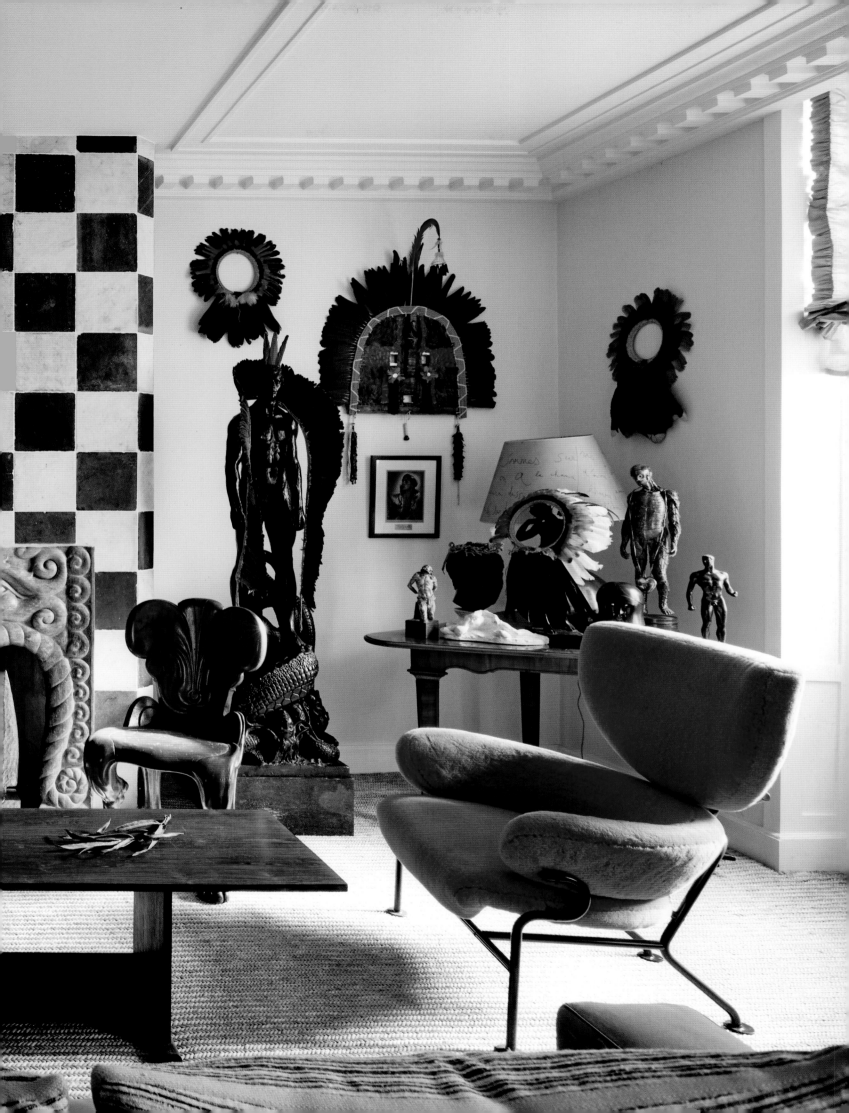

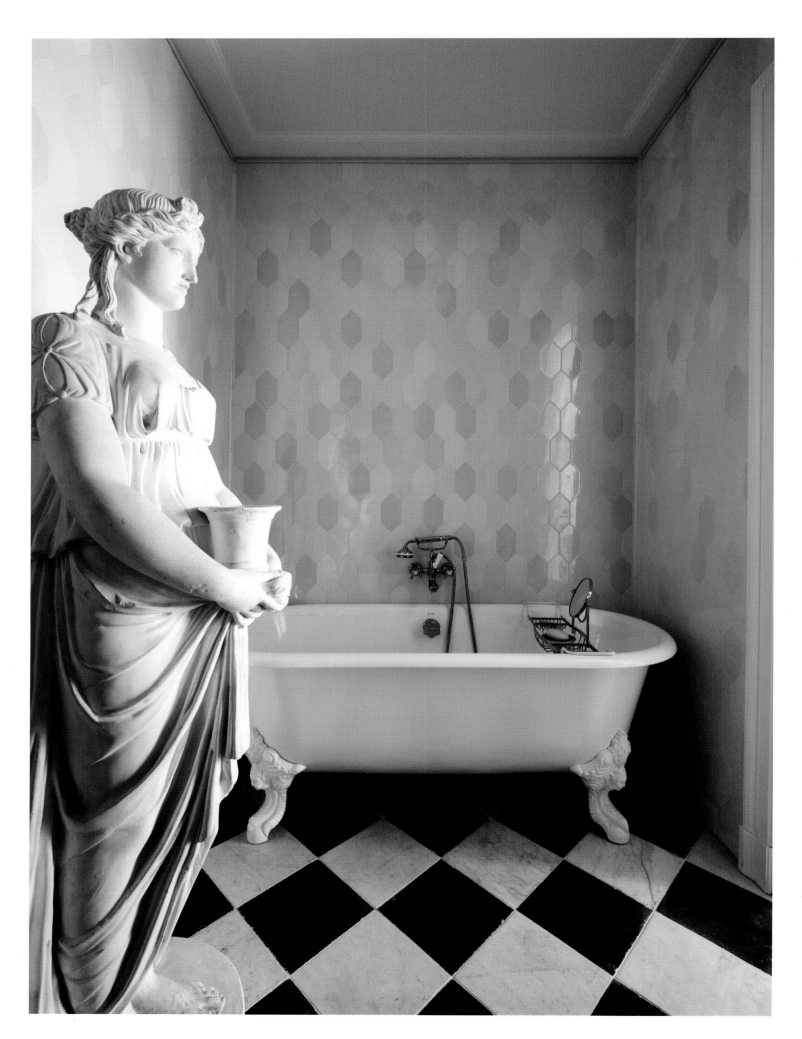

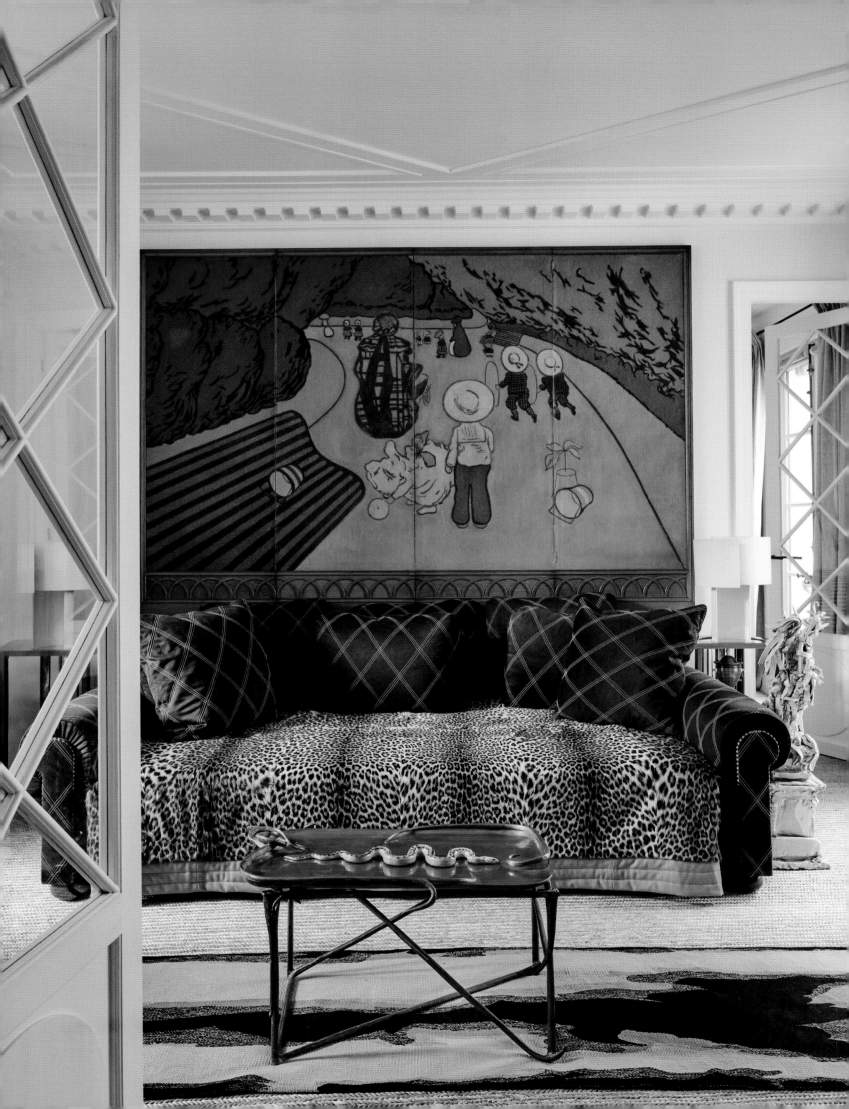

VIBRANT/ COLORFUL/ CREATIVE.

MATALI CRASSET

Matali Crasset's gaze is firmly fixed on the design of today—and of tomorrow. When I spoke with her for the first time, she invited me to see one of her most beloved projects, the house of her recently deceased friend, jewelry designer Michèle Monory. Matali had once converted an old abandoned space on Michèle's property in Loudun, in western France, into a studio for her jewelry project Le Buisson. The friendship continued, and many years later, when Michèle decided to renovate her house in Paris, she once again gave Matali carte blanche. The result couldn't have been more successful.

Michèle didn't like to dwell in the past; she preferred to look forward. Her small, conventional 1960s apartment had magnificent views but did not at all reflect Michèle's open and creative personality. Together, she and Matali transformed it into a bright, happy space, creating a relaxed and stimulating atmosphere, flooded with natural light, where she could welcome her friends. They called the project "The Rainbow and the Woods."

Low green furniture placed along the length of the house and all around (the Woods) accentuates the sense of spaciousness. A quadruple lounger marks the center of the main space, an area for comfortable exchanges, enveloped in energizing color that invites inhabitants and visitors alike to take advantage of the present moment each day (the Rainbow). Multicolored vertical dividers allow the area to be organized and shaped in different ways.

These two movements—the Rainbow and the Woods—set the furnishing conditions of the entire flat and open perspectives, both physical and mental. As Matali explains, "This invigorating framework helps one to remain active with a lively mind, to go beyond the bourgeois stereotypes that petrify one, to go beyond the cocoon status that over-protects and renders us insensitive."

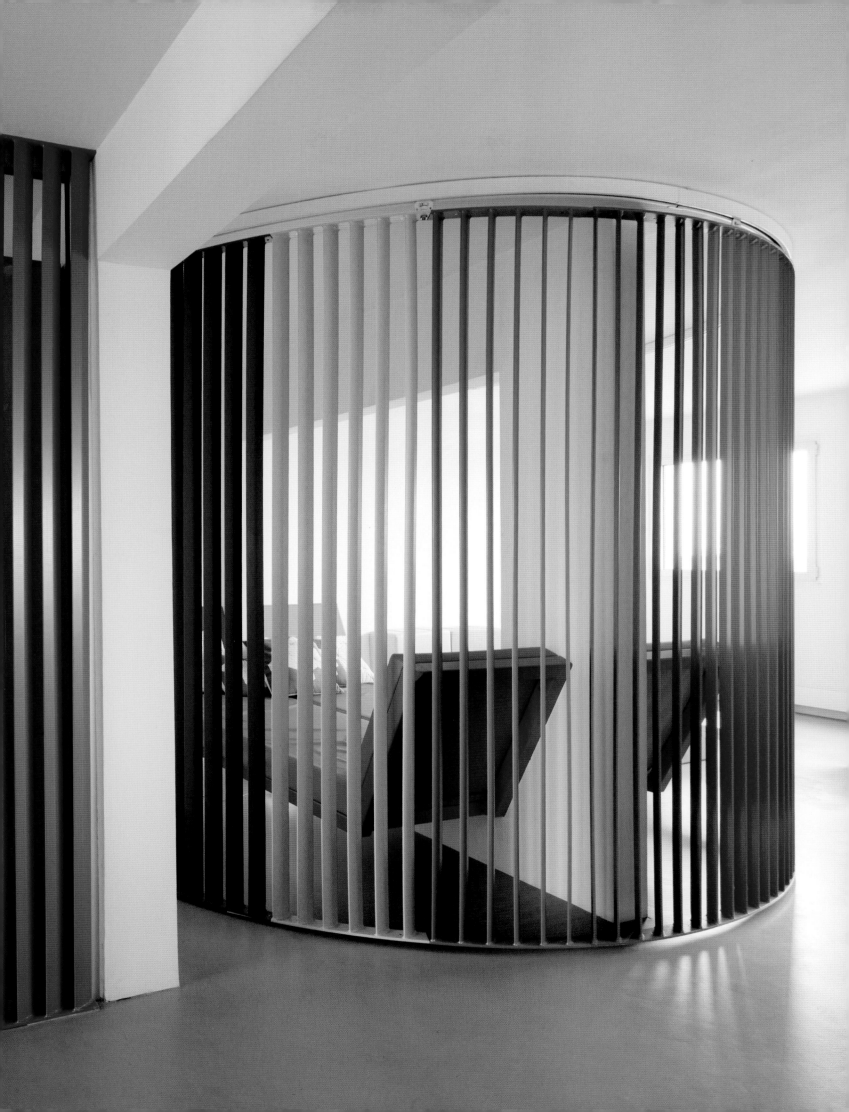

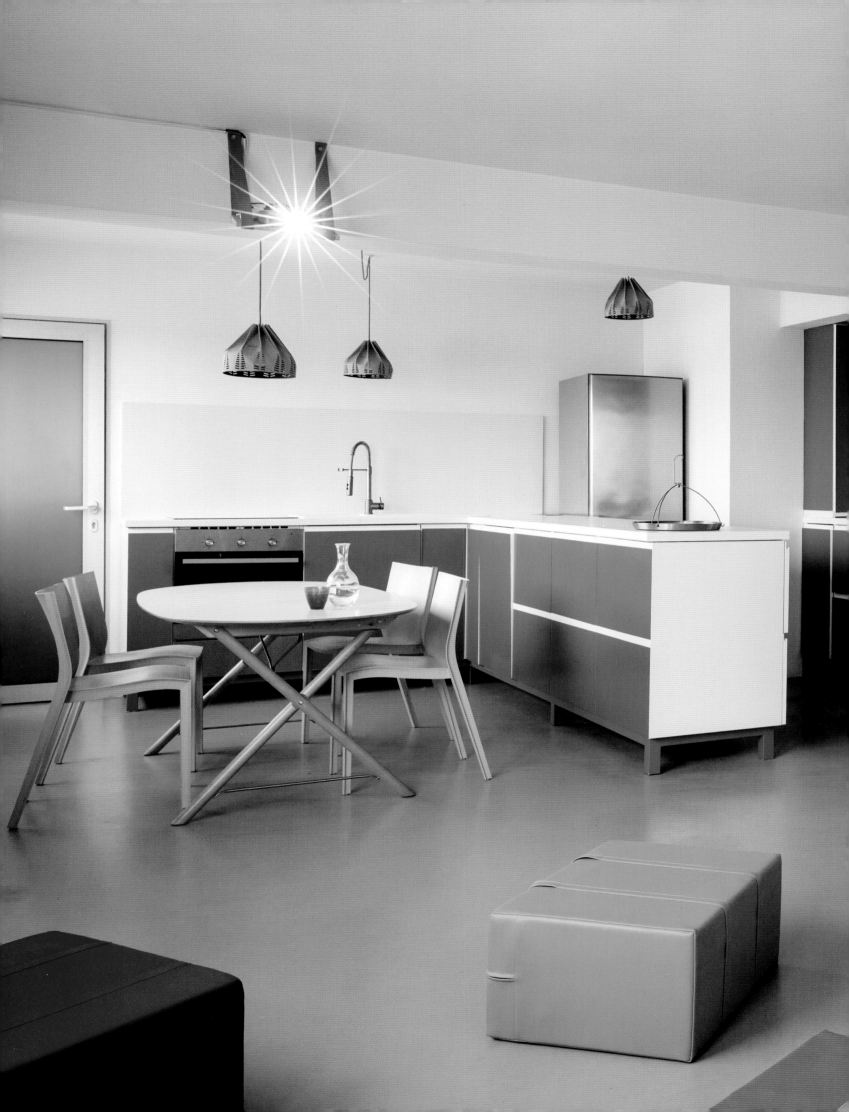

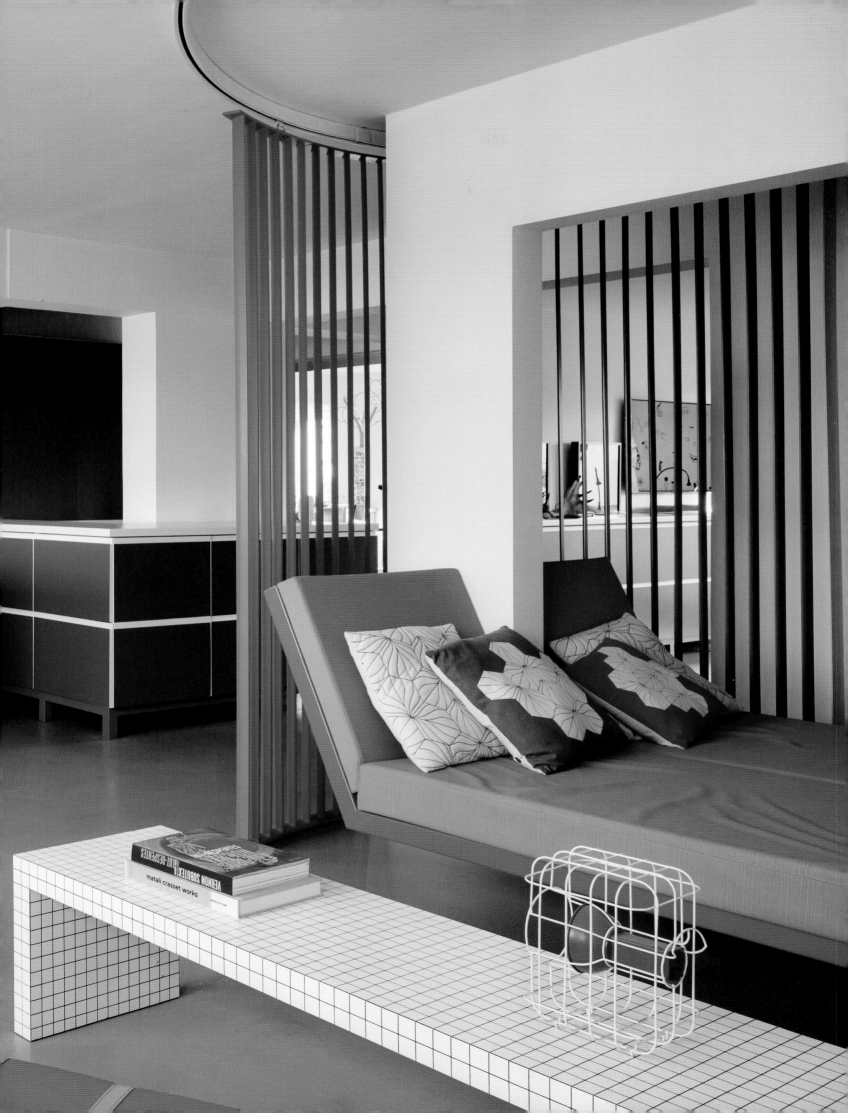

matali crasset works

VERNON SUBUTEX 1 VIRGINIE DESPENTES

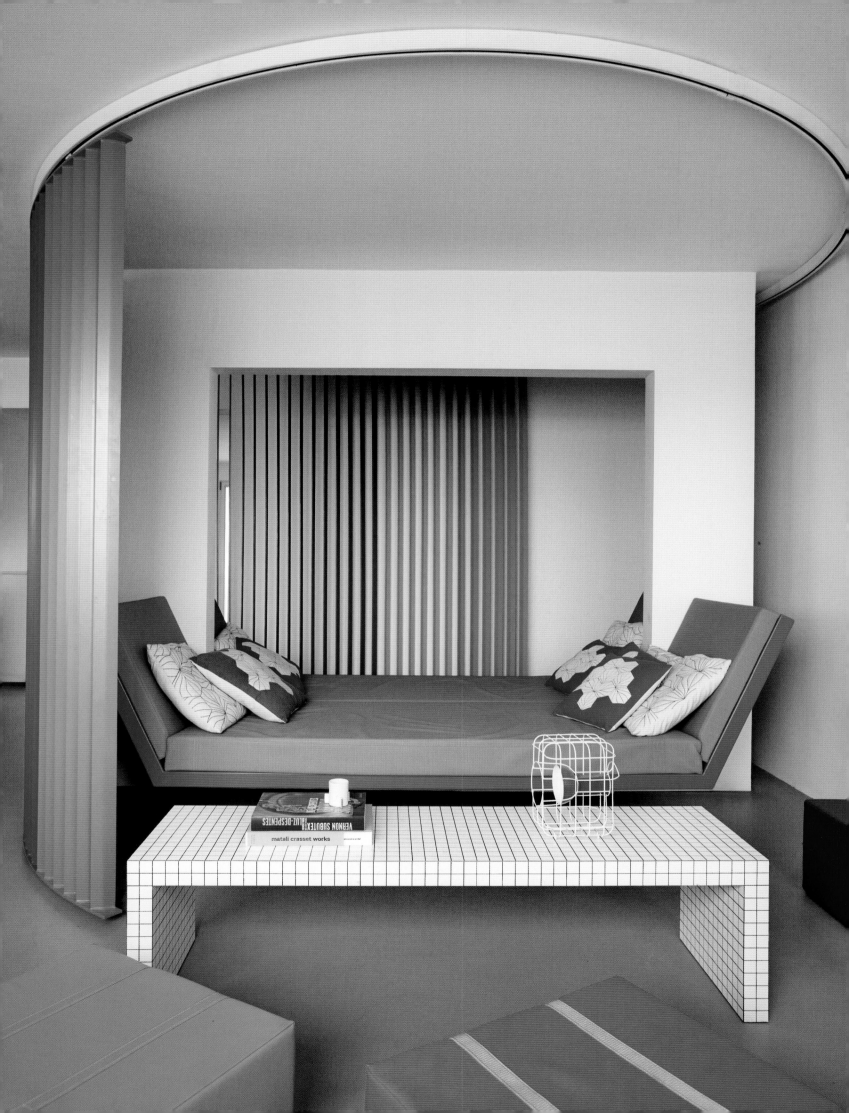

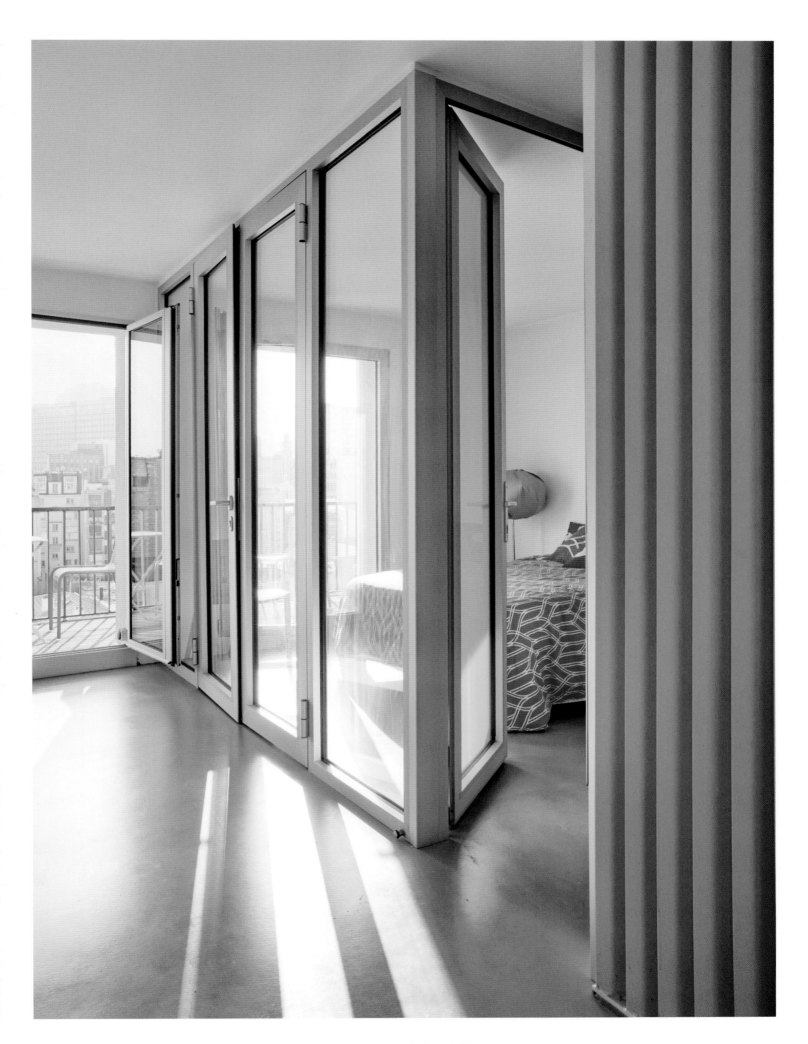

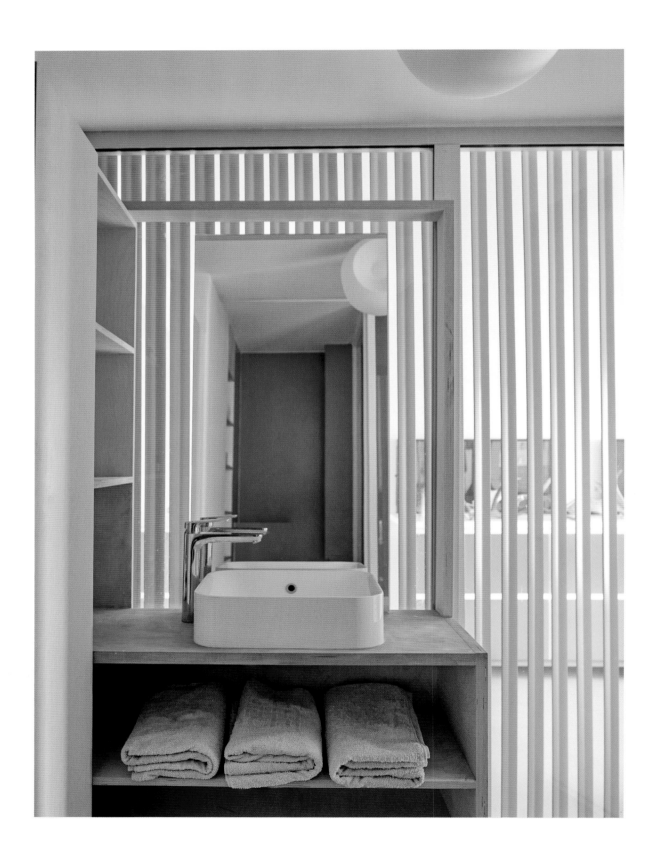

INTIMATE/ HARMONIOUS/ JOYFUL.

TERRY DE GUNZBURG

Terry never stops traveling, but on the very day that Jacques Grange provided me with her contact details so I could arrange to meet her, she happened to be in Paris. Quickly, I made my way to the Auteuil neighborhood to visit her in her astonishing house and garden, which remind me that in Paris there are as many ways of living as one can possibly imagine. Terry is a woman of incredible energy and talent. From her beginnings as a makeup artist to her years as an artistic director alongside Yves Saint Laurent, she has succeeded in establishing her cosmetics brand, By Terry, as synonymous with innovation and quality in the world of beauty.

Even though it's not where she spends the most time, her modernist-style house, designed by architect Hector Guimard in the early twentieth century, is the ideal place for family gatherings and enjoying time with her grandchildren. It is here that her passion for art is revealed. Terry calls herself a serial accumulator—which is perhaps why her collection keeps growing. Furniture from Biedermeier to pieces by Pierre Chareau, Jean Royère, Gio Ponti, Madeleine Castaing, and Mattia Bonetti, and artworks by Georg Baselitz, Antony Gormley, Latifa Echakhch, and François-Xavier Lalanne, all coexist with pieces acquired at flea markets.

The renovation undertaken with Jacques Grange's assistance allowed for the creation of necessary spaces to exhibit Terry's collection, especially on the first floor, where significant changes were made to achieve open and luminous spaces that she has filled with art. The wonderful garden is a backdrop for her collection of large sculptures.

Terry shares her passion for art with her husband, and they are regulars at their friends' galleries and at renowned specialized fairs. She isn't afraid to follow her own intuition, which, as we can see, is infallible.

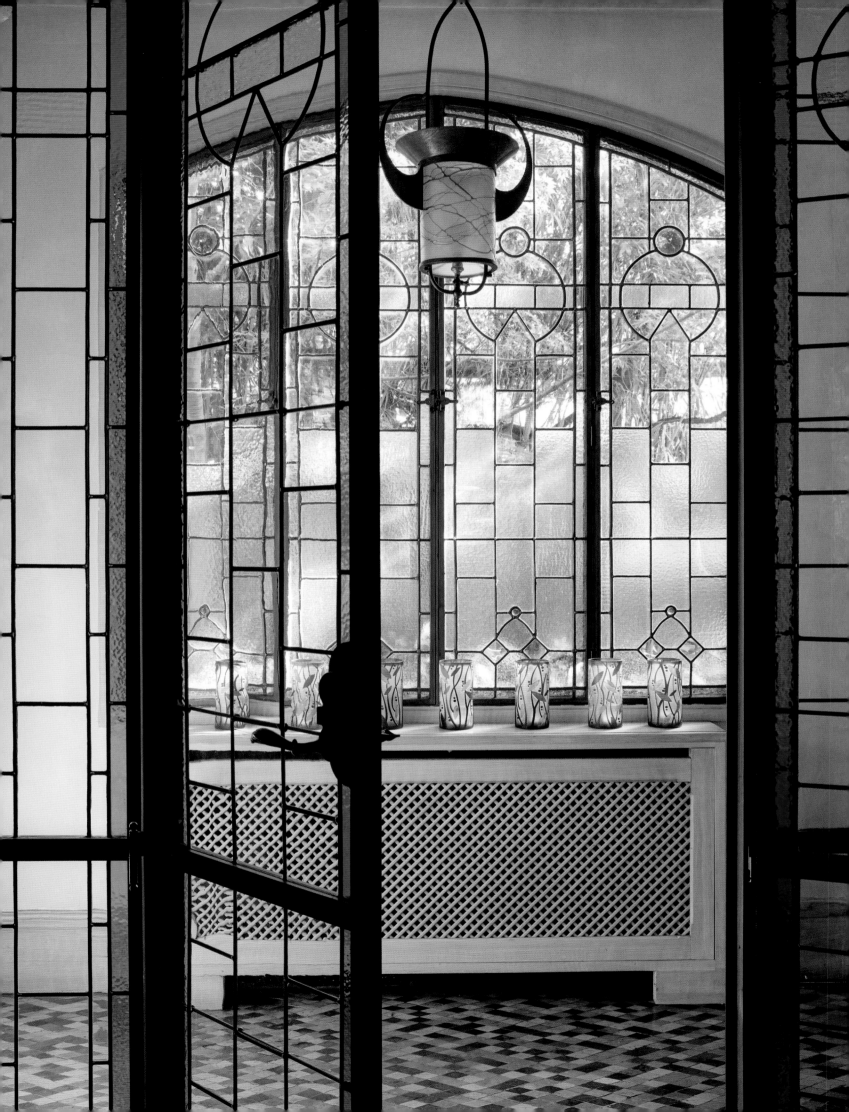

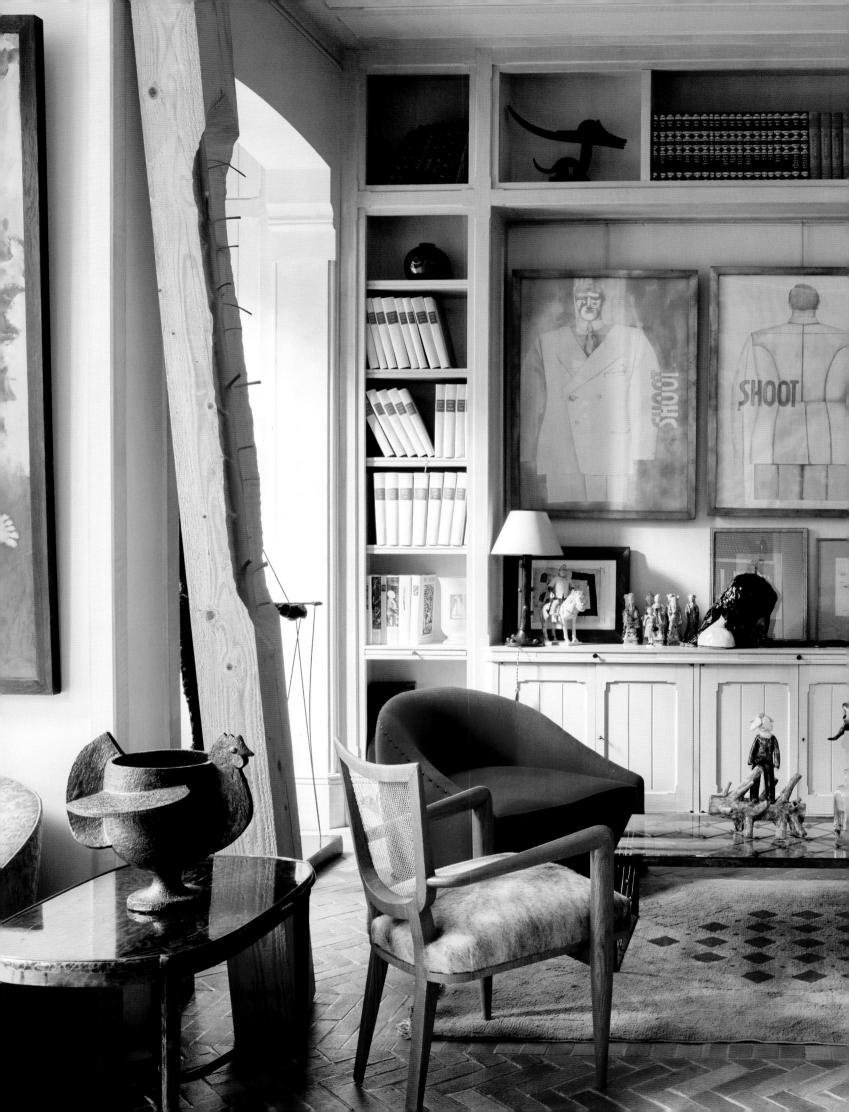

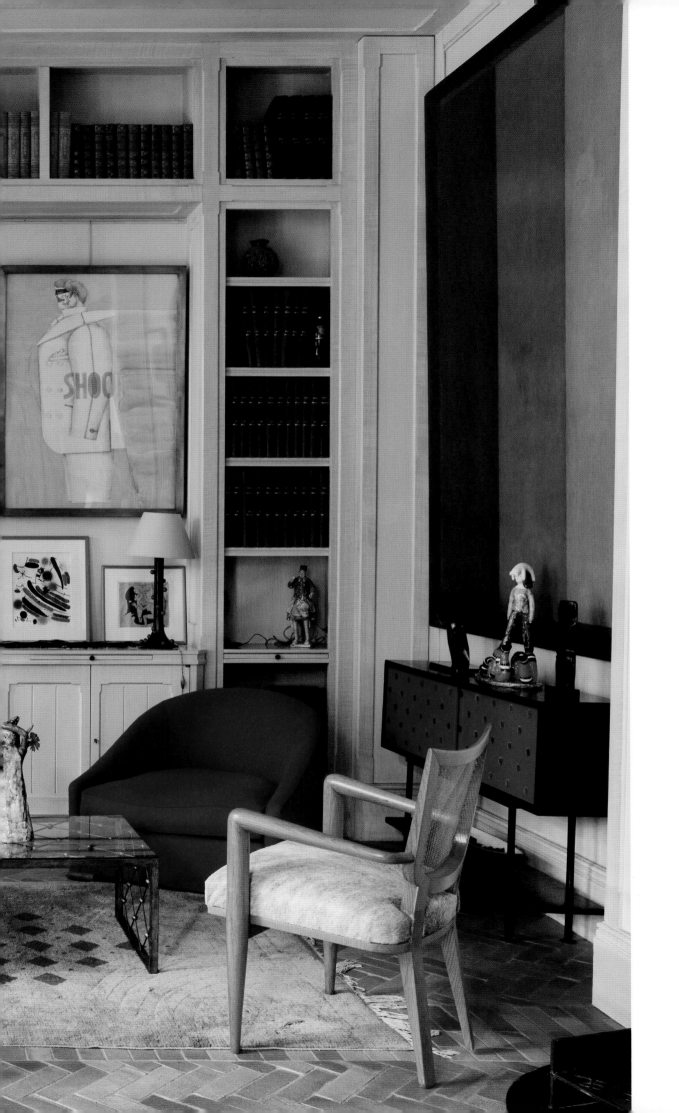

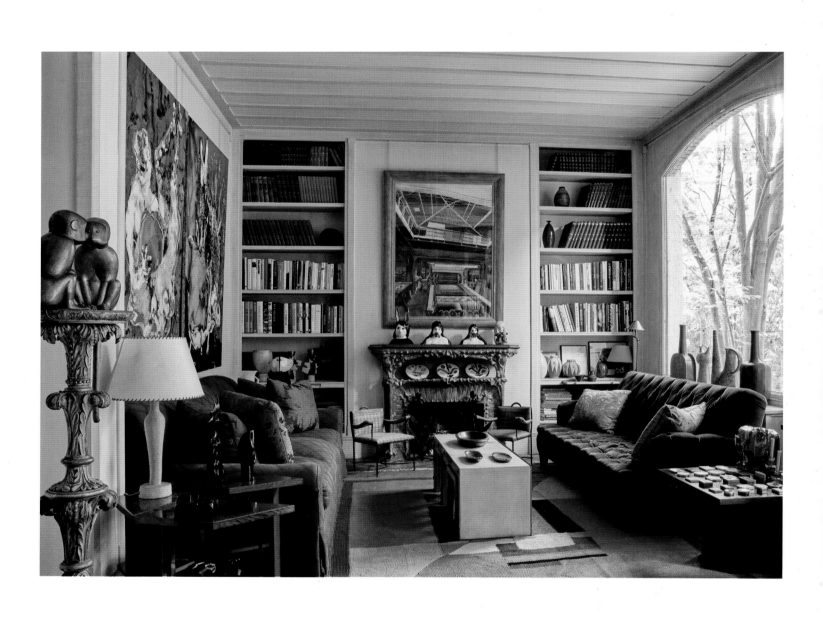

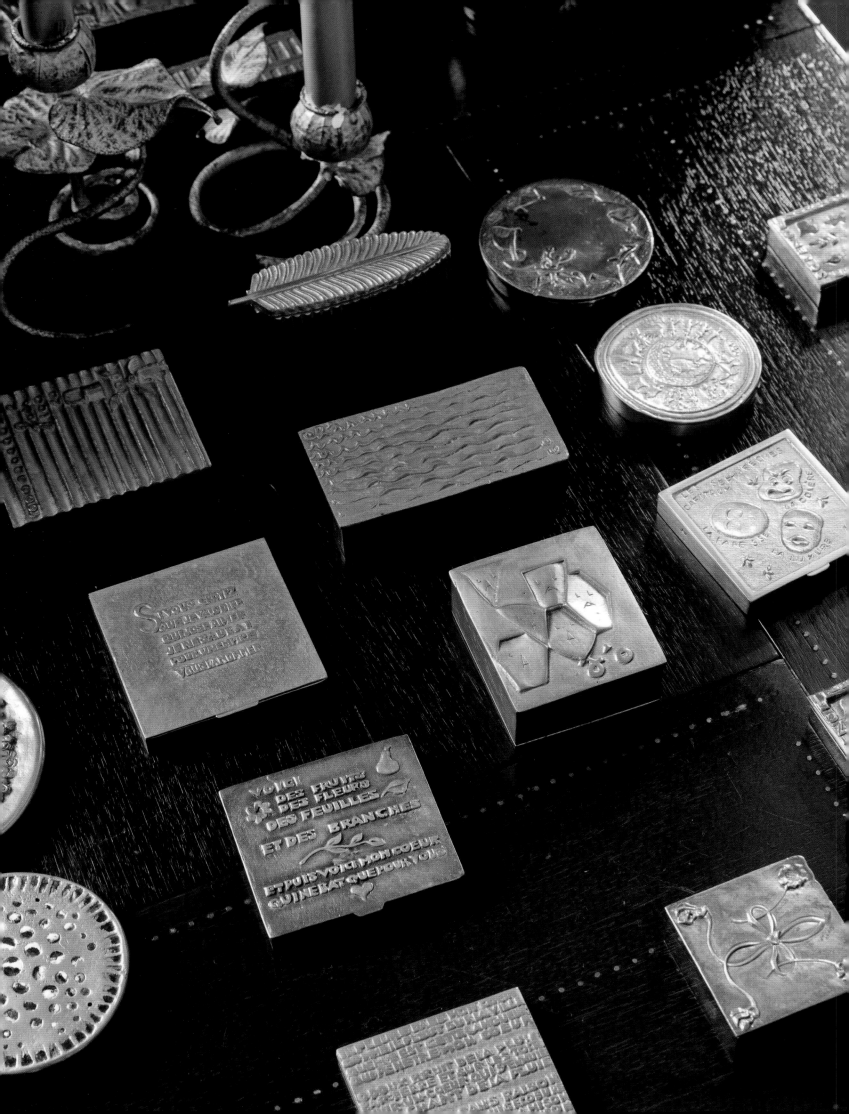

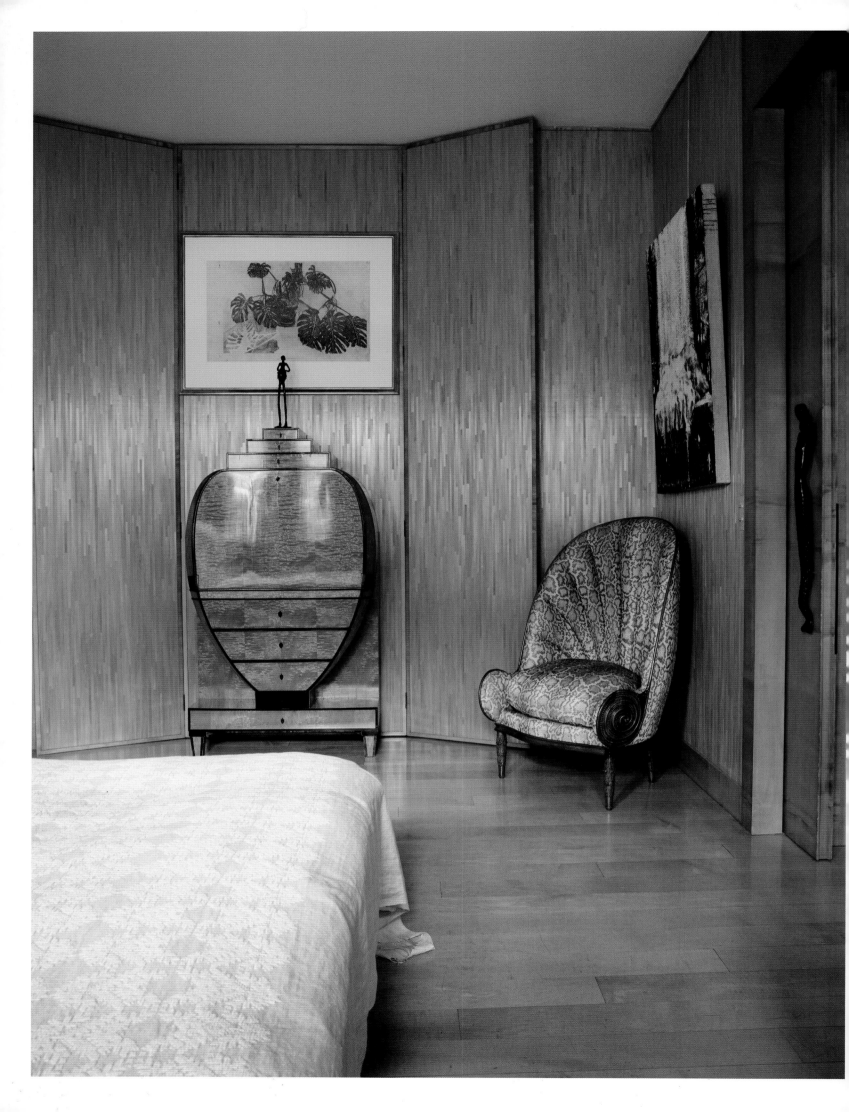

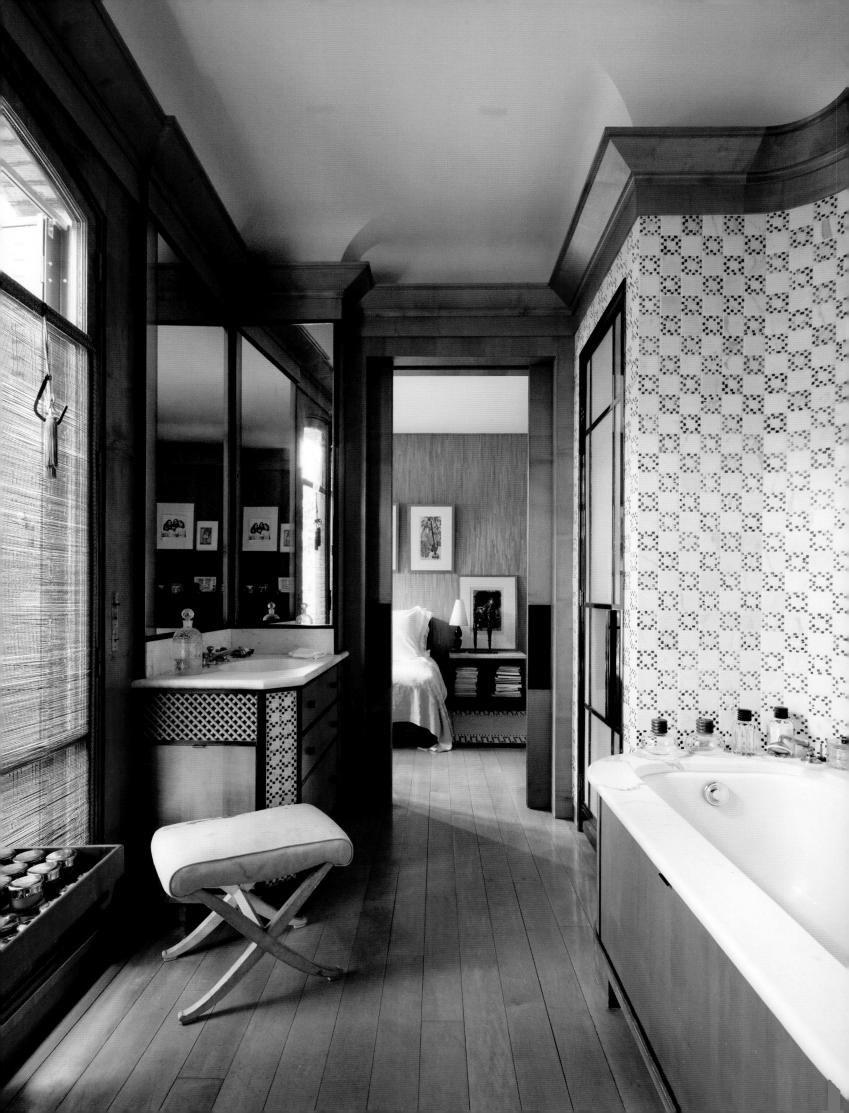

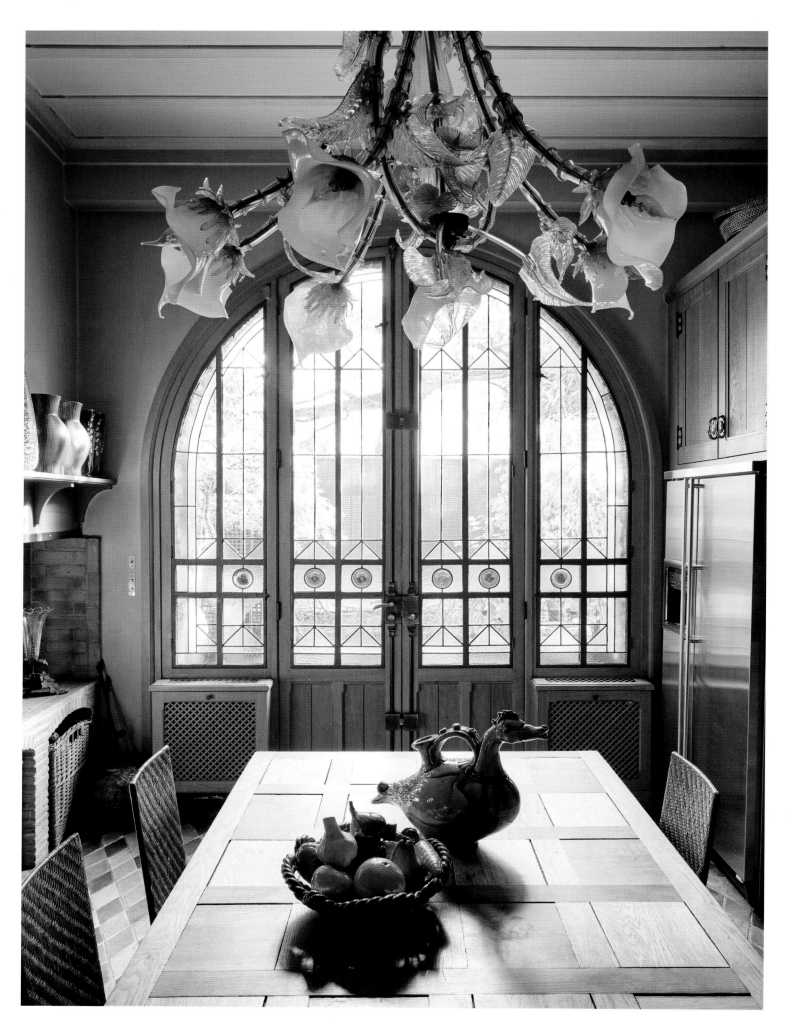

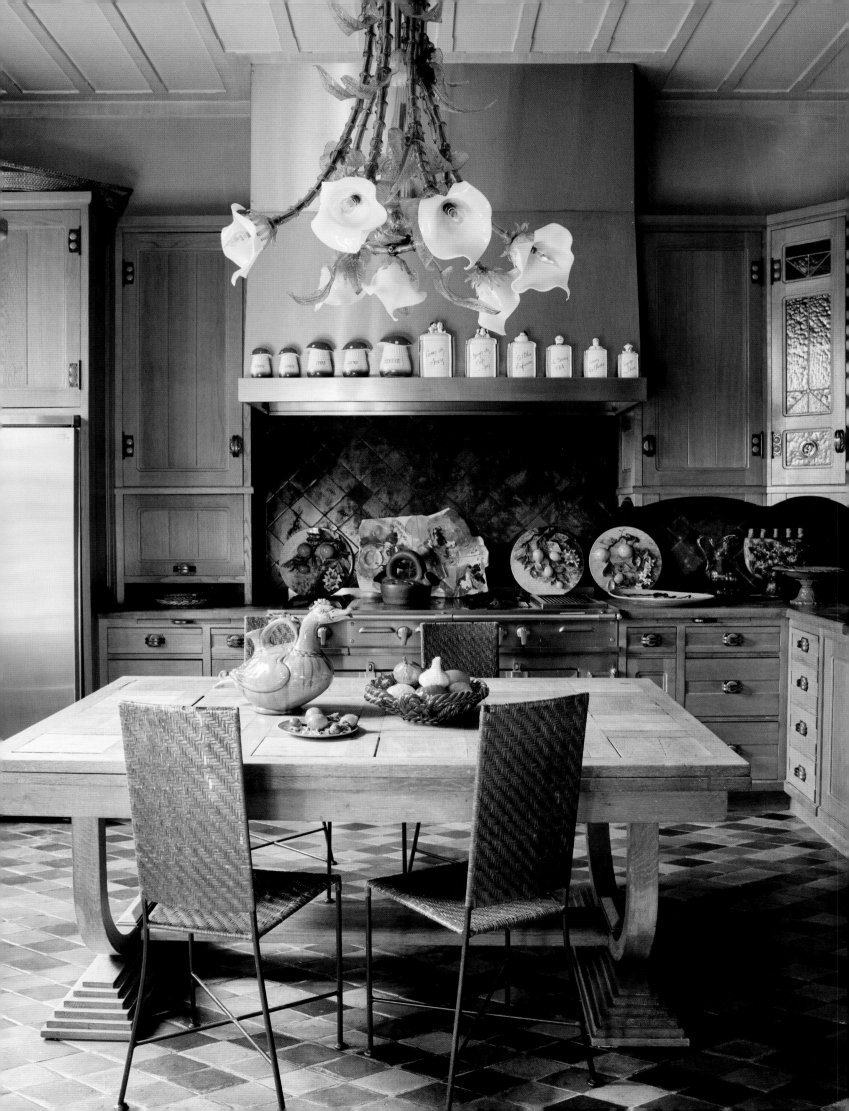

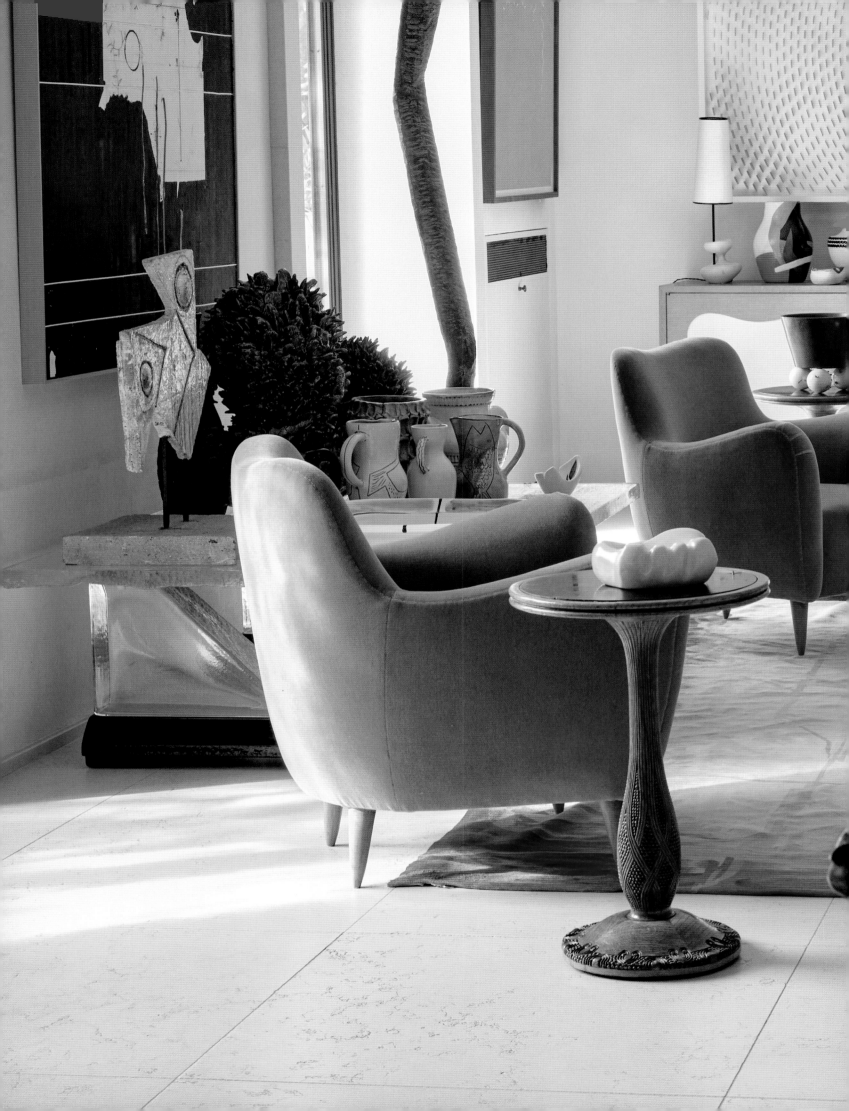

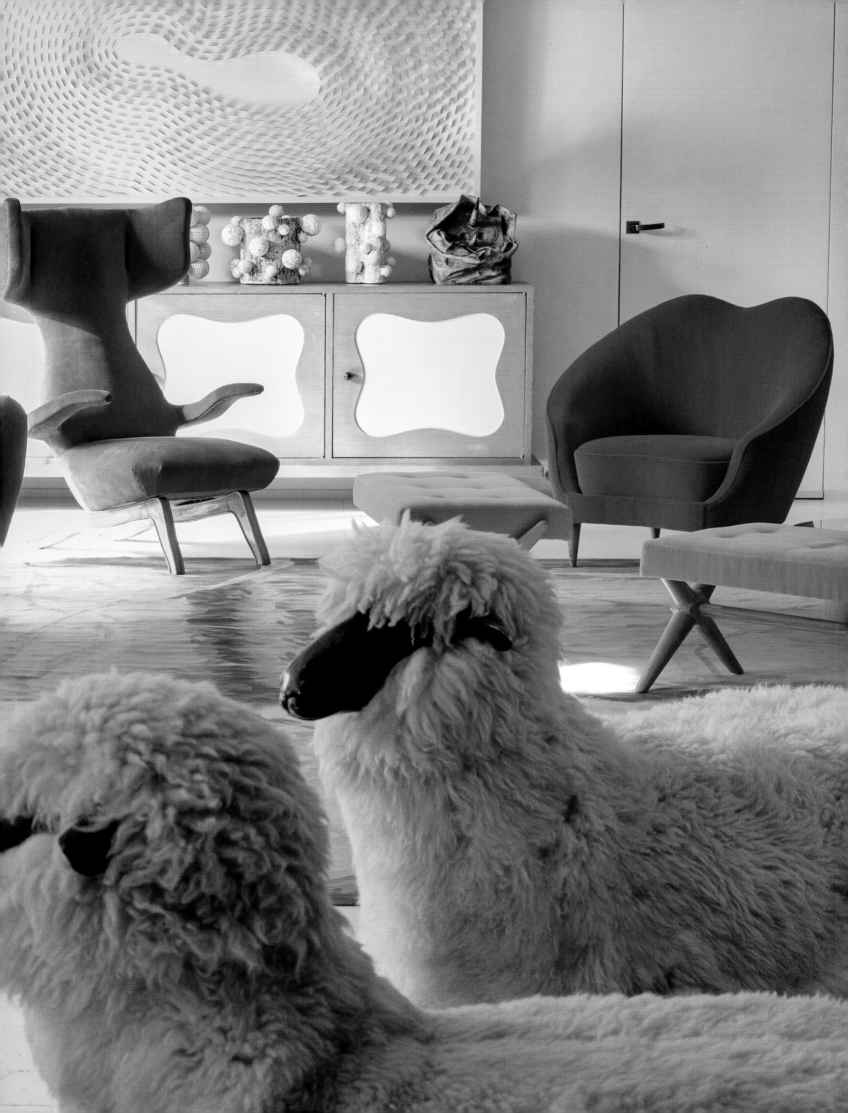

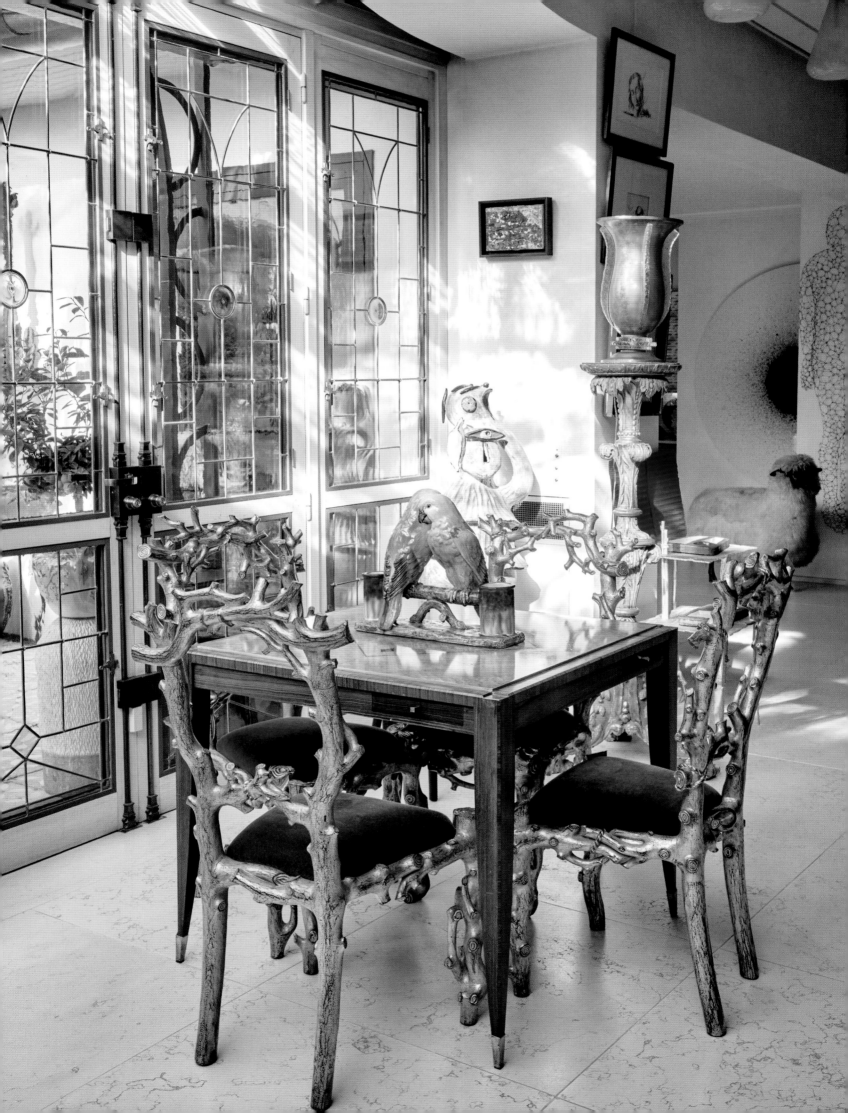

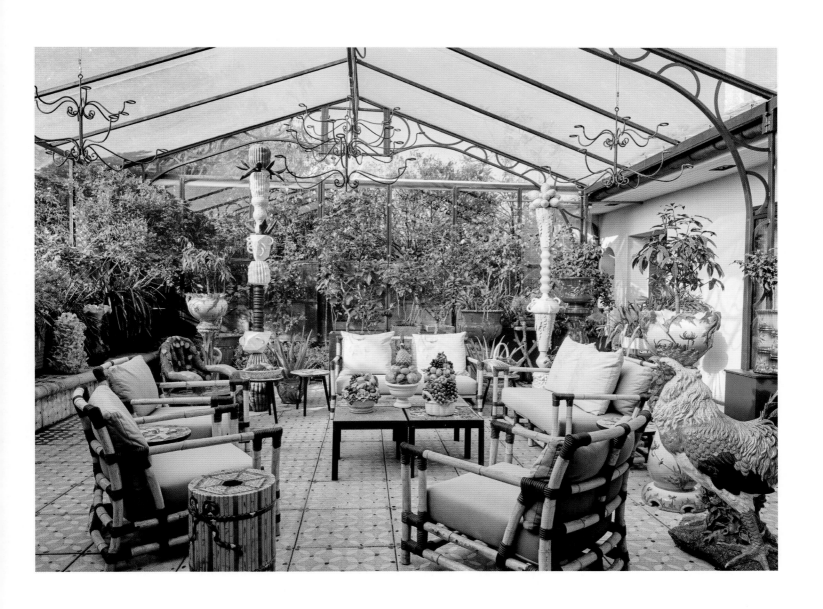

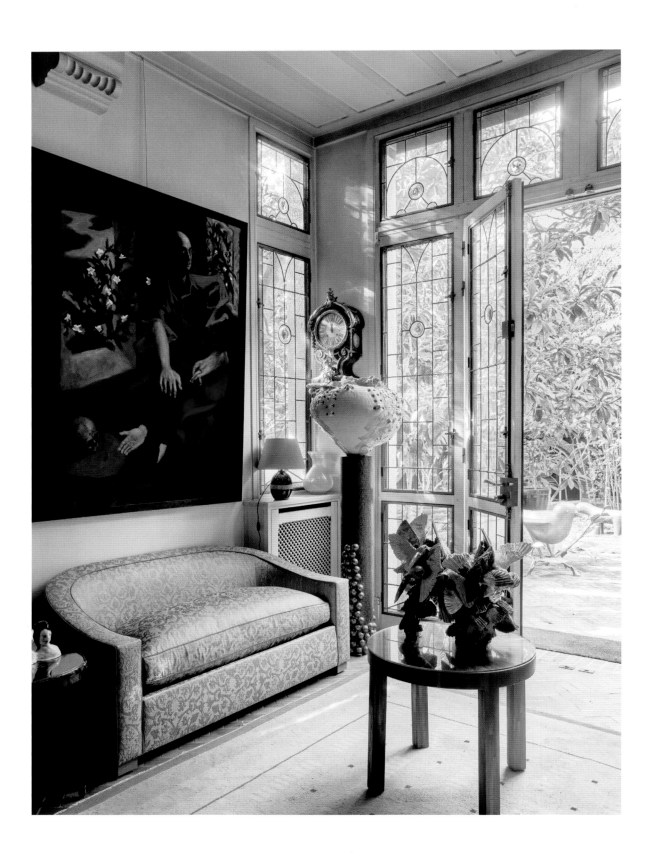

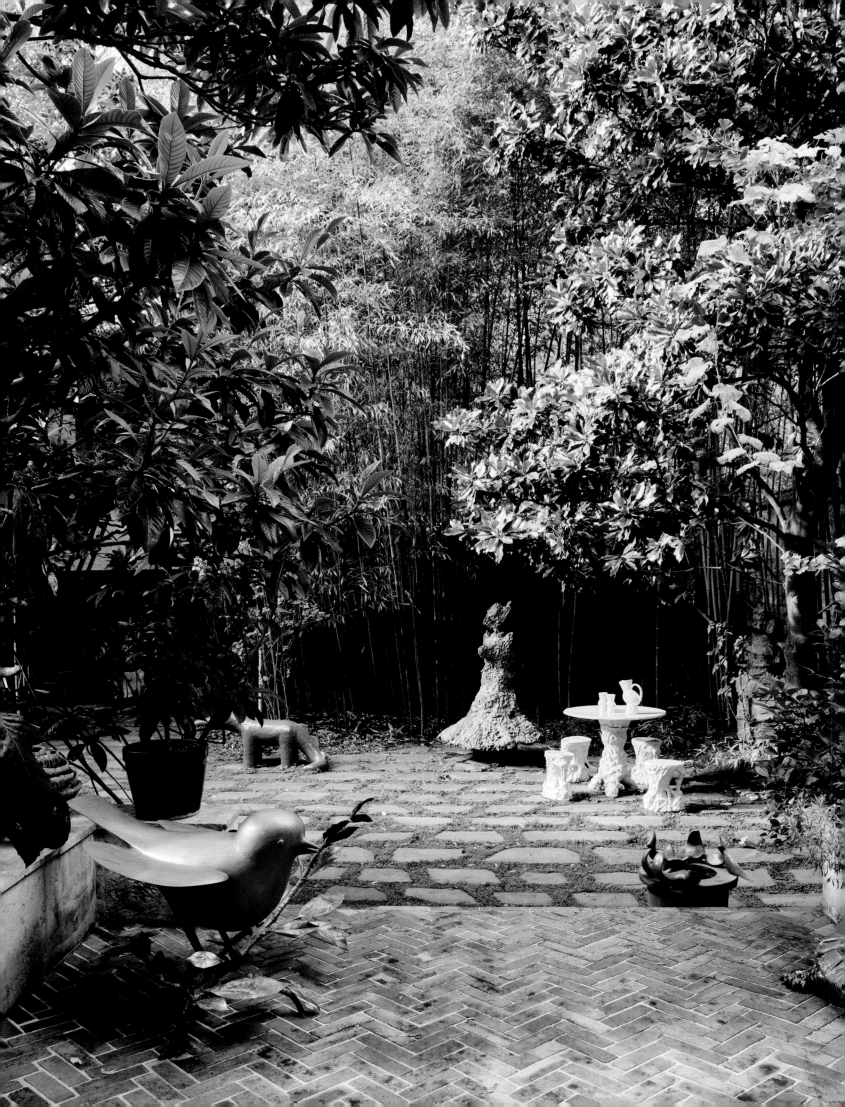

PLAYFUL/ STYLISH/ ECCENTRIC.

GRÉGOIRE MAROT AND THOMAS DU PRÉ DE SAINT MAUR

If Paris is a party, I imagine it in this apartment in the heart of Faubourg Saint-Germain—a sentiment undoubtedly shared by friends and celebrities from around the world. This ground-floor residence with a large garden in an eighteenth-century building has become the home of power couple Grégoire Marot, founder of PR agency Favori, and Thomas du Pré de Saint Maur, a creative director at Chanel. With the assistance of Eric Allart, a close friend, they have created an unexpected and playful atmosphere that breaks with formality—a home designed to receive and entertain, reflecting the extroverted and joyful nature of these great hosts.

Every room in the house has a different vibe, and it's impossible to anticipate what awaits behind the next door. Color gives each room a unique character, from the vibrant pink entrance hall, adorned with lamps by Mattia Bonetti and an extravagant daybed by Vincent Darré, to the cool green of the dining room, enveloped in a dramatic midnight-blue zodiac mural by Darré.

Thomas's studio, dominated by a Bauhaus-style desk in black and chrome, is calm and refined. The living room is an open, white-walled space to relax, surrounded by artworks including a totem by South African artist Cameron Platter and a painting by Venezuelan artist Mariana Bunimov. Large glass doors smoothly incorporate the garden into the ambiance. In the bedroom, another mural—this time by Belgian artist Sophie Whettnall, a friend of the couple from their vacations in Patmos—brings restful blue tones inspired by the Greek island.

The kitchen and an informal dining area are in a basement that can also be accessed by a staircase from the building's courtyard. With original dark stone walls and wooden beams, this is a serene and family-oriented space, away from the hustle and bustle of social life.

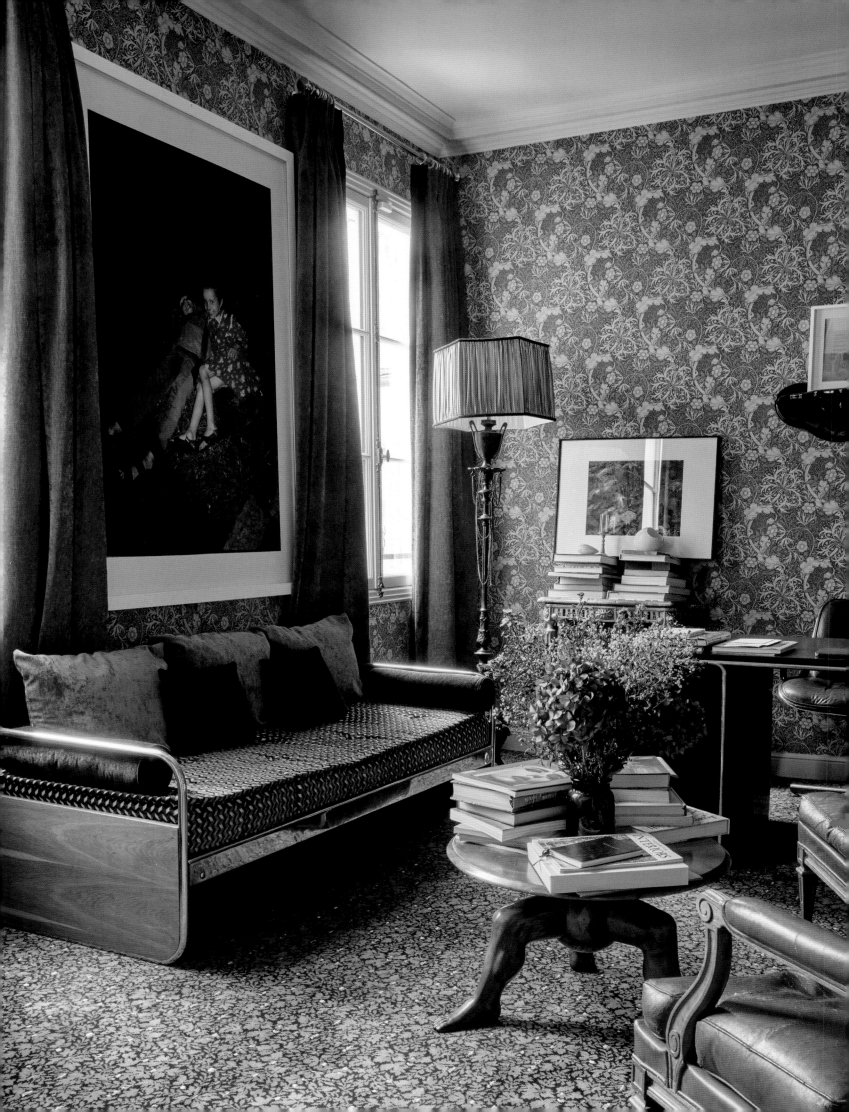

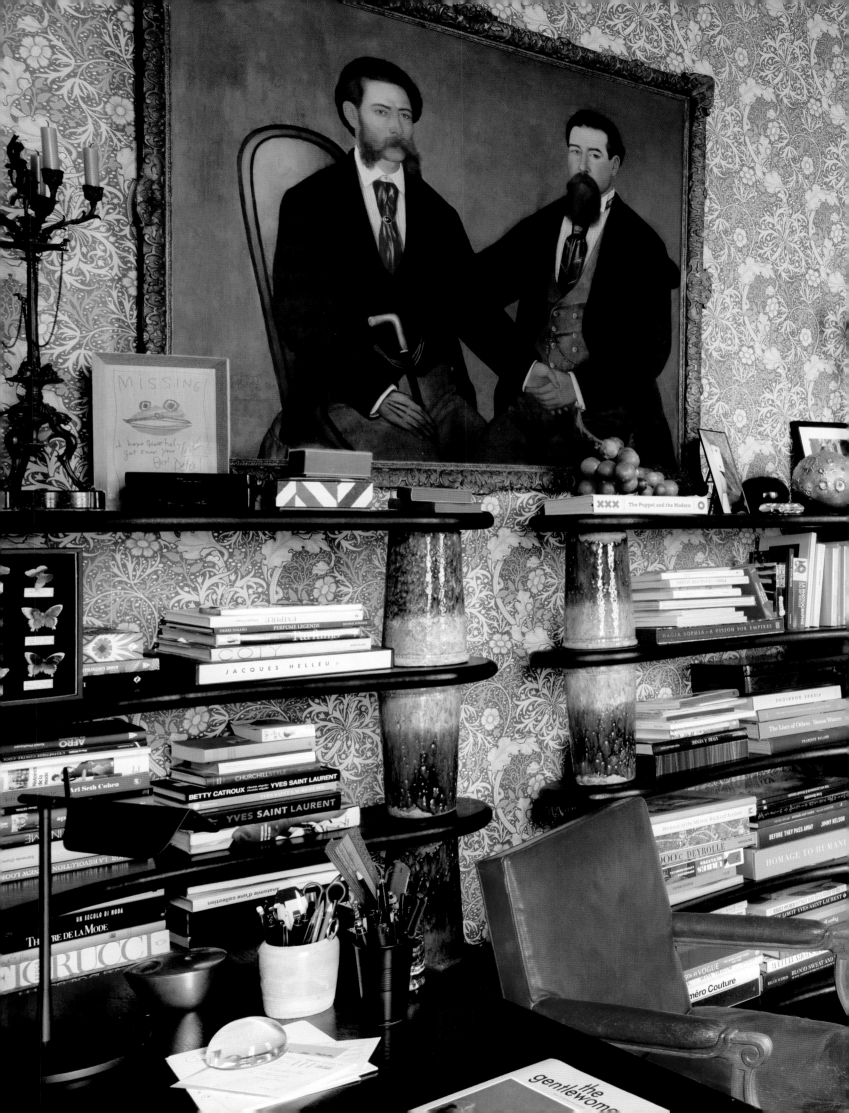

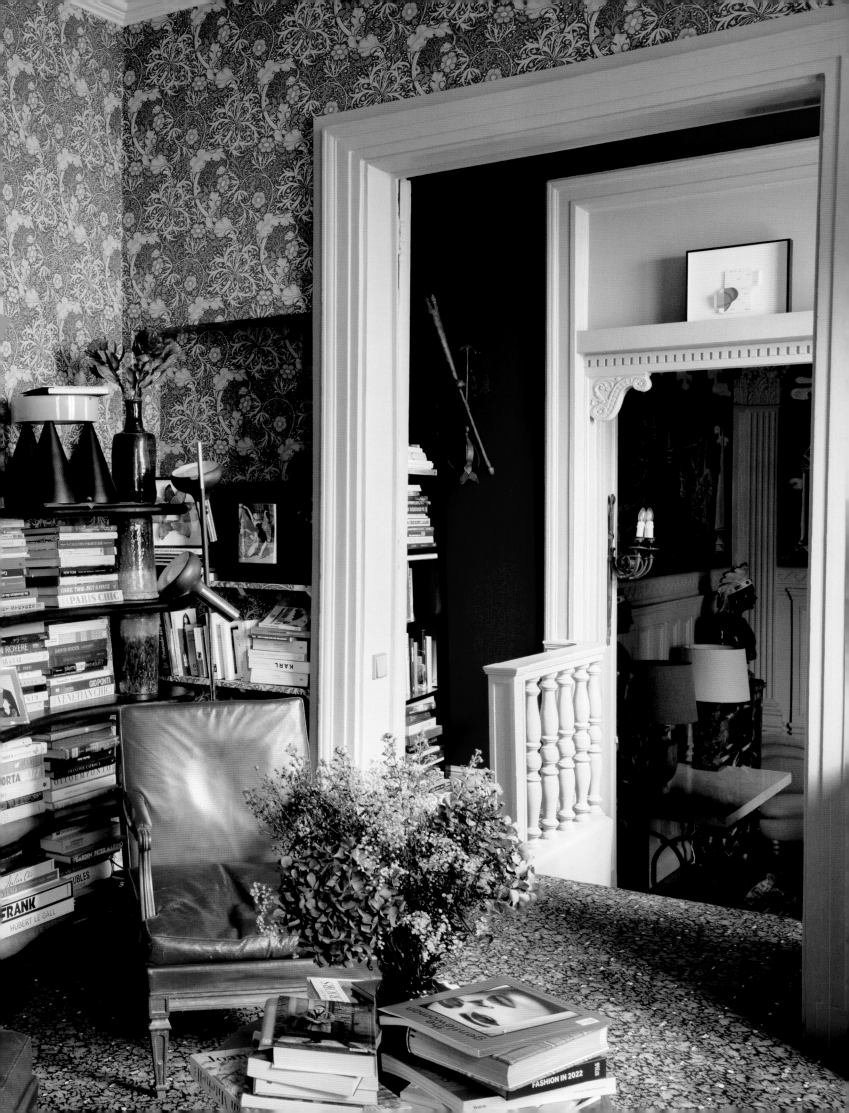

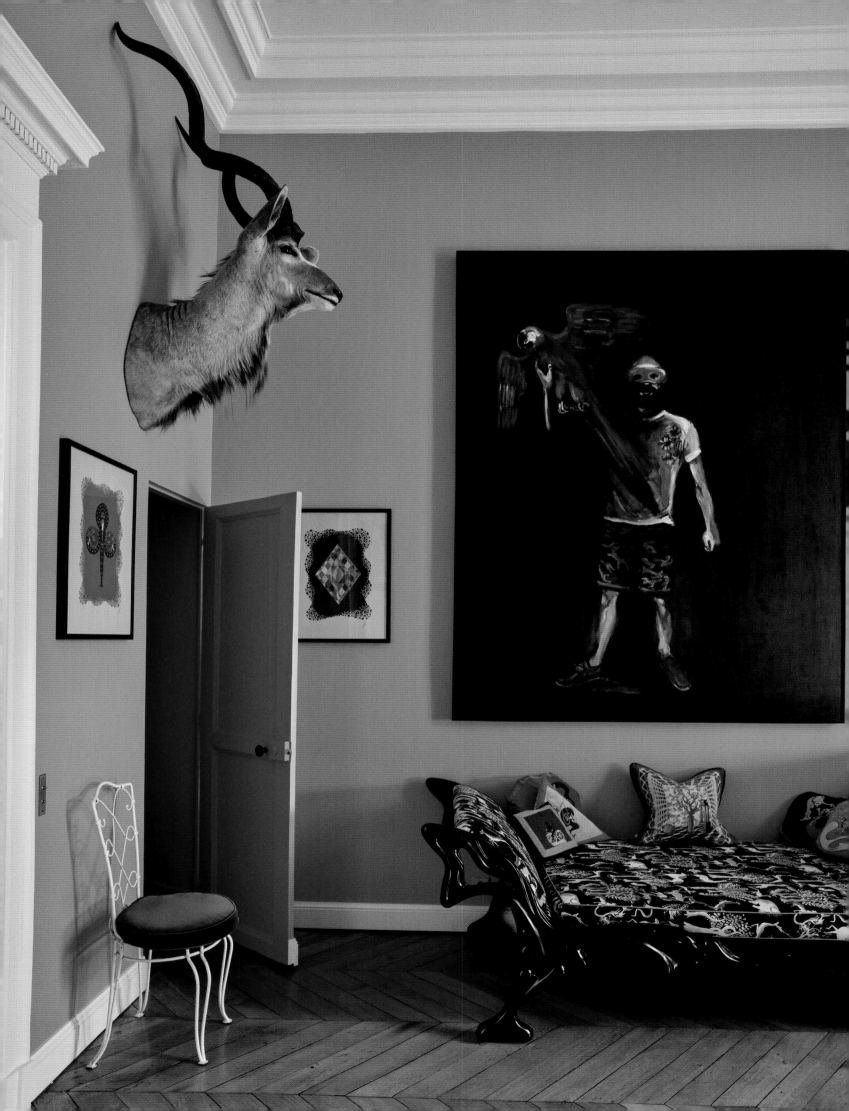

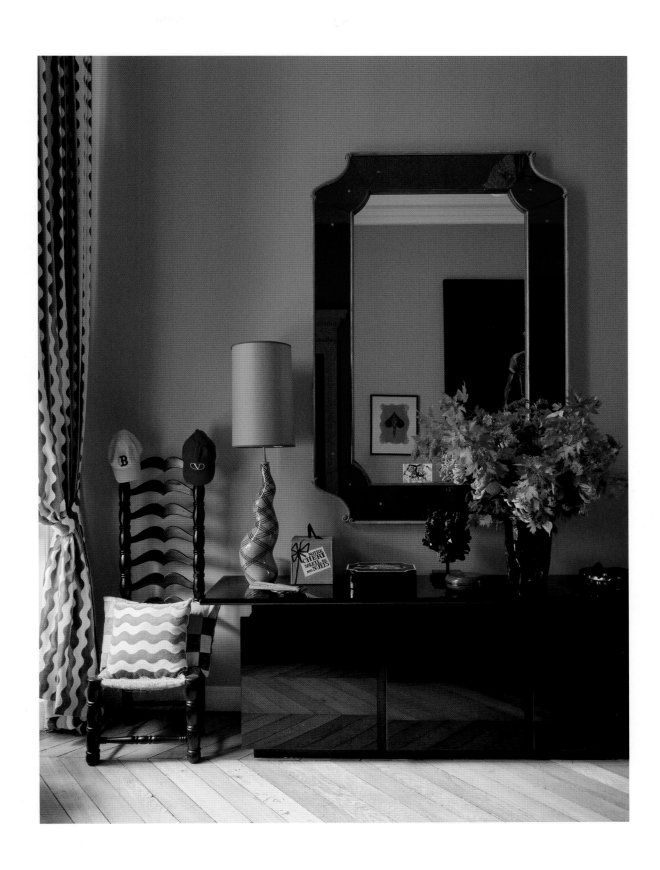

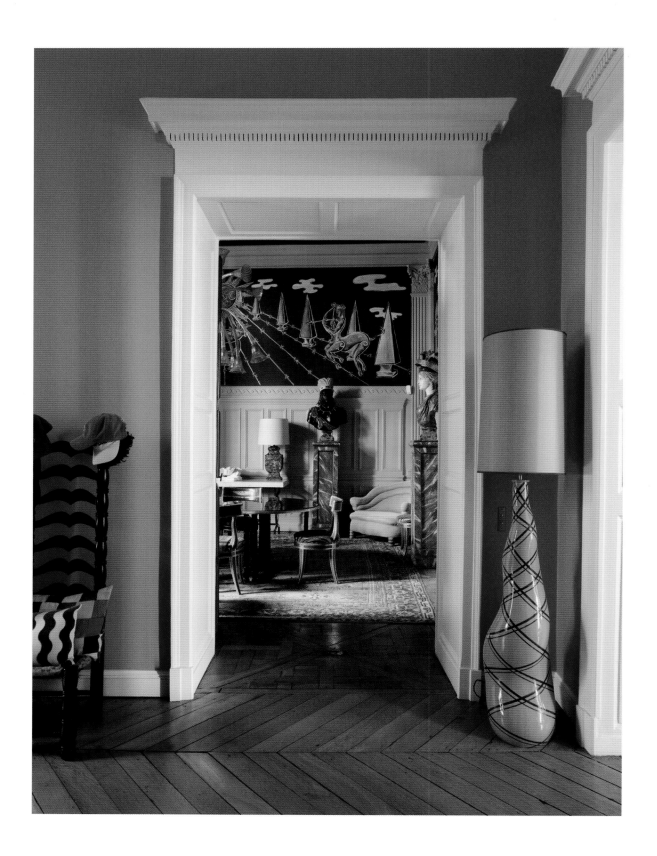

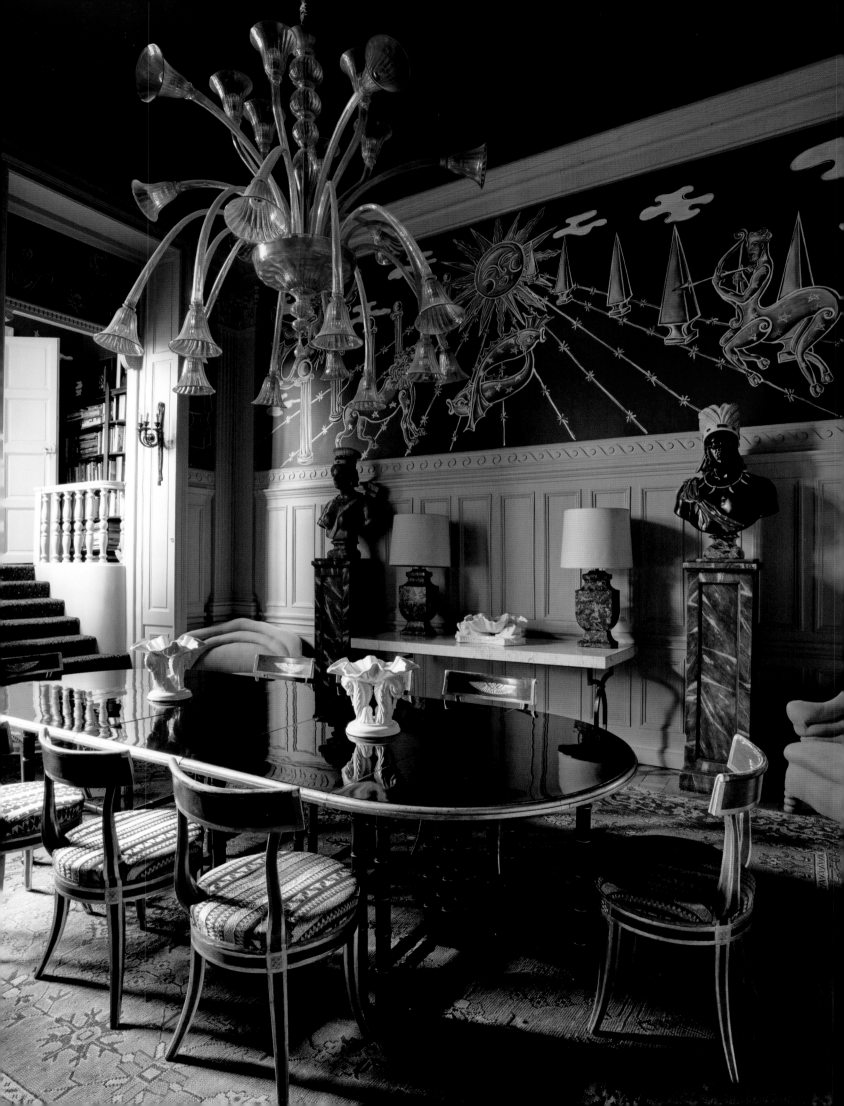

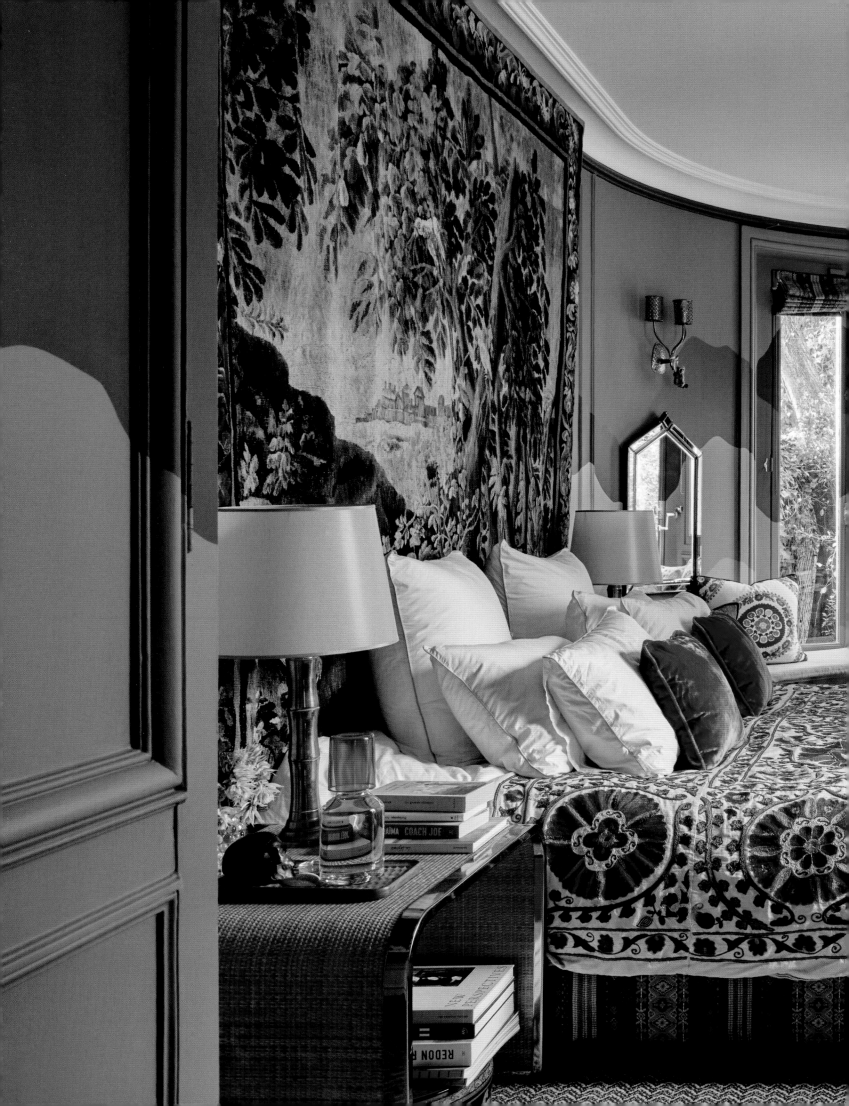

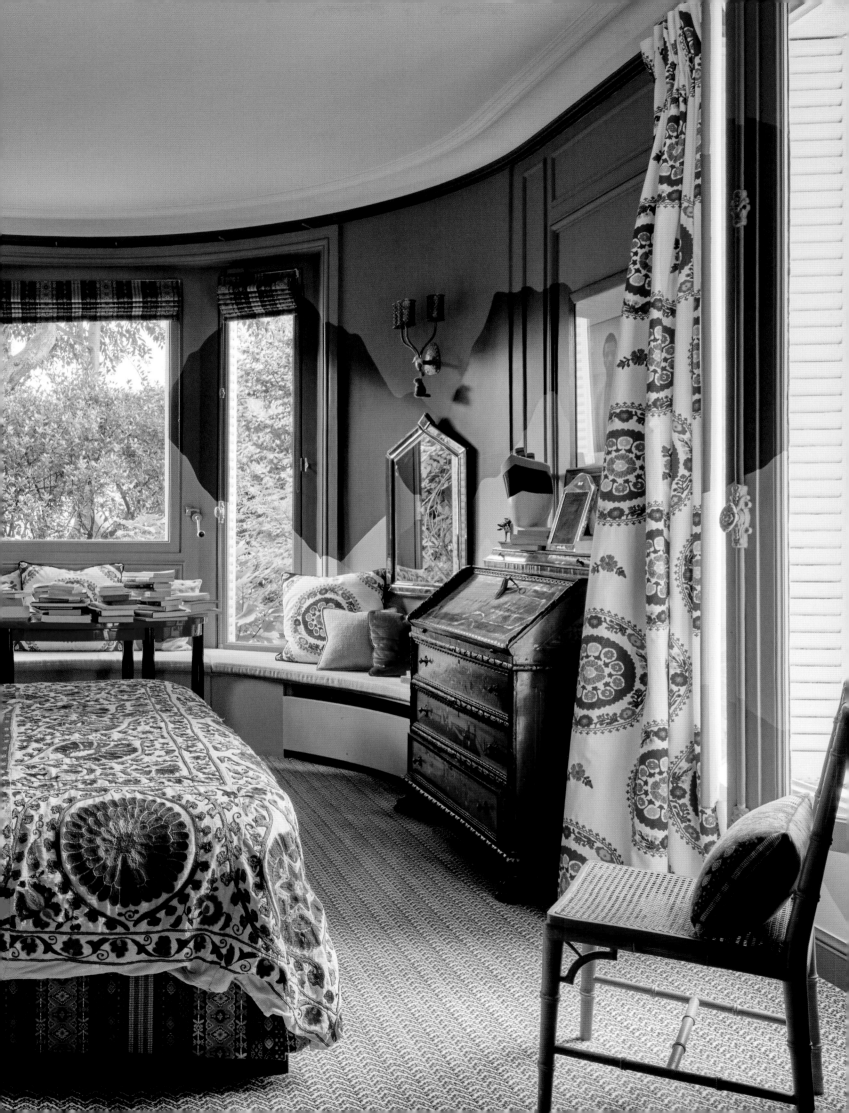

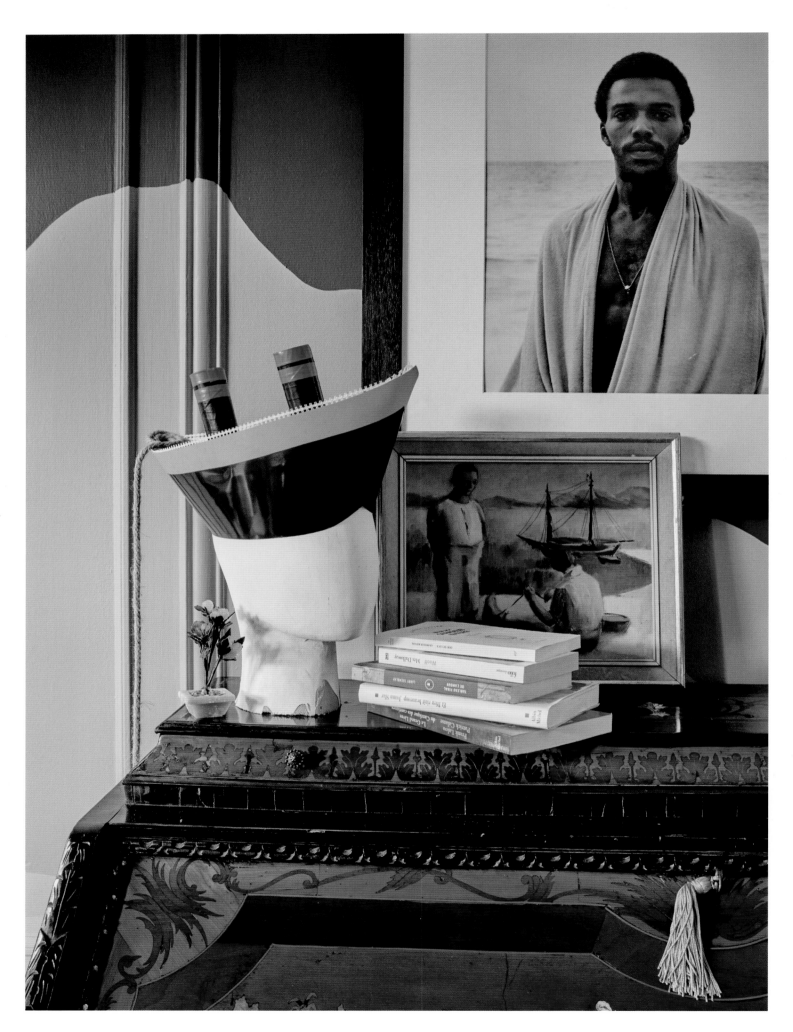

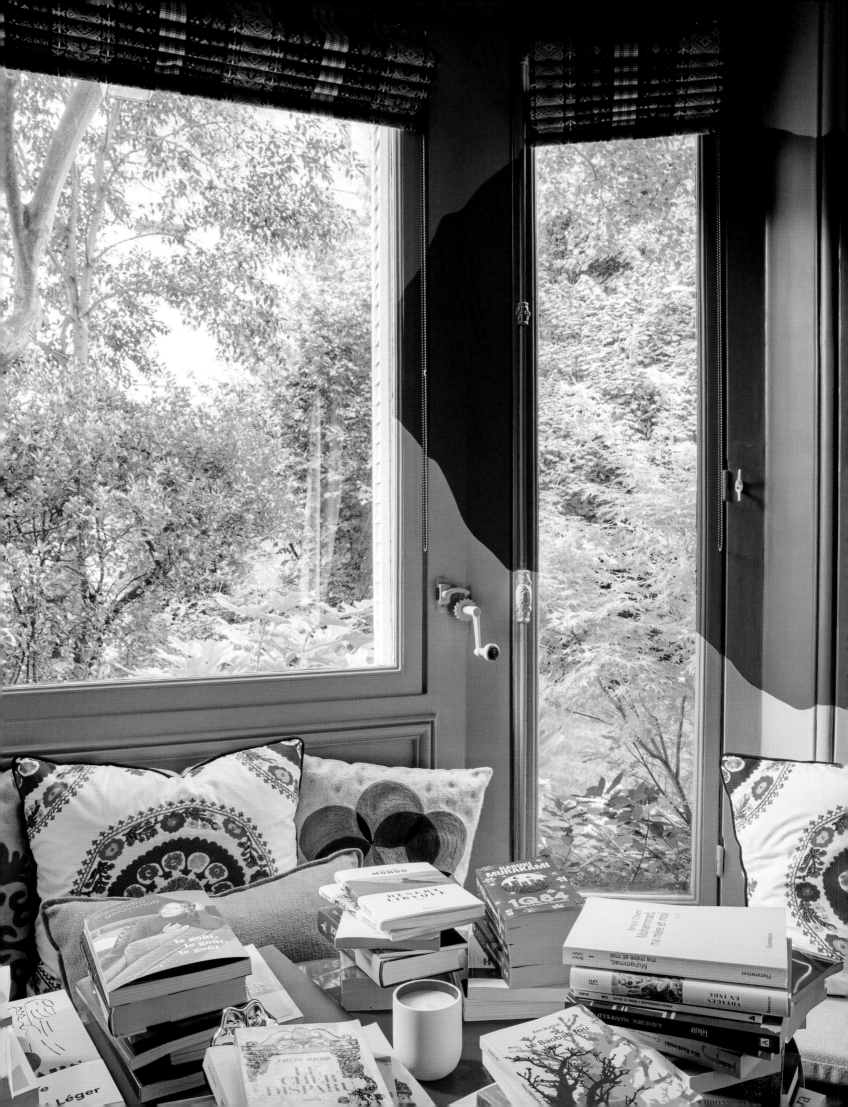

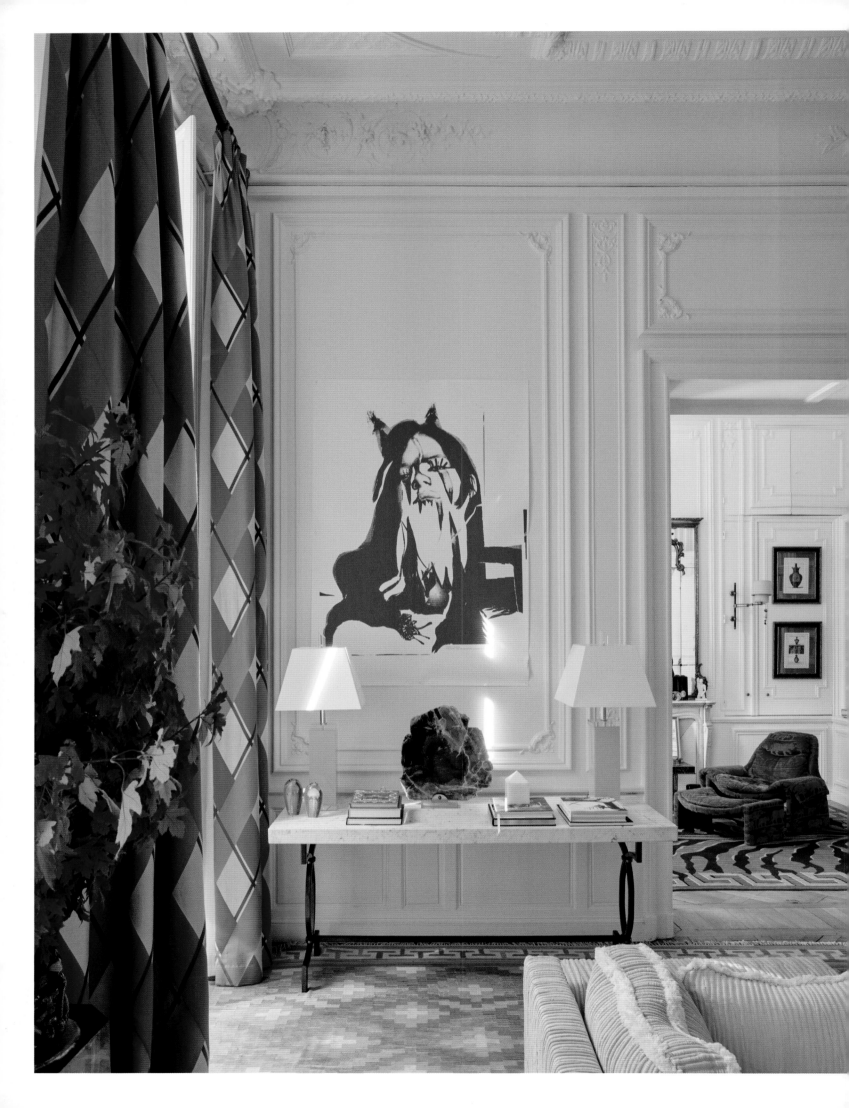

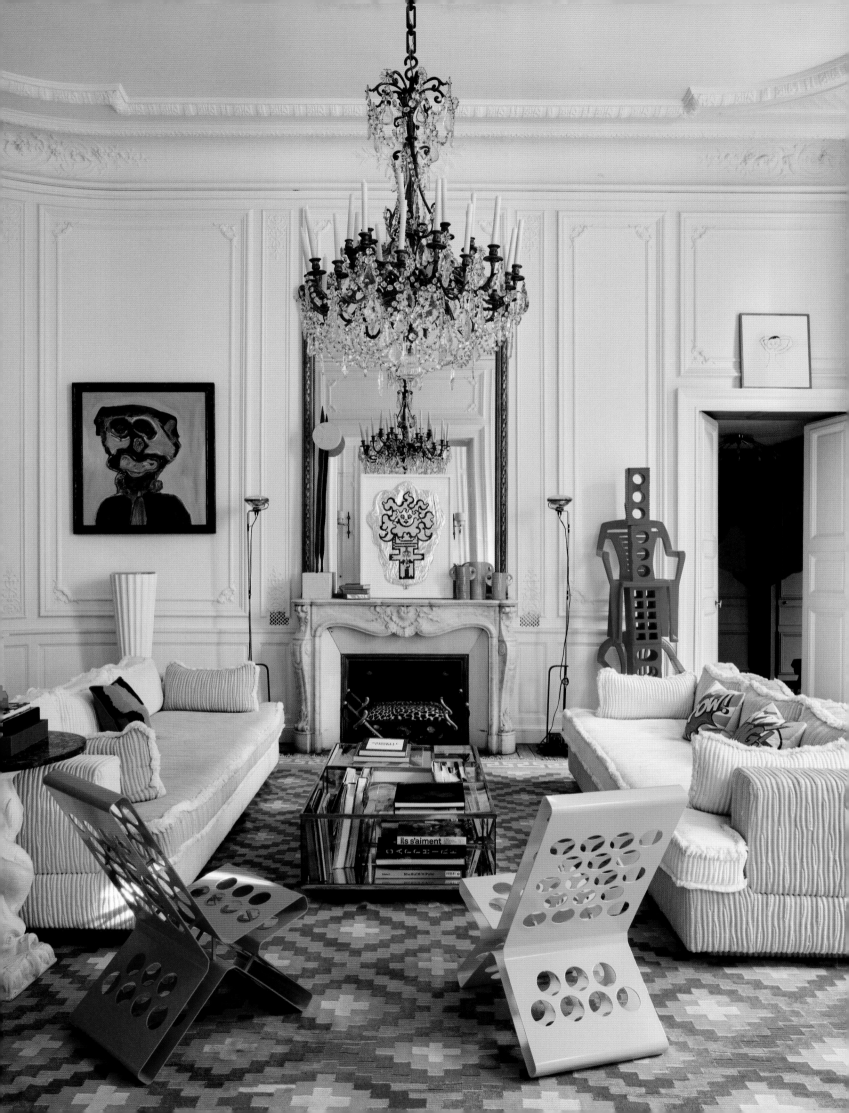

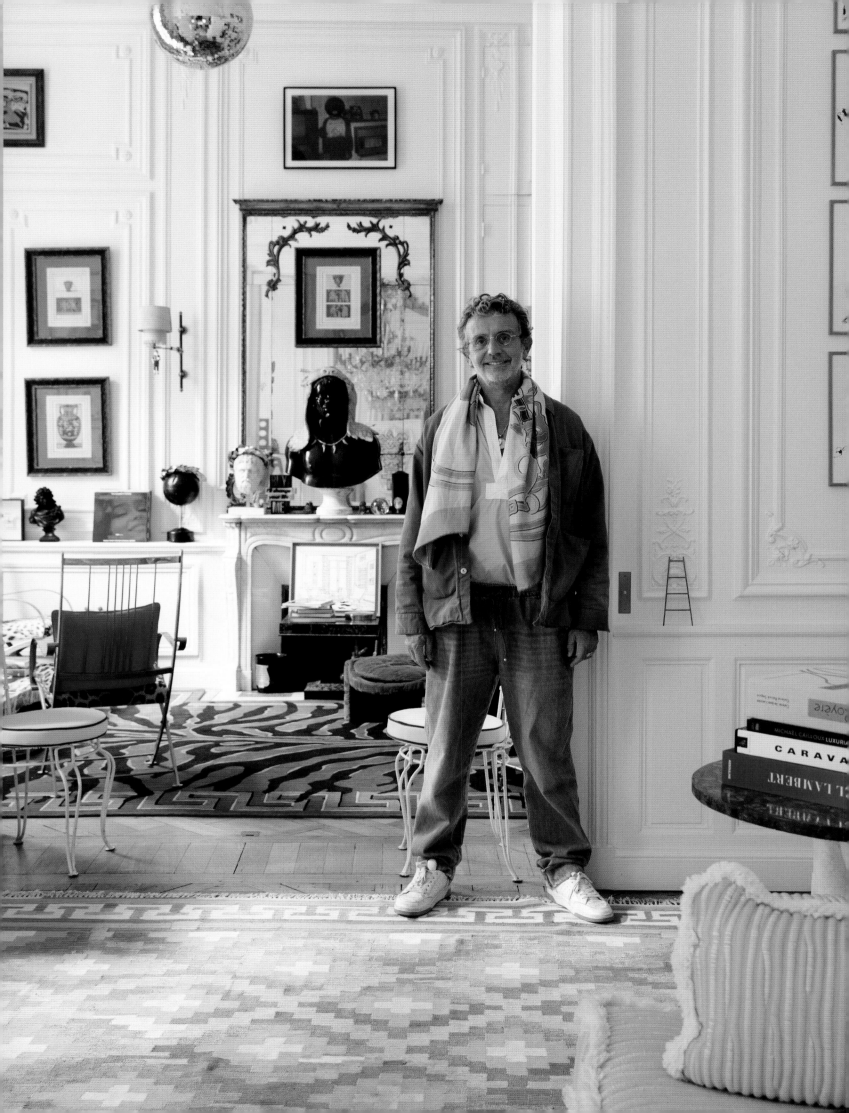

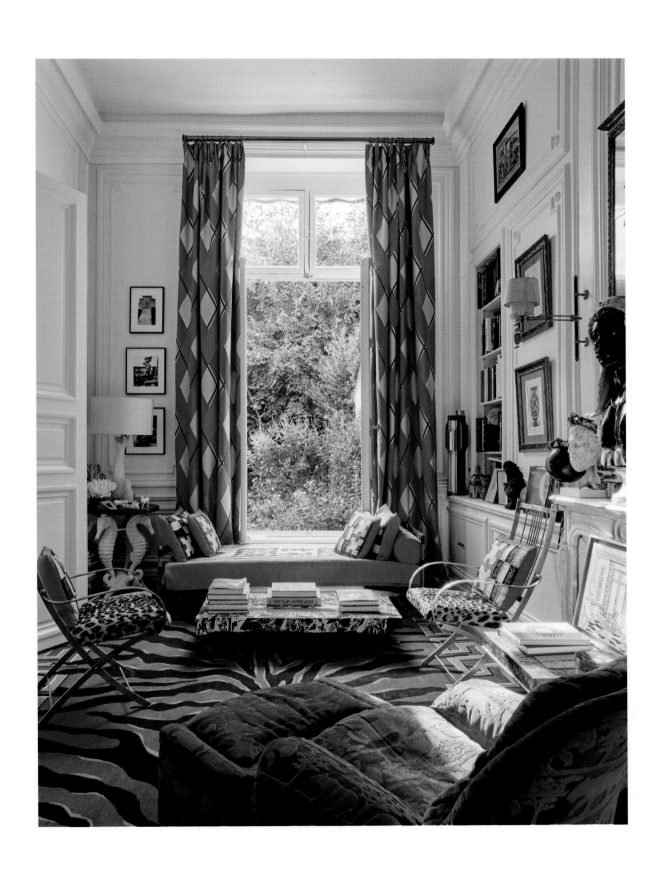

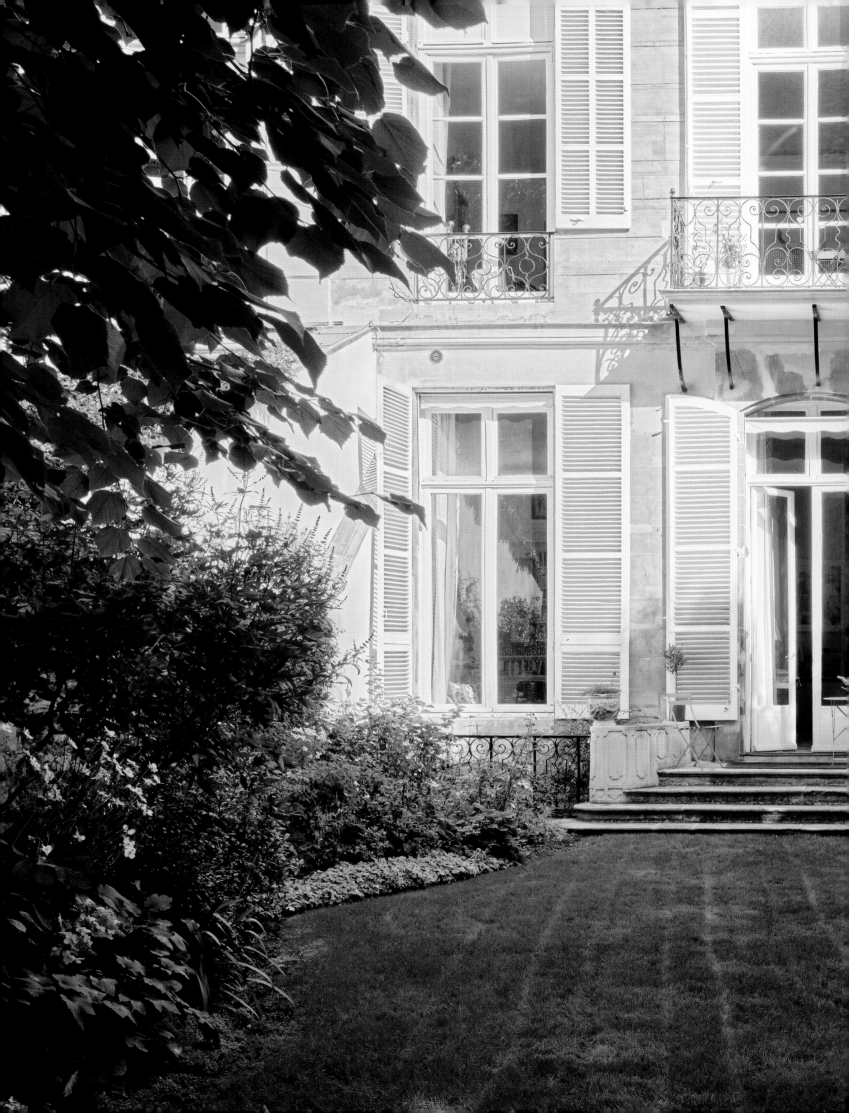

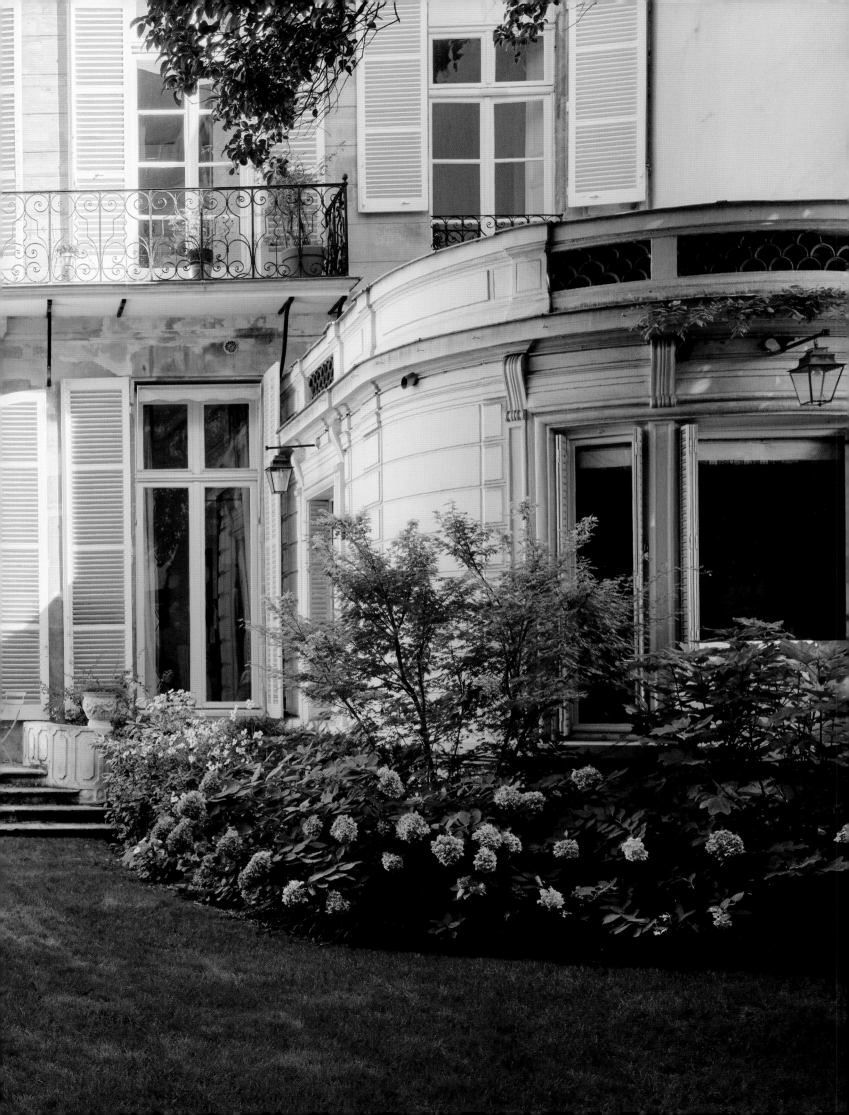

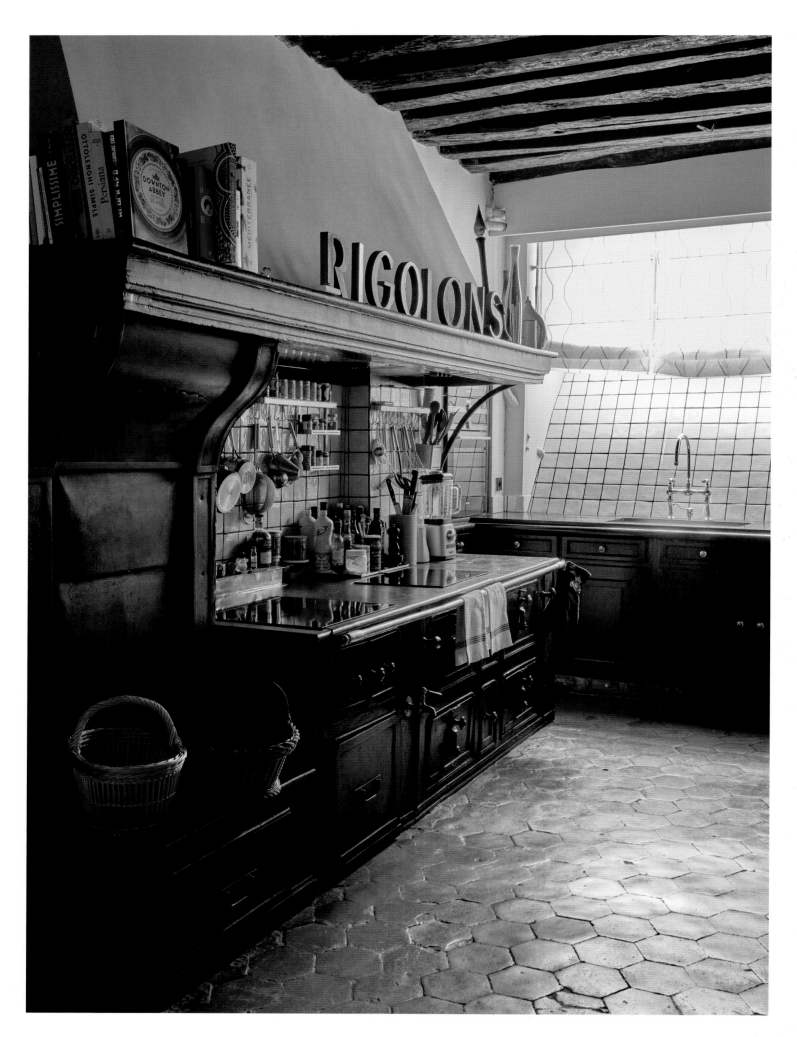

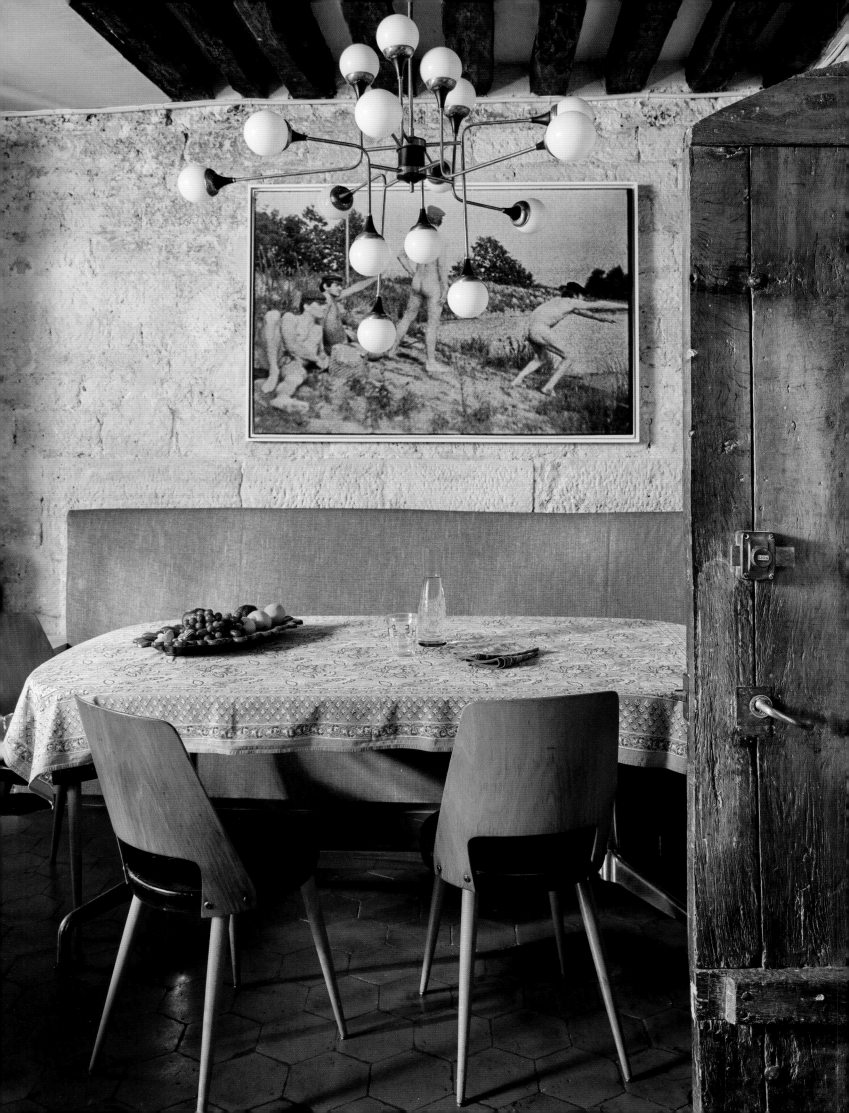

SERENE/ MODERN/ PERSONAL.

FELIPE OLIVEIRA BAPTISTA

I have heard it said many times that couples should not work together. However, Felipe and Séverine Oliveira Baptista are the exception that proves the rule. Since they met, they have done nothing but combine energies to ensure the success of all their creative projects. And they have indeed succeeded, both during Felipe's time at the helm of Lacoste and Kenzo and during their years working side by side at their own brand: Felipe Oliveira Baptista.

Felipe may rule in the fashion world, but when it comes to interior design, Séverine assures me that it's the other way around. She proposes the concepts and leads the projects, but as in their fashion work they exchange opinions and challenge each other to express the best of themselves in this field as well. Séverine and Felipe infused their personalities into this house. Despite their lives unfolding in environments of great exposure and demand, their lifestyle is far removed from current trends and modes, just like these spaces where a sense of serene energy prevails through colors and objects from different eras and styles.

When I ask Séverine about some of her favorite objects, she mentions Edgar, the pink flamingo from Deyrolle, the Wolfgang Tillmans photo in the dining room, and the suspended desk by George Nelson in the entrance hall, a wedding gift. The Mario Bellini sofas in the living room are an open invitation to comfort, and Felipe's drawings add a unique and personal touch.

Direct views to Sacré-Coeur and Saint-Georges seem to echo the expansiveness of Felipe and Séverine's ambitions. Now they are ready for a new challenge, this time in Lisbon, where they have already begun working on a new home: "A return home for this Azorean who carries Paris in his heart."

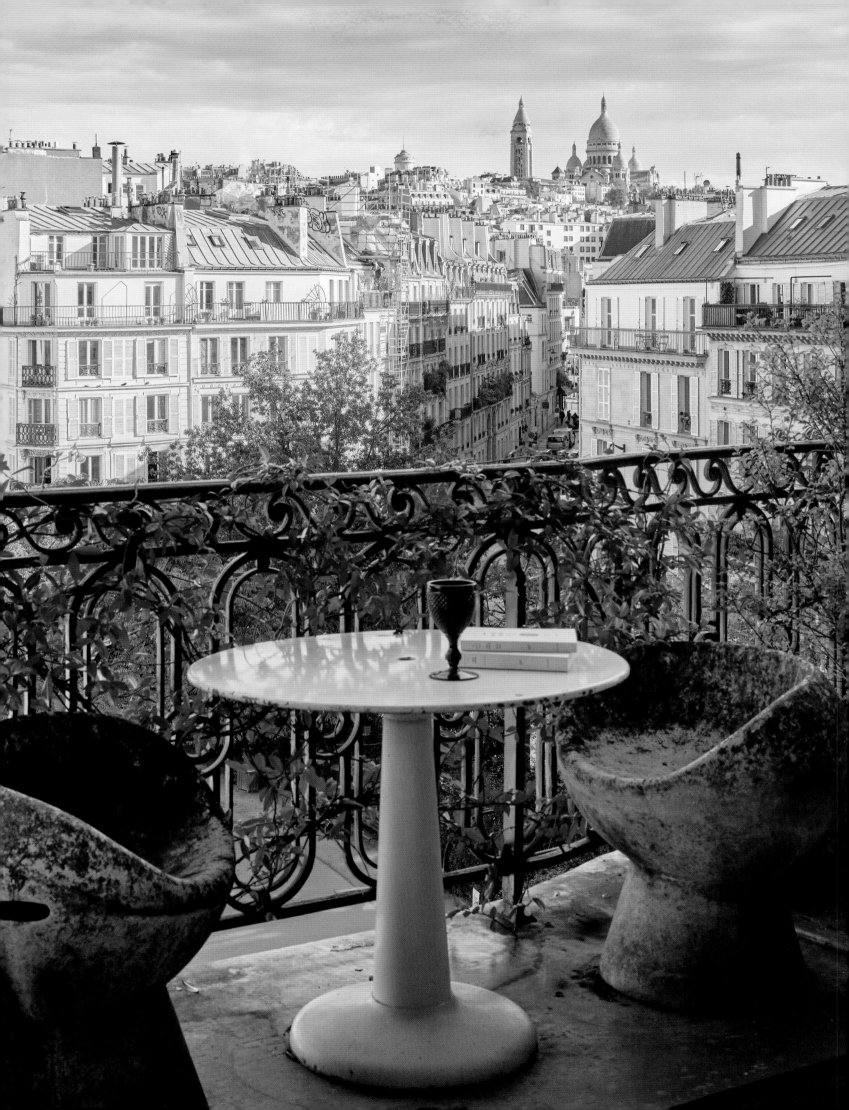

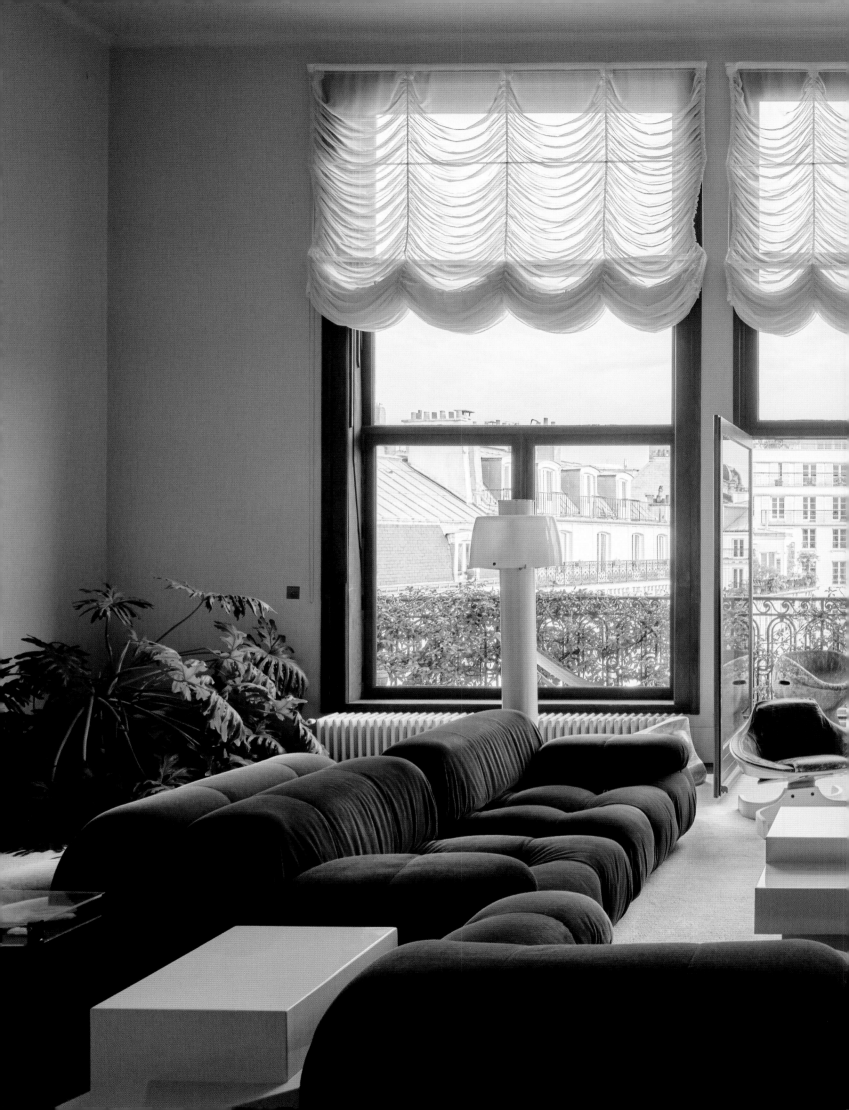

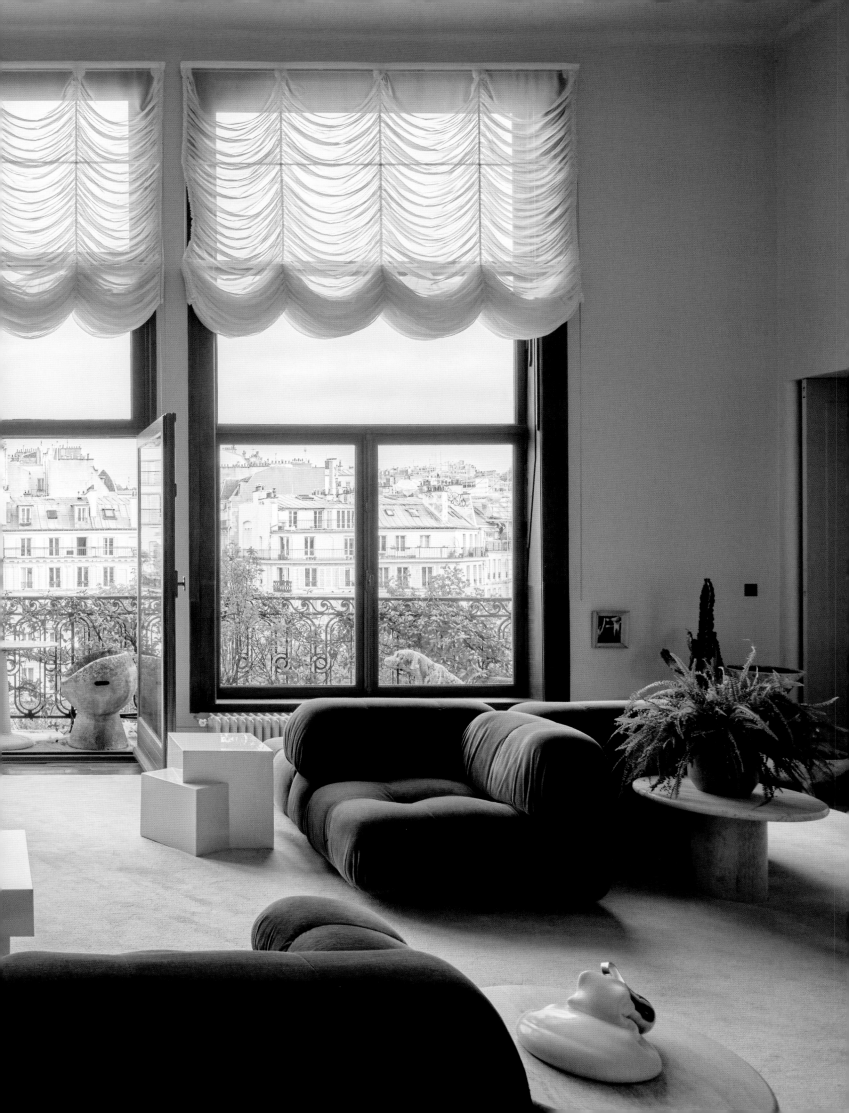

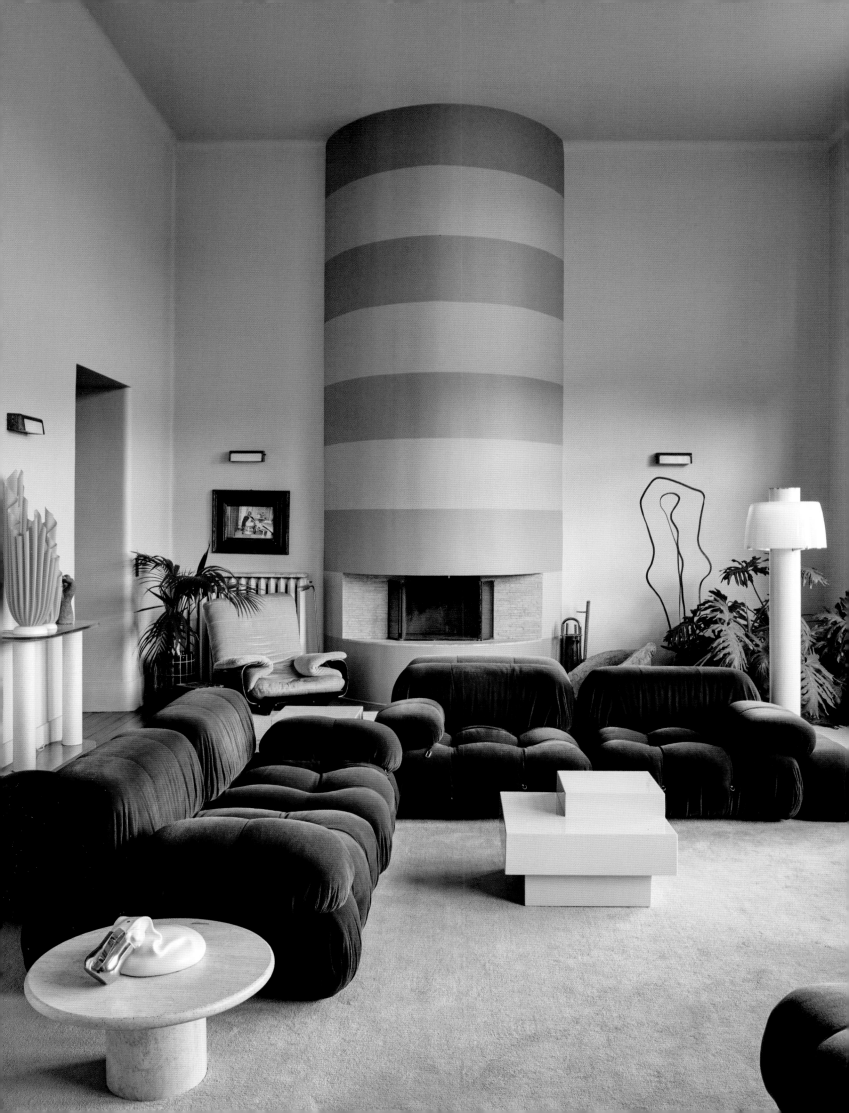

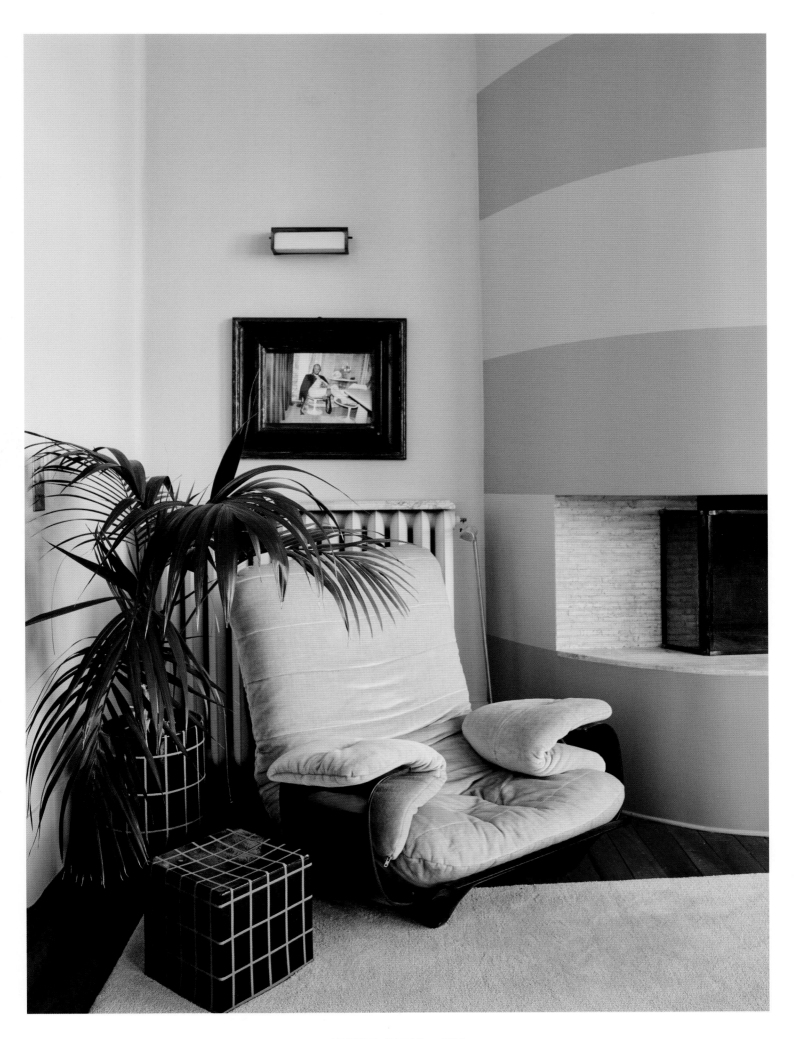

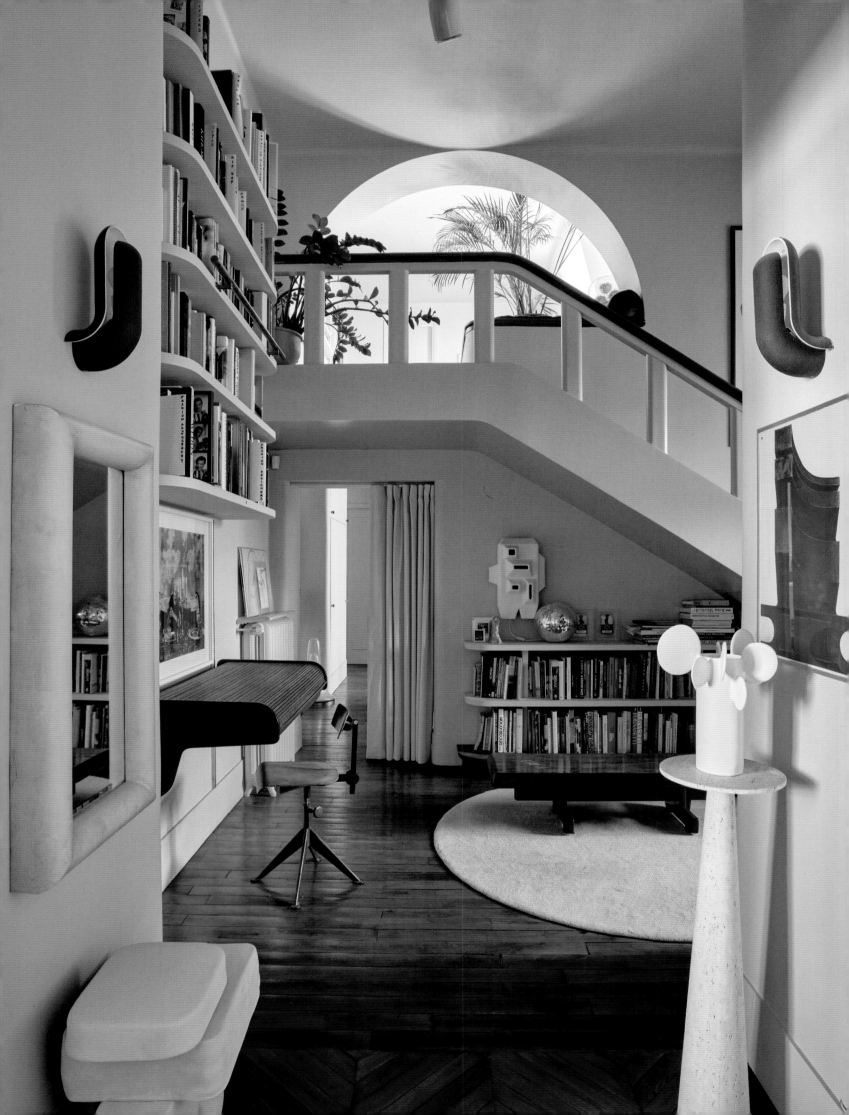

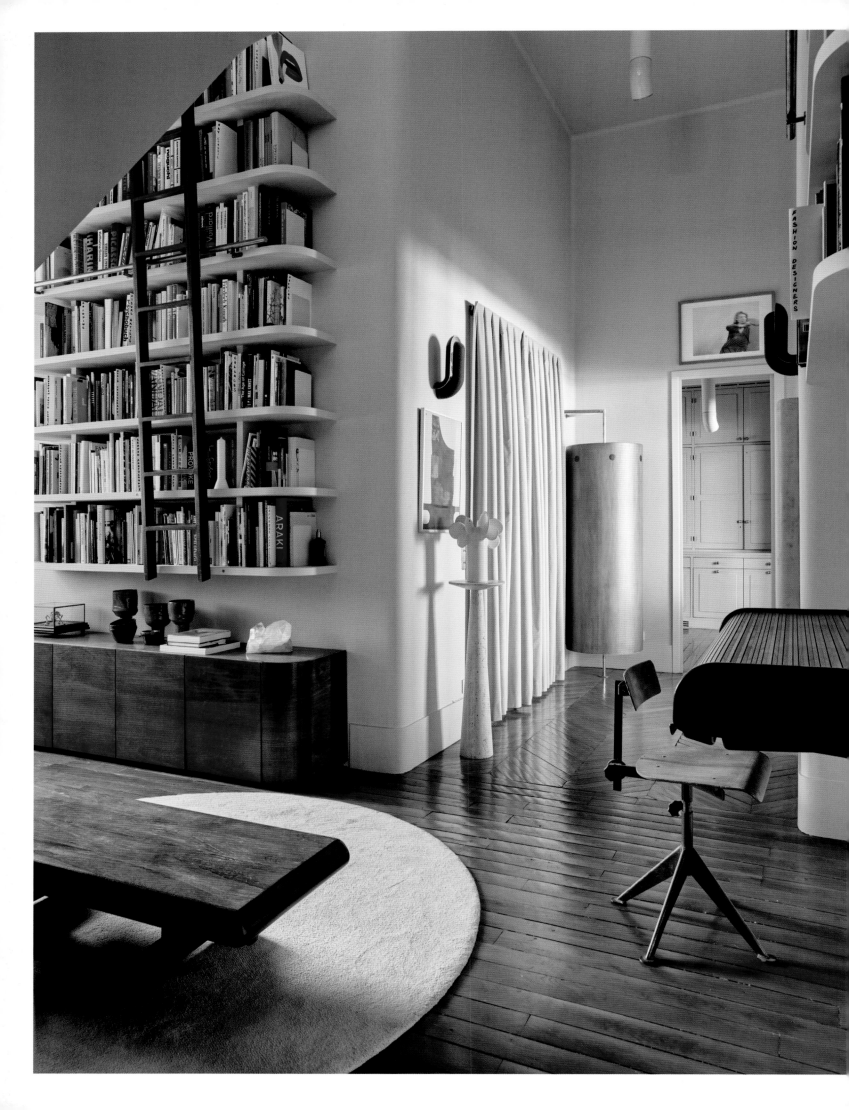

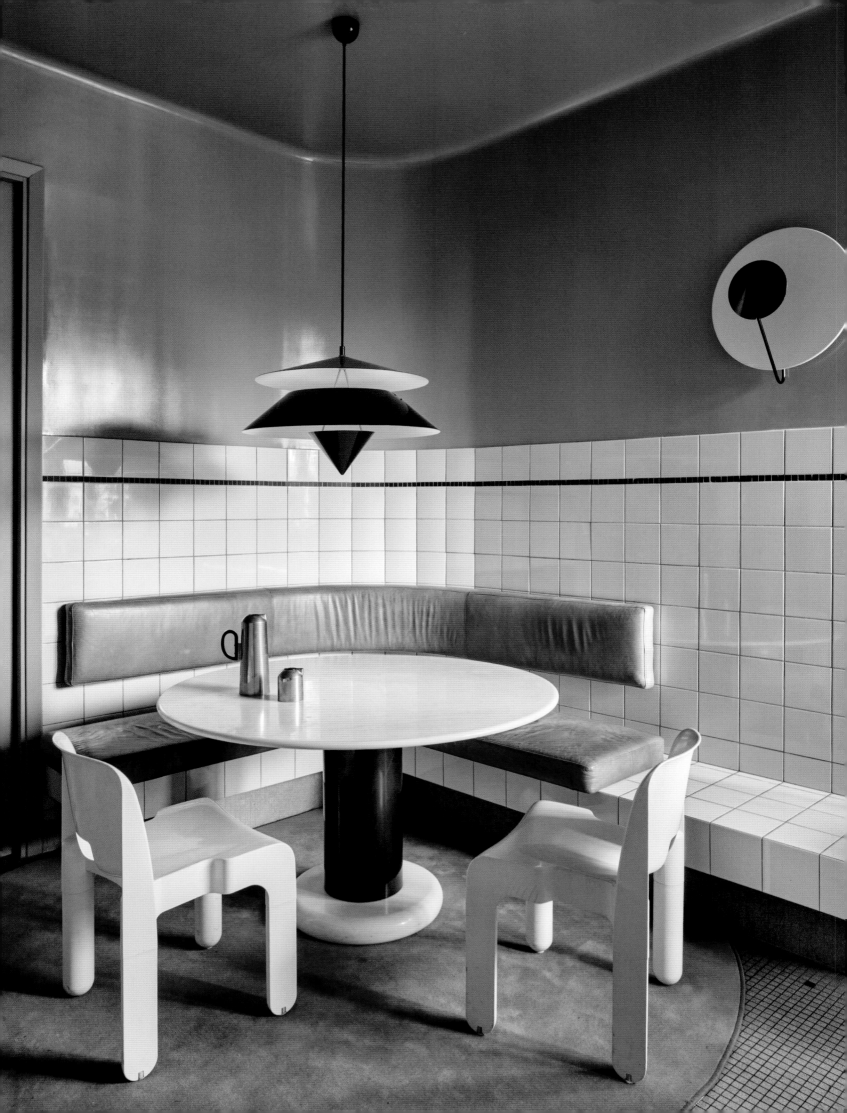

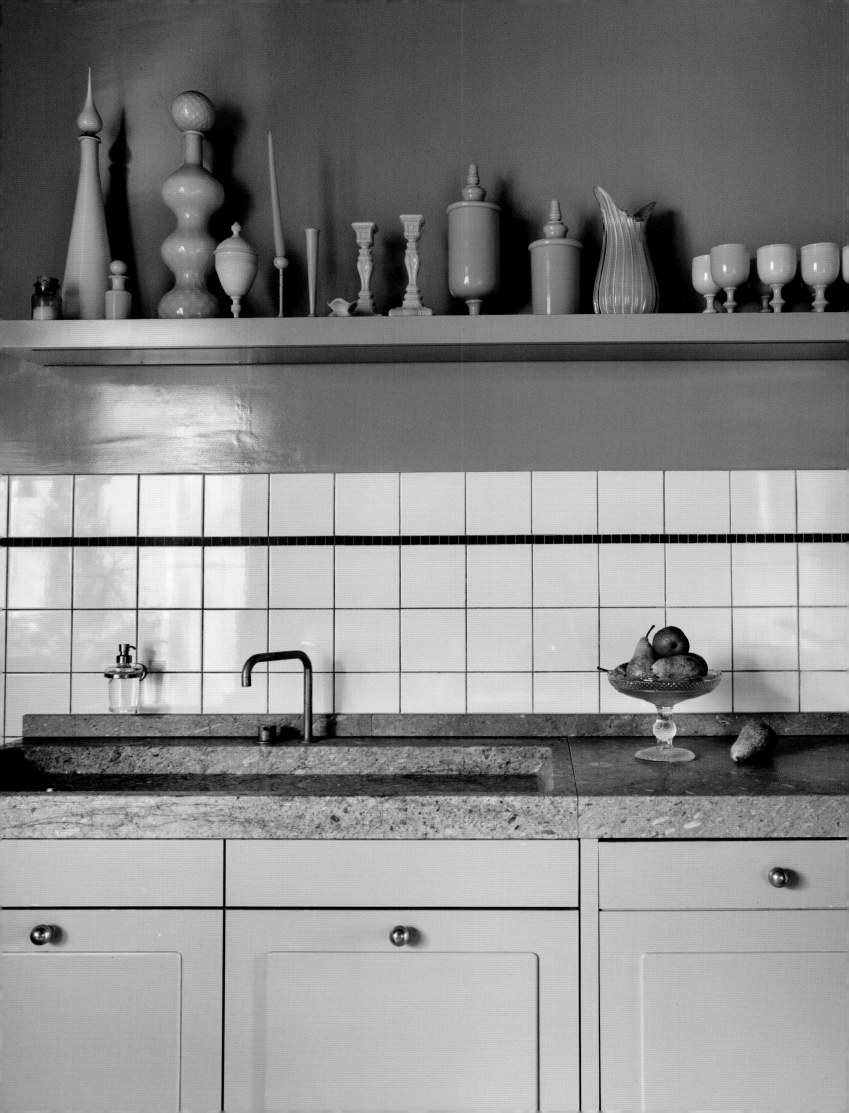

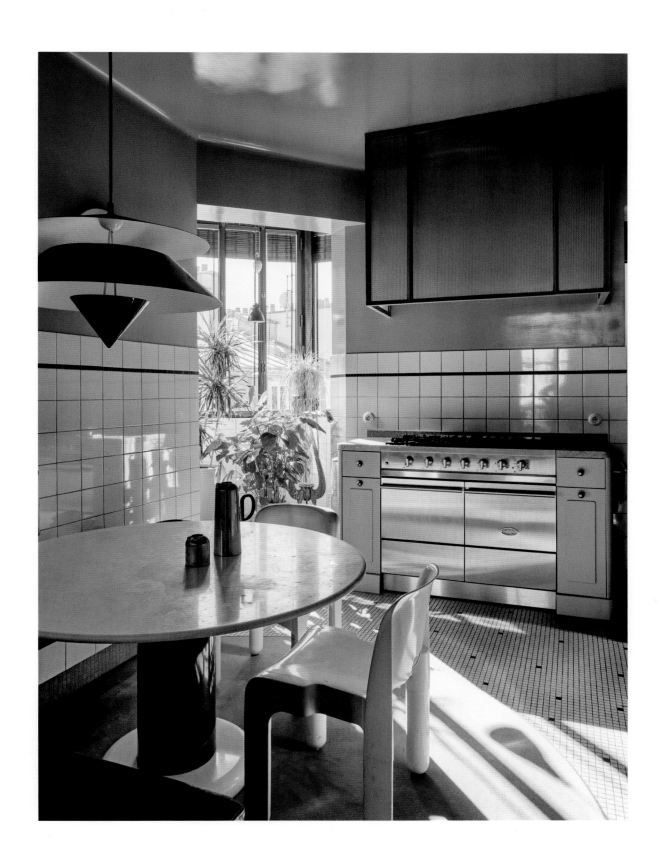

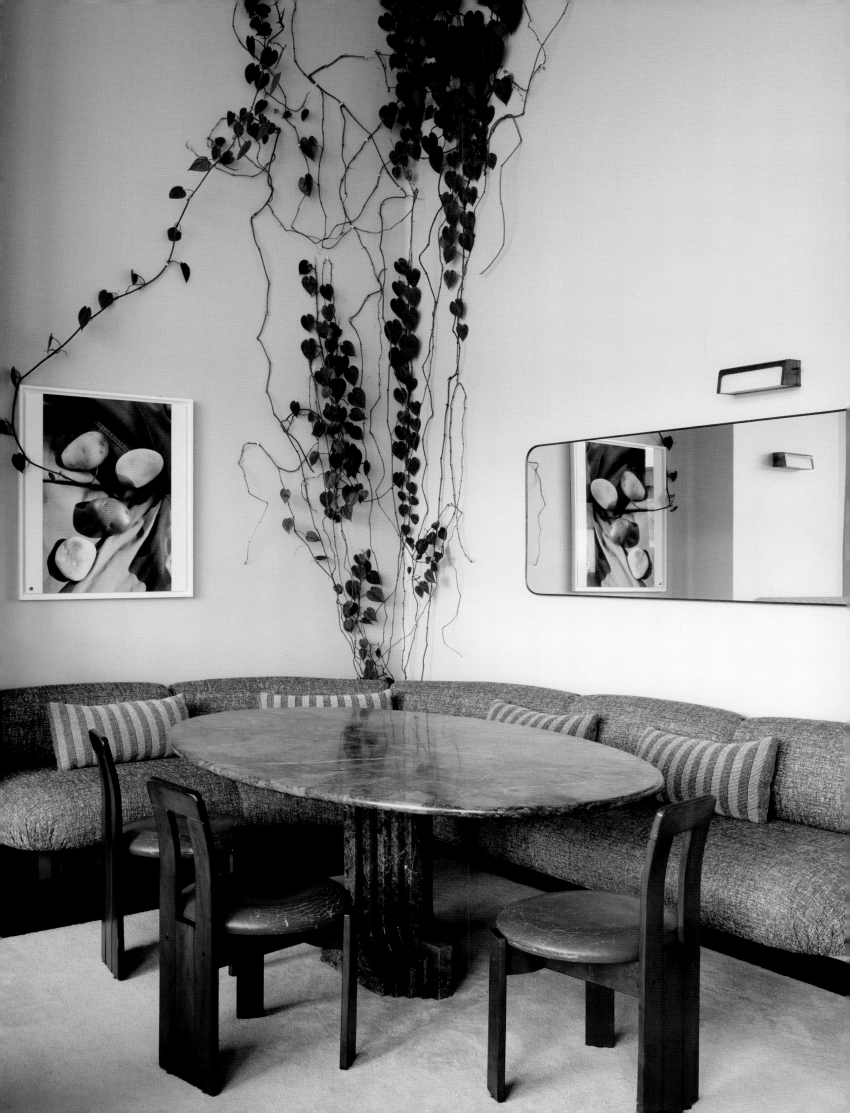

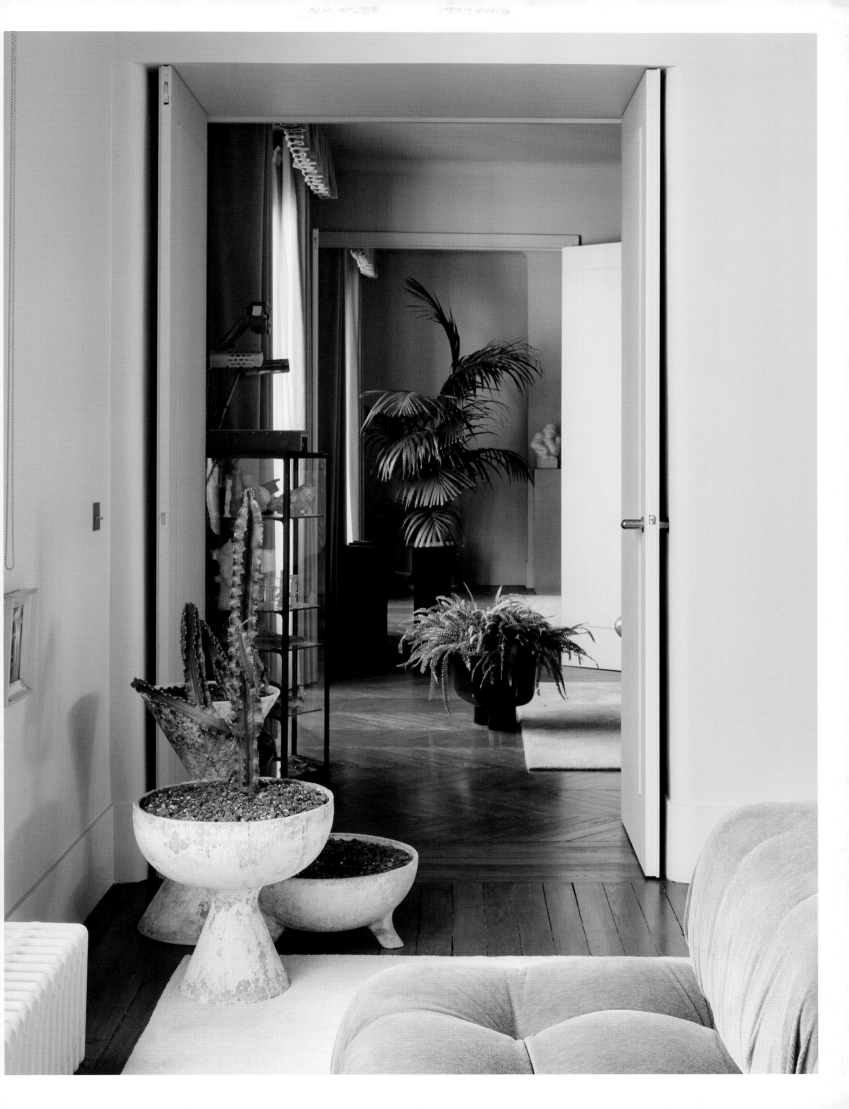

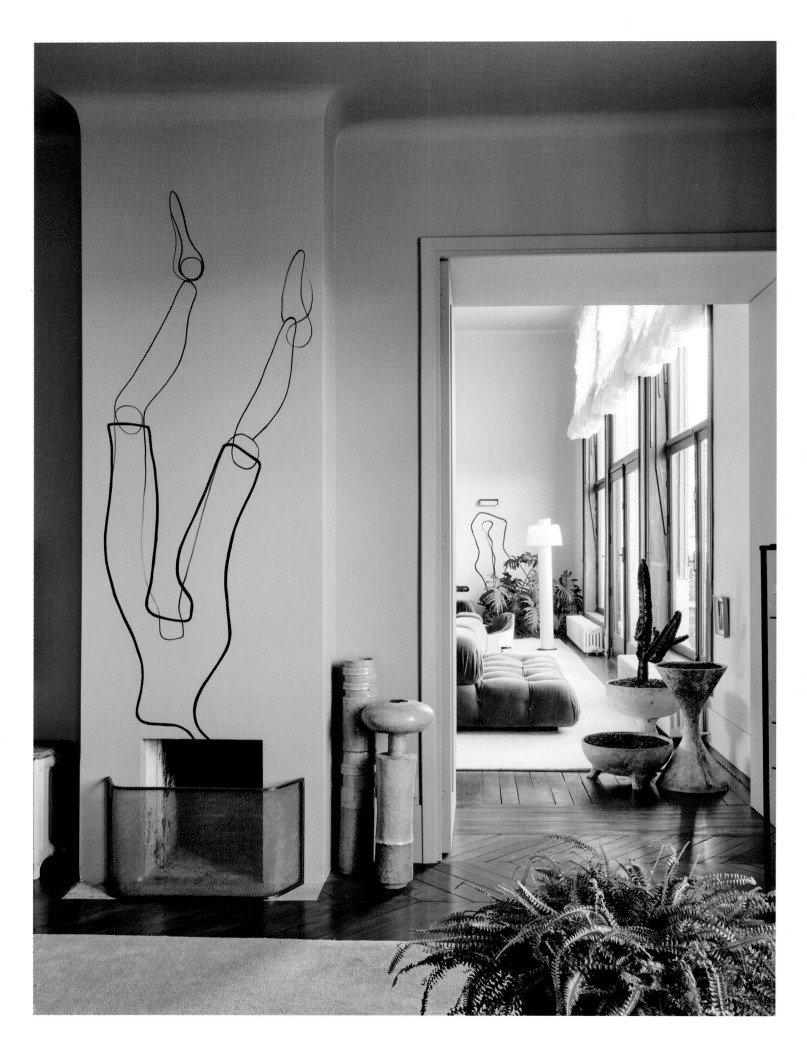

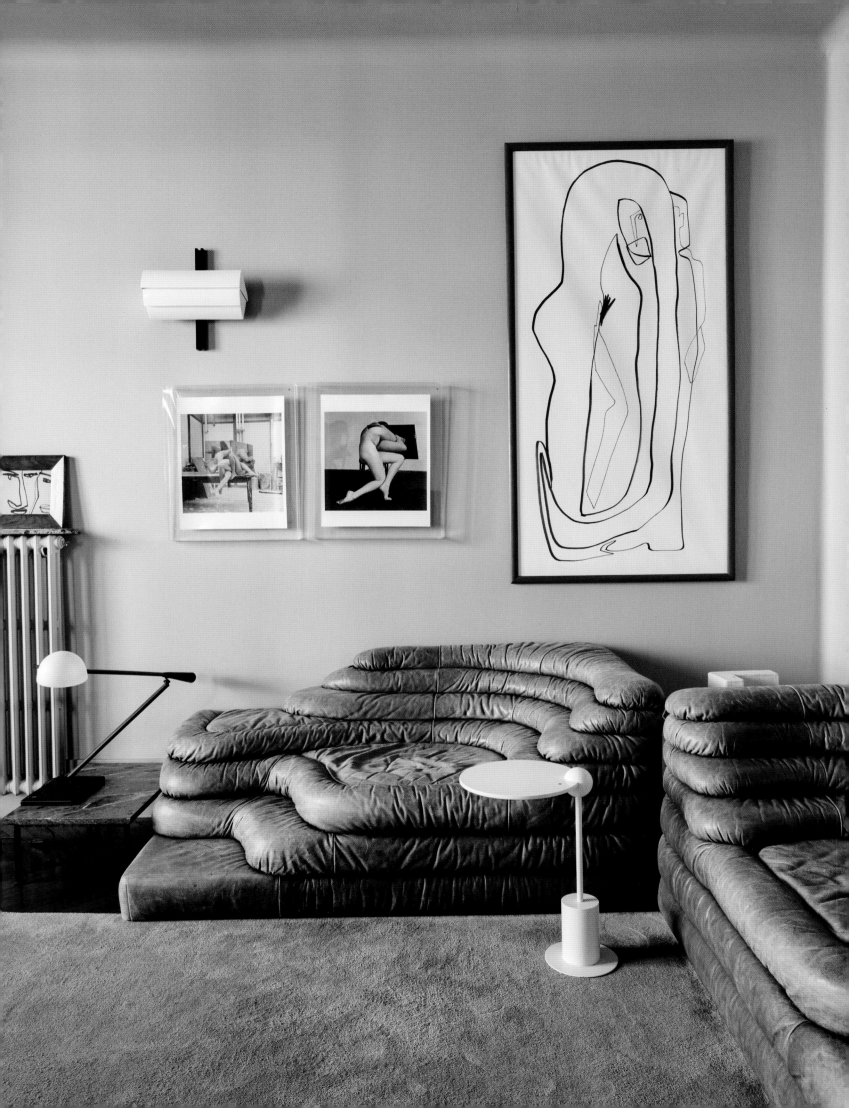

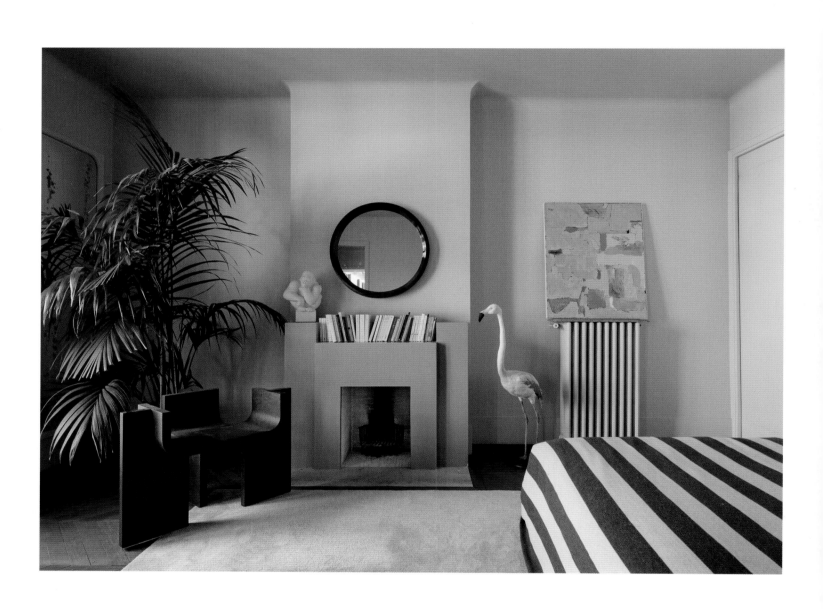

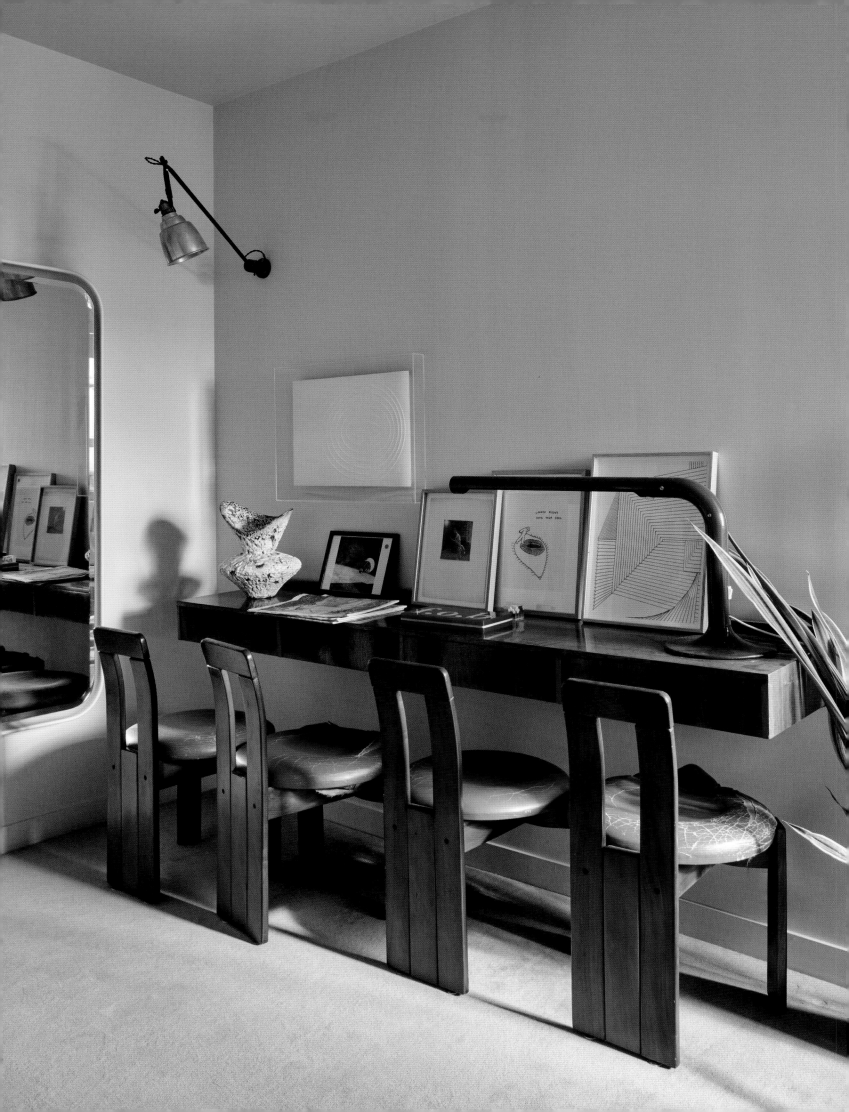

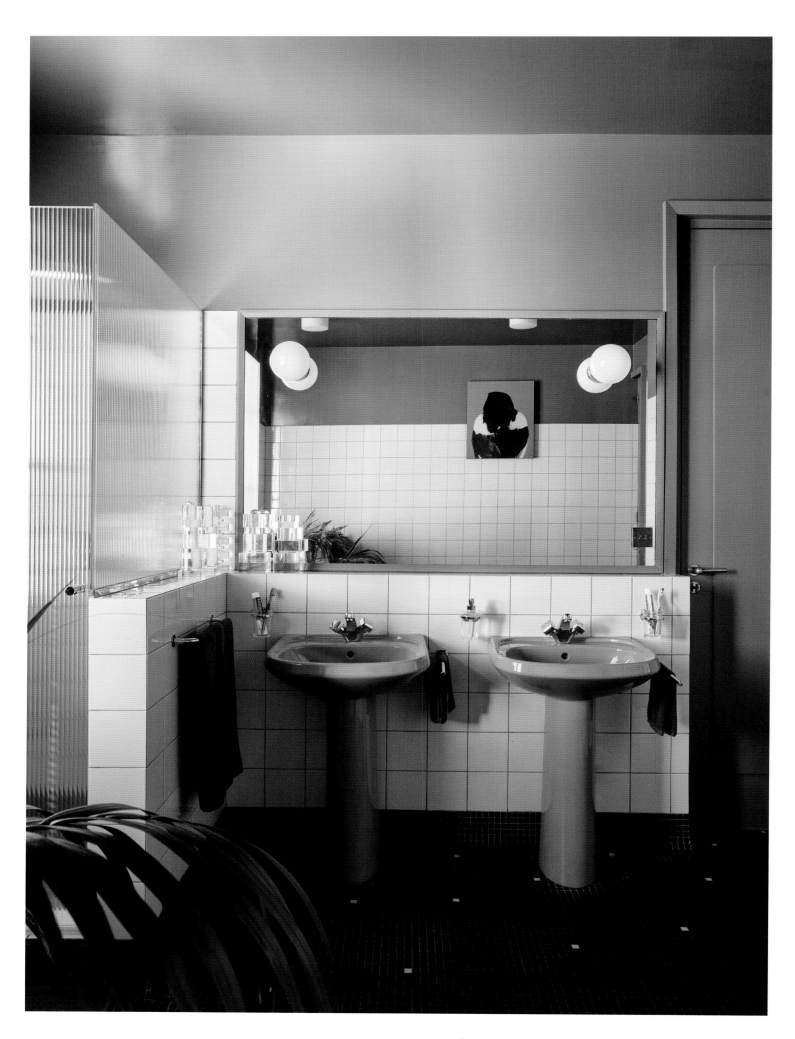

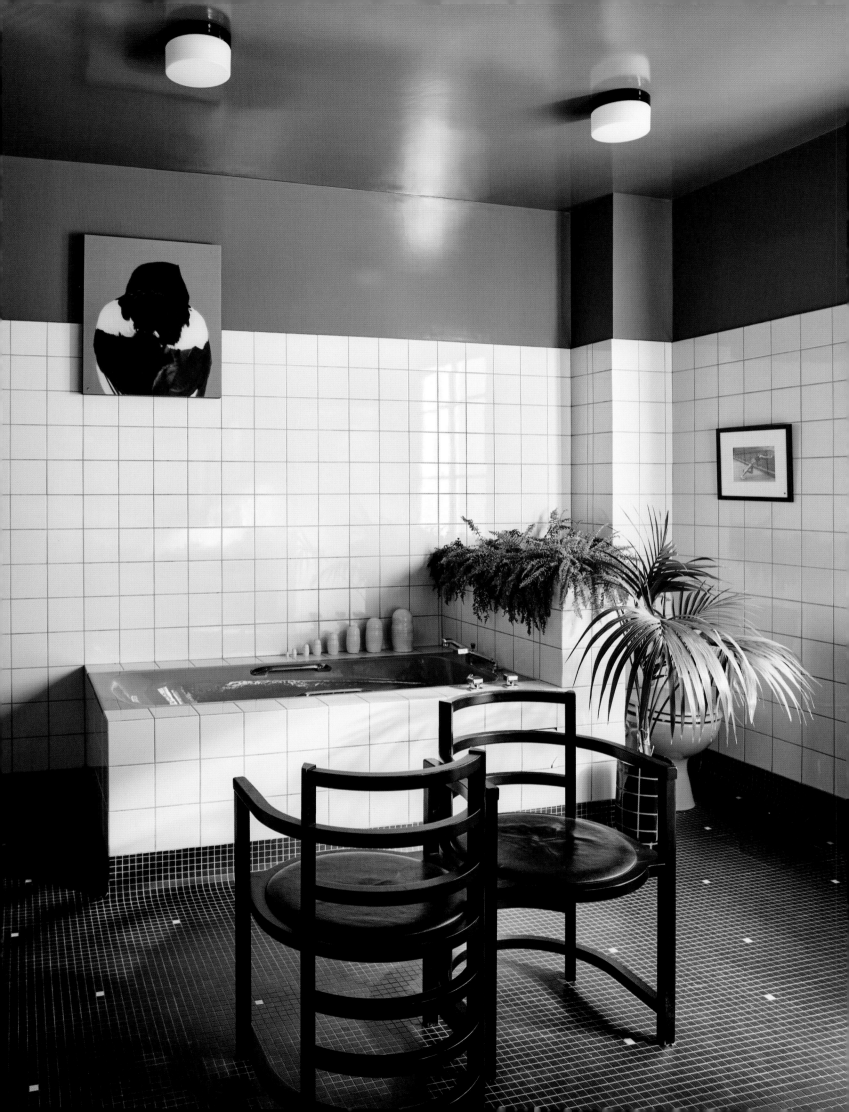

GRACIOUS/ MISCHIEVOUS/ ELEGANT.

MATHILDE FAVIER

A single phone call was all it took for me to fall under the charm of Mathilde Favier. A subsequent invitation to her home to discuss this project led to my immediate connection with her energy and vision. I visited her on a summer afternoon as she prepared dinner for her friends, and she spontaneously invited me to join the gathering. Mathilde is now the VIP PR director at Maison Dior, but her career in the fashion world began at the young age of fourteen, when she started an internship at Chanel, where her uncle, the designer Gilles Dufour, was Karl Lagerfeld's right-hand man.

Her house is a duplex in a nineteenth-century building that she shares with her partner, film director Nicolas Altmayer. Mathilde has moved several times and has ample experience and taste in redecorating her homes. Several of them were designed by Jacques Grange, from whom she undoubtedly learned valuable lessons. For this project, she sought assistance from Brenda Altmayer, but her touch is evident in every corner. As she always mentions, she doesn't mind making mistakes as long as the result is a home she enjoys being in and that reflects her personality.

She loves mixing everything she likes and finds important. Textiles from her travels coexist with tables and mirrors from Maison Jansen or Madeleine Castaing, alongside vintage flea-market pieces. She also likes to surround herself with more personal items, such as the first painting created by her sister Victoire de Castellane, who is also a jewelry designer for Dior, which sits over the fireplace.

The photo session was fantastic. Mathilde is a person who lives life with joy and spreads it wherever she goes, and her charisma, innate elegance, and sense of humor shine through in her home, showcasing the absolute essence of Parisian chic.

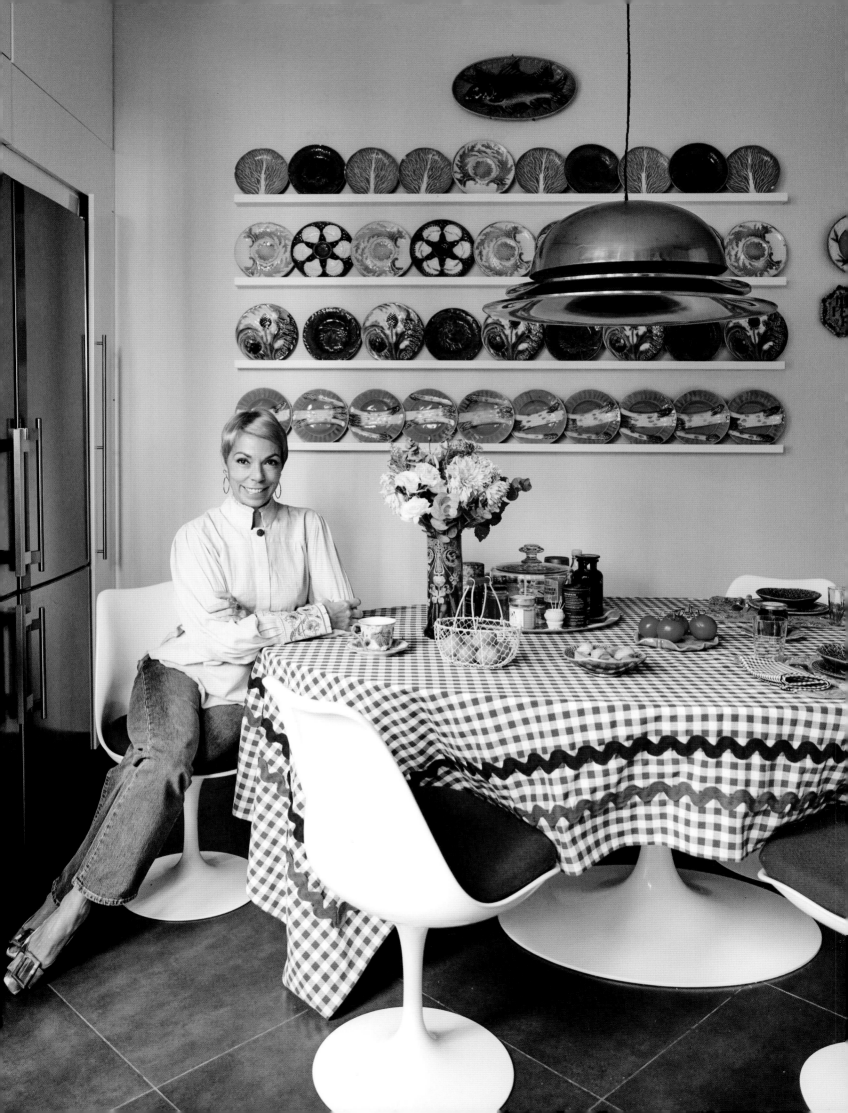

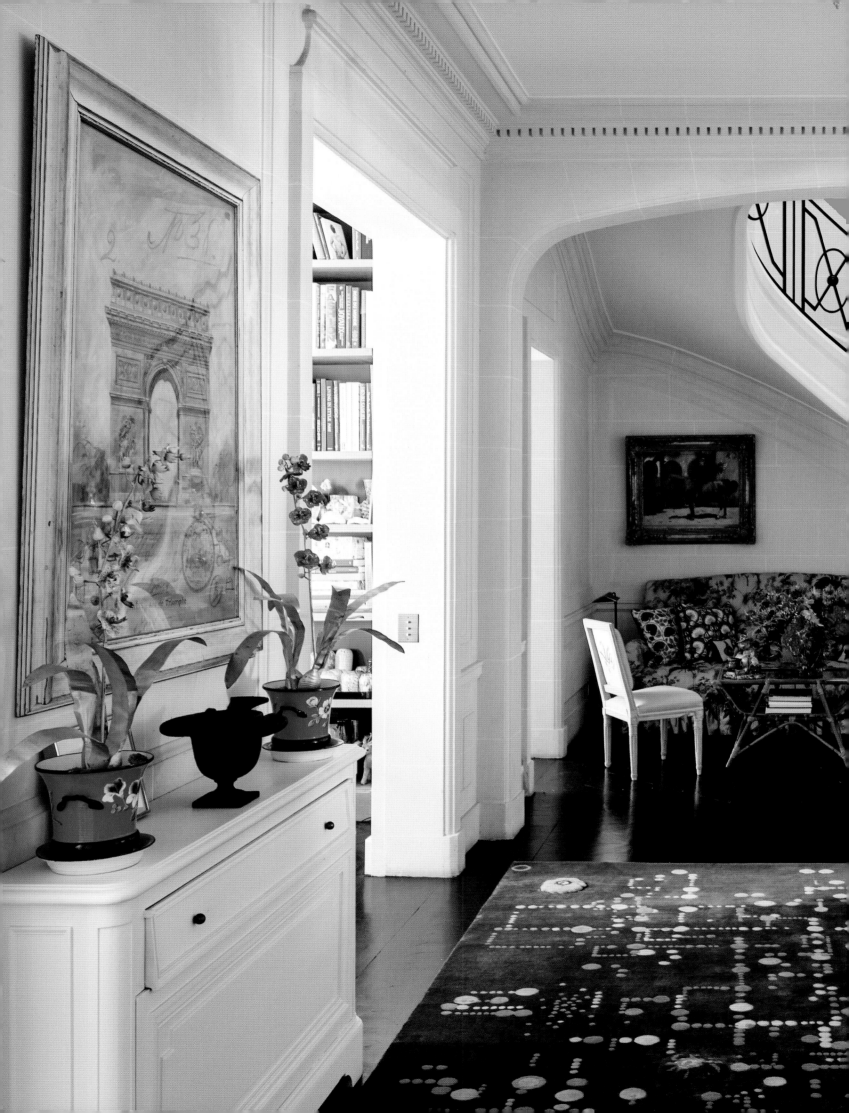

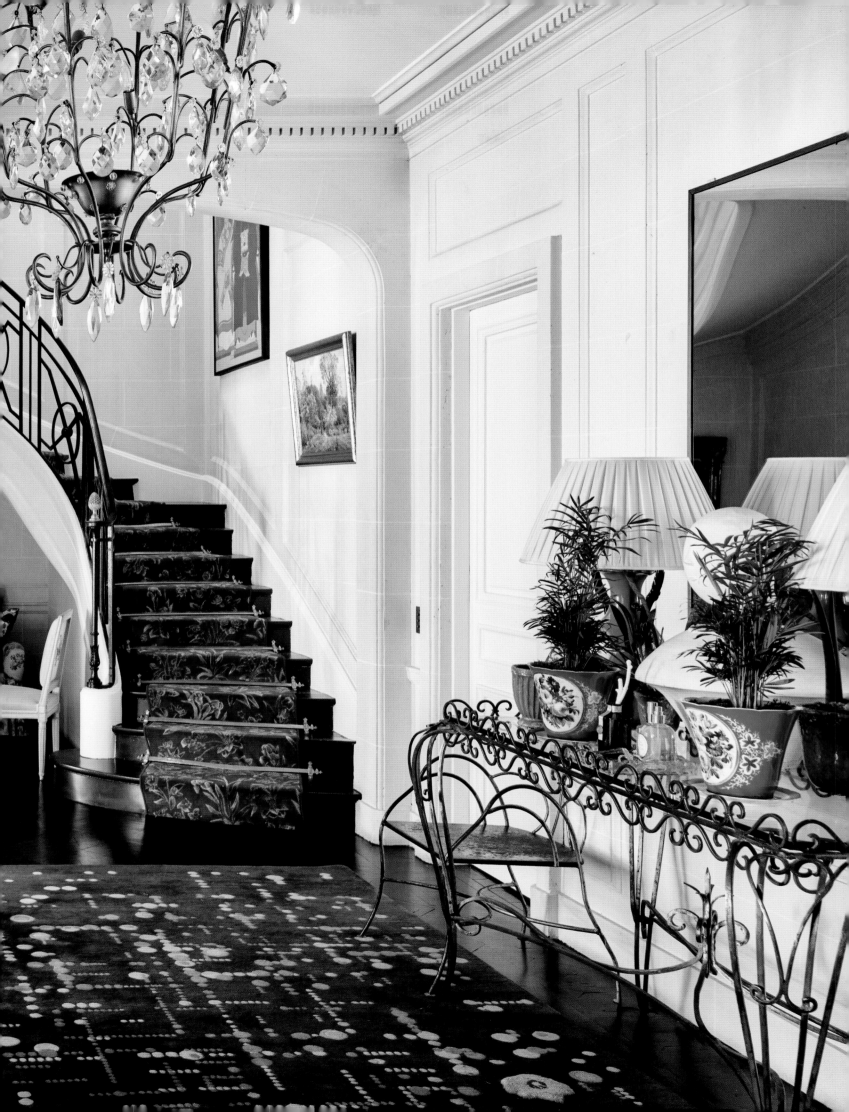

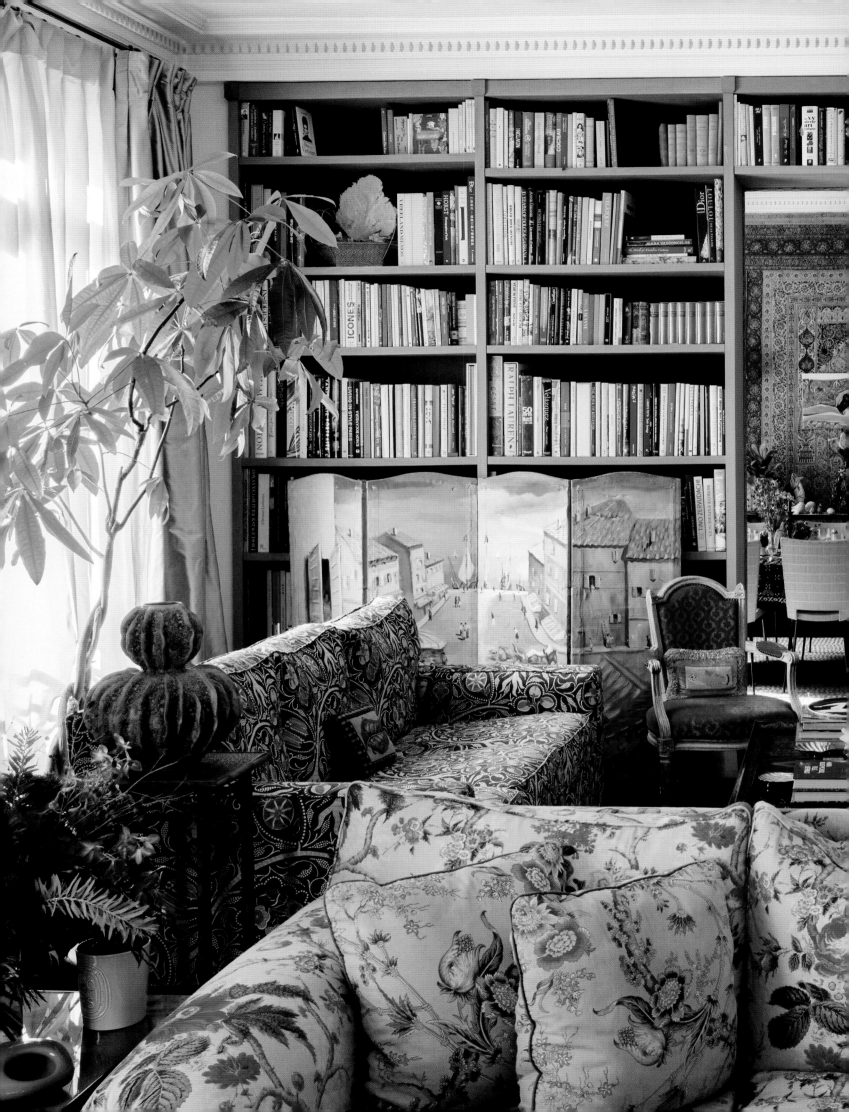

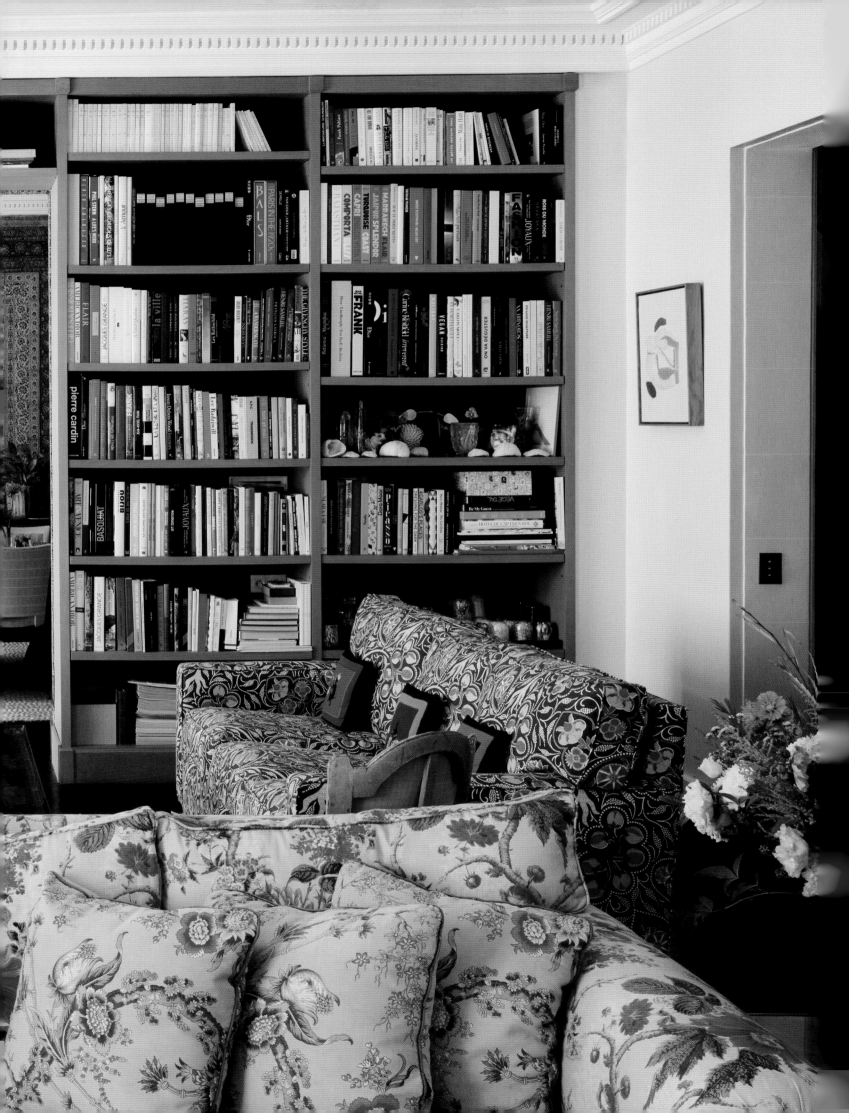

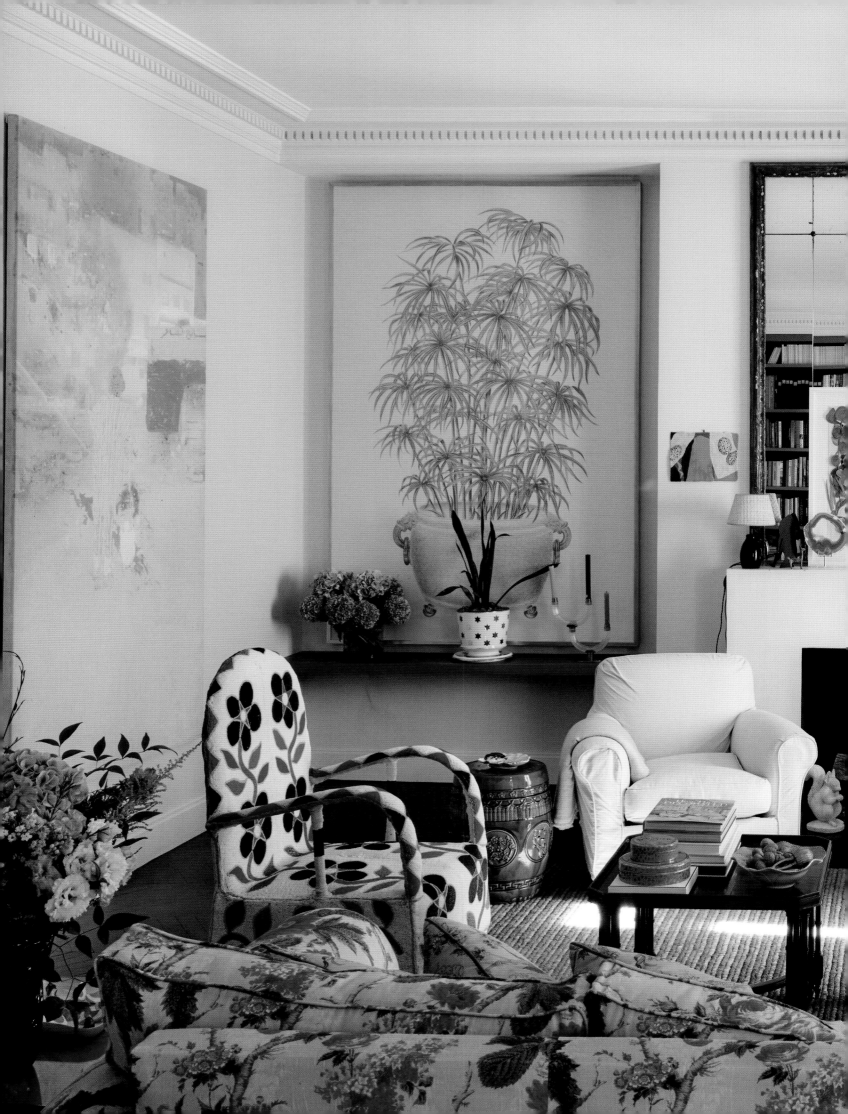

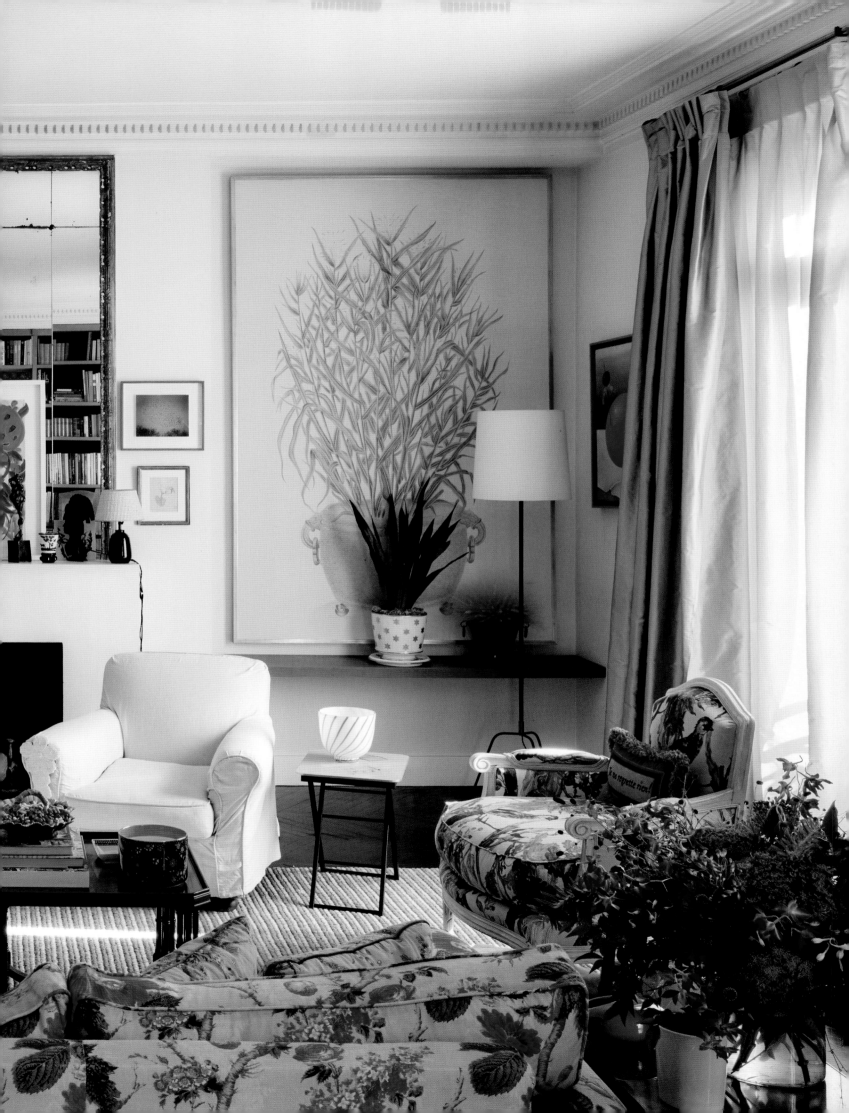

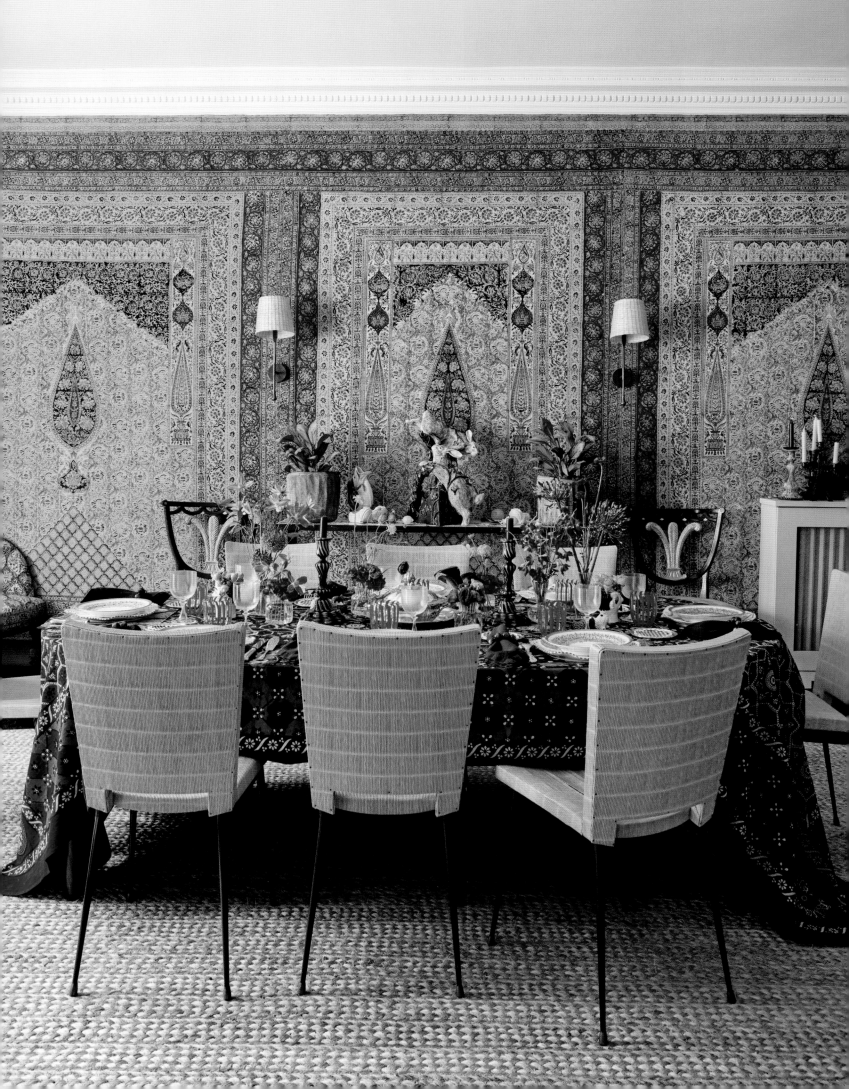

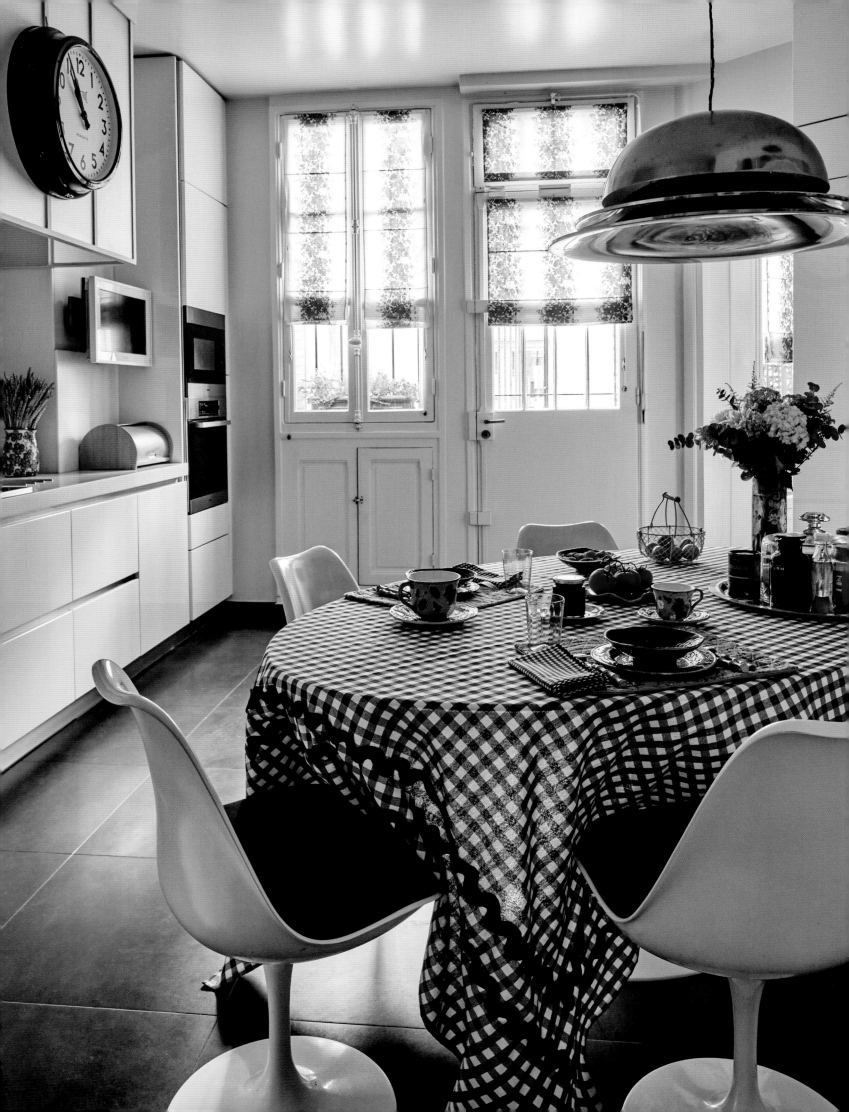

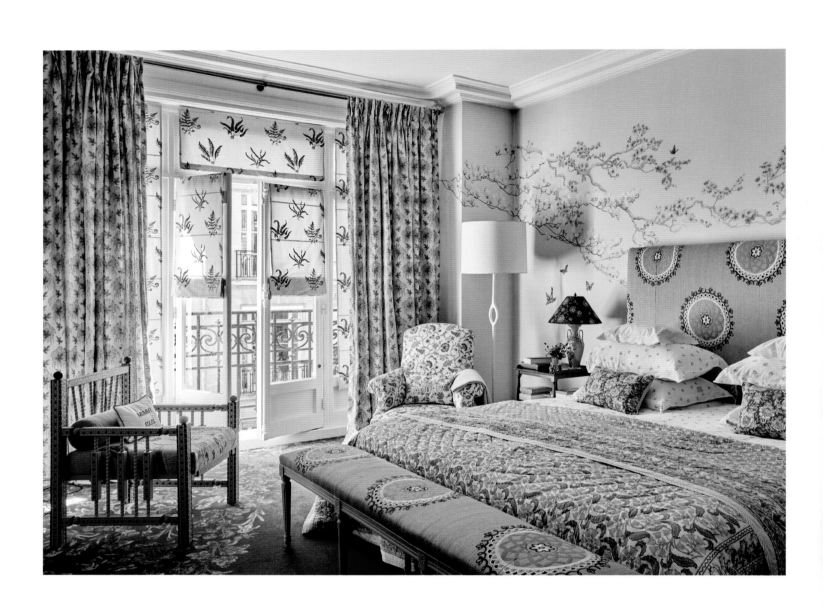

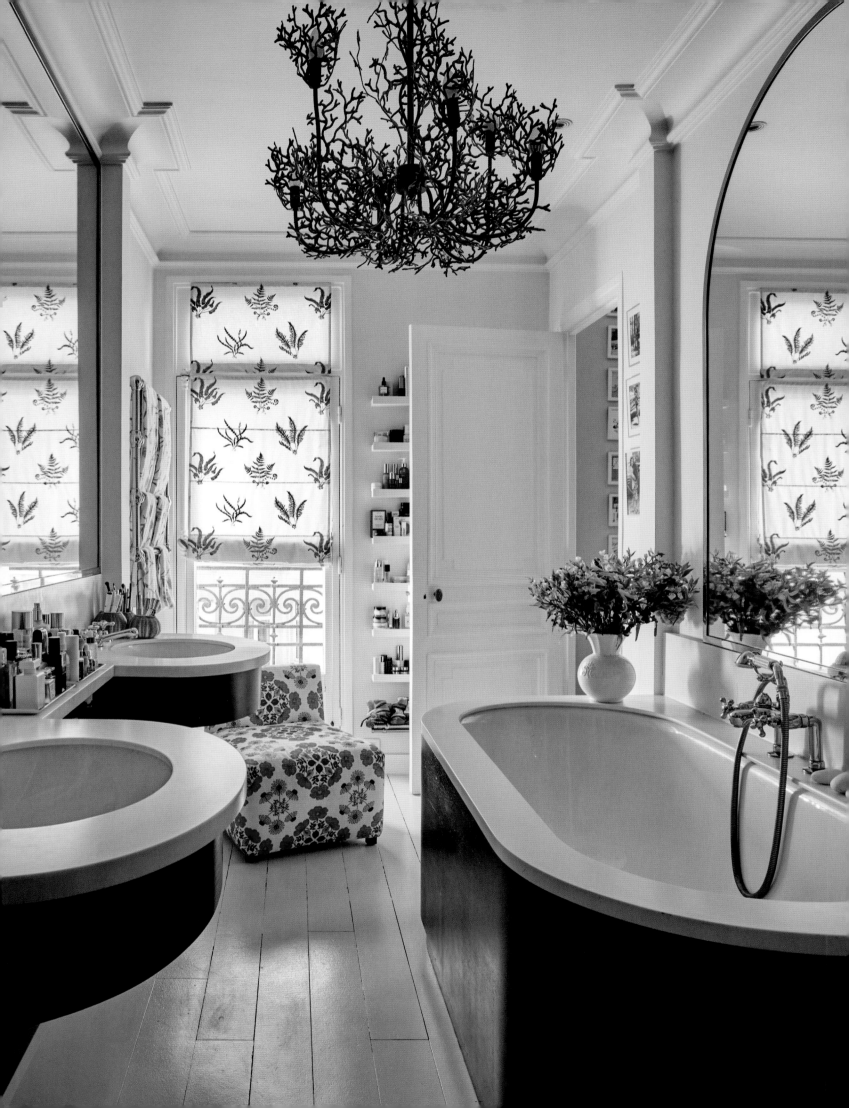

SOOTHING/ INTUITIVE/ EXQUISITE.

MURIEL BRANDOLINI

In the heart of the 7th arrondissement, with direct views of Sainte-Clotilde from Square Samuel-Rousseau, Muriel and her husband Nuno discovered the perfect place to establish their European base. They cherish the neighborhood, residing close to family and friends.

Born in France and raised in Saigon and Martinique, Muriel possesses a creative and highly professional personality. She has always viewed life through cosmopolitan eyes, finding beauty in natural light. She began her career in fashion, discovered by Franca Sozzani in New York, and now holds a privileged place in the world of decoration. She considers herself self-taught, a quality she wouldn't trade for anything, as she believes a lack of formal training allows her the freedom to follow her intuition.

"When I imagine a room, I tend to start with the walls and windows," Muriel says. Upholstery is crucial to her work, and she relies on it to transform a space. Her walls are covered in hand-block printed fabric made in India, from her first collection for Holland & Sherry, with metallic inks that add depth. The woven fabric on the windows is by Toyine Sellers, and the pelmets are adorned with custom embroidered appliqués by Jean-François Lesage. These textiles serve as a foundation for pieces such as the nineteenth-century pagoda-shaped bed, a gift from her mother-in-law Cristiana Brandolini, and the wooden armchairs in the living room that once belonged to the last Austro-Hungarian emperor, Charles I.

"Everything inspires me, whether it's the delicate lace of a fan or the set design of a movie, but my priority is how it makes you feel. Your home should be physically comfortable but should also convey a sense of comfort and tranquility." Muriel says arriving home makes her feel like she's in a cocoon, and she sleeps incredibly well.

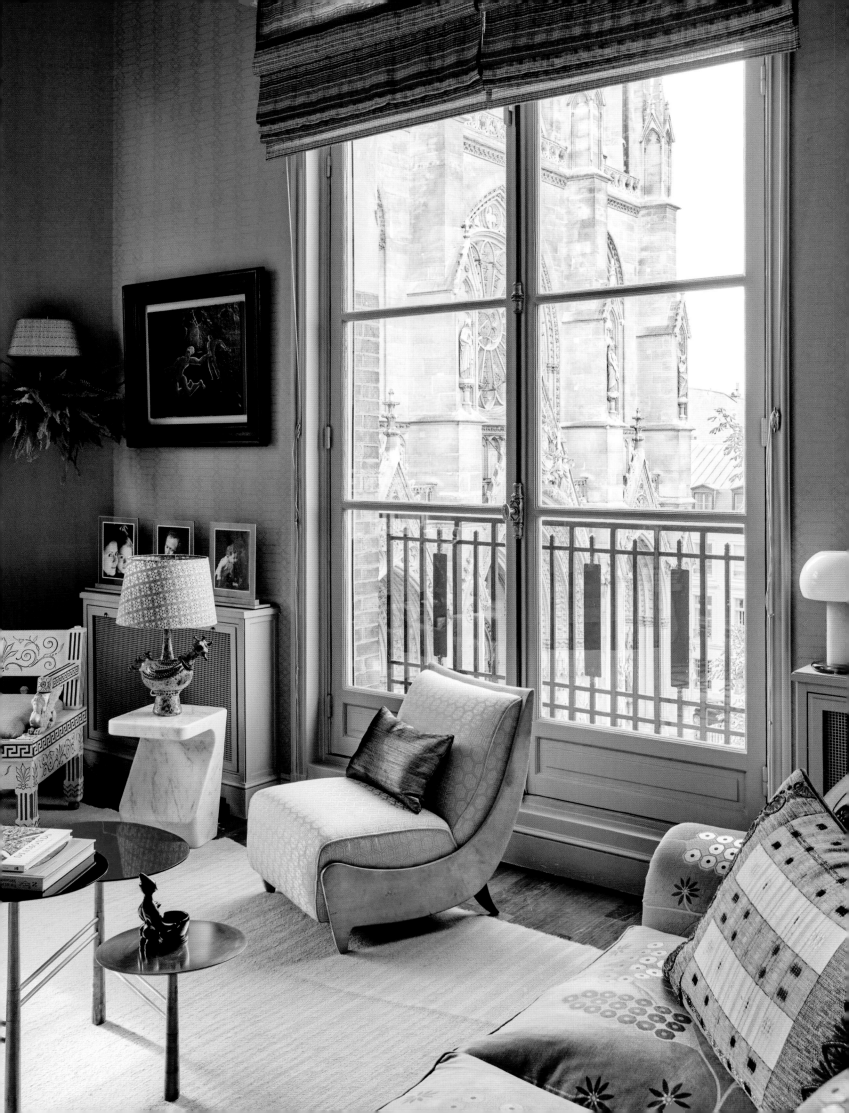

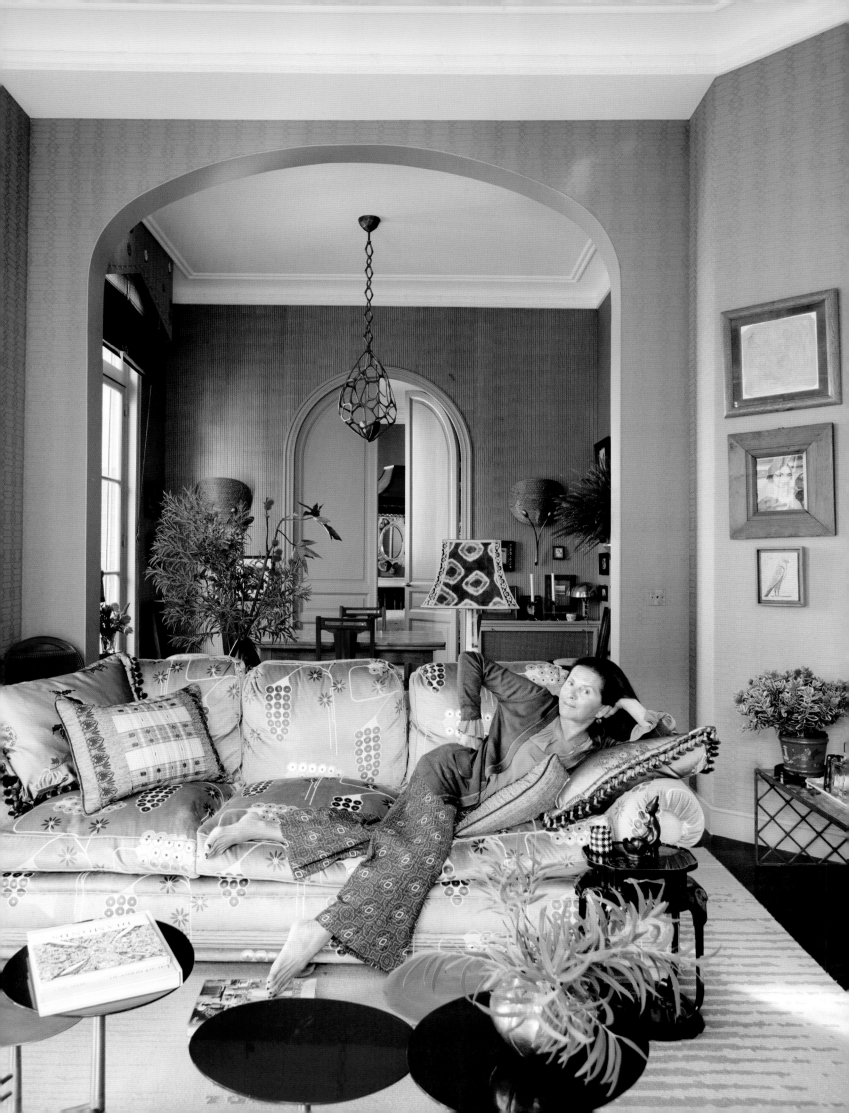

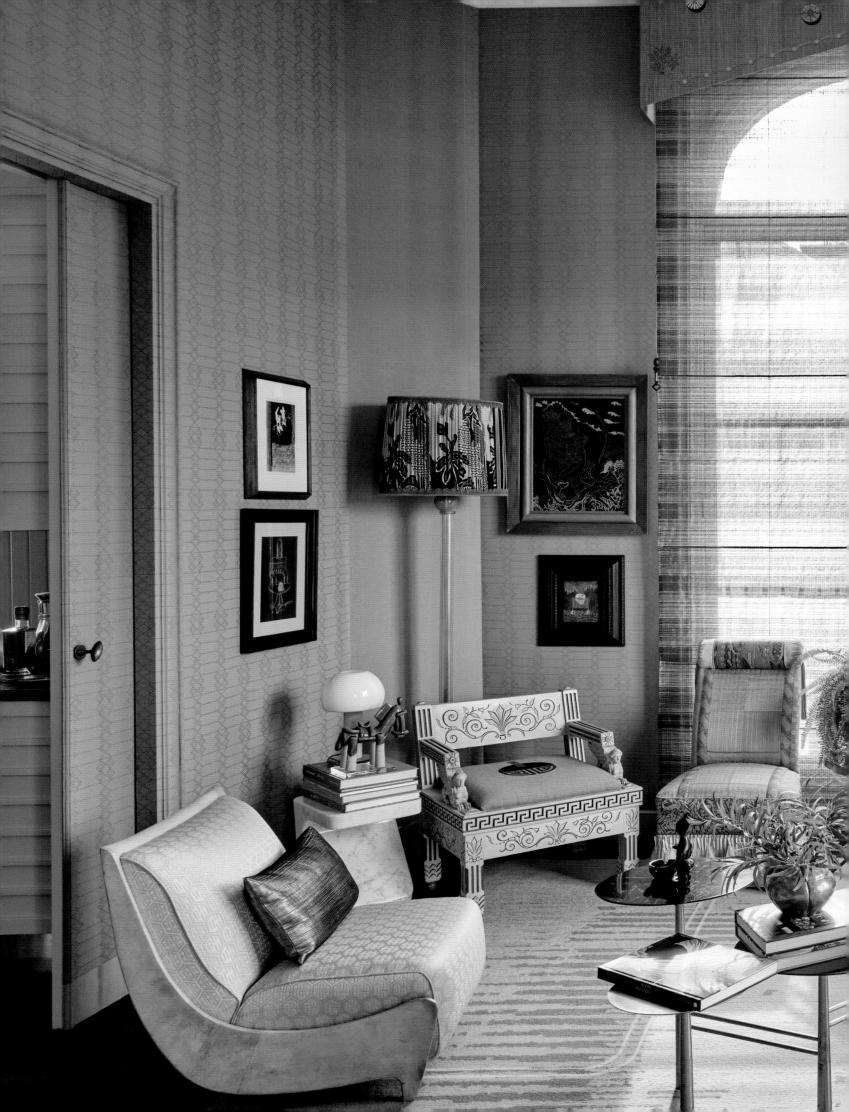

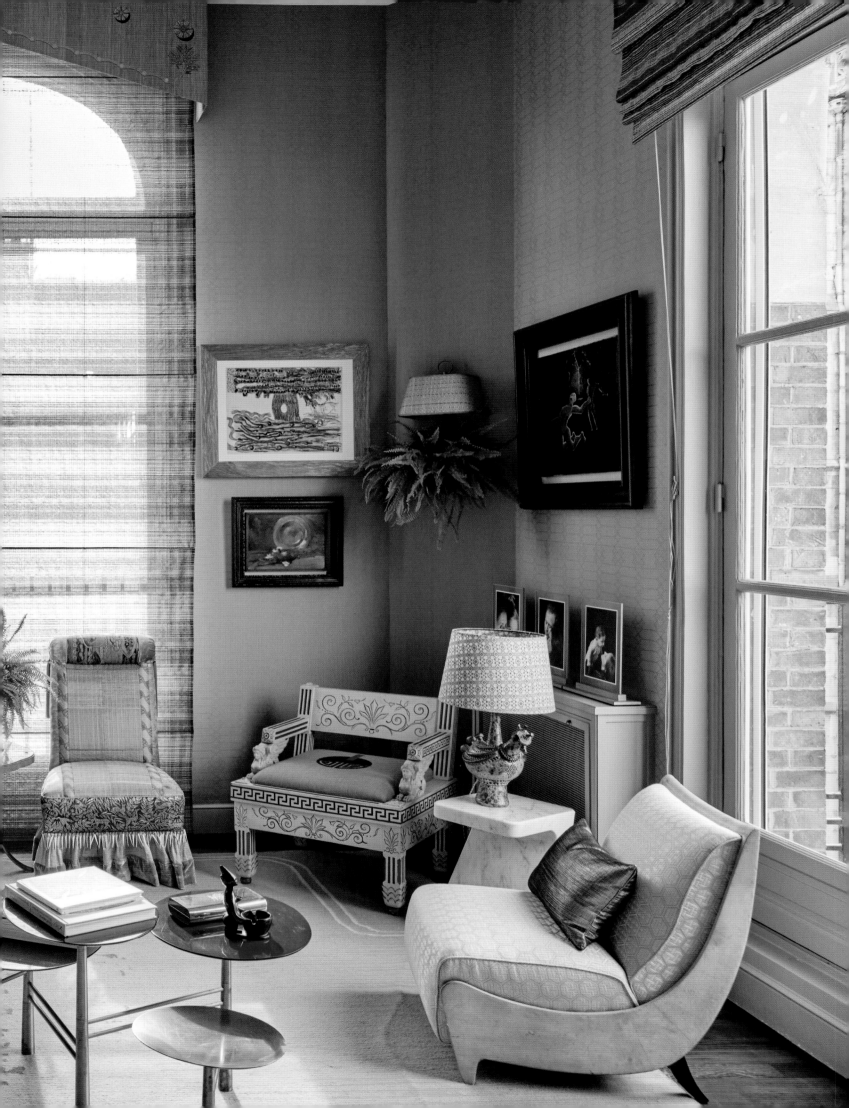

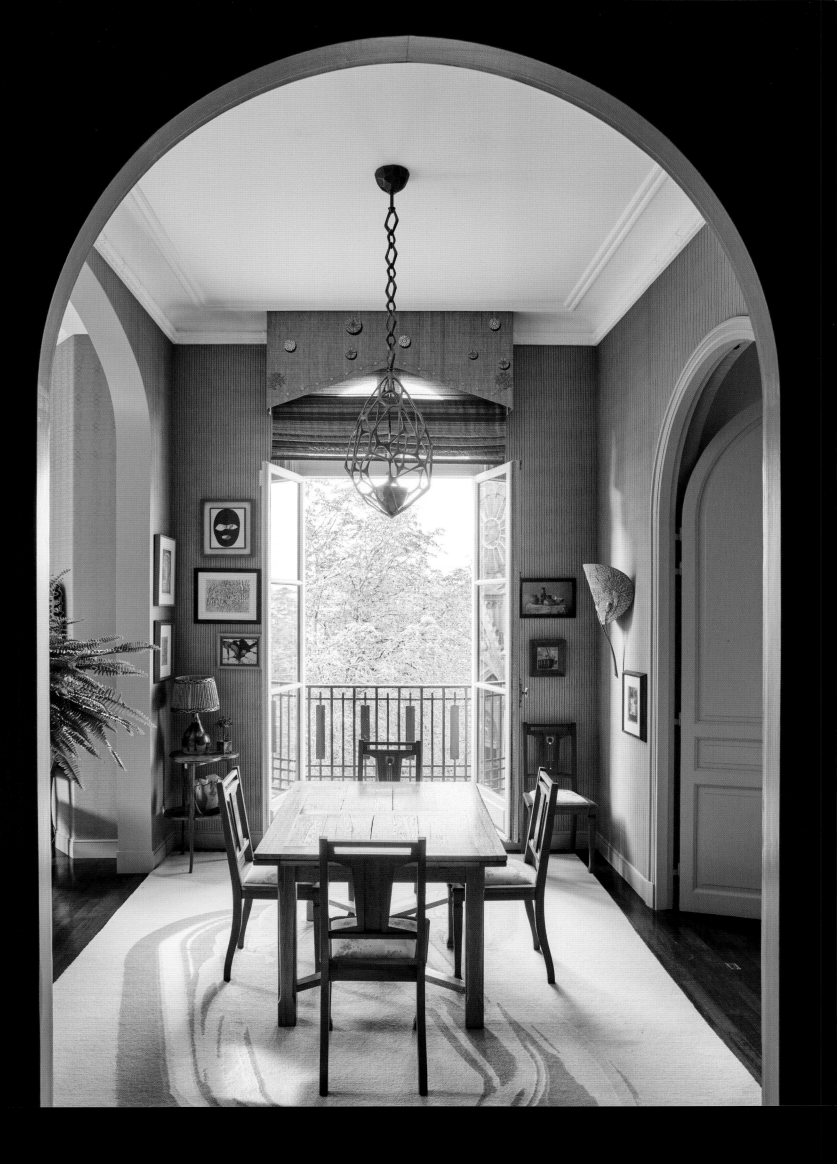

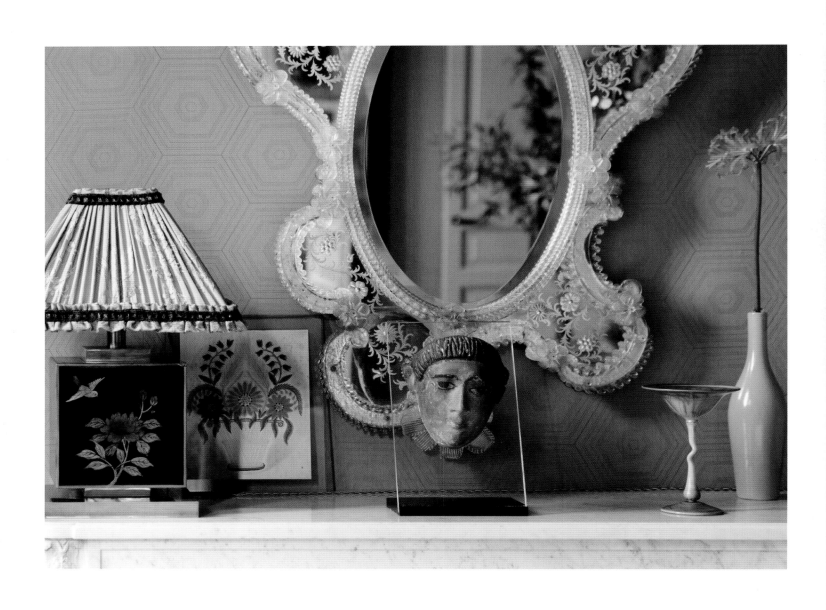

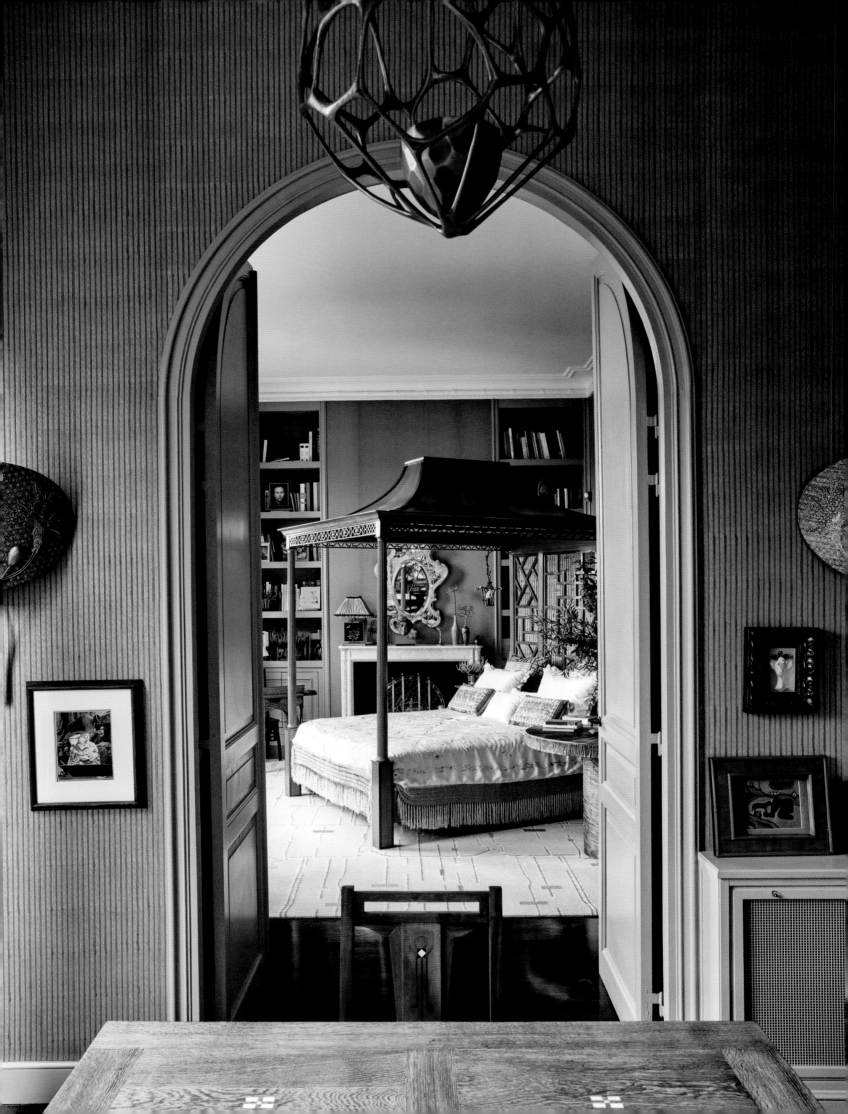

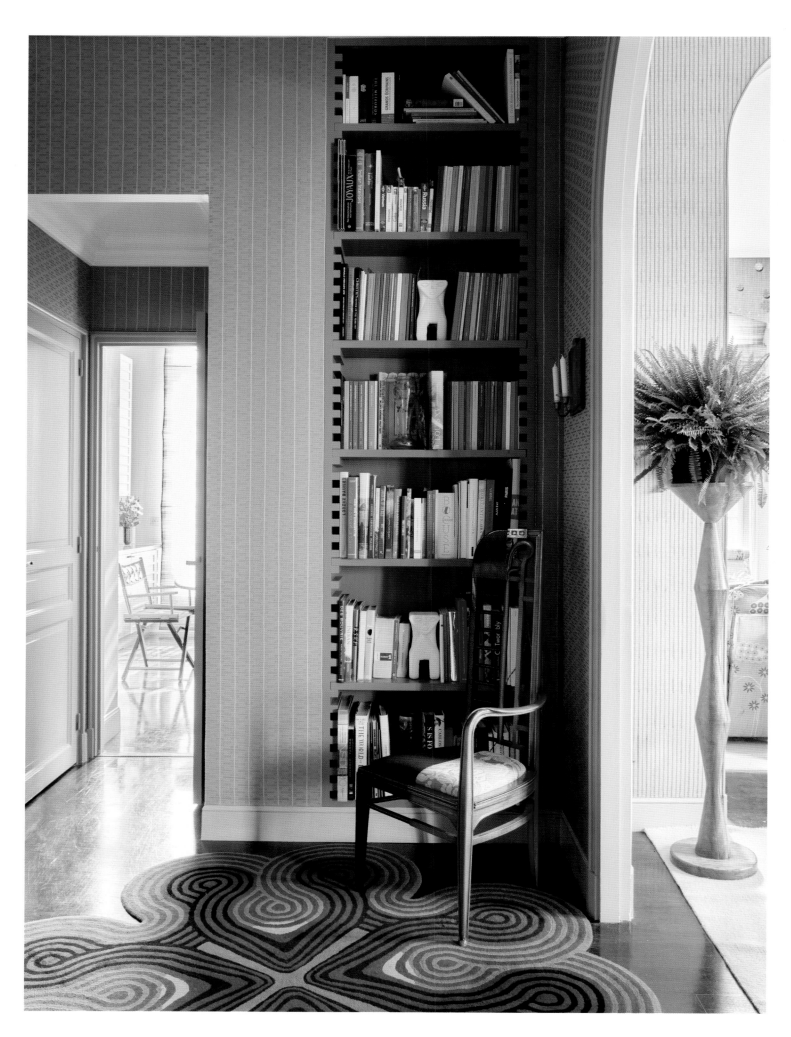

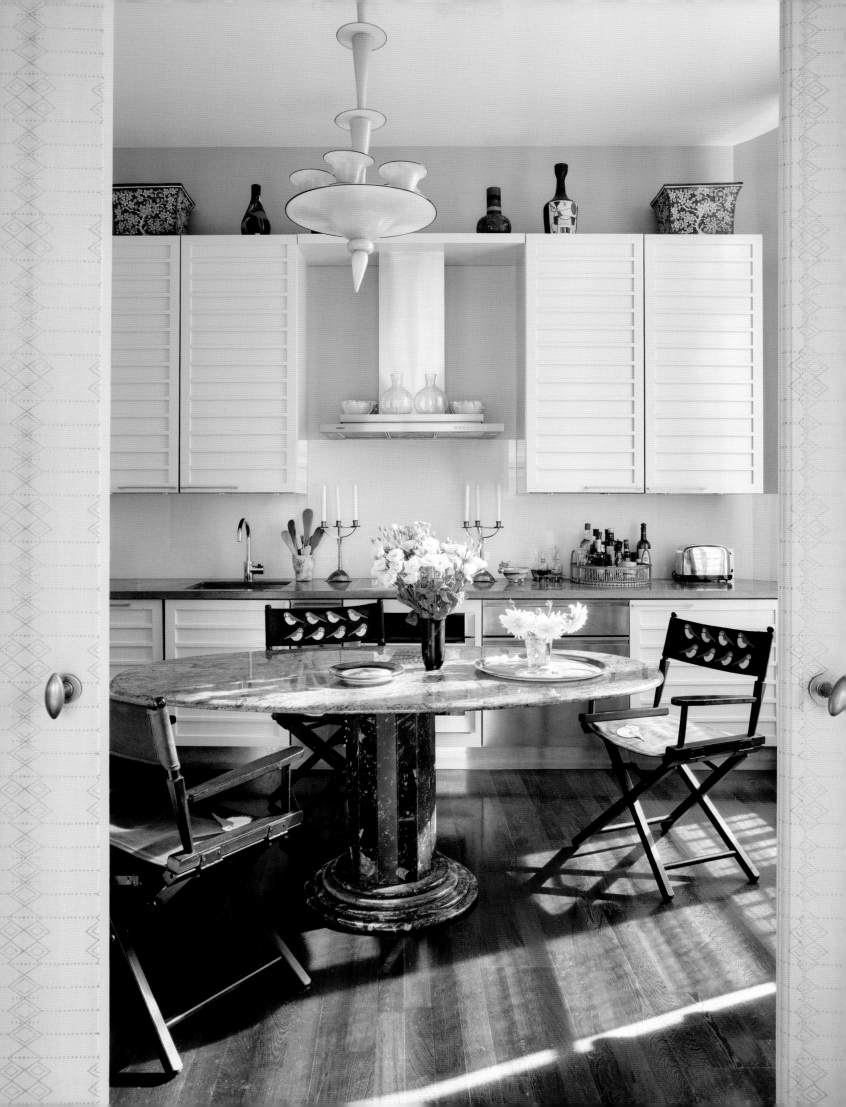

ORNAMENTAL/ VIVID/ WHIMSICAL.

PIERRE MARIE

Pierre Marie is an artist impossible to classify. He is a wave of creativity that ornaments everything he encounters along the way. He has the ability to create everything he needs to carry out a project without resorting to anything made by others. A lover of music, he played seventeenth-century baroque music on his harpsichord while I took these photos, completely transforming my experience.

Pierre lives in Nouvelle Athènes, in the 9th arrondissement. When I asked him what attracted him to this area, Pierre told me that he was inspired by his past, closely linked to a certain Romantic artistic scene (George Sand, Frédéric Chopin, Alexandre Manceau), and by the neighborhood's architectural daring, from 1820s private mansions to theaters and nightclubs, passing through the Napoleon III and Art Nouveau styles.

His apartment is a duplex artist's studio on the fourth and fifth floors of an 1890 building, with a large north-facing bay window and a ceiling height of over six meters in the workspace. Pierre undertook a major renovation of the space with architecture firm Lecoadic Scotto. This was his first project as a decorator, and he had much to learn but also many ideas. He wanted to place ornamentation at the center of the project.

In the dining room, his first tapestry, *Ras el Hanout*, on the theme of spices, took almost nine months to be woven at the Manufacture Robert Four in Aubusson. The bathroom and bedroom feature his first stained-glass windows, *Jasmine* and *Sirocco*, made by Ateliers Duchemin in Paris. The windows narrate a story written by his boyfriend, Ahmed Terbaoui, inspired by his childhood memories of Algeria. The apartment also features Pierre's first textiles, lighting, and his first attempts at furniture: "I wanted to design as much as possible by myself, as in a Gesamtkunstwerk—a total work of art."

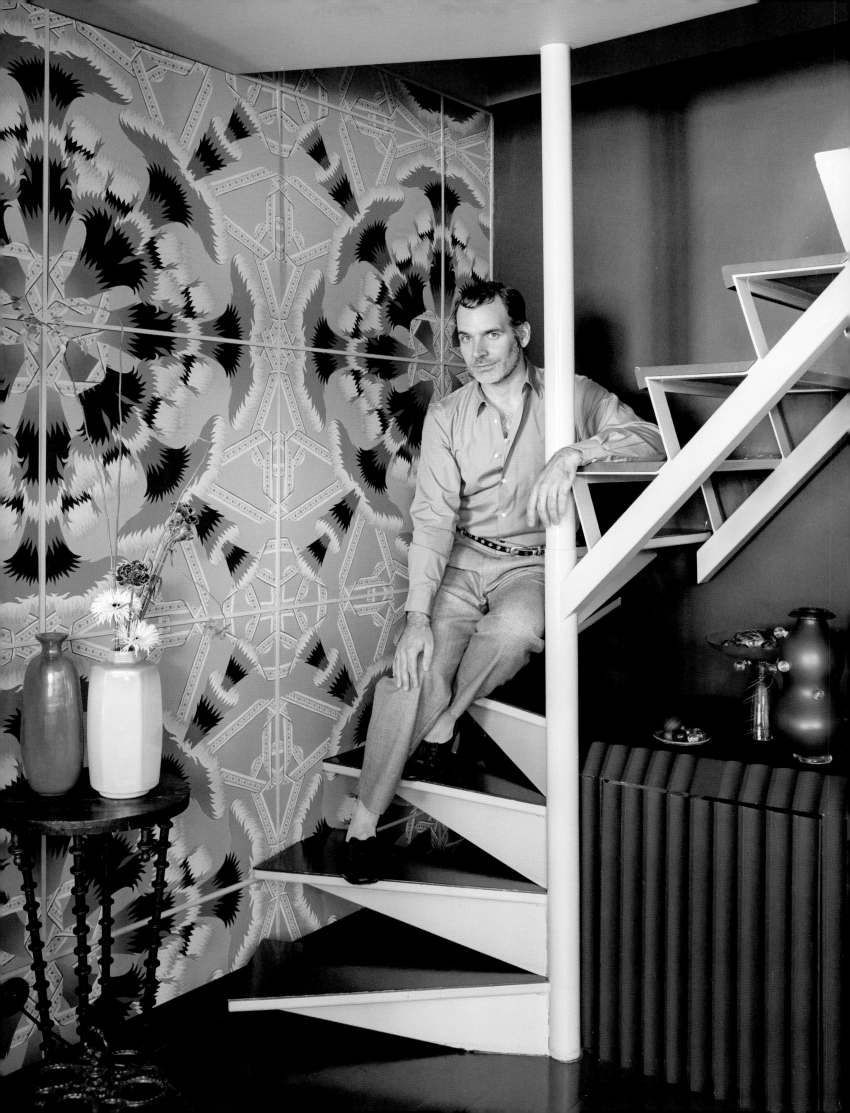

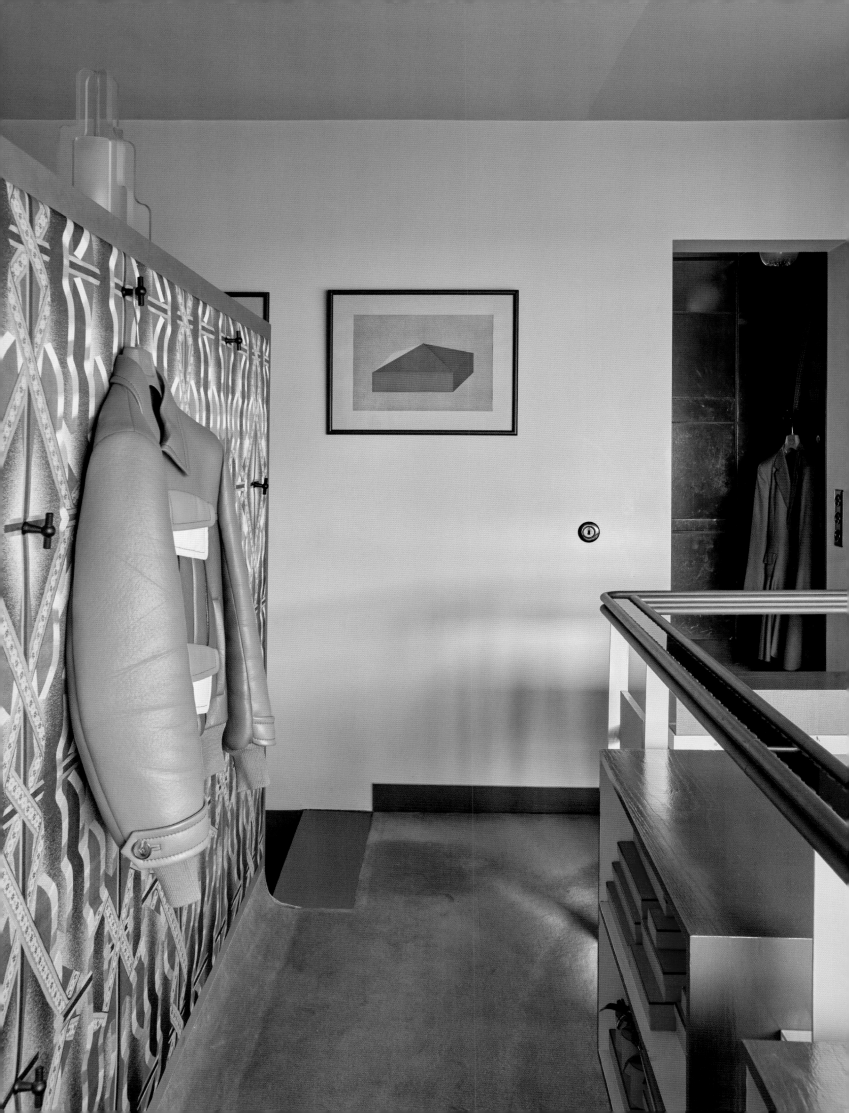

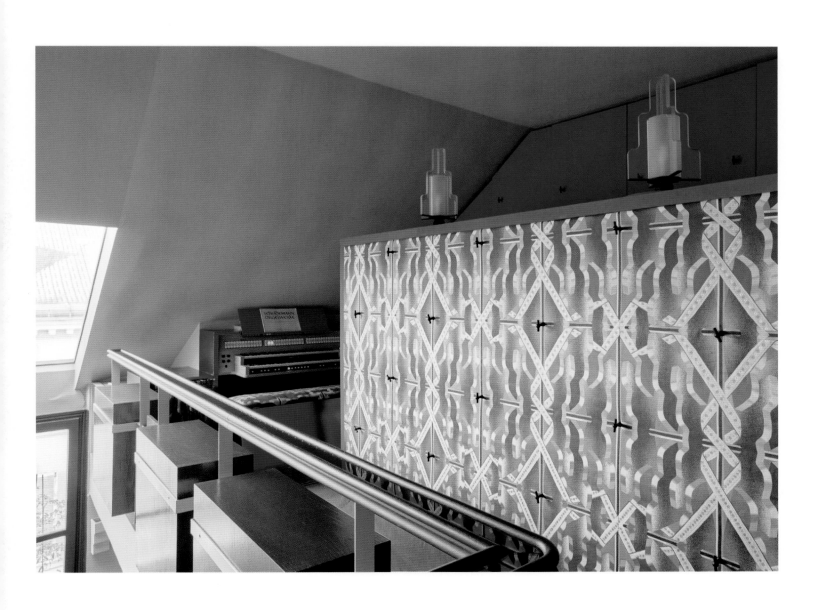

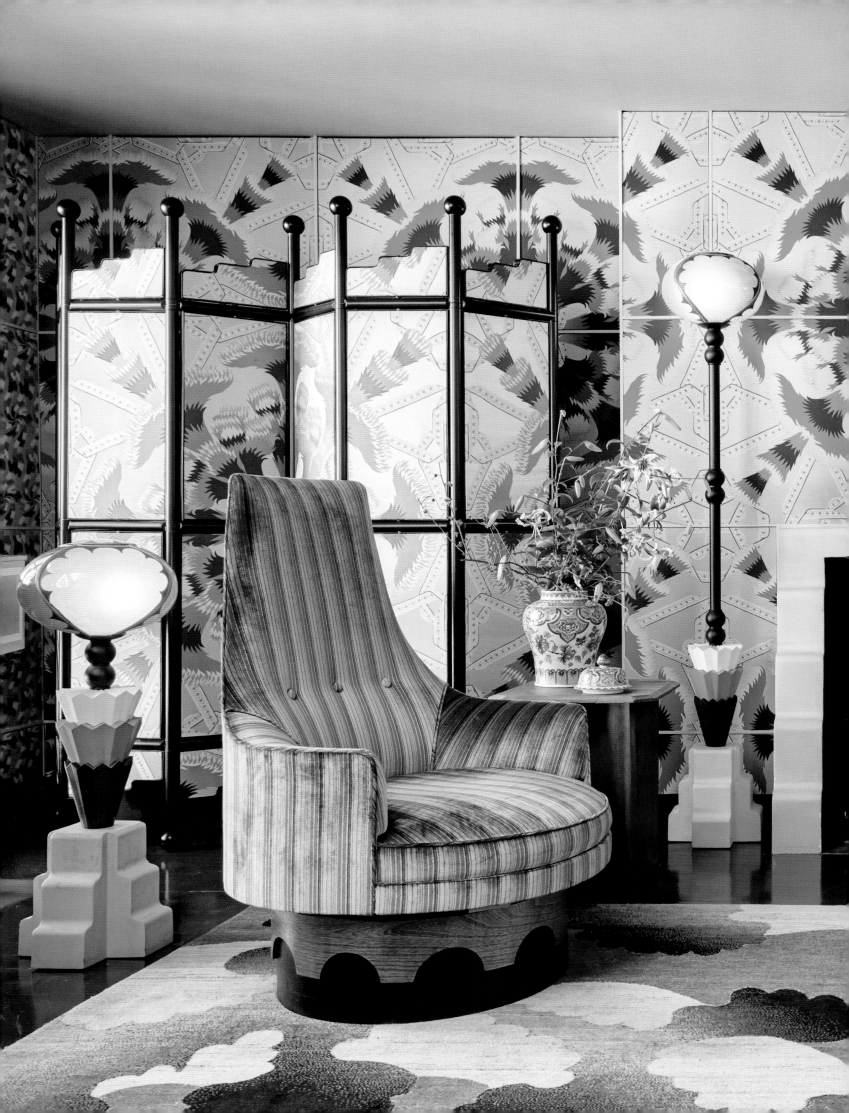

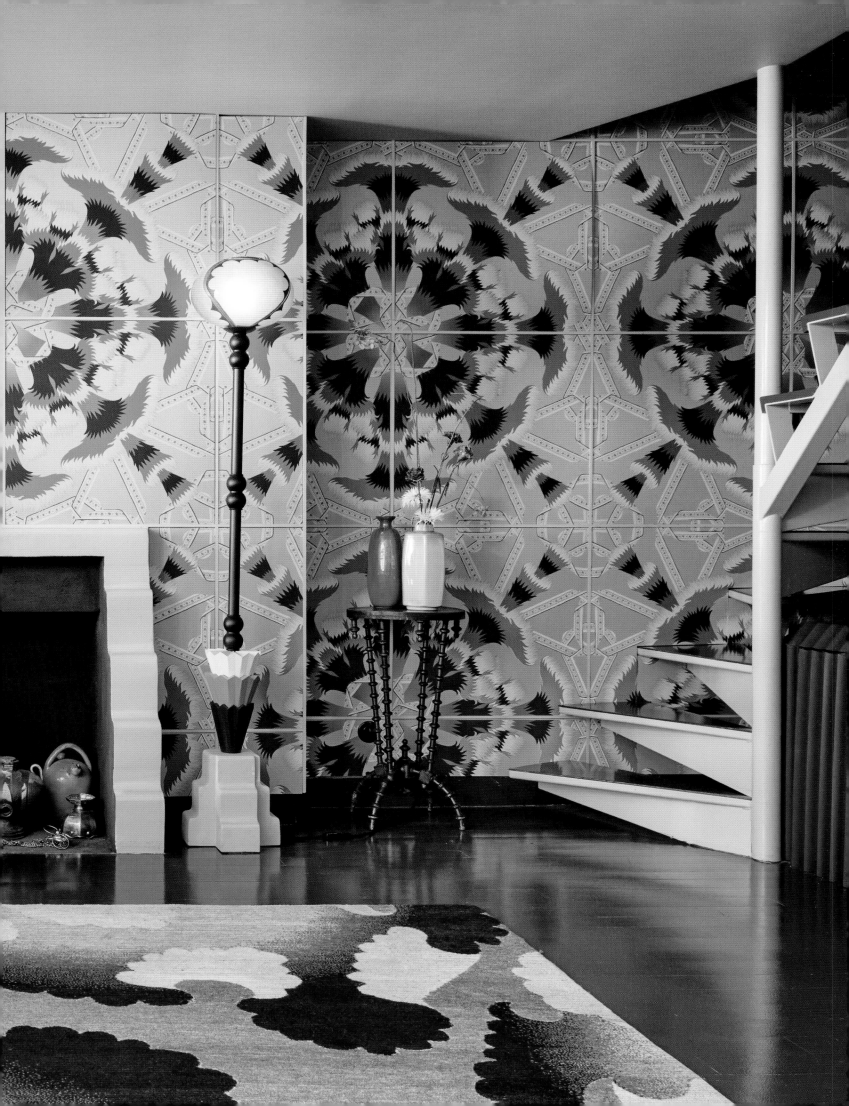

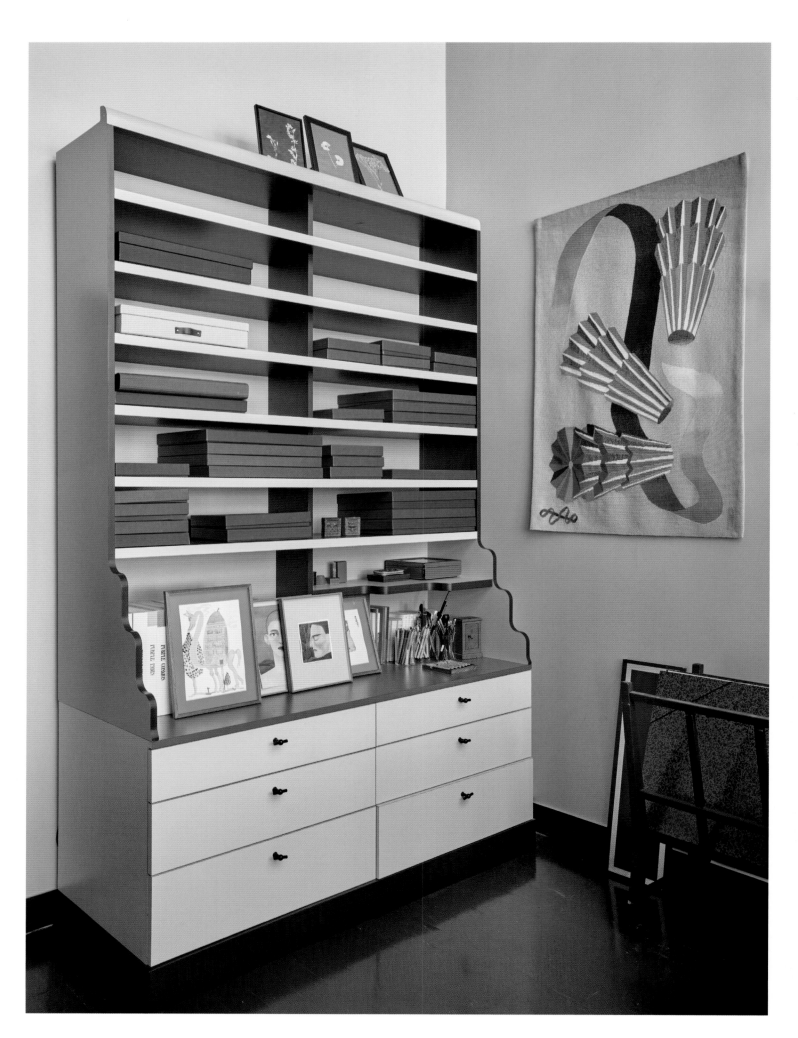

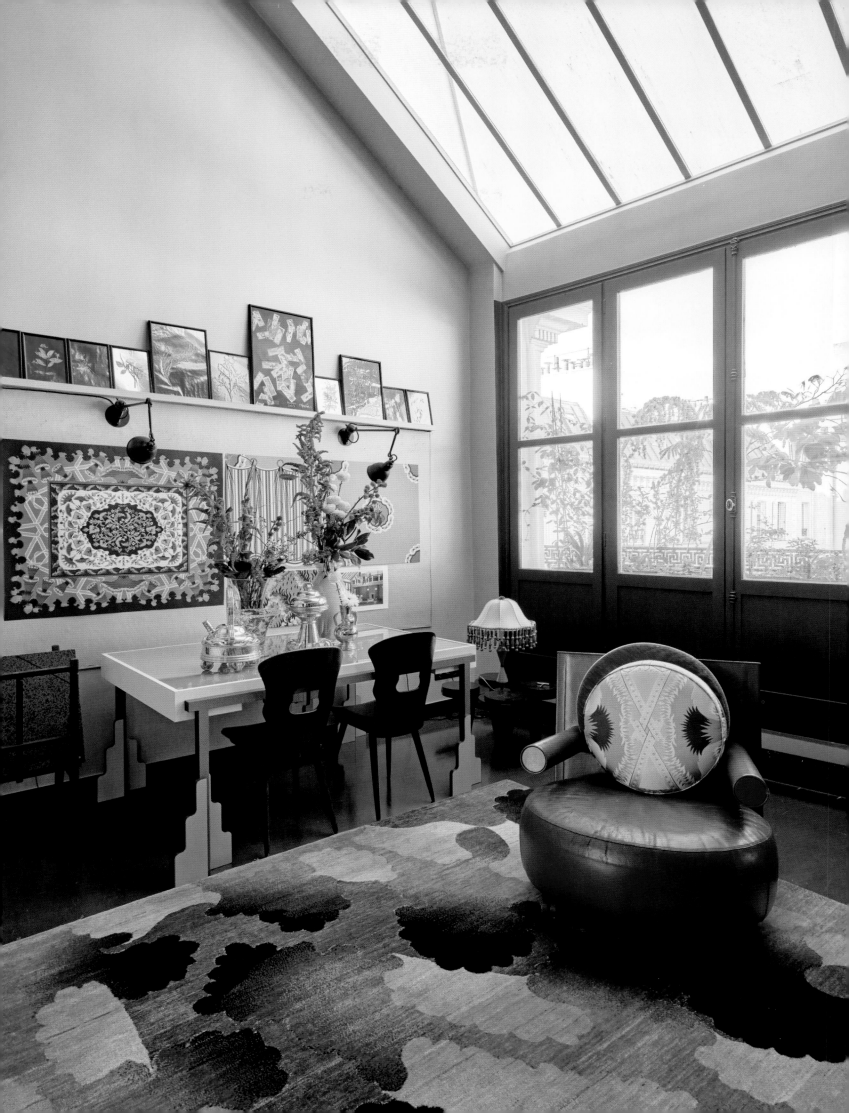

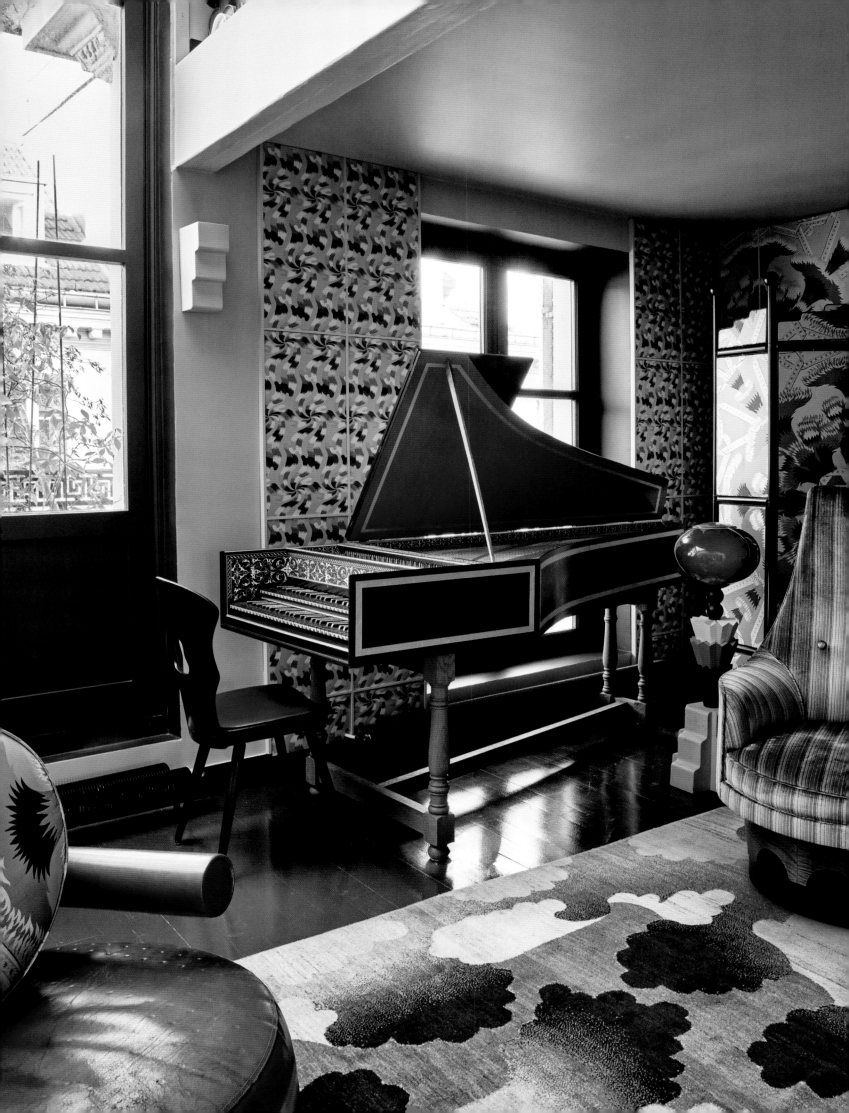

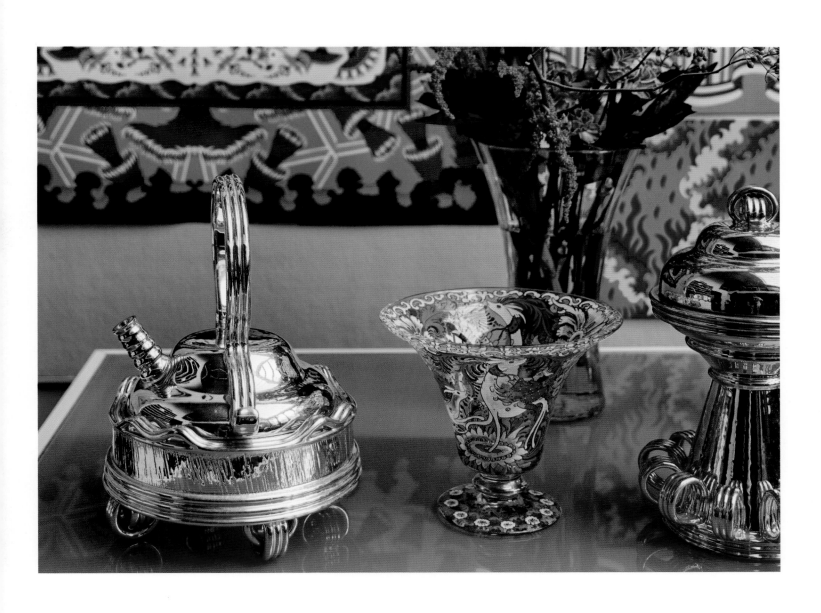

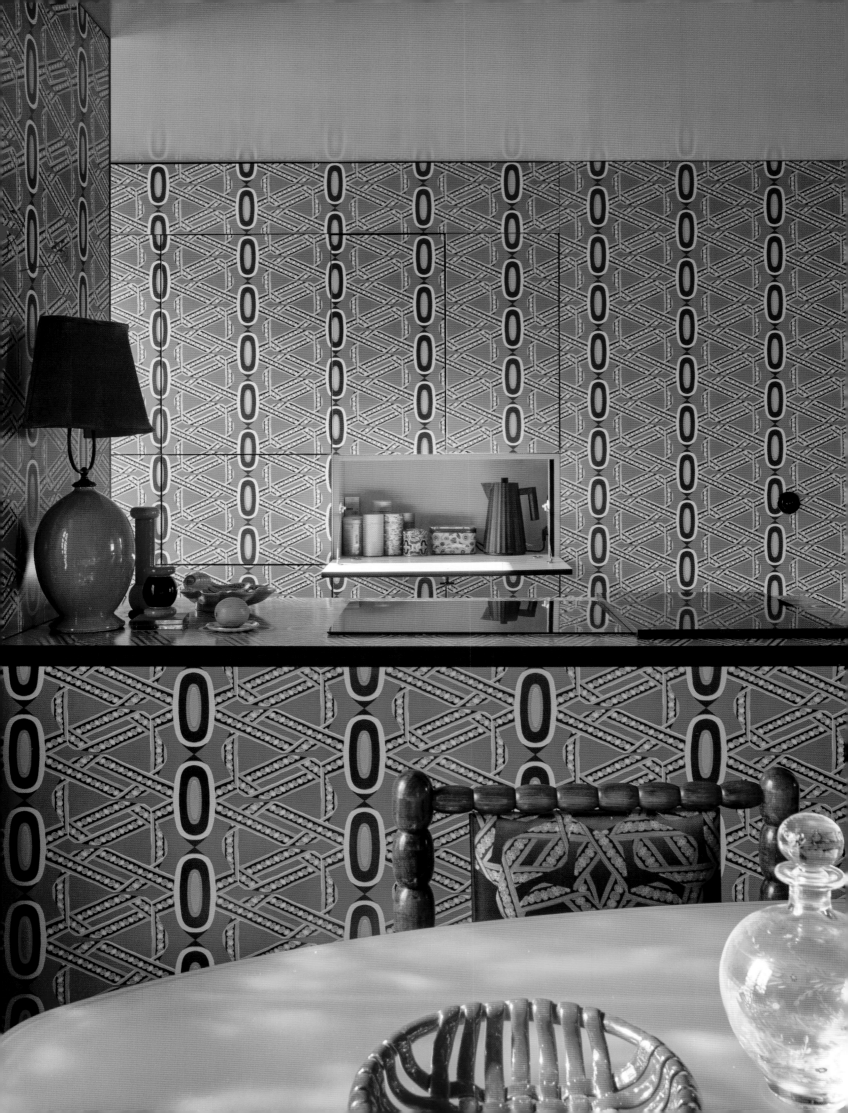

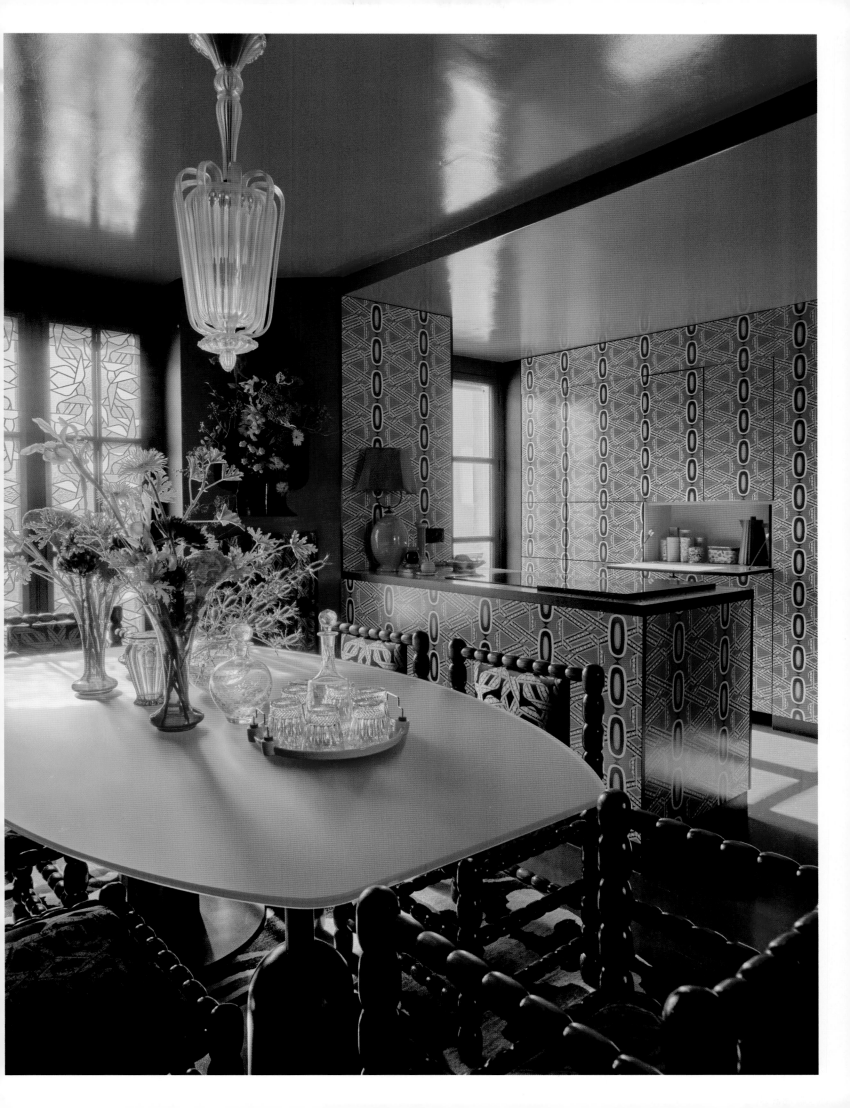

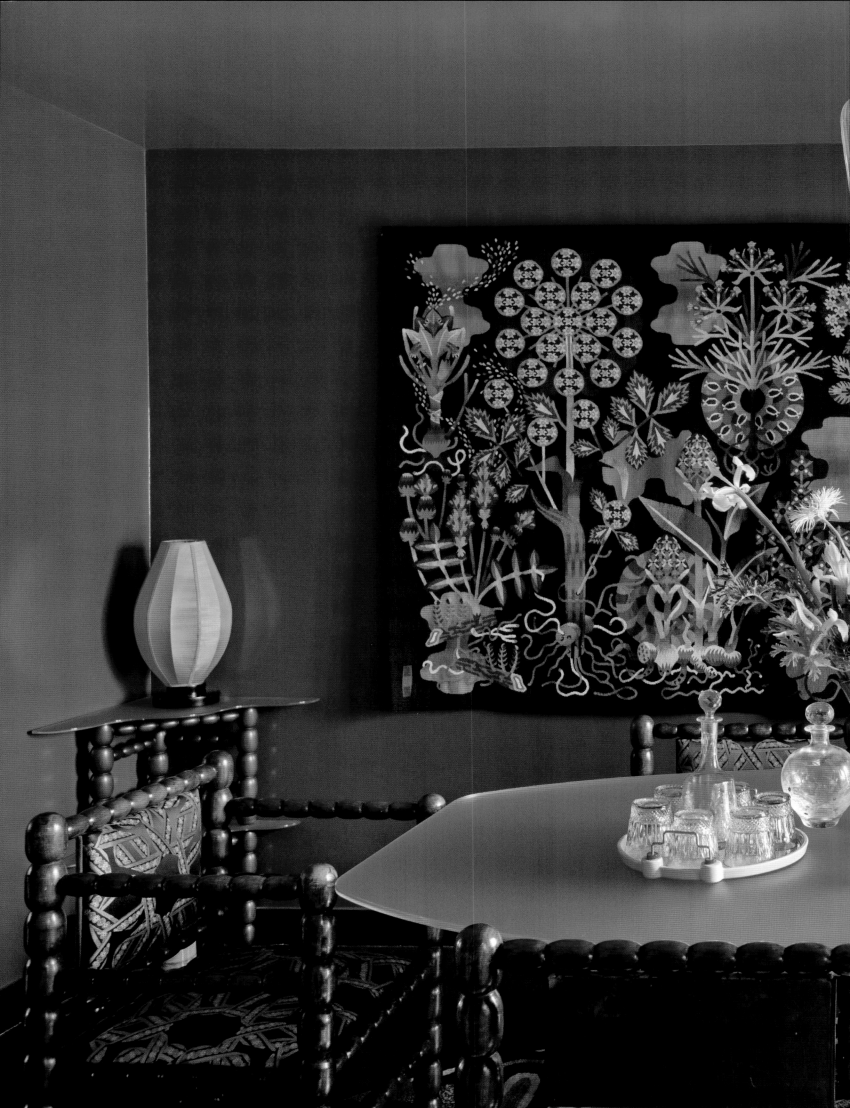

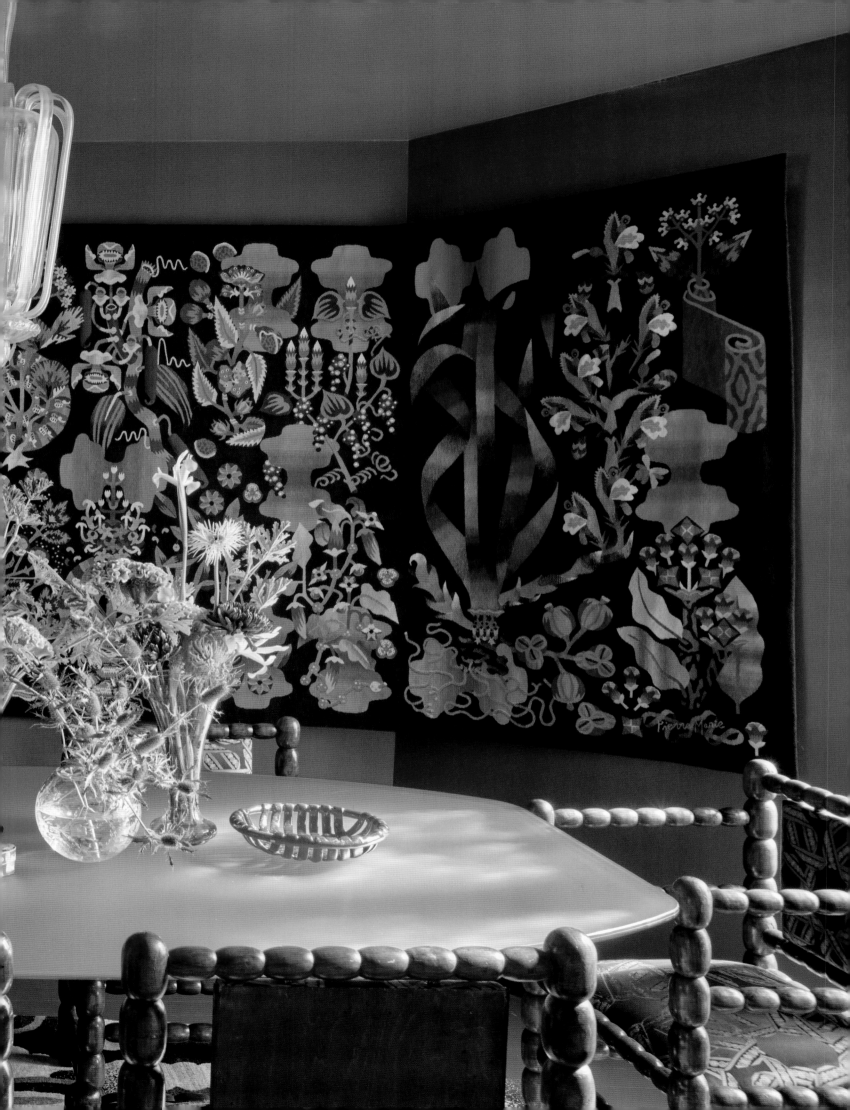

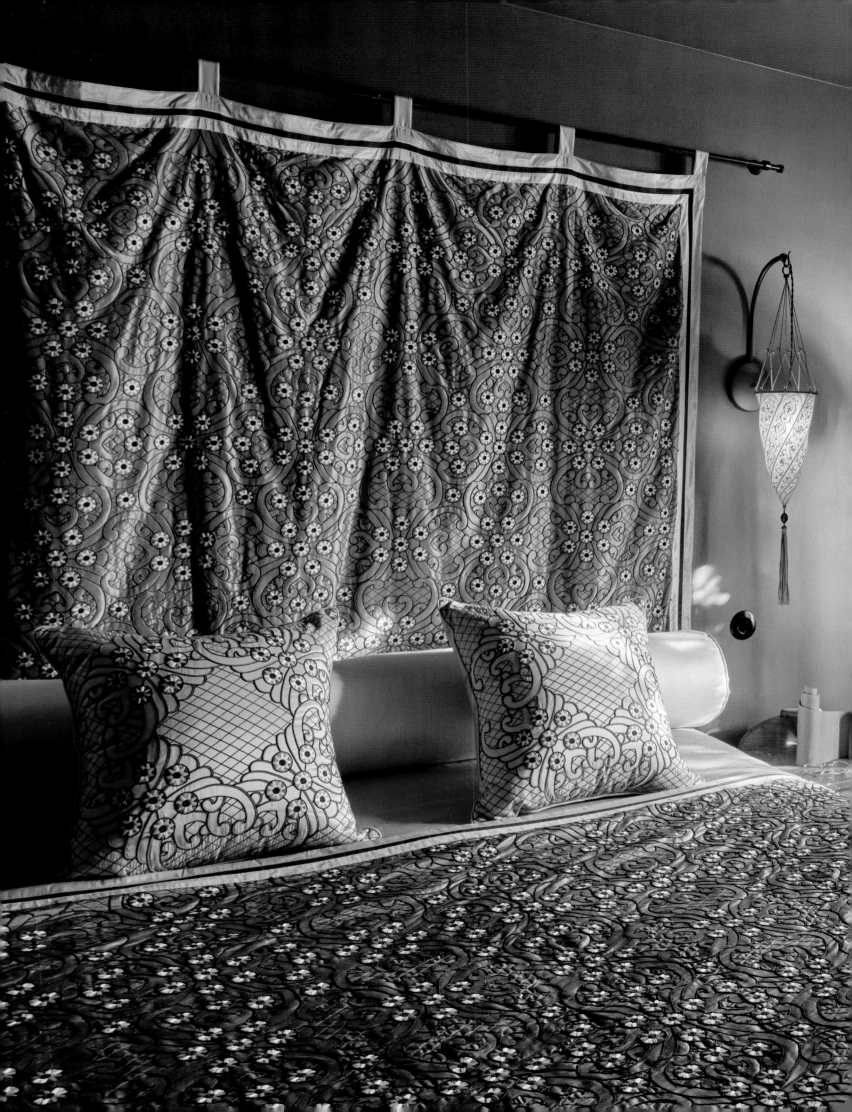

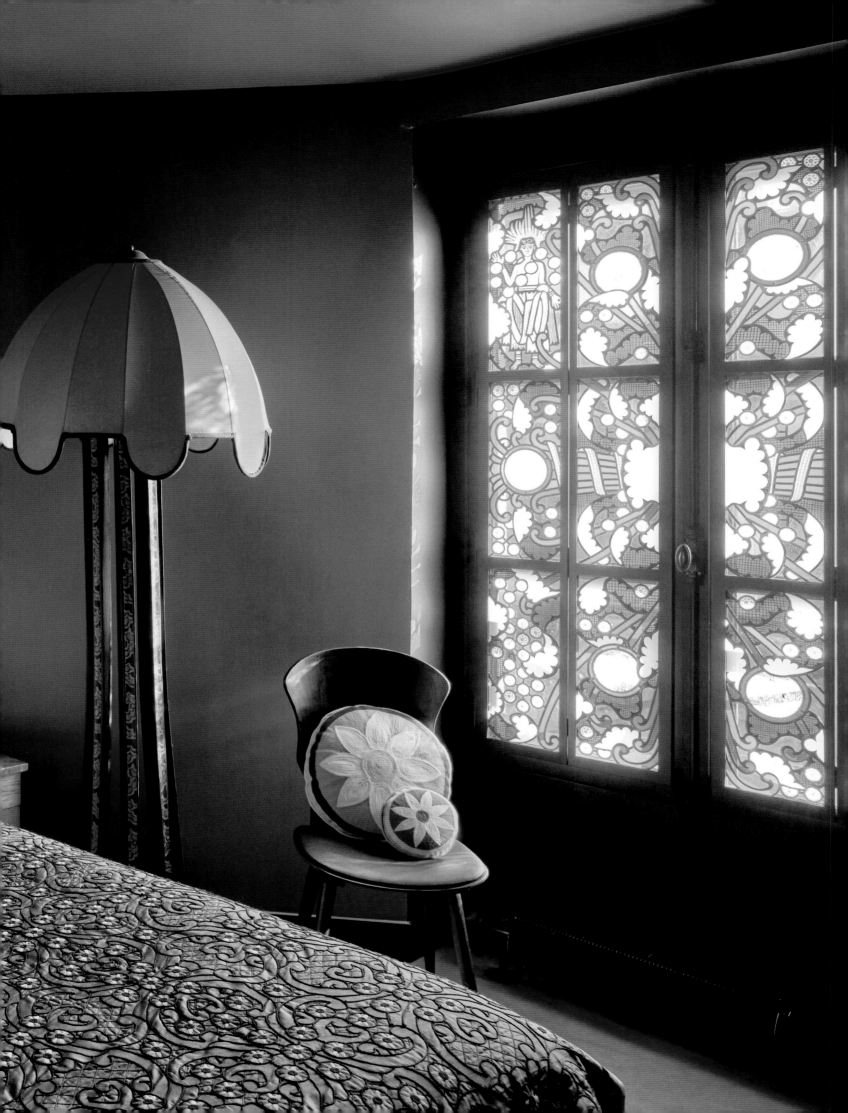

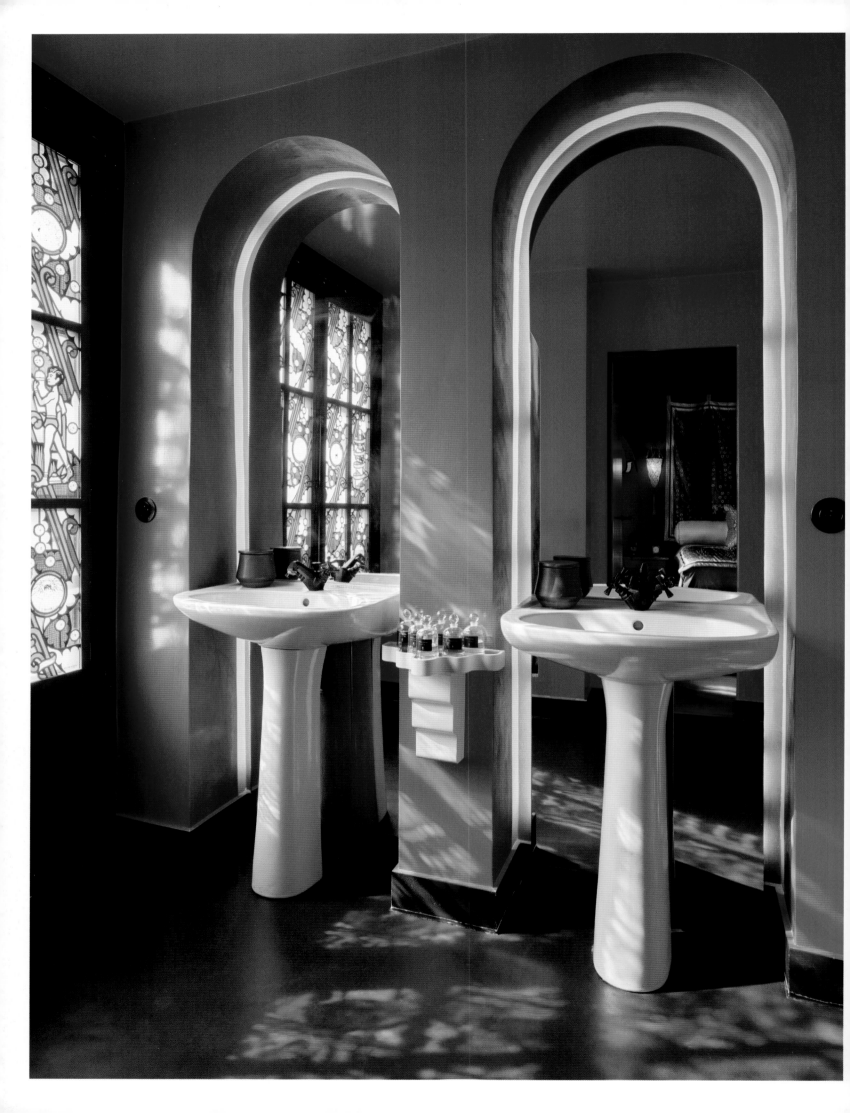

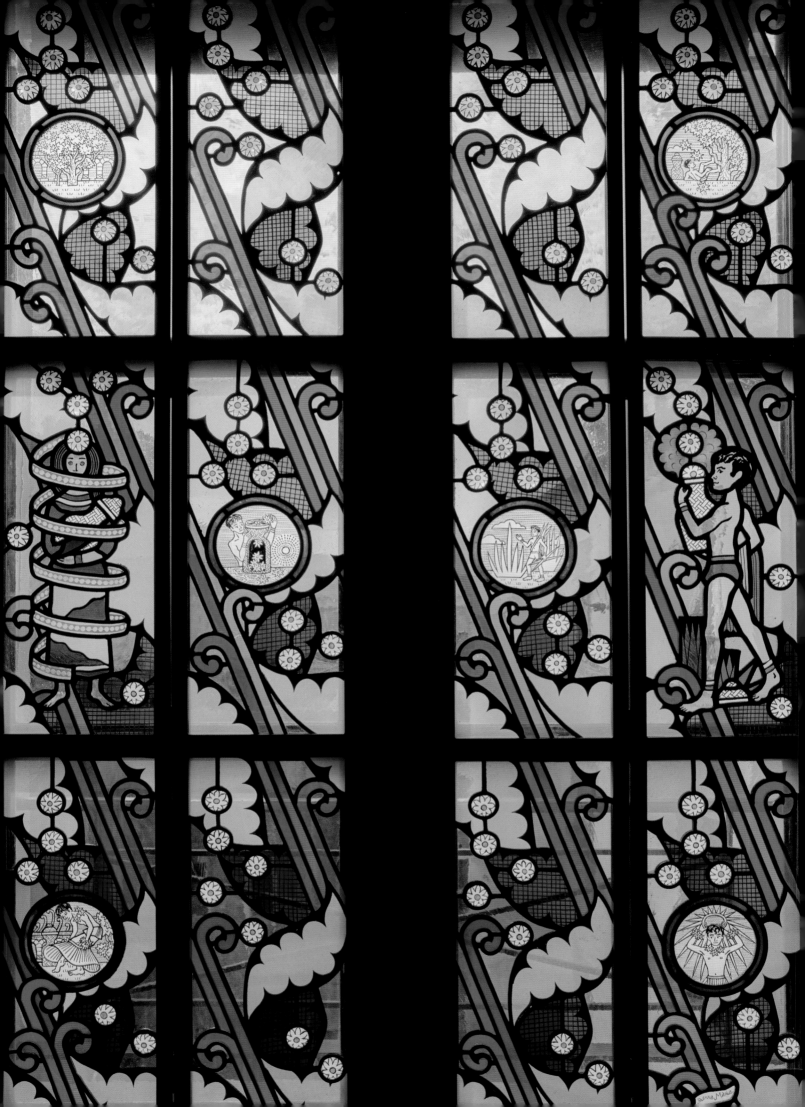

VISIONARY/ BEAUTIFUL/ INSPIRING.

ALEXANDRE DE BETAK

Alexandre de Betak is the kind of individual who meticulously plans everything. His lifestyle is marked by beauty, and he knows how to create it from scratch if necessary. Renowned for his fashion productions, he engages in architecture and interior design with the same enthusiasm and professionalism, with a highly personal taste that does not follow trends. After a significant restoration effort, Alex turned an office building on the banks of the Seine into the perfect home for his children Amaël, Aidyn, and Sakura, his wife Chufy, and himself.

Alex ensured that the classical seventeenth-century architecture was not a limitation when modifying and decorating the three levels of the house. He designed open spaces, taking advantage of the large windows and their direct views of the Seine and the interior courtyard. Furniture, objects, and art from different origins and cultures are distributed harmoniously throughout.

In the living room, Amanta sofas by Mario Bellini and a red Steltman chair by Gerrit Rietveld mix with pieces from the Saint Ouen flea market with total success. The staircase—a successful design by Alex—serves as a frame for the 1970s André Cazenave lamps piled in the corner. Alex loves entertaining, so an open kitchen was essential. The basement, which transforms into a cinema or disco depending on the occasion, is one of his favorite spaces.

The Japanese culture Alex admires is evident in his daughter Sakura's room, adorned with a hand-painted Japanese-inspired print that he designed, which has now been transformed into a wallpaper for Pierre Frey. But there are still more worlds to explore within this house, such as the office and its treillage, which supports a vine that dominates the environment and makes one forget the urban surroundings for a while.

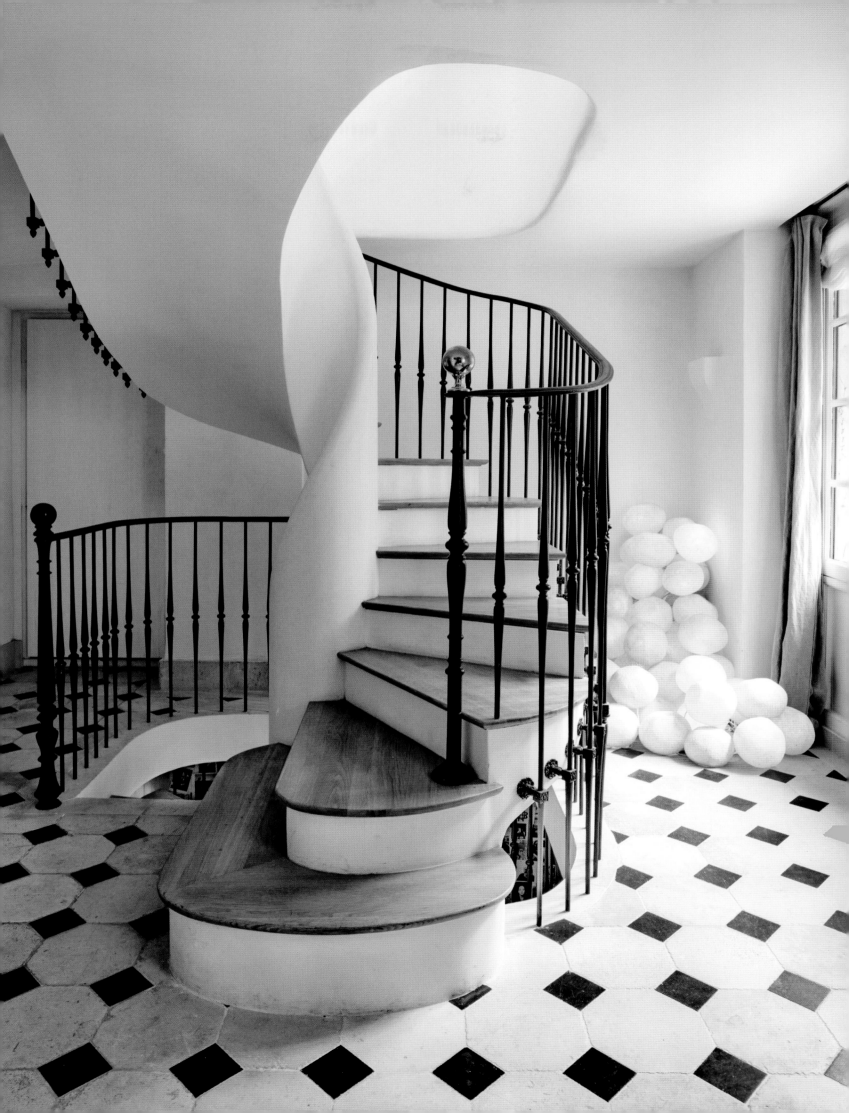

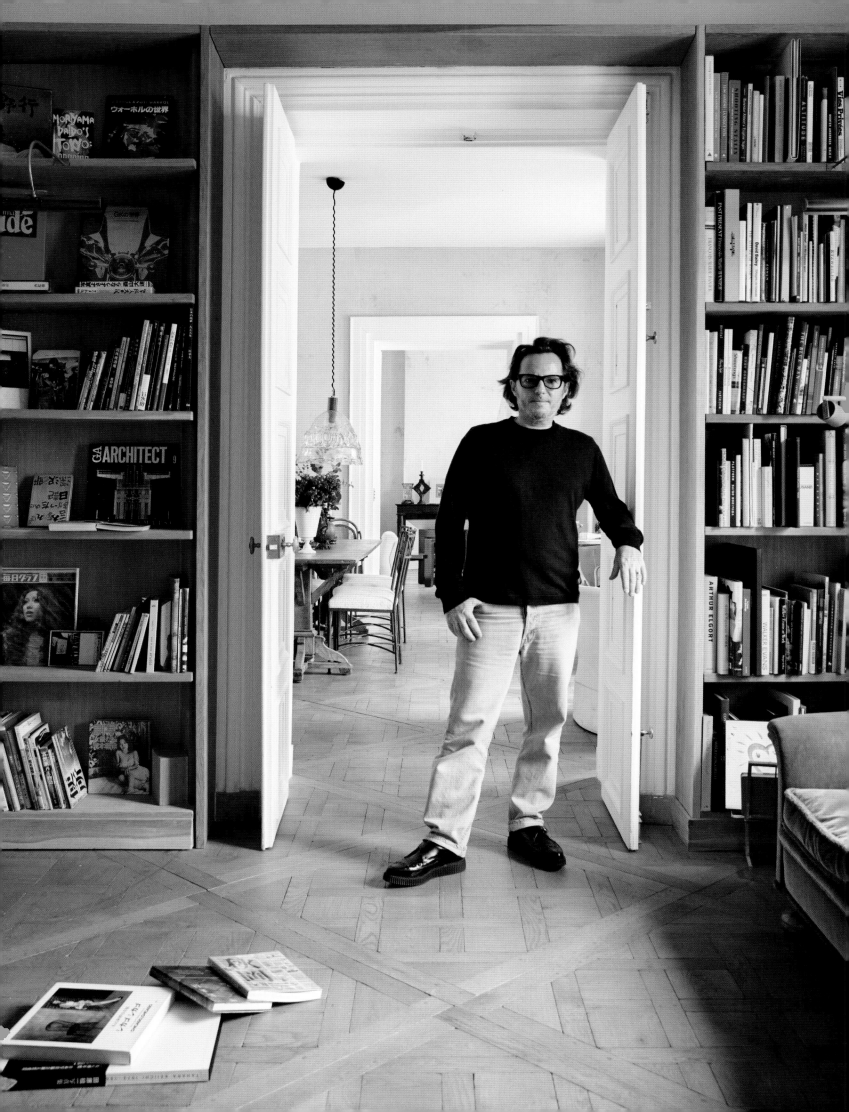

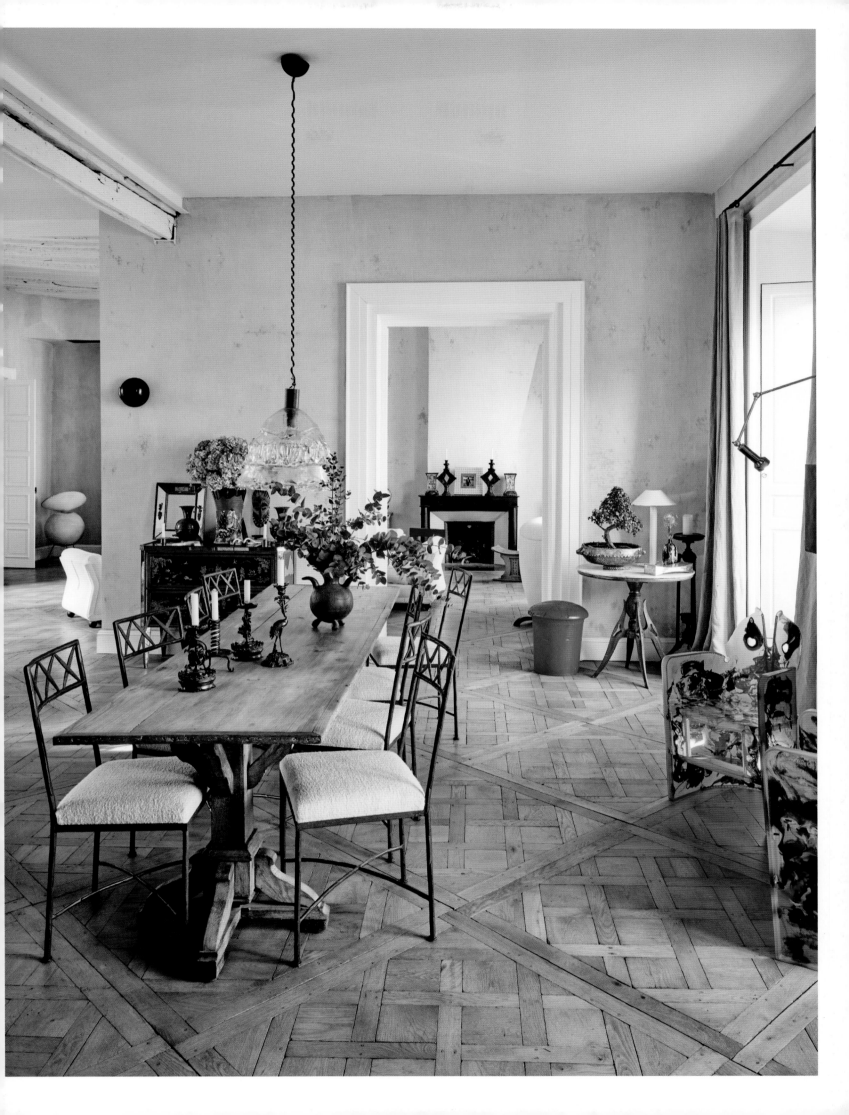

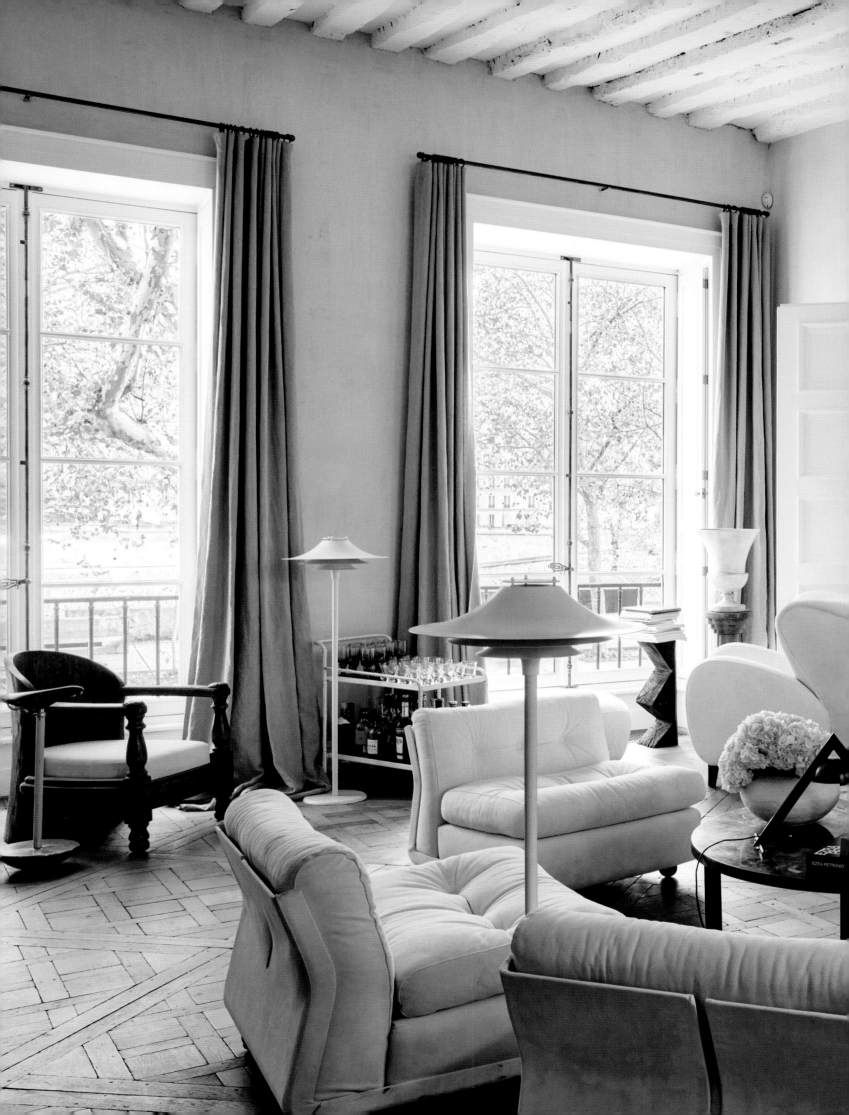

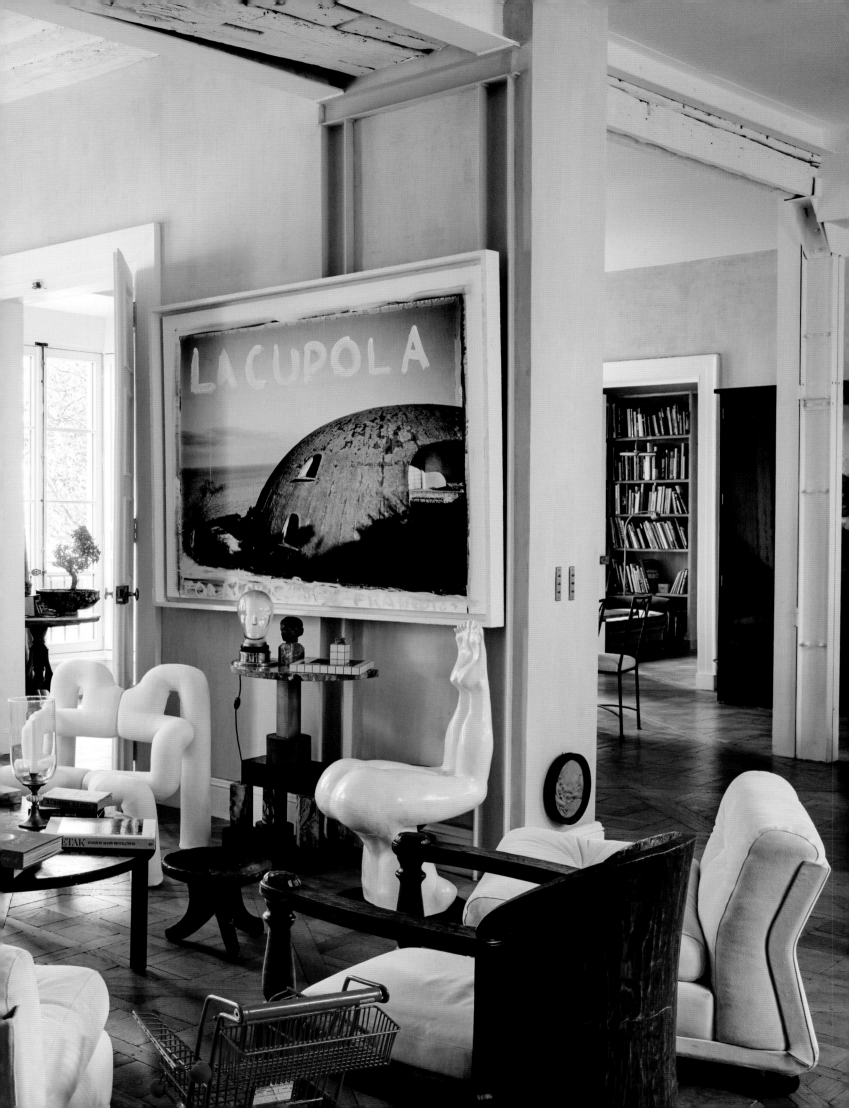

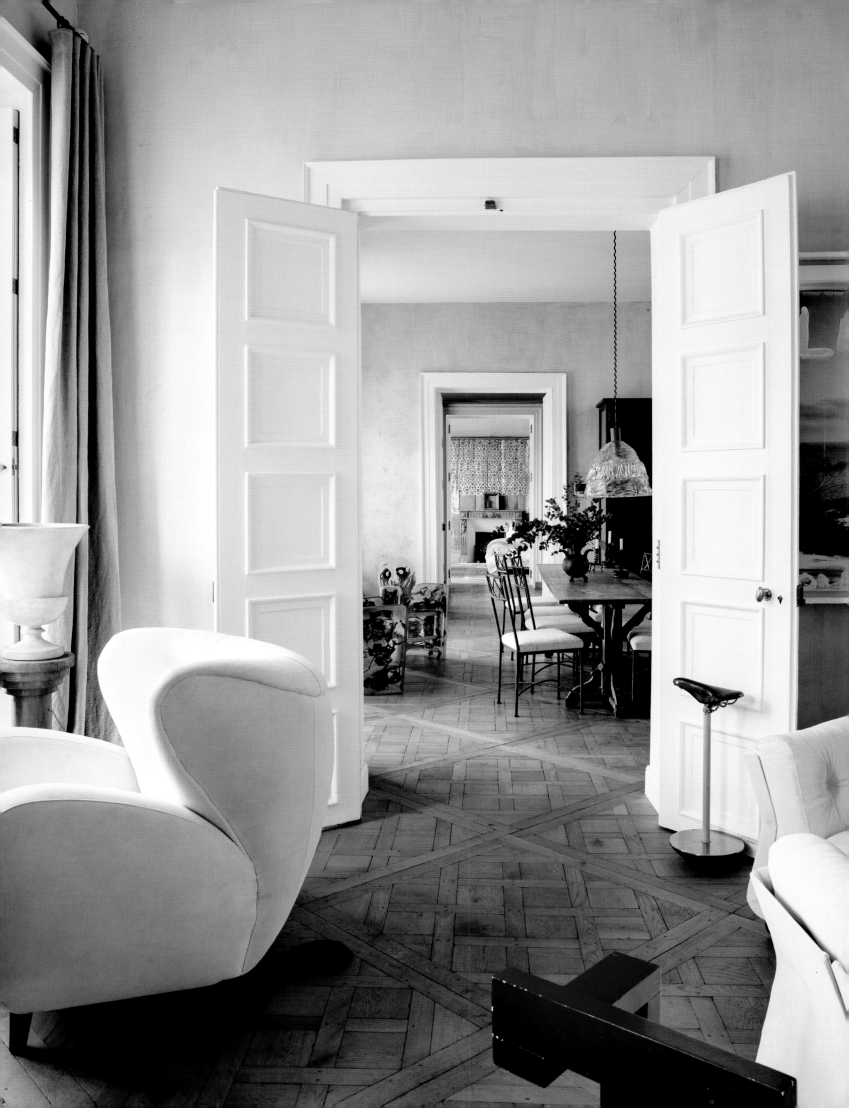

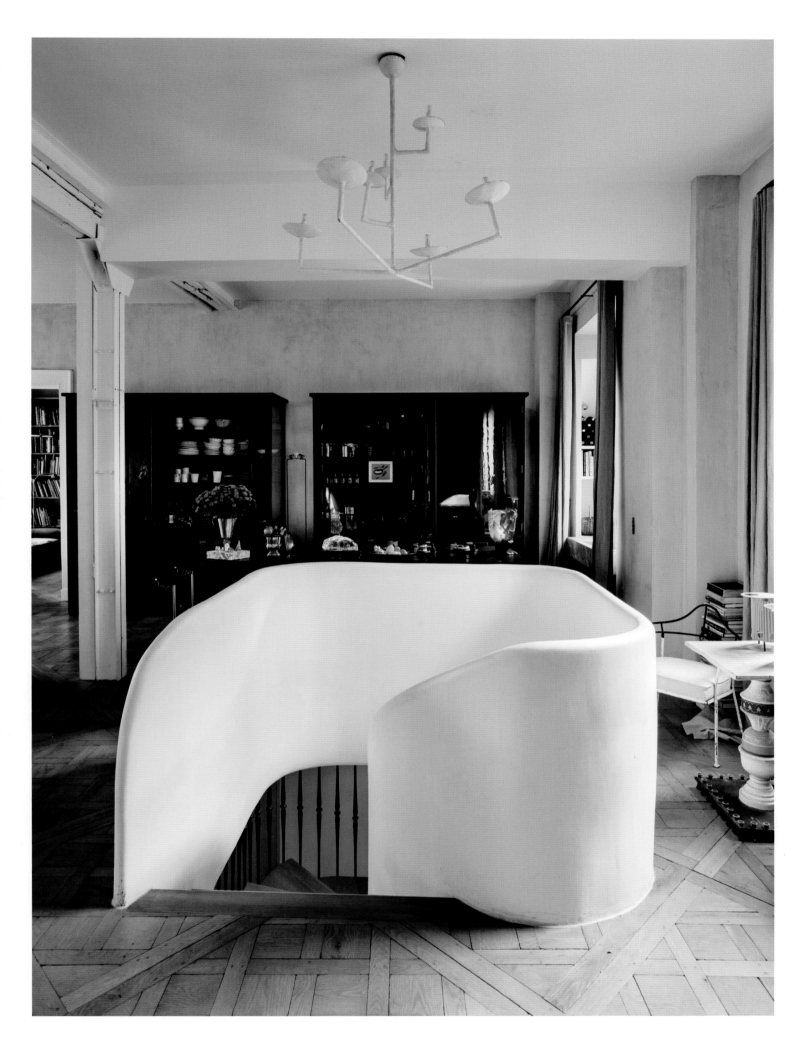

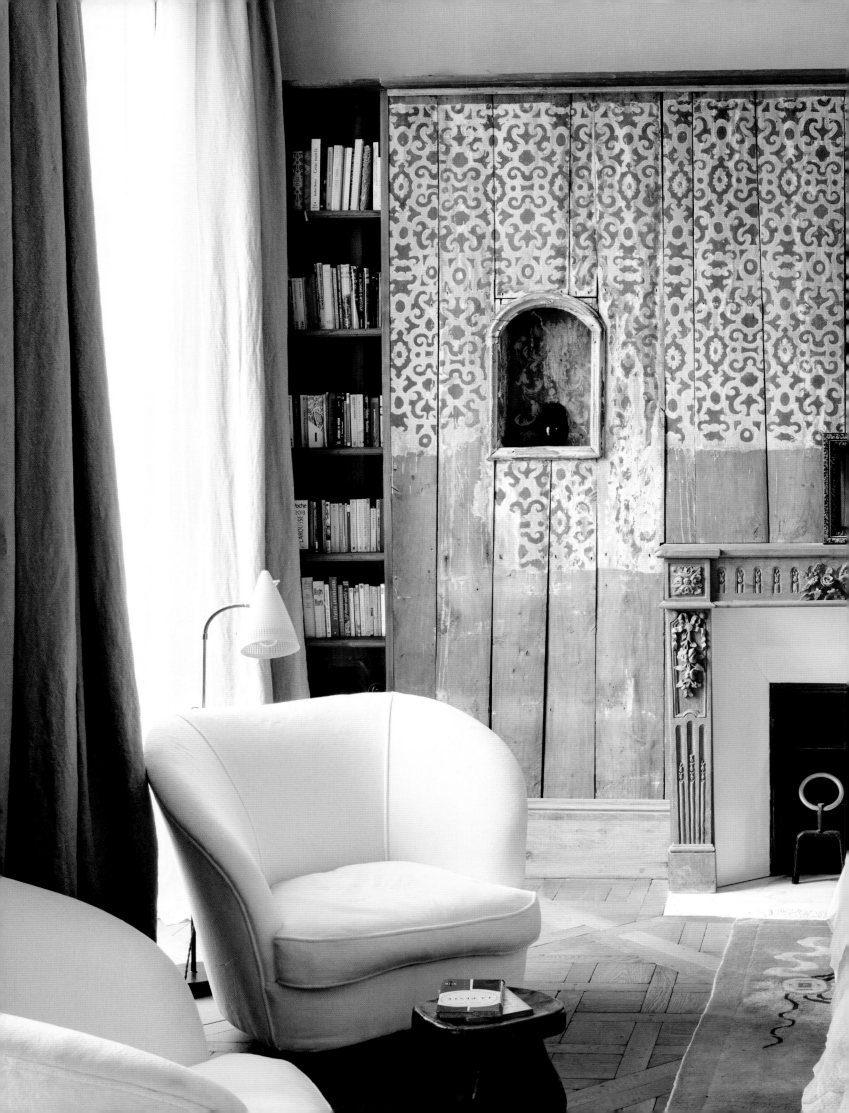

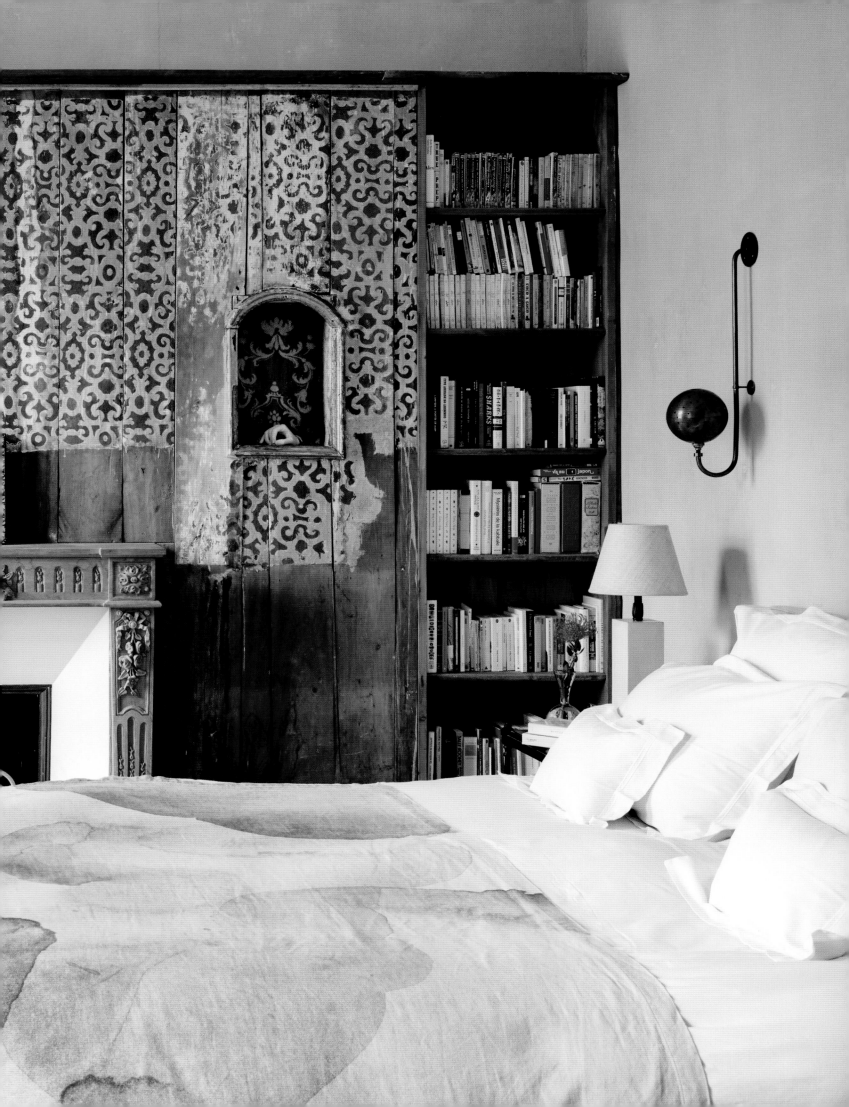

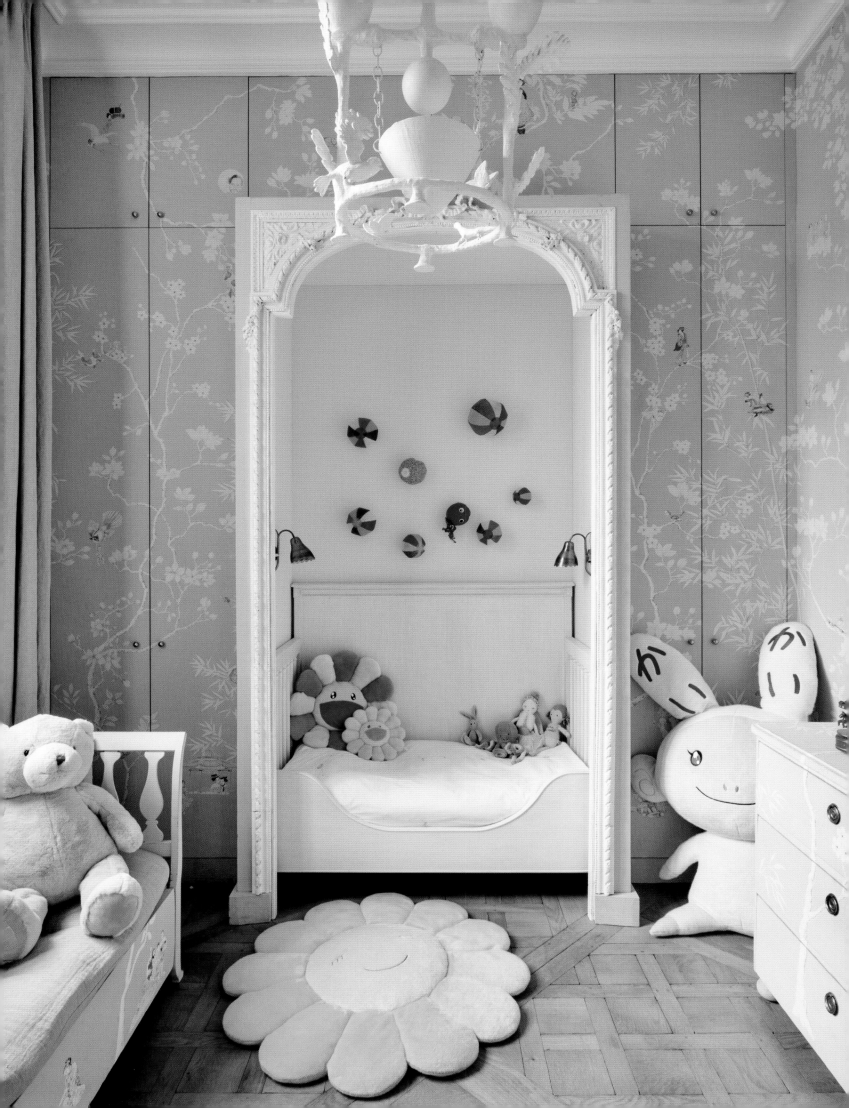

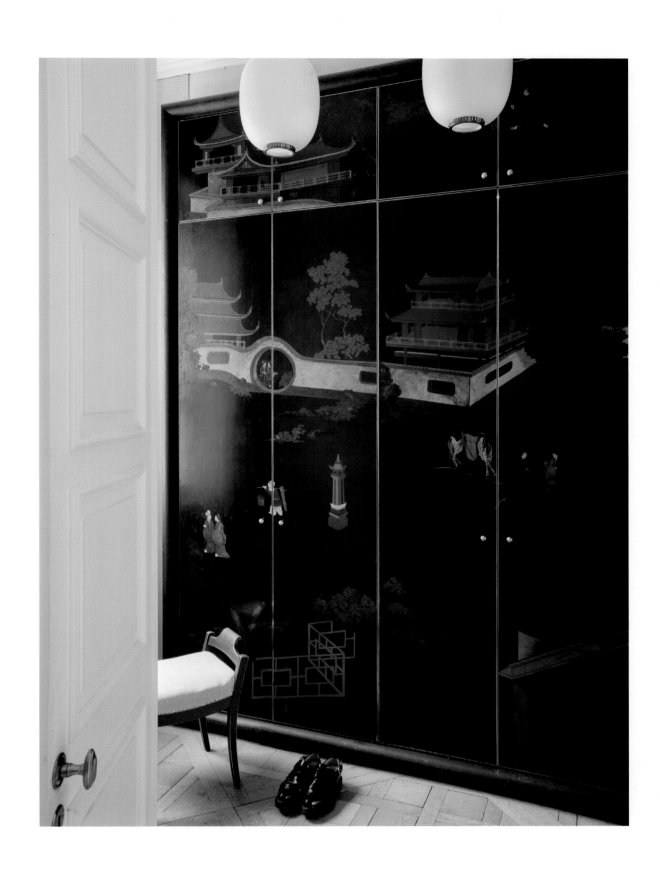

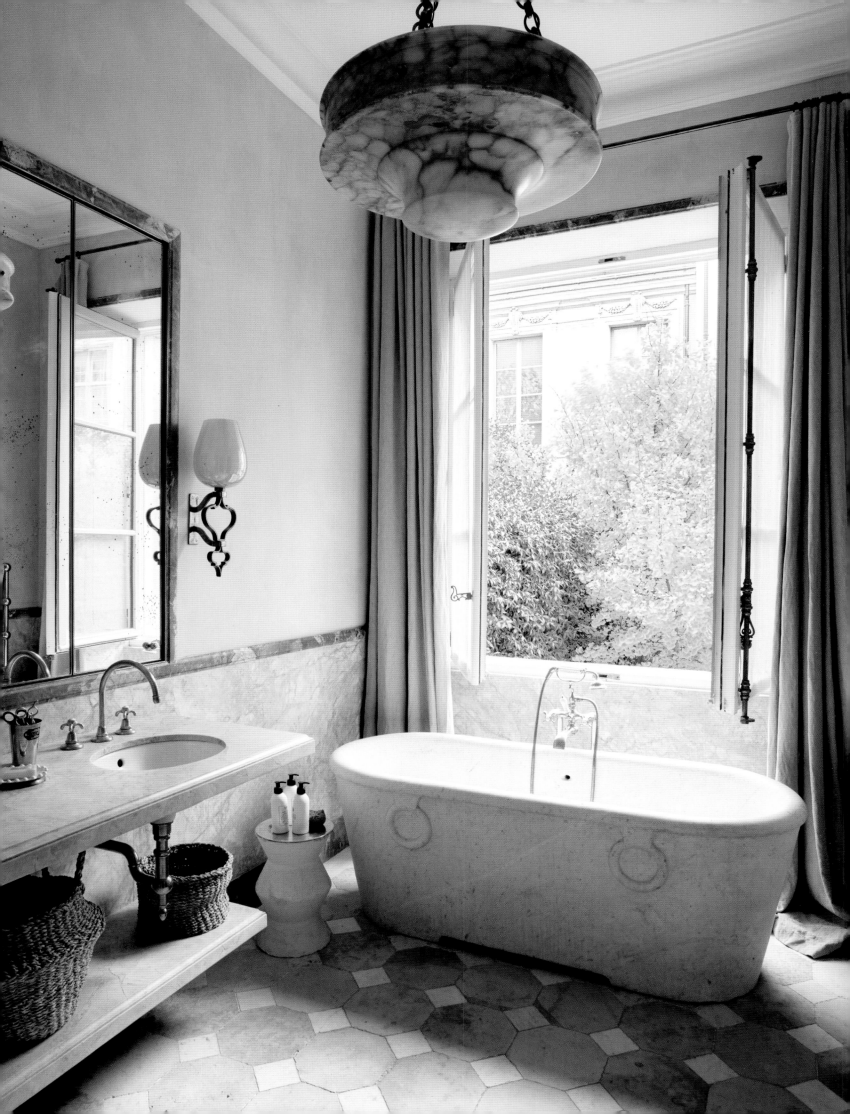

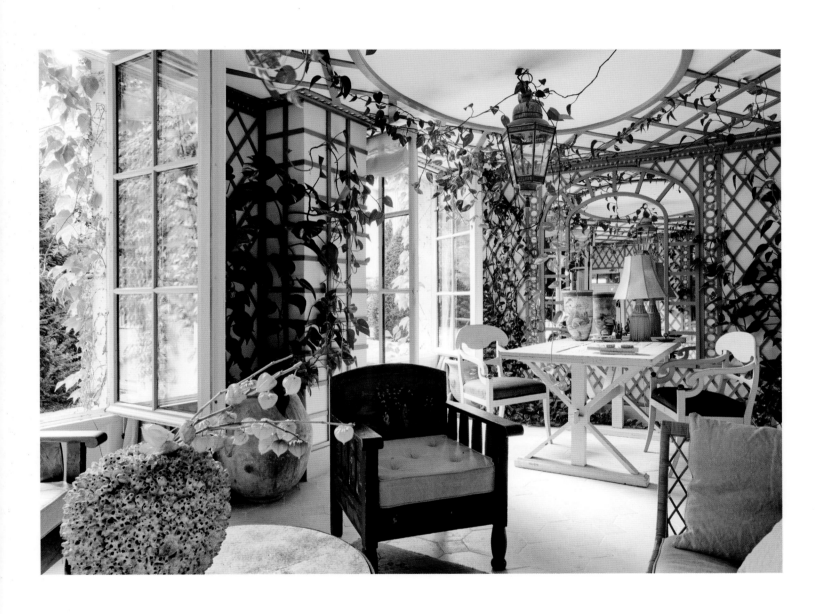

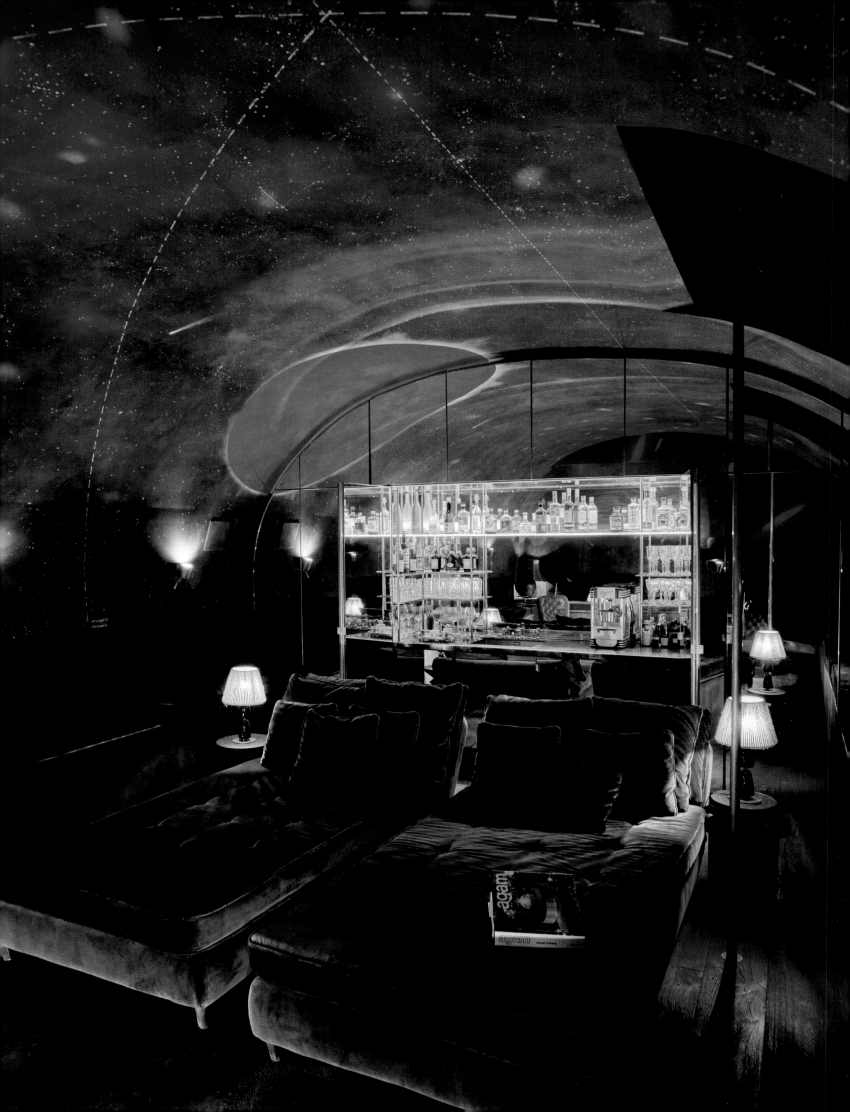

CALM/
FLOWING/
CURATED.

EMMANUEL DE BAYSER

Emmanuel de Bayser describes himself as a lover of art and interior decoration. He grew up in a family where art was a central part of his upbringing, shaping his future. Besides advising on these topics, he also runs a fashion and design concept store in Berlin. However, his heart lies in Paris, specifically in the 8th arrondissement near Parc Monceau and the Musée Nissim de Camondo. This neighborhood, which he considers quintessentially Parisian, boasts wide avenues and classic Haussmann-style buildings.

His home is located on the main floor of one of these buildings, and its size, layout, and ceiling height convinced him it was the perfect place to retreat to at the end of each day. When choosing where to live, his priority was to find a space that that would allow him to make a feature of his collection of iconic mid-twentieth-century furniture. Emmanuel describes his style as eclectic minimalism, blending contemporary art with antique sculptures, ceramics, and design. He chose white and cream colors for the ceilings and walls to promote calmness and enhance luminosity, amplifying the loft-like feel of the house, where spaces flow naturally into one another.

The formal and imposing building entrance, typical of Haussmann's architecture, contrasts with the softness and serenity experienced upon entering Emmanuel's home, where a comforting atmosphere envelops visitors. From there, one can't help but enjoy his collection, spread throughout the house. In the living areas, there are pieces by French masters, armchairs by Jean Royère, a green and white painting by Daniel Buren, an energizing piece in red by Arnulf Rainer, and one in blue by Anish Kapoor, among others. The dining area features a table and chairs by Jean Prouvé, and a shelf by Charlotte Perriand. These iconic pieces are capable of transporting one back decades, yet reflect a timeless modernity.

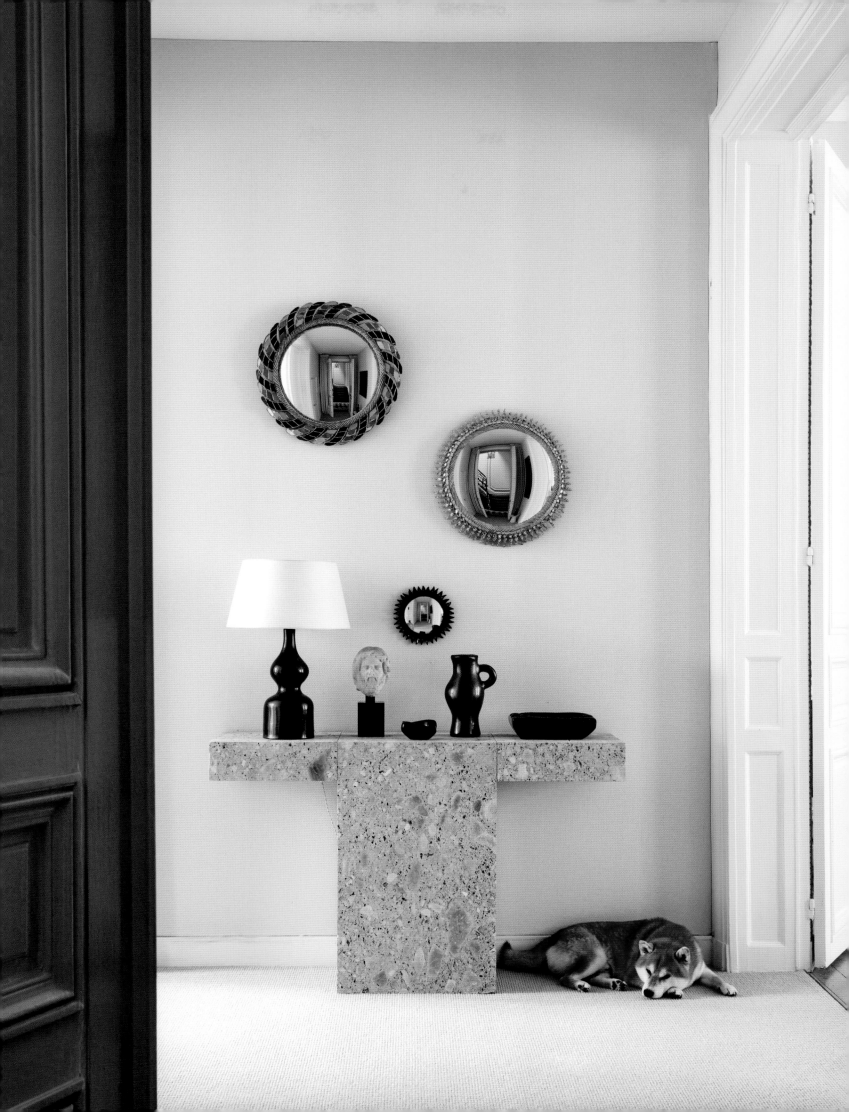

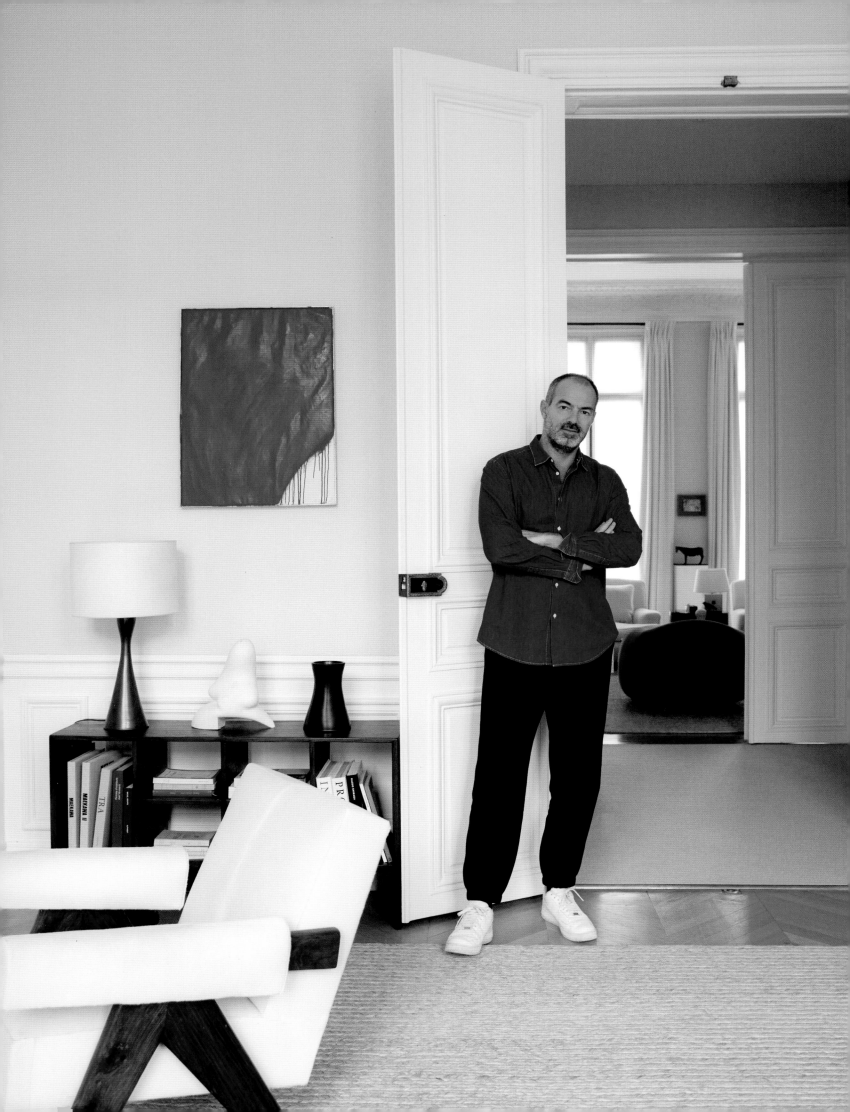

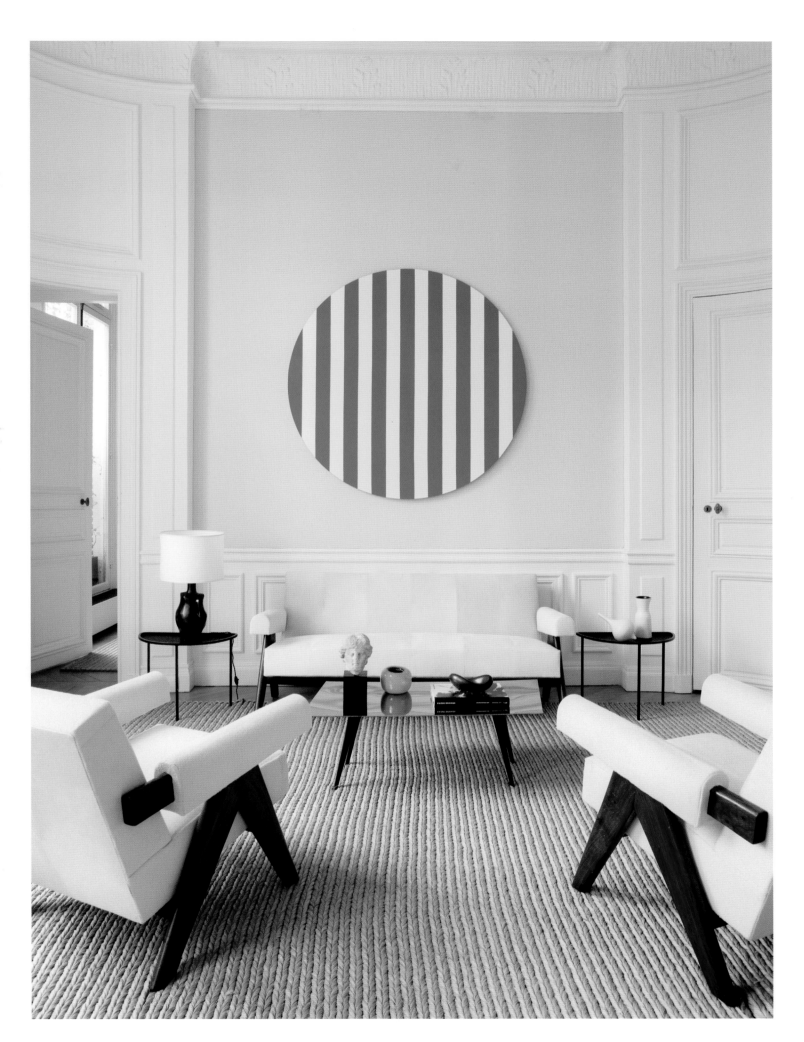

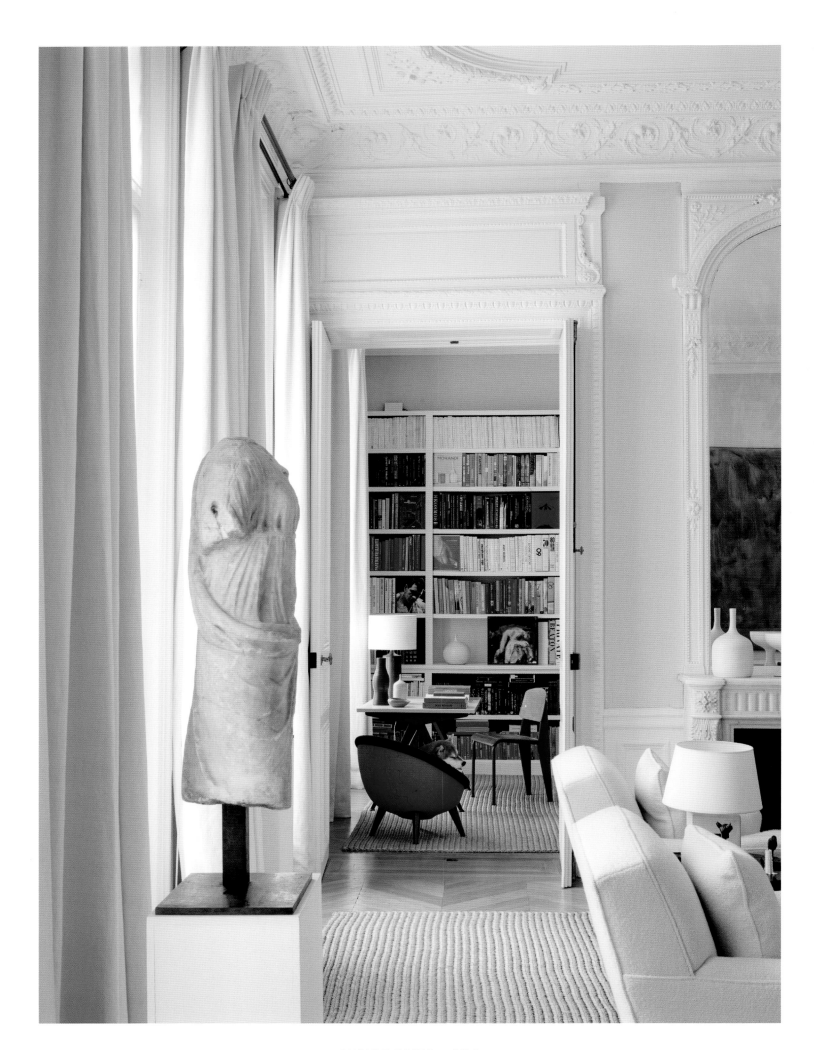

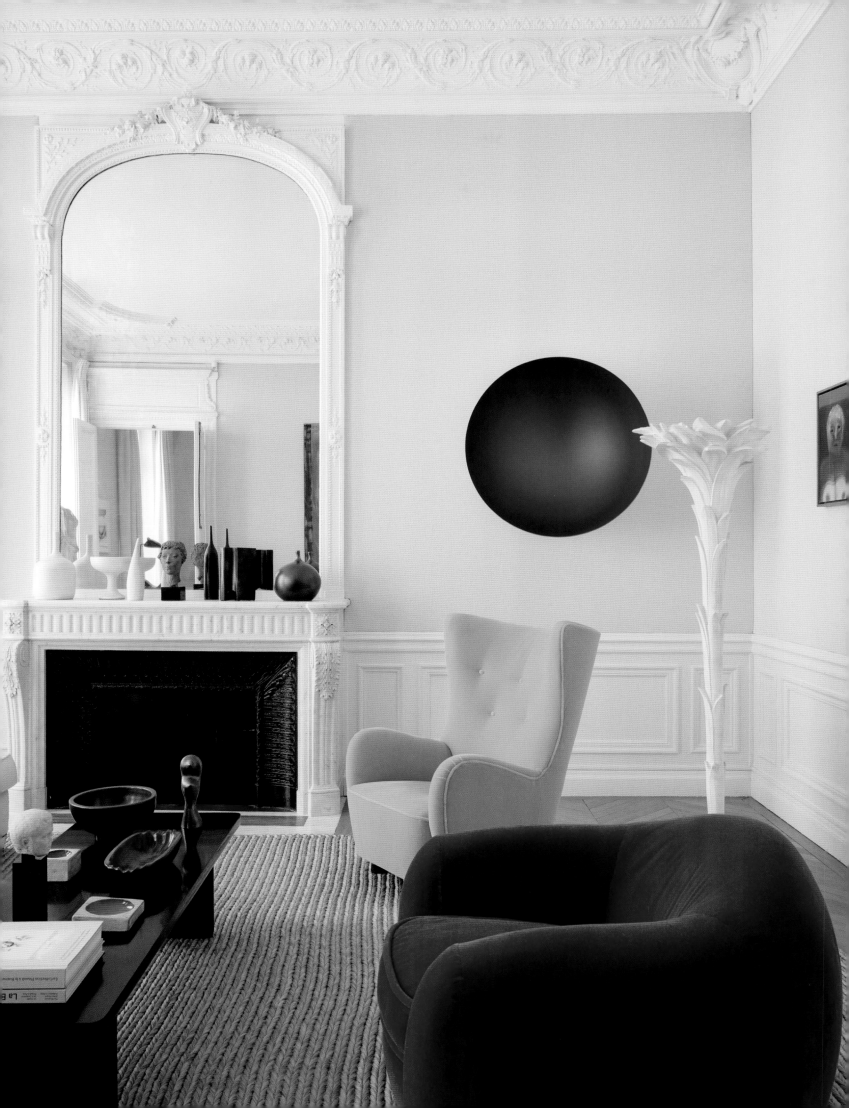

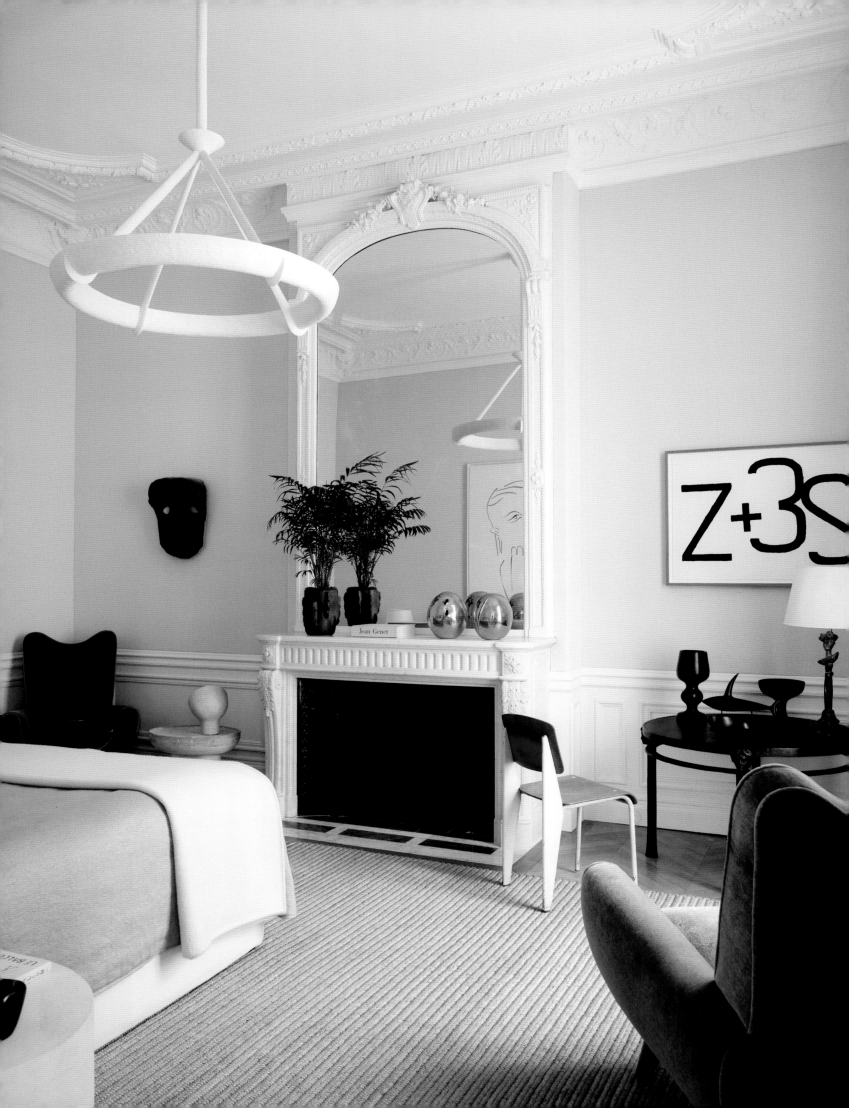

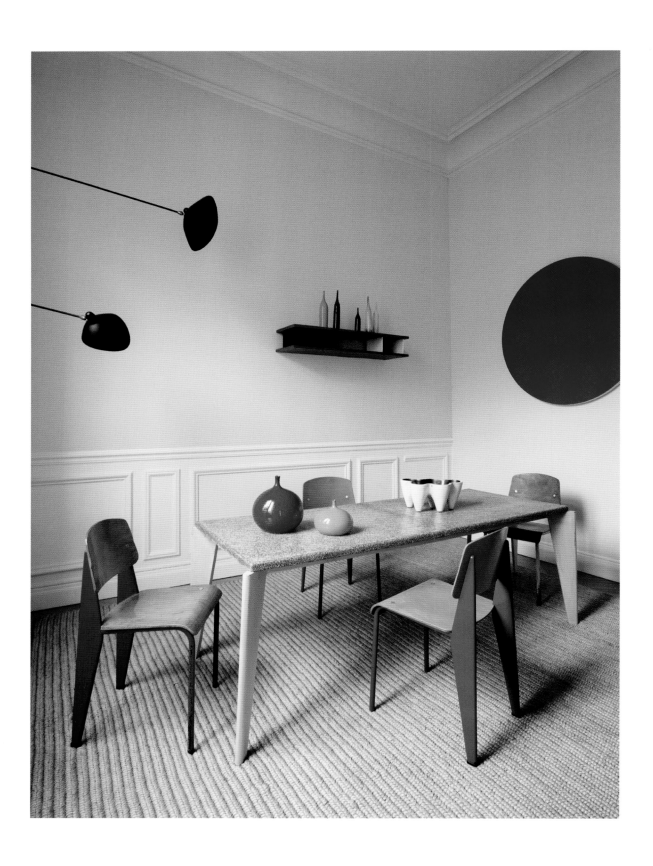

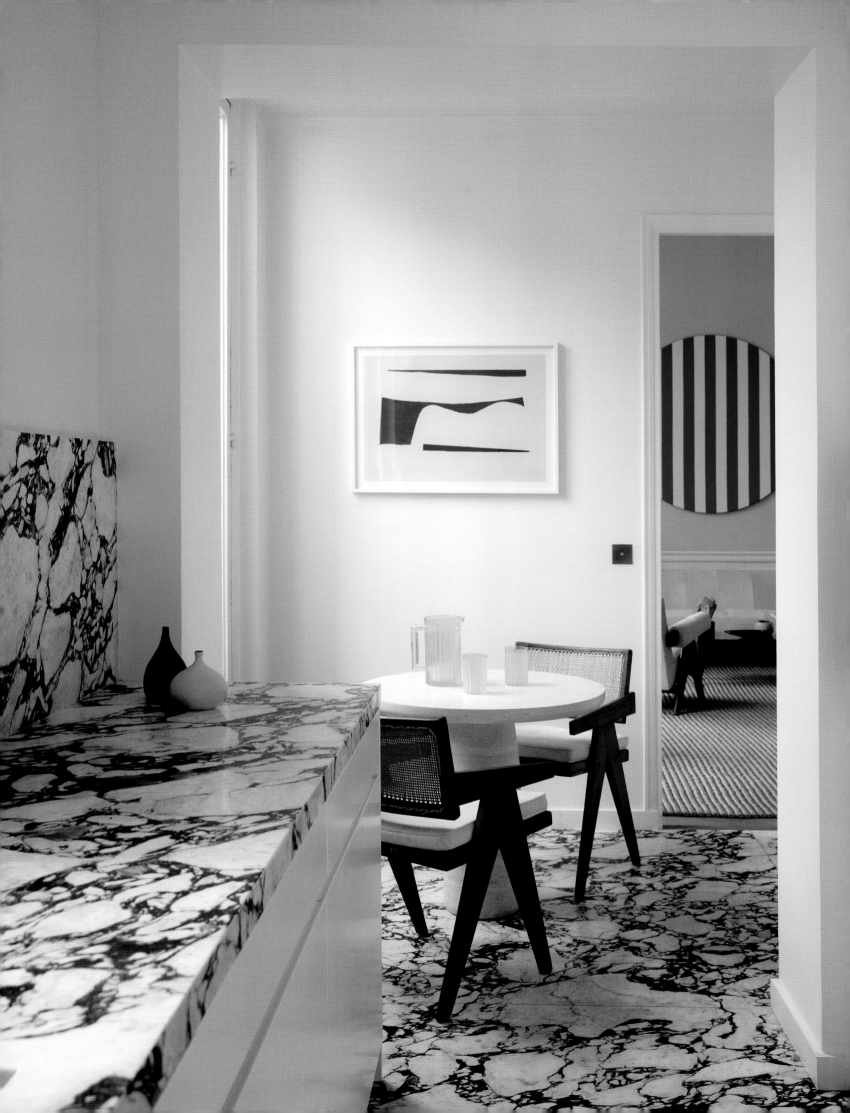

ROMANTIC/ COZY/ ENDURING.

FABRIZIA CARACCIOLO

As I was nearing the end of my tour of Paris, Mathilde Favier told me that her friend Fabrizia Caracciolo was finishing decorating her new pied-à-terre in the 7th arrondissement. Fabrizia lives between Paris and Italy, but her connection with France goes back to her days as a student here. She is a tireless traveler, and her nomadic and curious nature led her to a successful career as a journalist specializing in interior design and travel.

While we were taking photos, she told me that she and her husband found this apartment almost by chance. Marisa Berenson had lived here before, and its last owner was a close friend who had decided to sell it. When they saw the enchanting views, Fabrizia and her husband did not hesitate to turn the apartment into their new home.

The living-room sofas, which transform into beds when Fabrizia's daughters make unexpected overnight visits, are designed by the Piedmontese architect Toni Cordero. They are upholstered in turquoise, an atypical color for Paris but one that reminds Fabrizia of her childhood in Italy, and are complemented by her "Daisies"—cushions in David Hicks's Daisy Daisy fabric—and her collection of Sainte Radegonde vases. The mirrored panels of the cabinets on the wall opposite the fireplace, designed by her friend Ashley Hicks, extend the space without sacrificing charm.

The bedroom is covered in a mix of Indian fabrics from Simrane, one of her favorite stores in Paris; above the bed hang drawings by Cocteau. The kitchen is a minimal space that gains its personality from a Beata Heuman fabric wallpaper reminiscent of eighteenth-century ceramic designs. Here and there, objects collected by Fabrizia and her husband complete the home with a personal touch. All that's left to do is relax and enjoy the views of the Esplanade des Invalides and the towers of Sainte-Clotilde in the distance.

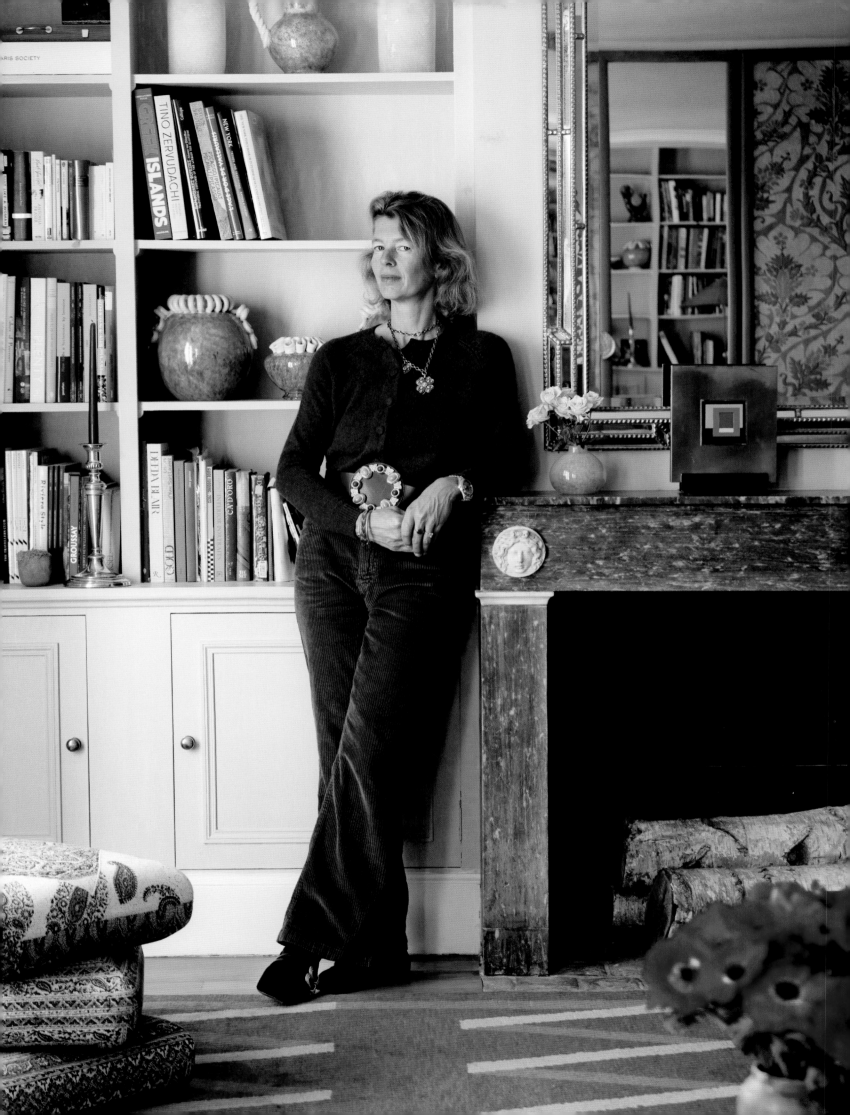

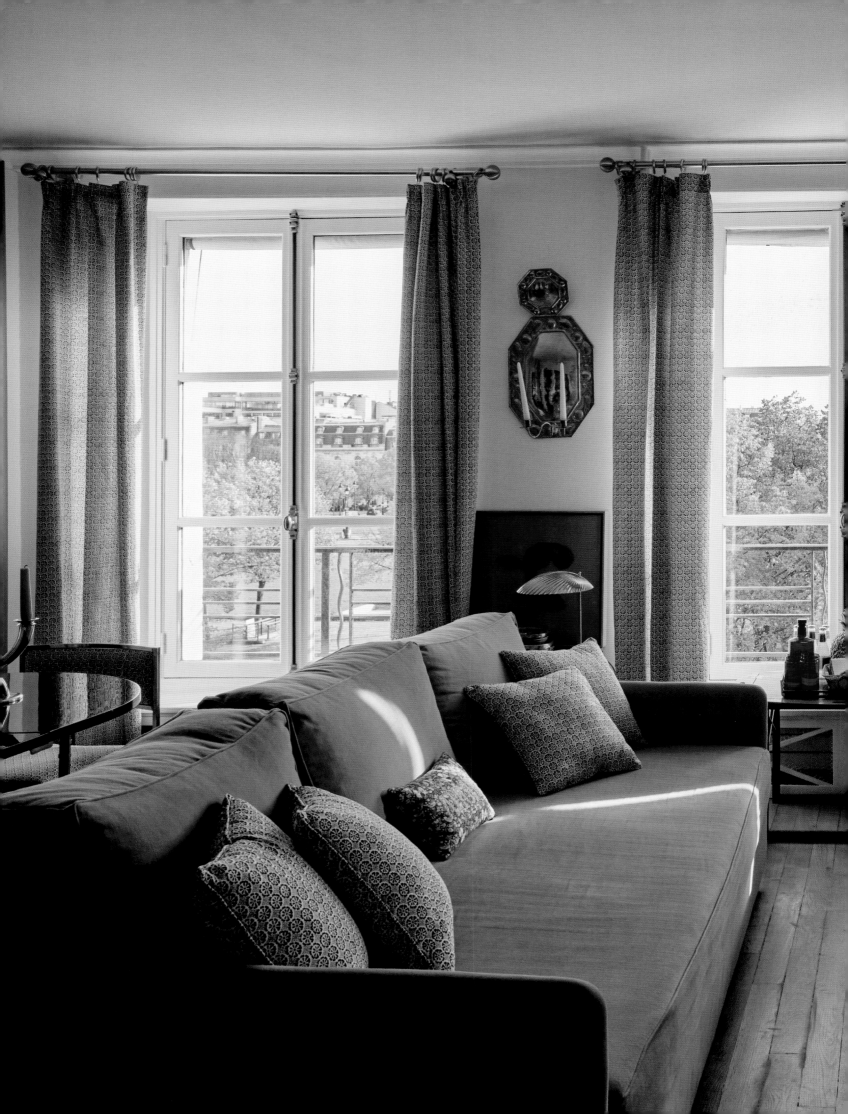

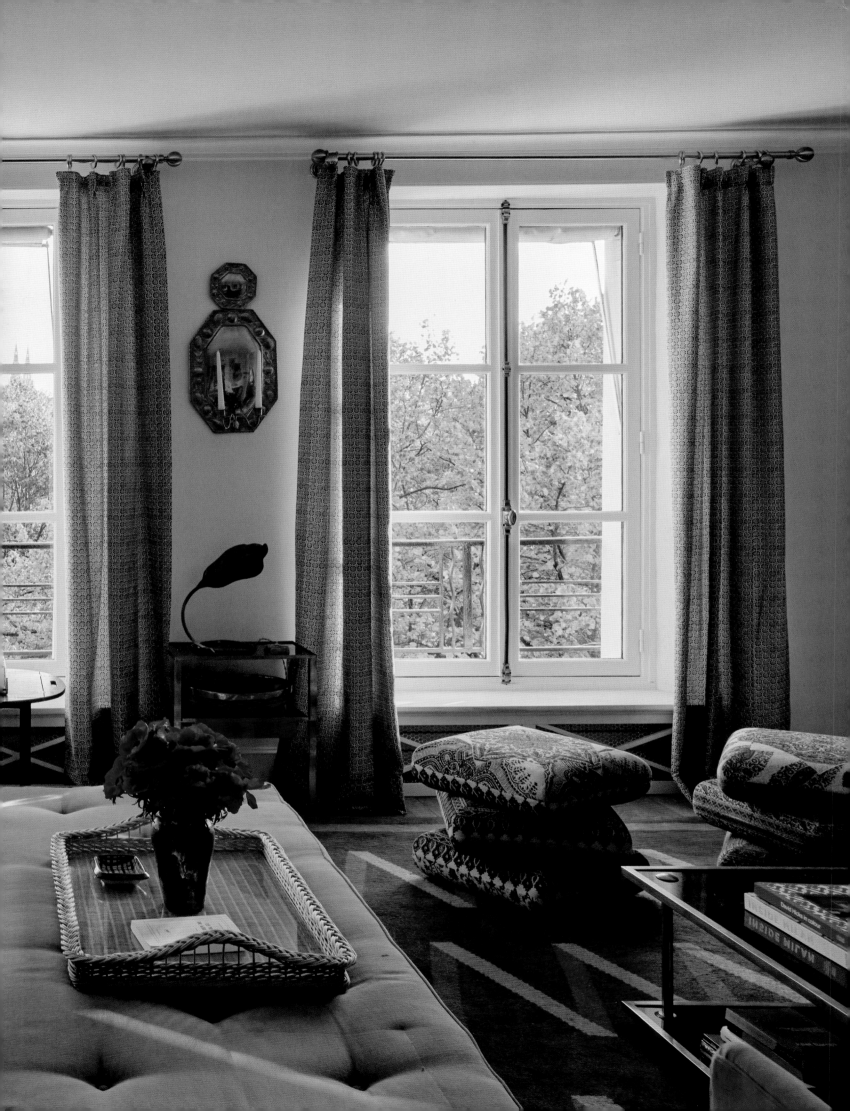

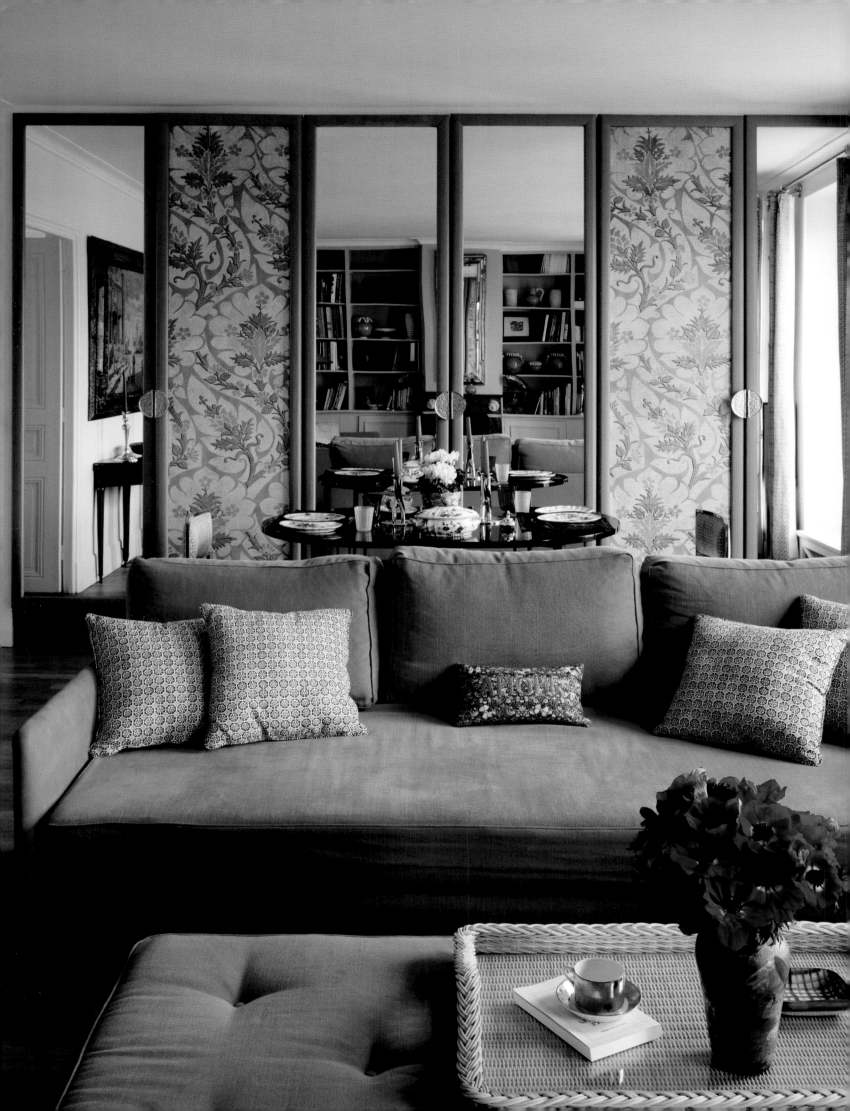

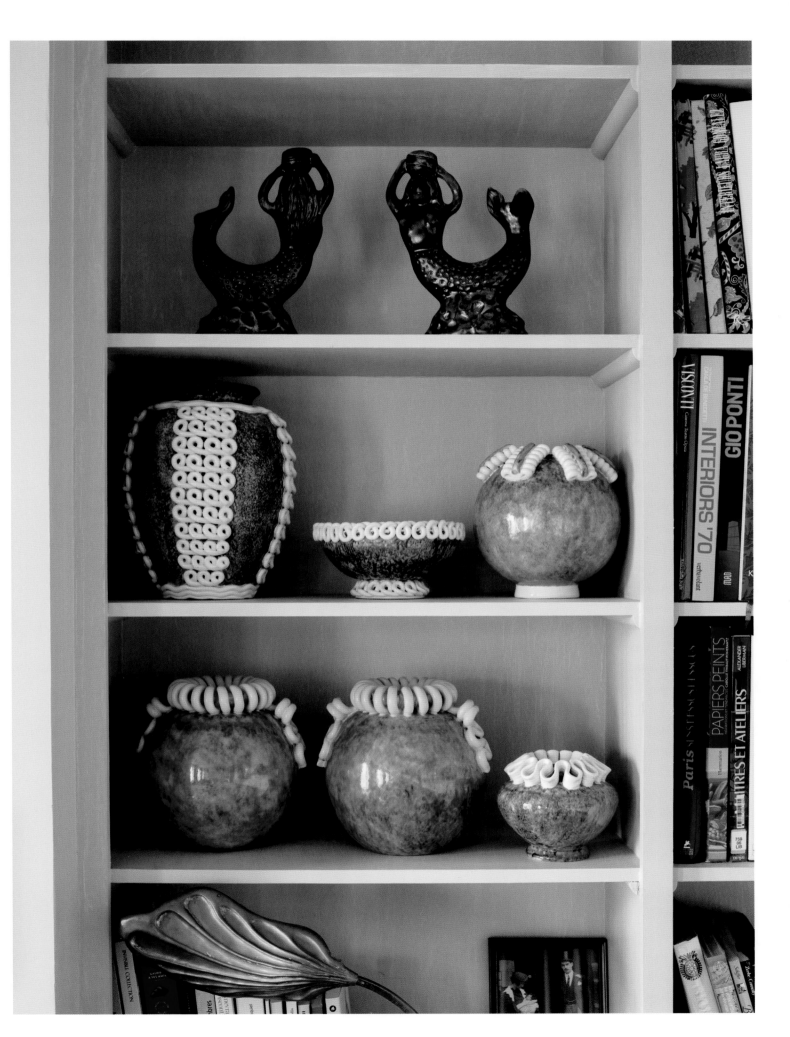

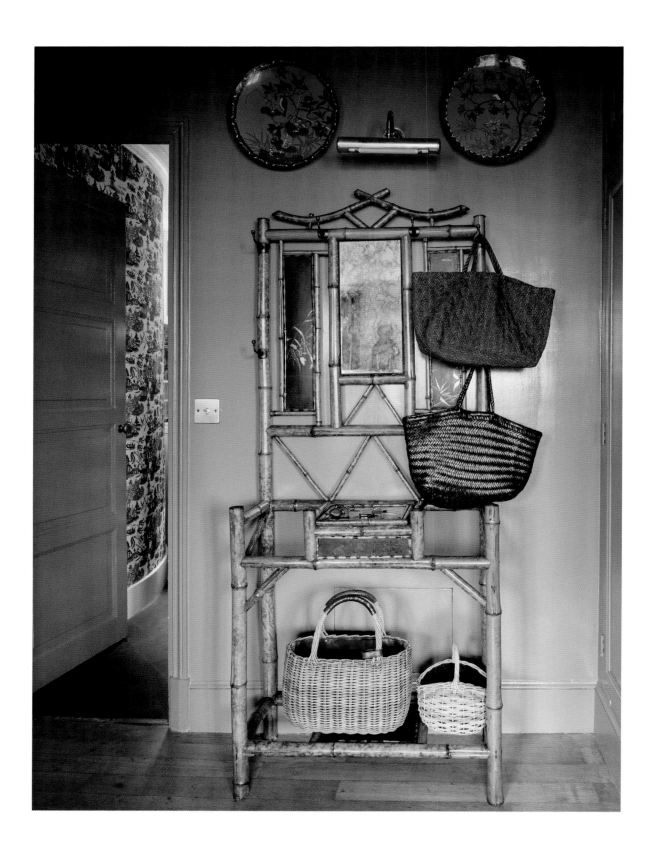

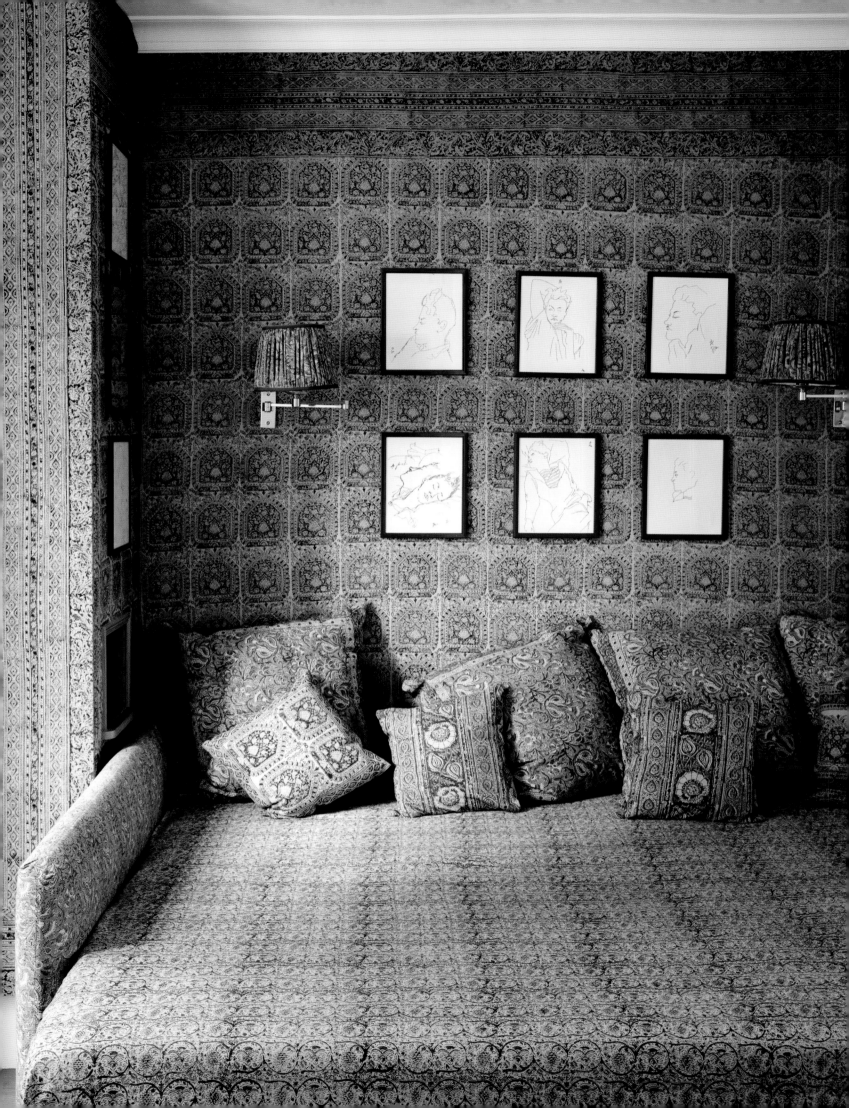

ACKNOWLEDGMENTS

I would like to thank each one of the homeowners for allowing us these intimate glimpses of their talent and their lives. Thank you to everyone at Vendome Press involved in this project for their professionalism and dedication, especially my publisher, Beatrice Vincenzini, for her constant support and for trusting in me and giving me complete freedom to carry it out and designer Peter Dawson for his patience and great eye. Thanks also to Jodi Simpson for her brilliant job editing my words, and to Mathilde Favier for her lovely foreword.

Special thanks to all the publications around the world with whom I have worked for decades now—in particular, *The World of Interiors*. To Min Hogg, Rupert Thomas, Hamish Bowles, and my dear friends Marie-France Boyer and Jessica Hayns, thank you for making me love interior photography.

Thank you to my mother, Ana Ines, who has always been an inspiration and aesthetic reference with her passion for beauty. And, last but not least, thank you to Gustavo Peruyera, my partner, in life and behind every shoot.

ABOUT THE AUTHOR

RICARDO LABOUGLE has been shooting interiors and portraits around the world for more than twenty-five years. His ability to capture public and private spaces with a perfect balance of elegance and life was discovered by Min Hogg, the legendary former editor of *The World of Interiors*, in 1996. Since then, his work can be recognized throughout the international publications that count him as a regular collaborator, such as *The World of Interiors*, *Architectural Digest*, *Vogue*, *Elle Decor*, *Vanity Fair*, and *T* magazine. He has co-authored and photographed several books on interior design and architecture. His personal work has also been shown at galleries in Madrid, Milan, and Buenos Aires. He lives in Spain.

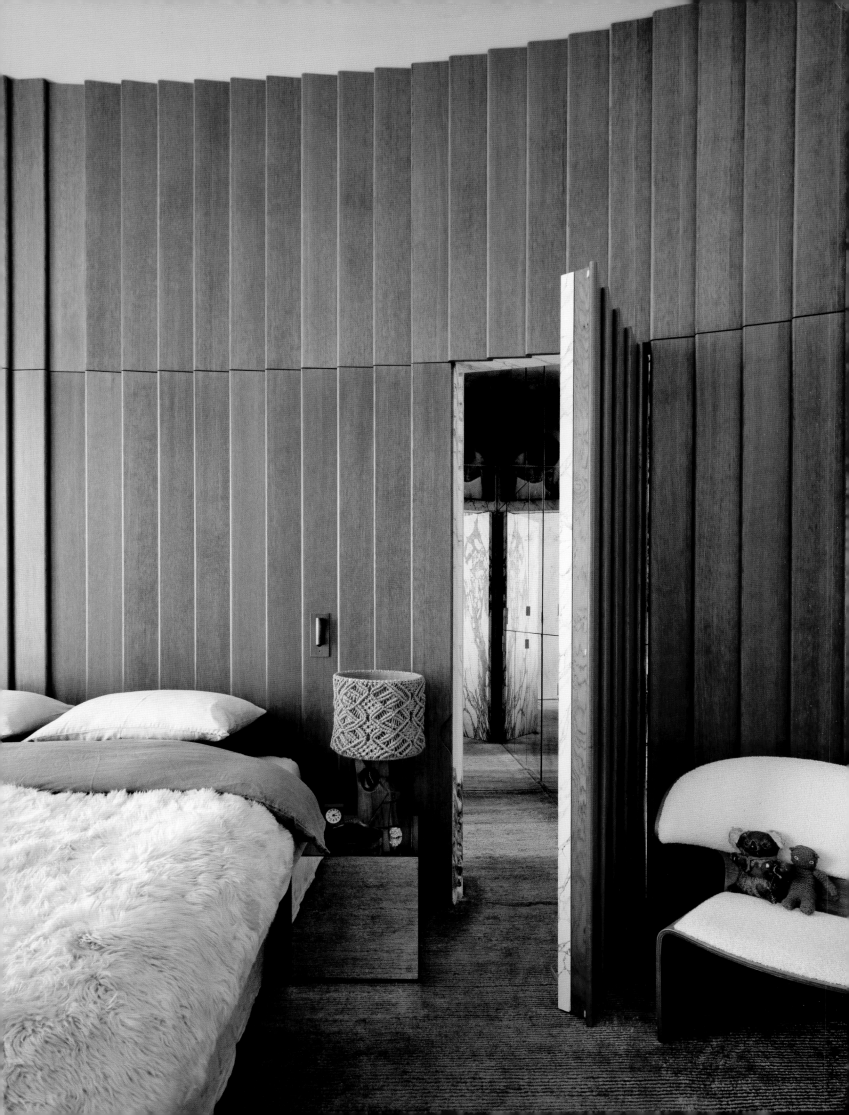

INSIDE PARIS
First published in 2024 by The Vendome Press
Vendome is a registered trademark of The Vendome Press LLC

VENDOME PRESS US
PO Box 566
Palm Beach, FL 33480

VENDOME PRESS UK
Worlds End Studio
132–134 Lots Road
London, SW10 ORJ

www.vendomepress.com

Distributed by Abrams Books

Every effort has been made to identify and contact all copyright holders and to obtain
their permission for the use of any copyrighted material. The publisher apologizes for
any errors or omissions and would be grateful if notified of any corrections that should
be incorporated in future reprints or editions of this book.

ISBN 978-0-86565-440-2

Publishers: Beatrice Vincenzini, Mark Magowan, and Francesco Venturi
Editor: Jodi Simpson
Production Manager: Amanda Mackie

Designer: Peter Dawson, www.gradedesign.com

Library of Congress Cataloging-in-Publication Data available upon request

Printed and bound in China by RR Donnelley (Guangdong)
Printing Solutions Company Ltd.

FIRST PRINTING